Mass Culture
and Everyday Life

Edited by Peter Gibian

Routledge New York and London

Published in 1997 by
Routledge
29 West 35th Street
New York, NY 10001

Published in Great Britain by
Routledge
11 New Fetter Lane
London EC4P 4EE

Library of Congress Cataloging-in-Publication Data

Mass culture and everyday life / edited by Peter Gibian.
p. cm.
Includes bibliographical references and index.
ISBN 0-415-91674-7 — ISBN 0-415-91675-5 (pbk).
1. Popular culture—United States. 2. United States—Social life and
customs—1971– 3. Mass media—United States. I. Gibian, Peter, 1952–.

E169.04.M367 1996
306'.0973—dc20 96-21130
 CIP

Contents

Everyday Life: A User's Guide

This collection of lively essays offers a clarifying overview of the development of critical practices in one of the most vital new academic fields—the study of mass culture as it transforms "everyday life." Contributors also provide a detailed, concrete survey of a wide range of the mass cultural phenomena that have come to define our everyday lives in recent years: from baseball cards to college curricula; from Reagan's body to Mike Tyson and Anita Hill; from tampons to exercise fads to visions of angels; from soaps to opera to rhythm and blues; from horror film monsters to the interrelation of cats, pigs, and mothers in *Babe*. Of special note are ground-breaking essays on the boom in talk radio and talk TV and the implications of such "airwaves dialogue" as a new forum for public discourse; on shopping mall spaces and new modes of shopping as cinematic spectacle; and on how "everyday life" in the university has become a key battleground in America's ongoing "culture wars."

This anthology brings together essays by leading theorists in the field, whose writings over the past decades helped to inaugurate the development of "cultural studies" in North America and continue to set the terms for current debates. But the direct, accessible, refreshingly personal essays collected here speak not only to an audience of academic specialists but to a wide general readership. Combining essays on theory and method with an extended series of concrete "case studies" which apply and test theoretical stances, this book offers familiar, compelling, lived examples of the ways in which critical analysis can arise out of the complex negotiations of everyday life practice.

All of these contributors are linked by their various associations with *TABLOID*, a small but seminal journal that emerged in the early 1980s, during the first wave of cultural studies interest in North America. With its critique of "manipulation theory" and of strict dichotomies between high and low culture, or between active cultural producers and passive cultural consumers, its insistence on the need for detailed analyses of everyday life practices from within, and its definition of these everyday life practices as potential sites for active, creative resistance to a dominant order, *TABLOID* made an important break on the one hand from the Frankfurt School—with its somber, angst-filled voice, its pessimistic resignation, and its fear of a monolithic, manipulated, and manipulative mass culture—and from a mindless celebration of pop-cultural liberation on the other. This anthology brings together essays that originally appeared in *TABLOID* with new work reflecting the current concerns of these *TABLOID*-related writers, allowing us to test the problems and possibilities for such a critical engagement with everyday life experience, in the context of developments in both critical and cultural practices over the past fifteen years.

Finally, *Mass Culture and Everyday Life* is meant not as a retrospective but as a call to future work, stimulating all of us to become close, critical readers of the oppressive and progressive political dynamics inherent in even the most seemingly mundane of our daily activities.

Where Did We Come From? Where Are We Going?

Critical Approaches to Mass Culture and Everyday Life

The *TABLOID* Story

Between Frankfurt,
Birmingham, and Bowling
Green—A Genealogy of
One Form of Cultural
Studies in North America

Jean Franco

Before cyberspace and desktop publishing, a group of us at Stanford University would spend days and days and days putting each issue of the journal *TABLOID* together using a beat-up light table, a messy waxer, impossible Letraset titles, and X-Acto knives and Scotch tape for primitive "collage" graphics. We took turns typing articles into columns on an electric typewriter and then spent hours whiting out typos by hand before taking the copy to the printer. We printed about one thousand copies, lined up at the post office to mail them to our scant list of subscribers, and gave a lot of copies away. But during the five years of the publication of *TABLOID: A Review of Mass Culture and Everyday Life*, from 1980 to 1985, the collective—a group of faculty and graduate students, most of them teaching and studying in literature departments, that got together regularly for brief discussions of editorial business and a great deal of lively talk—did a remarkably efficient job of digging into the motherlode of cultural issues—examining social fantasies, computer games, the use of radio talk shows to promote conservative propaganda, and the serendipitous new urban spaces of shopping malls or demolition sites. In common with other emerging groups, we felt ourselves to be engaged in a moral and political critique of late capitalism—though we did not feel the need to be solemn about it.

A lot of '60s attitudes carried over into the late '70s, when we began work on the journal. Some people still lived in communes where they grew their own food and wove their own clothes. Many still had a penchant for artisanal modes of production; handwritten postcards, string bags, and leather belts were sold from stalls on the campus. Poetry was still read at political meetings. And it was still possible to think of being an independent intellectual, even though these were a dying breed in the United States. Our mode of operation was inspired by the mimeographed and scarcely legible gray pages that reached us from the Birmingham School of Cultural Studies, and we were ini-

tially tutored by the film journal *Jump Cut*, which had huge pages and a small staff, and favored films that were impossible to see, at least in Palo Alto. A companionable network of little magazines published at that time: *Cultural Correspondence*, *Fuse* magazine, *Theoretical Review*, *Metamorphosis*, *Raw* magazine, and *Zippy 3*. Our artisan style (which went along with a nonacademic tone and orientation, and a perhaps crazy sense that we were addressing not only academic specialists but everyday readers, and focusing not on methodology but on concrete, familiar, lived examples of the ways in which critical analysis and creative resistance can arise out of the complex negotiations of everyday life) was not adopted—wisely, as it turned out—by another ally, *Social Text*, which also began publishing as a collective at about this time, but had a far more realistic idea of how to stay in business. *TABLOID* inherited a distrust of the academy, a yearning for community (or a collective), and a preference for the margins. We wanted to engage in critical debate, but playfully; we wanted to be independent of the academy, but without leaving it.

However, this was also a time when the '60s experiments in new kinds of pedagogy were disappearing and when such public intellectuals as existed were increasingly speaking for the right. The kind of oppositional, dropout, holier-than-thou position much cultivated on the left was not a position from which to understand the shift from confrontational politics to culture wars that was already taking place.

We learned the hard way. A roundtable on independent filmmaking addressed to a mythical beast called the "general public" was attended only by filmmakers. Our interview with Michel Foucault turned up so much mutual misunderstanding that it could not be published. Popular culture and resistance? The great man groped for some common ground, and so did we. And it's odd that we didn't find it given that the great panopticon—the Hoover Institution for the Study of War, Revolution, and Peace—was looming right over us. We also made an attempt to engage in debate with the sectors of the left that were then promoting Italy's autonomia movement, expressing a hope "to hear from our readers and to use this debate to further strategies for political resistance in a period of ever-increasing threats from the Right" (winter 1982). There was, sad to say, absolutely no response.

Bruce Robbins's description of the left's "deprived but after all mildly self-flattering self-image of inner exile, alienation, detached and unencumbered oppositionality"[1] aptly describes the place where the *TABLOID* collective at first imagined itself to be, though fortunately it did not stay there. Defying the prevalent anomie, *TABLOID* tried to show that intellectuals could work collectively. But what bonded the *TABLOID* collective was not only a sense of inner exile but their dissatisfaction with the anti-intellectualism of the new left and a consciousness of the disparity between what counted as culture for most people "in the world" and what was dispensed as culture by the institution. What R. Radhakrishnan has criticized in some contemporary culture critics, namely, their suspended animation in "an anomalous scenario in which the

best of progressive theory seems bereft of objects of explanation, while emerging historical realities seem oblivious of high theory,"[2] was our impetus for trying to revive the mass culture debate at a moment when it seemed to have been prematurely foreclosed in the United States. At that time, "mass culture," when spoken about at all, was represented as the "other" of the academy, the place of mindless pleasure and capitalist manipulation. And it was what Andrew Ross calls "the specter of *Kulturpessimismus*" that we set out to exorcise.[3]

TABLOID's first position paper, "On/Against Mass Culture Theories," staked a place between the uncritical, celebratory popular culture studies at that point associated with the Popular Culture Association based in Bowling Green and the manipulation theory of mass culture that still underpinned the empirical research of the vigorous "alternative" communications theories. In the first issue of *TABLOID*, the inclusion of an essay by Herbert Schiller titled "Media and Imperialism" was a recognition of the historical importance of the group of scholars that included Schiller and Dallas Walker Smythe, who were then analyzing the globalization of the media and, more importantly, stressing the cultural impact of U.S. media in what was then termed the periphery.[4] At that time "alternative communications" scholars were engaged, for example, in the UNESCO dispute with U.S. corporations over the latter's disingenuous insistence on the "free flow of information." In contrast to this sort of global analysis, *TABLOID* turned to examination of the micropractices of everyday life, exploring sometimes wild forms of reception, and stressing not only mass culture's capacity to absorb and deploy all possible repertoires but also its potential liberatory tendencies.

A lot of preliminary work went into this first collective paper, which explored and tried to describe these as-yet-elusive forms of "resistance." Mass culture and everyday life were seen here as a multiplicity of practices rather than of manipulative products or artifacts: "The artifact of mass culture is not so smooth and seamless as manipulation theory would have us believe, like a sheer and polished rock face that allows for no scrambling; on the contrary, it is a rough, irregular surface, with fissures that enable one to find footholds." With a certain amount of hubris, we then proclaimed that "discovering those footholds is the first step toward understanding *and* transforming the meanings and political function of mass cultural phenomena."

Given the rapid institutionalization and commercialization of what is now called "cultural studies" in the United States, it is important to pause and consider this particular moment, modest as it was. In England, cultural studies were institutionalized in Birmingham as an at first precarious offshoot of an English department, exploring the possibilities of an interdisciplinary dialogue among sociology, anthropology, and literature. Stuart Hall and his Birmingham colleagues were able to build upon the work of Richard Hoggart and Raymond Williams as well as on structuralism's interruption and questioning of this culturalist tendency in the early seventies. *TABLOID*, on the other

hand, found itself confronting the remnants of a counterculture that had opted for psychedelic mysticism and ascesis. In the first issue of *TABLOID* we paid respectful farewell to the guru of the new left, Herbert Marcuse, though the statement in Carol Becker's obituary that "as the culture begins to admit the profound level of alienation we have reached, it will look more and more to the work of Herbert Marcuse" was, in fact, a line not taken.

TABLOID indeed reclaimed mass culture (a term that was always under erasure) as a network of practices too diffuse and polysemous to be appropriated and always pliable to rearticulation and recombination. The sources were eclectic: Foucault, Deleuze and Guattari, and (with some reservations) Jean Baudrillard and Fredric Jameson. Indeed Fredric Jameson was, perhaps, more important than we explicitly acknowledged. His essay "Reification and Utopia in Mass Culture" had appeared in 1979 and proposed what then seemed a novel way out of the high culture/mass culture binarism that was so deeply rooted in university disciplines. His proposal was to rethink the opposition high culture/mass culture so as to get beyond "the emphasis on evaluation to which it has traditionally given rise—and which, however the binary system of value operates (mass culture is popular and thus more authentic than high culture, high culture is autonomous and, therefore, utterly incomparable to a degraded mass culture) tends to function in some timeless realm of absolute aesthetic judgment."[5] What attracted us to Jameson's work was his respectful and detailed analysis of Hollywood films—*The Shining, Jaws, Dog Day Afternoon*—which took full account of all the mediations of genre, coding, and reception. This kind of reading was current in cinema studies in this period, thanks to such journals as *Screen* and *Jump Cut*, but it had rarely been extended to television, radio, and everyday life. And Jameson's insight that mass culture offered no "primary object of study," no "first time of reception, no 'original' of which succeeding representations are mere copies," helped us to avoid the fetishizing of mass culture.

But out of the enormous spectrum of contemporary culture, how do you select without treating each object of analysis as a portentous "symptom"? *TABLOID* contributors almost always started from fortuitous matches between everyday occurrences, mass cultural trends, and their own lives and tastes. Ed Cohen was a participant in the everyday rites and rituals of the true Dead Heads; Jon Spayde played Space Invaders and pachinko often in arcade holidays from his studies in Japanese literature and culture; the mysterious Emmenagogue Sisters clearly spent a lot of time in the supermarket shopping for tampons. At some point all of them realized that *TABLOID* offered something new: the possibility of seriously discussing, and writing about, these experiences. Wahneema Lubiano, busy with her analyses of English Renaissance literature, found a tremendous release in writing out her ongoing meditations about Prince and the dynamics of African-American subcultures and music—and this has now become a primary area for her research. Similarly, Tania Modleski easily made connections between her studies in the eighteenth-century English novel of sensibility and the groundbreaking writing she would

do on Harlequin romances and television soaps. And Mary Louise Pratt's training in linguistics came into play as, using the pseudonym of Ricky Smith, she sussed out the menace of the letter x, while her work in "conversation analysis" led to her fascination with the moment-by-moment interactions of talkers on call-in radio.

Although many of the *TABLOID* pieces were written in the spirit of the *flâneur* guided primarily by a desire for entertainment and distraction, these analyses also always reflected a consciousness of the flow of history beneath the pavement. This was certainly the case with Dana Polan's overview of the telling changes in social vision implied by a new generation of horror films — defining a "paradigm shift" that continues to shape the mass cultural imagination today. And Peter Gibian's study of the Toronto shopping mall Eaton Centre is a journey not only through one particular arcade but also through the history of arcades, exhibitions, and department stores, describing a process of deterritorialization, or abstraction, as the solid and compact edifice of the nineteenth century began to desolidify. Gibian evokes history against the grain of the mall, which seeks to promote "containment and introversion," surface over depth, and timeless revery over any attempts at historical reflection. This cross-hatching of centralized ownership, mobility, isolated environments, and simulation that Gibian discovered in the shopping mall was, at the same time, an invitation to read space differently, something that, though we did not know it yet, was being theorized as "postmodern geography."

The *flâneur* spirit also surfaced in *TABLOID*'s lone attempt to go bicoastal. "New York is a Third World City" was an excursion along the margins of the major global finance capital, at a time when new urban cultures such as hip-hop and rap were being taken over by art galleries and the music industry and when the city was gearing itself to clean up the trains and improve the quality of life. This *TABLOID* issue sported a cover designed by the graffiti artist Lady Pink, showing her on the top of a tagged subway train. Using Pedro Rivera's photographs of the "casitas" (the simulated peasant dwellings of Puerto Rico that no longer exist on the island but were built playfully in the rubble of demolished NYC buildings) and Nancy Guevara's interviews with hip-hop artists, *TABLOID* read New York as a running battle over public space in which resistance was momentary, a quick gesture before the police dogs came down the tunnel.

In this happenstance way we came upon the conservative takeover of the airwaves and picked up on the then almost unnoted phenomenon of talk radio — which fascinated several of us so much that we couldn't help but tune in and tape talk shows for later analysis. We found that while most of us slept, insomniacs all over the country were calling in and demanding that the government nuke Iran. "Hello, You're on the Air" (Franco), "Newspeak Meets Newstalk" (Gibian), and "No, She Really Loves Eggs" (Pratt) engaged with what Gibian termed the "striking garrulity of 1980s America" that had surfaced in the heterogeneous radio call-in talk shows and in talk TV. The new talk media interested us because, in the words of Mary Louise Pratt, who examined

the micro-practices of talk-show interactions, they illustrated the fact that "the improvisatory character [of talk] is a crucial dimension of much mass culture and everyday life activity"; and, as she goes on to point out, this is "a dimension that tends to be obscured by structure-oriented kinds of analysis that can only approach the dynamic of everyday life practices and interactions by first defining and isolating discrete texts or artifacts and monolithic subjects playing fixed roles" (winter 1983). But talk radio also undermined assumptions that dialogue was conducted on an even playing field and the notion that "heterogeneity, disorder and spontaneity" were "inherently beneficial or emancipatory." What we caught was the first groundswell of discontent and vituperation that would make radio call-in shows such a potent recruiting ground for the conservative vote. A pity that we couldn't have bought some airwaves of our own before they were taken over by the likes of Oliver North, G. Gordon Liddy, Newt Gingrich, Pat Buchanan, and World Christian Radio. Even in those days, the talk show provided a place where being politically incorrect could be turned into a virtue. The journalist Diane Rehm commented recently on the fact that talk shows are the places "through which the public's worst suspicions are confirmed daily," observing, for example, that, after the Oklahoma City bombings, "the talk shows were filled with the rage of listeners and hosts around the country who believed the blast had been carried out by foreign nationals."[6] This kind of groundswell we sensed and began to analyze in the early '80s as what seemed to be a new form of participatory dialogue between media and public turned out to be a silencing mechanism that shut out liberal opinion while opening the sluice gates to dangerous and powerful prejudices.

TABLOID's first issue coincided with the moment when "culture" began to be seen as a new kind of politics, especially on the right. Despite our archaic mode of production, and indeed a positive preference for hand-held cameras, pirate radio stations, and the Grateful Dead, it was the first rumblings of this march of those we had considered political dinosaurs that, in retrospect, differentiated our project from that of cultural studies — at least as it later came to be institutionalized in the United States.

The election of Reagan in 1980 heralded conservatism's long and destructive march through the institutions. The second TABLOID position paper (winter 1981) registered the transition: "The right now holds the initiative in the United States. In the last few weeks, conservative institutions have emerged like toadstools out of the rain." Under these circumstances, what kind of resistance can be practiced? The virtual impossibility of "an alternative hegemony" in any foreseeable future is implicitly acknowledged in the position paper, which tackled the formation of subjectivities in our racially mixed and class-stratified society. Noting that "relations of race, class, sex and geographical position in the world economy *are all categories used in the overall organization of production*," we concluded that "an alternative hegemony to that of capitalism can come into being only when relations in *all* categories are

changed"—a utopian possibility that now seems as remote as the Planet Rapture described by Jon Spayde in his *TABLOID* piece on evangelical apocalyptics. In reality what seemed to bother us was the difficulty of those desirables—solidarity and group identity—given the serialized experience of everyday life, which was rapidly being intensified by "mobile privatization" of the electronics revolution and struggles over ethnic identities that were leading increasingly to dangerous visions of racial separatism. Our solution was to arrange a forced marriage between (of all people) Foucault and the Sartre of the *Critique of Dialectical Reason*. Foucault's attention to the micropractices of diffused power and his antifoundationalism do not sit easy with Sartre's attempt to account for the formation of groups and societies, especially as Sartre built his theories on the assumption of a sovereign subject. But like our attempt in publishing our own early translation of excerpts from Michel de Certeau's *Arts de faire* (later translated as *The Practice of Everyday Life*)—where cut up passages from de Certeau were placed in a sort of collage dialogue with brief interventions developing *TABLOID* perspectives through North American case studies—the marriage of incompatibles was eventually productive, allowing us to get beyond those unanswerable questions and impossible totalizations and look at what was happening in our own backyard. It was, however, the Republican victory of 1980 that gave us the necessary shove in the direction of examining what we had hitherto denied: the relevance of our institutional base.

The Leland Stanford Junior University had been founded in 1885 by Leland Stanford, the railroad baron, who endowed his university generously, hoping to create an instant West Coast rival to Harvard and Yale, a place where students would be instilled with "an appreciation of the blessings of this Government, a reverence for its institutions, a love of God and humanity."[7] For many decades the university was known primarily for its engineering school; early on, it distinguished itself by making life difficult for sociologist Thorstein Veblen, and this tradition returned in the 1960s as Stanford became notorious for its petty treatment of economist Paul Baran and its unprecedented dismissal of a tenured English professor, Bruce Franklin, for his participation in Vietnam War protests on campus. By the time we arrived in the seventies, then, "the blessings of this Government" and "reverence for its institutions" were not much in evidence at Stanford.

The campus had been built on the site of Leland Stanford's horse-breeding farm. Students referred to it as "The Farm," as if half-consciously ironizing the pastoral yearnings of its founder, who no doubt saw "nature," in the form of acreage, as the appropriate barrier in the spatial deployment of class and racial difference. To this day, U.S. 101 separates the unpaved roads of East Palo Alto from the immaculate gardens and classy shopping malls of the other Palo Alto. And while many American universities separate town and gown, often by a visible barrier, a gate or archway, Stanford's "ivory tower" isolation is especially marked. To leave Palo Alto and enter Stanford's campus, one has to pass

over a moatlike bridge and then follow a long, palm-lined drive through an expansive wilderness of eucalyptus before arriving at the buildings of the Inner Quad (or "cloisters") and the Memorial Chapel. In this other world, the Spanish Mission architecture, termed "romanesque" by some, is implacably symmetrical. The large, beige stone blocks capped by the red-tiled roofs are monumental—to the point where you begin to feel like Aida as she entered the tomb. Then, on the hour, bells clang and a murderous charge of cyclists looking neither to left nor to right bears down from all directions. The most visible landmark is the tower of the Hoover Institution for the Study of War, Revolution, and Peace, a right-wing think tank that housed Kerensky and later Sidney Hook. The dominant sensation in the bleached emptiness of the appropriately named White Plaza, experienced by anyone who has walked on crowded city streets or traveled on buses or subways, is one of extreme disassociation. The questions "Where am I?" and "What am I doing here?" spring readily to the lips, and these were intensified in the late seventies and early eighties by visitations from other planets. Edward Said, Clifford Geertz, Julia Kristeva, Noam Chomsky, and E. P. Thompson dropped in and then almost without a pause for breath winged their way rapidly back to whatever intellectually stimulating environment they came from.

But, as TABLOID came to realize, the isolation was in fact imaginary. In 1983 TABLOID sent out notices inviting participation in an open forum on the state of the university under the Reagan administration. The forum was attended by faculty and students, including some faculty working at the Stanford Linear Accelerator, and finally resulted in one of the most significant and prescient issues of the journal: "Disciplining the University: Life in Reagan's Backyard" (winter 1984).

"There are ways in which Stanford's privateness and privilege make it an especially revealing vantage point from which to study change under Reagan," we observed, coming to understand that Stanford's ongoing relationship with the Reagan machine in fact made it "an especially apt place to look at how that machine operates when it gets the upper hand." What the TABLOID forum and the position paper set out to detail was the conservative project for the university: "We began to ask how one might link together politically based changes in things like the research priorities of funding agencies, with internal changes in intellectual fashions inside particular disciplines. . . . We began to ask what kinds of things political machines and elected governments might need universities for, and what relationships the current administration and Reagan machine in particular were trying to construct with universities." The redefinition of the curriculum, the stress on expertise and other changes, often concealed behind a bureaucratic use of vague language, were taken to be symptomatic of vaster changes "in the relationship between the university, business, and the state, changes that tend to eliminate much of the looseness and space for diversity that academics have counted on in the past."

Whereas the standard conservative narrative has depicted universities as

being held hostage to fanatical feminists and bullying leftists, the reality explored by the *TABLOID* collective showed something very different: a move away from knowledge "as life-enhancing activity" and toward "seeing knowledge as expertise aimed at producing hierarchies of authority." The diffuse sense of alienation felt by faculty and students alike was a symptom of lack of control in an environment in which decisions were made by distant governmental and academic administrations. The resistance that we had looked for within mass culture had turned into a diagnosis of global policies carried out on a local terrain. Indeed, an amazing number of actual and potential battles of local, national, and international importance are registered in the position paper on university life: the struggle over the Hoover Institution's attempt to encroach on the appointment of faculty in academic departments (despite the fact that the Institution was supposedly independent of the university), the proposal for a Reagan Presidential Library at Stanford, and an attempt to tie language teaching to U.S. foreign policy. Although these initiatives from the right were contested and defeated by faculty and students, the very fact that they had to be fought at all demonstrated the seriousness of the struggle for the academy. Another significant sign of major storms to come that was noted in the position paper was the university's reinstatement of the Western Civilization course requirement which, in our view, gave students the impression "that they have grasped the essence of what is pointedly presented as *their* finest cultural heritage, without ever really having been forced to examine the complexities, contradictions, and omissions inherent in the concept of *a* Western Civilization."

The preoccupation with what passed for "Western civilization" was shared by others on the campus, and eventually resulted in a broadening of the requirement. But this initiative, which became the focus of nationwide publicity and mass-media attacks from the right and is still cited as a bad case of so-called "political correctness," was, in fact, a reaction to the threatened reorganization of the university on pragmatic lines.

In a retrospective overview, Stuart Hall said of the Birmingham Centre for Contemporary Cultural Studies: "We never produced organic intellectuals. . . . We never connected with that rising historic movement; it was a metaphoric exercise. Nevertheless, metaphors are serious things."[8] I would claim that *TABLOID*, on the contrary, did at least for a moment connect to the rising historical moment in linking the reorganizations and changes in the university to the military economy of the Reagan years, an economy that has left an inheritance of immense national debt. *TABLOID* dissented from an attitude common among academics that their academic interests could be pursued without reference to global change, an attitude that has recently been held up to scrutiny by Gayatri Chakravorty Spivak in her book *Outside in the Teaching Machine* .[9]

In retrospect, the folding of *TABLOID* in 1985 is a great pity, because many of the trends attributed by *TABLOID* to militarization and disciplining (in

position papers on "The Militarization of Everyday Life," as well as in the analyses of university affairs) were intensified later by post-Cold War policies. As Rey Chow shows in her essay "The Age of the World Target" (in this volume), deterrence did not stop with the end of the Cold War but led to "a blurring of the boundary between war and peace," ushering in "a new age of relativity and virtuality, an age in which powers of terror are indistinguishable from powers of 'deterrence,' and technologies of war indissociable from the practices of peace." Indeed, as Chow shows, these developments continue to be most evident in the "disciplining" of our modes of academic knowledge: "The United States has been conducting war on the basis of a certain kind of knowledge production, and producing knowledge on the basis of war." As a corollary to Chow's thesis that "the disciplining, research, and development of so-called academic information are part and parcel of a *strategic* logic," one could mention the wide-ranging increase in control, surveillance and censorship in the epoch of the "free market"—censorship of text-books, of "offensive" art, camera eyes in shopping malls and along streets, attempts to control Internet and television viewing. In a recent interview (*New York Times* , March 11, 1996), Dan Rather stated that pressures on the media "are greater today than almost any time in the past, except the McCarthy era or the late 1960s," adding that the reaction of journalists is most likely to be self-censorship.

What Rey Chow sees as the expansion of military strategies into everyday life may look different if we reintroduce the old-fashioned term *contradiction*. Market forces have no respect for religion, tradition, or history. According to an obituary in *La Nacion* of Bogota (March 6, 1996) for a particularly irreverent Brazilian pop group who were killed in an air crash, their songs undermined every conceivable form of human and family values and were especially popular with four- and five-year-old kids. In Catholic Colombia, naked bodies simulate orgasm on cable TV. Sexual liberation, once the pride of the avant-garde and the counterculture, has become part of a visual and auditory repertoire that is too prevalent to shock anyone but pre-school children. The other side of the coin is, not surprisingly, the retreat into fundamentalism, an increase in the number of topics defined as taboo (including the teaching of evolution in some parts of the United States), and a resurfacing of isolationism. Militarization was one overt form of control, but control is now far more dispersed and insidious.

Once the avenue of opportunity, the university is becoming either an ivy-clad walled city or a containment area for minorities, a glaring example of the latter being the City College of the University of New York, once the stepping-stone for aspiring immigrants who wished to enter the professions. A campus building completed in the eighties resembles a high security prison. Apart from the cafeteria, there is no large central meeting place where students can congregate; there are very few places where they can even sit down. A glass-enclosed bridge between two buildings provides a handy vantage-point for surveillance of any overt signs of dissent. But this open vigilance has been accompanied by economic constraints that are making even more significant inroads

into intellectual life. Under the guise of producing a cost-effective university with an emphasis on results (a trend that has been pushed to the point of absurdity in England), the widespread movement toward rationalization and downsizing has emerged as a major force for cultural retrenchment, calling out for new kinds of academic politics, especially as the downsizing most seriously affects those who are unrepresented in the decision-making process. Even as I write, the underpaid administrative and service staff at Barnard College are marching in protest, having been asked to contribute more of their meager salary to pay for their medical benefits. Many of the faculty stand on the sidelines, not daring to intervene.

TABLOID ceased publishing largely as a result of these broad-based movements toward the "disciplining" of university life; group members found themselves increasingly dispersed geographically and harried professionally—the leisure space for "extra-curricular activities" was rapidly shrinking. But *TABLOID* had progressed from its beginnings as a journal operating in the ruins of the '60s to become a remarkably sensitive monitor of a conservative program that has yet to be fully implemented. For this reason it is as relevant in the desperate '90s as it was in the '80s. Even in its earliest critical explorations of emerging everyday life practices—from TV ads to soaps and horror films, from exercise fads to fashion trends, from baseball cards to video games, from talk media dynamics to new modes of shopping—*TABLOID* brought to the fore key questions and issues that we must face with a new urgency today.

Notes

1. Bruce Robbins, ed., *Intellectuals: Aesthetics, Politics, Academics* (Minneapolis: University of Minnesota Press, 1990), x.
2. R. Radhakrishnan, "Toward an Effective Intellectual: Foucault or Gramsci?" in Robbins, ed., *Intellectuals*, 57.
3. Andrew Ross, *No Respect: Intellectuals and Popular Culture* (NY: Routledge, 1989).
4. See, for example, Herbert Schiller, *Mass Communications and the American Empire* (NY: A. M. Kelley, 1969).
5. Fredric Jameson, "Reification and Utopia in Mass Culture (1979)," in *Signatures of the Visible* (NY: Routledge, 1990).
6. "Time for the Hot Mouths to Cool It," *Washington Post*, reprinted in *Guardian Weekly* (March 10, 1996).
7. George T. Clark, *Leland Stanford, War Governor of California, Railroad Builder and Founder of Stanford University* (Stanford, CA: Stanford University Press, 1931).
8. Stuart Hall, "Cultural Studies and Its Theoretical Legacies," in L. Grossberg, C. Nelson, and P. Treichler, eds., *Cultural Studies* (NY: Routledge, 1992), 282.
9. Spivak, *Outside in the Teaching Machine* (NY: Routledge, 1993).

On/Against Mass Culture Theories

The *TABLOID* Collective

Though we describe *TABLOID* as a review of mass culture and everyday life, neither term precisely designates our area of concern. Like such terms as popular, folk, highbrow, lowbrow, consumer culture or culture industry, mass culture and everyday life are usually deployed in the service of particular ideological positions. Our first task is to criticize them.

People were first referred to as "the masses" when the working class began to gain access to literacy and knowledge and to acquire cultural capital. To some intellectuals, this immediately revealed the dark side of democracy: masses do not think, they react; they do not discriminate, they consume. More significantly, mass obliterates class, race, and sex. Mass society was defined and described by culture critics such as Ortega y Gasset as a society in which the heedless many use the creativity of the few: his "mass man" does not invent, but merely uses other people's inventions. Mass culture would inherit all the negative aspects attributed to "mass man"—programmed, vicious and mindless, a kind of Dracula sucking the blood of a maiden called High Culture. Yet on examination this creature is more an invention of the culture critics than a reflection of reality.

Historically, terms such as folk and popular culture have had a ring of authenticity that came from association with the people. Mass culture, because of its association not only with mass society but also with mass production, invariably implies a dehumanized technology; it is made an instrument in the rationalizing process of capitalism. Indeed it is true that the new technologies produced new cultural forms. The type-revolving press ushered in the nineteenth-century popular press; engraving and photography ushered in the technological reproduction of the image. Then came the phonograph,

This collectively written "position paper" opened the first issue of TABLOID 1:1 (spring–summer 1980): 1–12.

the cinema, radio, television, cable, and video. These offered a potential restructuring of the cultural field and eventually allowed a broader access to music, drama, and literature and, more positively, to new types of cultural participation. But this democratization was contained, precisely because these technologies were deployed within a patriarchal, discriminatory, and class system, which both organized demands and stigmatized popularity. The terms yellow press, penny dreadful, melodrama, canned music, the Hollywood dream machine, the idiot box, express to perfection capitalism's schizophrenia—its elevation of the market and its depreciation of popularity as suspect.

While liberal and conservative culture critics (e.g., F. R. Leavis in England and Dwight McDonald in the United States) rationalized this situation by

"We see mass culture not merely as the source of false consciousness, but also as the source of the collective energy that might help overcome that false consciousness."

carefully discriminating between the creativity of a privileged high culture and the programmed nature of mass culture, orthodox Marxist critics were also dismissive. Leo Lowenthal's study of popular literature and Arnold Hauser's massive study of art both view mass culture as simply a degenerate form of high culture. The first serious criticism from the Left was in fact initiated by Walter Benjamin, Theodor Adorno, and Max Horkheimer, who, along with Herbert Marcuse and others, have come to be known as the Frankfurt School. This group first came together in Germany in the twenties and much of their work was initially directed to the study of the mass phenomenon of Fascism, and its use of radio, film, and spectacle to reinforce and reproduce the norms of the totalitarian state. Despite the Frankfurt School's tendency to see mass culture solely as an instrument of propaganda, Benjamin grasped one crucial factor about the new media that had hitherto been overlooked—namely the fact that they had already modified our ways of seeing, that the work of art was irrevocably changed since mass reproduction inevitably called into question the status of art works as unique and unrepeatable artifacts. Not only were art objects transformed by the media, but so also was audience reception; instead of contemplation, the cinema (for example) encouraged "distracted" viewing. Benjamin's early death meant, however, that these observations remained brilliant insights rather than systematic contributions to mass culture theory. The migration of Adorno, Horkheimer, and Marcuse to the United States led to new theoretical developments as well. Unlike the totalitarian state in Germany, the United States offered the example of democracy in which the legitimation of capitalism came "from below," that is, from the market itself. Instead of the government orchestrating a vast totalitarian spectacle focused on a mythic leader, the democratic process was decentralized, "internalized" in individuals who perceived themselves as exercising discrimination and choice. The process which Max Weber, the nineteenth-century German soci-

ologist, had described as "rationalization" involved the conversion of science and technology into an ideological force that had now gathered its own momentum: traditional values and cultural forms were now deployed not for the sake of ideological control but as tools in an ever-expanding process of production.

Though Herbert Marcuse made the most sweeping analysis of advanced capitalism (see *One-Dimensional Man*), it was Adorno, particularly in his article on popular music, who attempted to show precisely how the formal elements of an art can be pressed into the service of capitalist rationalization. And yet, though *TABLOID* recognizes the pioneer work in cultural analysis done by Adorno, we believe that his rigid distinction between high and low culture, serious and popular art, glosses over a number of important issues raised by mass cultural activity. The drawing of boundaries within culture presumes clear criteria for isolating and then evaluating cultural phenomena. It is our opinion that mass culture questions as much as it confirms. To speak of an absolute separation between great art and mass culture is to ignore unsettling questions about the making and the value of culture. What *TABLOID* intends to develop here and in the future is a field of inquiry that opens up problems and possibilities beyond such restrictive categories.

The American university system has attempted to absorb this problematic area into a recognizable discipline: communications. Since the Second World War, during which a great explosion of electronic media and data-gathering processes took place, communications has grown as an academic discipline to become a science based almost solely on information theory. This development, as well as the more recent one of semiotics (i.e., the study of sign systems), represent efforts to devise an objective and scientific approach to media studies. The isolating of cultural activity from specific contexts and practices, however, has resulted in the seemingly bland and harmless pursuits that characterize the pietistic university department today—pursuits that are remote from the complex strategies of power in which communications plays only one part.

Manipulation Theories

Most discussion of mass culture today, both inside and outside of the university, centers on manipulation theory, that is, the notion that mass cultural artifacts convey to a passive consumer the ideological message that the designing or manipulating class intends to be conveyed. We wish to question the assumptions behind and the applicability of such a notion. This is not to say that *TABLOID* completely dismisses all theories based on the notion of manipulation; to do so would be unrealistic and naive and would lead to the unthinking celebration of mass culture characteristic of, for instance, the *Journal of Popular Culture*. We recognize that the manipulation of desires is intended, attempted, and often successful in capitalistic society. What *TABLOID* objects to is the universal and arbitrary application of the theory to all of mass culture,

as though manipulation were a self-evident fact of mass cultural activity—or worse, as though manipulation were the condition of mass culture itself. On the contrary, capitalist society is too complex and decentered to maintain such unrelieved manipulation of people and their desires. Manipulation is only a part of the picture, and *TABLOID* intends to explore the other parts as well.

Some of the most important studies of culture under capitalism do employ some version of manipulation theory. Two cases in point: Marcuse's concept of a "one-dimensional society" that incorporates and neutralizes liberatory or erotic opposition; and Stanley Aronowitz's depiction of mass culture as a sort of social regulator that functions by creating a system of "pseudo-gratification" for defusing creative energies. Both of these models underline the importance of manipulation theory to the left. Jerry Mander's recent attack on television plays upon a widespread fear of being controlled by the networks—the tube has imprinted the worst that has been thought and said on our brains, dickered with our mental structures, and scrambled all the gray matter: the synapses will never be the same. In a significant elaboration of this line of thought, Fredric Jameson (in his *The Political Unconscious*) has offered a Freudian analysis of mass culture attempting to trace the power of manipulation to its tapping and containment of unconscious energies.

Nearly all mass culture theorists recognize in mass culture a utopian element, which acknowledges real lacks in society and points toward solutions. In the crucial words of Hans Magnus Enzensberger, another critic in the tradition of the Frankfurt School, "the attractive power of mass consumption is based not on the dictates of false needs, but on the falsification of quite real and legitimate ones." Some theorists, such as Jameson, see this utopian element as serving only to further the work of containment of desires; it is the component that ensures the success of the mechanisms of manipulation. Others, like Enzensberger, see in it a great progressive potential. The "real and legitimate needs" spoken for in some mass cultural forms, which give these mass cultural practices their attractive power, are not always and everywhere held in the service of manipulation. Enzensberger resists ceding the power of real needs to the exclusive use of manipulation and control, and rather sees the utopian element as a challenge to the radical critic: "A socialist movement ought not to denounce these needs, but take them seriously, investigate them, and make them politically productive." In Enzensberger's argument lies an implicit criticism of all theories based on the notion of manipulation, because in effect all manipulation theories end up simply denouncing those expressed needs as forms of "false consciousness," not taking them seriously, since those needs are seen to function, finally, as mere accessories to the manipulative crime of mass cultural life. If they have no function apart from their role in drawing the masses in so that they can be more fully and forcefully manipulated, these "needs" can never be "politically productive" in Enzensberger's sense. But Enzensberger's formulation defines precisely the areas of special concern to *TABLOID*: we take the pleasures and attractions of mass culture seriously, and want to investigate these "real needs" with an eye to under-

standing them and opening them to new channels of fuller expression—thus perhaps helping to bring out and give voice to the "politically productive" energies they embody. Following Enzensberger (and also inspired by the crucial, groundbreaking work of Walter Benjamin in his Arcades Project), we see mass culture as a complex process drawing upon multiple contradictory impulses, and so take it not merely as the source of false consciousness, but also as the source of the collective energy that might help to overcome such false consciousness. In our view, the "utopian" urges embedded in mass cultural practices and products can become prime sites for radical criticism of the dominant order. It may be possible, then, after all, to envision forms of engagement with mass cultural life that are also in some ways resistant to its manipulative tendencies.

Manipulation theory, in its various versions, sets up a structure of control (manipulation/containment/repression/regulation) on the one hand and a well of deep energies (fantasies/desires/instincts/needs/creative or liberatory forces) on the other. It reduces mass culture to a well-oiled machine that runs on the steam we provide but that produces nothing of value in return. It assumes that we have all signed on for the duration as zombies, that we like to walk in a straight line, watch, listen, and read as if in a dream. In drawing this scenario, manipulation theory parcels out our humanity in an arbitrary fashion: all the brains go to the mechanisms and mechanics in charge while the involuntary processes, like breathing, are left to us. There is in short no allowance for the possibility of intelligent and conscious and critical participation in mass culture, because only those energies beyond individual control are finally beyond manipulative control. This simple assumption underlies all versions of manipulation theory, no matter what qualities are given to the "deep" energies seen to be working in mass culture. For critics like us who believe that strategies of resistance and productive action can and have been developed within mass culture and everyday life, such a framework for analysis settles all the important questions before they can even be raised.

Mass Culture and "Everyday Life"

"Everyday life" emerged as an important area of inquiry only in the early 1950s (although important precedents may be found in the work of Walter Benjamin and in a certain "rightist" sociological tradition best represented by George Simmel's studies of the sociology of the modern industrial city). In this period, the analysis of daily life was undertaken by French existentialist critics, most notably Henri Lefebvre, motivated by the fear that working classes of the advanced capitalist nations had ceased to be "revolutionary" in the context of a "bureaucratic society of controlled consumption." In their view, the traditional Marxist emphasis on the decisive role of the workplace in the formation of political consciousness had to give way to an analysis of the role of leisure-time pursuits and everyday life. Societal values, they believed, were constituted and reinforced in schools and universities, in stores, at football games, at the

dinner table, in clubs and movie houses, and so on; in these places individuals participated in the policing and containment of their own lives. The term "consumer society" came to replace the older concepts of "class" and "mass" society, and the new media (television in particular) were seen as instrumental in the casting of mass man's fulsome successor: the consumer. Needless to say, certain family traits were preserved. Like his or her amorphous ancestor, the consumer (according to this theory) does not produce, but rather passively and ravenously feeds his (or her) consumer habit.

In the wake of these early efforts two significant contributions to the analysis of everyday life came from the French structuralist camp. The study of sign systems in everyday life, or "cultural semiotics," as practiced for example in the work of the late Roland Barthes (*Critical Essays* and *Mythologies*), has led to elaborate formal analysis of fashion, food, interior decoration, architecture, and a wide range of mass cultural phenomena. These sorts of inquiry, conducted with the sophisticated tools of modern linguistics, have occasionally yielded interesting theoretical results. Yet such studies as "Hubcap and Mag wheel designs as a formalized combinatory system" can hardly be expected to lead us toward an adequate mass culture theory. Cultural semiotics has as a whole tended simply to describe the various codes and systems through which individuals participate in a given society or social class, while ignoring the dynamic interaction that takes place between these individuals and these codes. In short, in the thinking of most cultural semioticians, reception is still a passive ingestion of messages, not, as *TABLOID* believes it to be, participatory.

The work of Jean Baudrillard, on the other hand, represents an attempt to incorporate the analysis of everyday life into a general sociopolitical theory. In *Le système des objets* (1968), for example, beginning with a detailed consideration of furniture design, household appliances, interior decoration, and other elements of daily life, Baudrillard attempts to explode the myth of "consumption" by showing how commodities function as signs in advanced capitalism. Baudrillard increasingly finds (see *The Mirror of Production*) that the traditional "productivism" of Marxist analysis, with its emphasis on the material modes of production as the determinant social instance, leads to the systematic undervaluing of the sociopolitical importance of symbolic, semiotic, and/or linguistic exchanges. In Marx's time it was easy enough to trace the commodity back to its materiality (i.e., the material conditions of its production), and in turn to its use-value and surplus-value. Yet in the age of the media blitzkrieg, when a breakfast cereal can say "I love you," it would certainly seem that we are confronted not with an economy of *production* so much as an economy of *promotion*.

If we follow for a moment the history of the marketplace, Baudrillard's point about the economy of promotion becomes particularly clear. During the nineteenth century, the traditional open-air farmer's market was gradually assimilated into the space of the modern industrial metropolis by a process of progressive *enclosure* and *interiorization*. This initial centralization of the mar-

ketplace led to the further ordering and specialization of its interior space. The modern supermarket, radically specialized and compartmentalized, organizes the competitive multiplicity of vendors and their wares into competing packages. The actual commodity is thus itself "interiorized" as the significance attached to its cosmetic surface grows; it appears first and foremost within the codes of packaging and promotion, and only subsequently in the codes of use and of nature. Producers themselves are led to adopt this new point of view; producing for the code of packaging, they invent such wonders as the flavorless, ruby-red tomato, the perfectly bag-sized carrot. The supermarket interior furthers this process of semantic reversal and accretion by offering itself as a sort of meta-package: establishing a playful dialogue with the discourse of packaging (its calligraphy, its designs, its materials, its surfaces), the supermarket assembles a general "image" that identifies the products themselves as clean, cheerful, true, glossy, modern . . . and appeals to our own self-images.

One of the most notable cultural shifts during the advent of advanced capitalism is this move from a market organized around individual categories of products to one organized around buyers investing in diverse and multifaceted "images," and for whom the actual consumer goods are nothing but a single element in a more general economy of self-identification.

The processes of appropriation (e.g., an advertising jingle becoming a common link between people), and of identification (such as with the cosmetic — "looks," fads — or with brand-name products: Dodge vans, Motown) can help form new social groupings that elude the manipulative control of industry. In such a socioeconomic system individuals can find in commodities meanings that have nothing to do with their uses and functions. Consequently, every act of consumption must be understood as the *active* participation in a set of generalized codes.

Baudrillard's argument, however, fails to live up to its promise, because he attributes such all-embracing power to the code. He refers to the *terrorism* of the code in order to account for the way that the signifier is monopolized by capitalism. Capitalism's appropriation of the signifier is so complete that affirmation and opposition are simply generated as an interplay of signs and can no longer be anchored in any real situation. Real opposition can only come from outside the encoded system: we are left with the spontaneity of revolutionary insurrection and spontaneous free speech as the only viable forms of resistance. Two criticisms can be leveled against this idea. First, the term "code" implies a relatively static system abstracted from any specific use. Second, Baudrillard's theories appear to explain more appropriately a particular aspect of everyday life (i.e., advertising) rather than culture in general. We can agree with his analysis if it is applied in a less sweeping way. For advertising does exist in the absence of any traditionally conceived ideology: instead of basing itself on firm ideological principles, its mode of operation is tactical, strategic, and positional. Its repertory is, to say the least, amazingly versatile: it may recall nostalgic utopian pasts, locate itself within the avant-garde, or affirm its allegiance to all society. Strictures and structures — whether moral, erotic, formal,

historical, social—are all so many stimulants to ensure the effectiveness of its discourse. Advertising may evoke Taboo and Opium; it may celebrate Tsarist Russia (Wolfschmidt's vodka) or describe a product as revolutionary; it may celebrate the exclusiveness of the upper class (the hand-numbered object or the classic book) or the democracy of the common man (everyone has a Bud coming to him). But in the more general life of the culture, when capitalism operates in this sort of "advertising mode," appropriating older belief systems, high cultural forms, popular culture, myth, atavistic fears, and progressive hopes, and redeploying them as signs, it is always involved in a high risk operation—it risks posing seriously the very contradictions that are trivialized by advertising. Far from enforcing the "terrorism of the code," then, advanced capitalism is engaged in a dangerous play.

Stressing Contexts and User Practices over Manipulative Producers and Products

The incorporation of taboos, traditions, and principles into the play of signs is itself ideological, as Fredric Jameson has argued in his article "Reification and Utopia in Mass Culture" (*Social Text* I). In his discussion of the movie *Jaws*, Jameson mentions the many interpretations of the shark, which range from its representing the communist or Third World Other that threatens our society to its embodying the relentlessly organic ("a machine designed for survival"), adding that to fasten on any one interpretation is to miss the ideological point of the shark:

> Now none of these readings can be said to be wrong or aberrant, but their very multiplicity suggests that the vocation of the symbol—the killer shark—lies less in any single message or meaning than in its very capacity to absorb and organize all of these quite distinct anxieties together. As a symbolic vehicle, then, the shark must be understood in terms of its essentially polysemous function rather than any particular content attributable to it by this or that spectator. Yet it is precisely his polysemousness which is profoundly ideological, insofar as it allows essentially social and historical anxieties to be folded back into apparently "natural" ones, to be both expressed and recontained in what looks like a conflict with other forms of biological existence.

According to Jameson, what we now experience in mass culture is a more subtle confounding of our senses than that brought about by the single ideological message. Like the consumer society which produces it, mass culture offers us an array of items to choose from—only, in this case, the items are meanings. Pluralism, the ideological mainstay of late capitalism, is thus reproduced, or re-presented, in mass culture. It is the single message behind all individual interpretations, the pitch behind all freedom of choice. Yet Jameson's example, *Jaws*, is one which depends on the ability of the biological or the natural to organize and dominate all other meanings. In this respect, *Jaws* belongs to a more anachronistic mode of producing the ideological, in which nature

itself as the given and the unalterable is used to effect a closure of meaning. The more sophisticated products of advanced capitalism no longer need these archaic resources, however. And though *TABLOID* believes that Jameson's argument about polysemousness (or multiplicity of meaning) does bear directly on the production of meaning in contemporary mass culture, we would propose shifting the focus of attention from the "deep" symbol, a favorite notion of an analysis basically literary, to the processes that produce the various meanings.

To talk about the symbol and its mysterious capacity to mean several different things seems to us an evasion of the harder and more important question. This harder question is not *where* the plurality of meaning is located, but *how* the plurality of meaning emerges. *Jaws* again provides a sample instance. On the one hand, the shark in *Jaws* takes on diverse meanings from its interplay with other elements of the film. Clearly the most important of these is the response of the three major characters to the shark. If, for example, the shark assumes mythic proportions (Leviathan) or literary status (Moby Dick), this is largely due to the web of meaning spun around the creature by the old salt Quint, who functions both as Jeremiah and Ahab. Similarly, if the shark embodies a threat to bourgeois order (i.e., the smooth operation of the tourist economy as well as the earned enjoyment of the Labor Day holiday), we can look to the actions of Brody the cop as the source of that interpretation. The list also includes interplays specific to the medium of film. If, as some argue, the shark represents some primitive urge to violence in all creatures, including man, the opening sequence in which the audience cruises the shallows with the shark to the accompaniment of the ominous coda might encourage such thinking. In short, thematically and technically, the shark is constituted and given meaning in many different ways.

On the other hand, the meaning of the shark also depends on forces external to the film. An understanding of the context for the reception of *Jaws* must complement the analysis of its internal workings, for its meaning will vary according to the social, historical, economic, and political context in which it is viewed. Needless to say, a manipulative attempt to control the context is elaborately made. Consider the release of *Jaws*, for example. Having made a film with various and intriguing possibilities for interpretation, the people behind *Jaws* then concoct the "right" context for its reception, using all the resources of advertising (terrifying fliers: "Just when you thought it was safe . . . "), of the press hype (reports on movie crowds, shark sightings worldwide), and of commercial retailing (T-shirts, stuffed animals, rubber floats, etc.). The result is an overwhelming vote for the fear of the biological enemy as *the* way to interpret the movie—much as Jameson claims. Yet the point is that the "natural" meaning is not so much pushed forward by the movie itself, as Jameson claims, as it is drawn out by a particular, historical context for viewing, intense and hard sell at the beginning, now no longer with us. Now with the threat of worldwide military violence in view, the blind butchery of a large fish seems almost pastoral in comparison. One wonders what "natural" mean-

ing, what dominant context for reception, takes place under present circumstances.

An examination of specific contexts for reception is one way to challenge the model of meaning production proposed by manipulation theory. As contexts vary, so also vary the different meanings of the mass cultural process, and the possibility of fully manipulating response seems increasingly unlikely. Another more radical strategy is to question the status of what is examined in the study of mass culture. It is customary to speak of mass culture "objects" or "artifacts" or "products." These terms are indispensable in the absence of more precise ones, but they are nevertheless unsatisfactory. In mass culture there is no primary object or "original" to be preserved and reproduced in "mere" copies. To use Fredric Jameson's words, there is in mass culture no "primary object of study," "no first time of repetition, no 'original' of which succeeding representations are mere copies." One commonly finds among mass culture critics a nostalgic demand for those solid, no-nonsense objects that provide the stable reality to which we can return again and again. TABLOID takes a different approach. We believe that a notion of *practices*, of determinate activities repeated and redeployed throughout mass culture, comes closer to describing the peculiar nature of mass culture than the other more "solid" terms. The focus of our analysis, then, is the network of interrelated mass cultural practices, not the isolated artifact. As part of the network that links it to other practices, the artifact (another unsatisfactory term) is actually a field or space in which diverse practices—from both "high" and "low" culture—meet and recombine. *Apocalypse Now*, for example, brings together the plot line of a Conrad *novella*, the narrative voice of the hard-boiled detective novel of the '30s, the montage techniques of an Eisenstein film, the sexual titillation of *Playboy*, and the vicarious violence of the newsclip (to name a few) into something we could call a "primary object"—but to what purpose? TABLOID would attempt to understand such mass cultural phenomena as a redeployment—repetitions but with differences—of practices, techniques, strategies, fantasies, and so on, that are readily available in capitalist society.

Once the object of our analysis is "dissolved" or, rather, seen for the conjuncture of various practices that it is, we can begin to perceive the tensions and contradictions in mass culture. The artifact of mass culture is not so smooth and seamless as manipulation theory would have us believe, like a sheer and polished rock face that allows for no scrambling; on the contrary, it is a rough, irregular surface, with fissures that enable one to find footholds. TABLOID believes that discovering those footholds is the first step toward understanding *and* transforming the meanings and political function of mass cultural phenomena. Identifying and then forcing the contradictions in capitalist society has long been a tactic of radical analysis and activity, but in the field of mass culture, it takes on a new significance. Mass culture and everyday life involve us, obviously, at every turn: there is little chance of escaping the network of meanings and ideology that defines our lives in so many hidden and not-so-hidden ways. Yet to see the contradictions in the supposedly univo-

cal message directed at us is to establish a site of resistance *within* mass culture, a place where one opposes manipulation and devises strategies of subversion.

Contexts for Reception/Sites for Resistance

Here the work of Michel Foucault should be briefly invoked. Perhaps Foucault's most productive contribution to the study of cultural phenomena is his demonstration in recent works that power operates in capitalist society as a system of relations of force embedded in the lives which it seeks to dominate. That is, power permeates our daily lives and routines, even our bodies, with specific material effects that suspend us in a network of forces and counter-forces: "In short, this power is exercised rather than possessed; it is not the 'privilege,' acquired or preserved, of the dominant class, but the overall effect of its strategic positions—an effect that is manifested and sometimes extended by the position of those who are dominated." These positions—the effects of "micro-powers," as Foucault calls the deployed, embodied instances of power—constrain and fix us in our everyday activities; but, as Foucault recognizes, such positions do not always function reliably. In other words, the exercising of "micro-powers" entails a certain risk, for the positions also "define innumerable points of confrontation, focuses of instability, each of which has its own risks of conflict, of struggles, and of an at least temporary inversion of the power relations." Herein lies a promising paradox: according to Foucault, the deployment of power is too complex and too ambitious to be assured of complete success; the very materiality of power, the means of power's effectiveness, is also a strategy for turning the tables, for inverting power relations. Possible sites of resistance begin to emerge, at precisely the points of contradiction and conflict that our analysis of mass culture discovers. "Micro-powers" exercised rather than possessed are actually "micro-practices," and it is an important part of *TABLOID*'s project to explore, in specific cases, the strategies of appropriation possible *within* mass culture and to disclose the common ground of individual, class, and mass cultural practices.

Some Readings on Mass Culture

T. W. Adorno, *Introduction to the Sociology of Music*, trans. E. B. Ashton (NY: Continuum, 1976).

———, *The Culture Industry: Selected Essays on Mass Culture* (London: Routledge, 1991).

Roland Barthes, *Mythologies* (NY: Hill and Wang, 1975).

Jean Baudrillard, *Le systeme des objets* (Paris: Gallimard, 1968).

———, *The Mirror of Production* (St. Louis: Telos, 1978).

Walter Benjamin, *Illuminations*, Hannah Arendt, ed., (NY: Schocken Books, 1969).

———, *Reflections*, Peter Demetz, ed., (NY: Harcourt, Brace, 1978).

John Berger, *Ways of Seeing* (Harmondsworth, England: Penguin, 1973).

Stephen Bronner and Douglas Kellner, eds., *Critical Theory and Society* [A Frankfurt School reader, including Horkheimer, Fromm, Lowenthal, Marcuse, Pollock, Adorno, Habermas, Kracauer, and Benjamin] (NY: Routledge, 1989).

Susan Buck-Morss, *The Dialectics of Seeing: Walter Benjamin and the Arcades Project* (Cambridge, MA: M.I.T., 1989).

Michel de Certeau, *The Practice of Everyday Life*, Steven Rendall, trans., (Berkeley: University of California Press, 1984).

Simon During, ed., *The Cultural Studies Reader* (NY: Routledge, 1993).

Hans Magnus Enzensberger, *The Consciousness Industry* (NY: Seabury Press, 1974).

John Fiske, *Reading Television* (London: Methuen, 1978).

— — —, *Understanding Popular Culture* (Boston: Unwin Hyman, 1989).

Michel Foucault, *The History of Sexuality*, R. Hurley, trans., (NY: Pantheon, 1978).

— — —, *Power/Knowledge: Selected Interviews and Other Writings 1972–77* (NY: Pantheon, 1980).

Lawrence Grossberg et al., eds., *Cultural Studies* (NY: Routledge, 1992).

Dick Hebdige, *Subculture: The Meaning of Style* (NY: Routledge, 1979).

Stuart Hall and Tony Jefferson, eds., *Resistance Through Rituals: Youth Subcultures in Post War Britain* (London: Hutchinson, 1976).

Stuart Hall et al., eds., *Culture, Media, Language* (London: Hutchinson, 1980).

Max Horkheimer, *Critical Theory* (NY: Herder and Herder, 1972).

Fredric Jameson, *The Political Unconscious: Narrative as a Socially Symbolic Act* (Ithaca, NY: Cornell University Press, 1981).

— — —, "Postmodernism, Or the Cultural Logic of Late Capitalism," *New Left Review* 146 (1984): 53–92.

— — —, "Reification and Utopia in Mass Culture," in *Signatures of the Visible* (NY: Routledge, 1990).

Donald Lazere, ed., *American Media and Mass Culture: Left Perspectives* (Berkeley: University of California Press, 1987).

Herbert Marcuse, *One-Dimensional Man* (Boston: Beacon Press, 1964).

Tania Modleski, ed., *Studies in Entertainment: Critical Approaches to Mass Culture* (Bloomington: Indiana University Press, 1986).

Raymond Williams, *Television* (London: Fontana, 1974).

— — —, *Culture* (London: Fontana, 1981).

— — —, *Keywords* (London: Fontana, 1983).

Susan Willis, *A Primer for Daily Life* (NY: Routledge, 1991).

Whose Cultural Studies?

Cultural Studies
and the Disciplines

Renato Rosaldo

What follows is the text of a talk given to literary scholars at a forum of the December 1992 Modern Language Association convention called "Cultural Studies and the Disciplines: Are There Any Boundaries Left?" It reflects on the possibilities and anxieties aroused by cultural studies for anthropologists and ethnic studies faculty. It also tries to explain the potential of anthropology and ethnic studies to members of English departments that, at times, see themselves as the owners of cultural studies.

Recently a speaker came to my home institution and promised to tell us about cultural studies. The turnout was tremendous. Graduate students came wondering whether or not to invest their careers in cultural studies, and curious faculty members came hoping to find out what it was. Courses on cultural studies, not to mention the 1990 Illinois megaconference on Cultural Studies,[1] have been similarly mobbed, most probably for similar reasons. In certain quarters cultural studies raises apprehensions about the dimly known and the vaguely threatening; in other quarters it promises to solve all problems and satisfy all customers. Faculty members who "do" cultural studies often feel marginalized and beleaguered because they have come under attack from departmentally confined colleagues and because they have been underfund-

First presented at a forum on "Cultural Studies and the Disciplines" at the Modern Language Association Annual Convention in 1992, this essay was then published in American Anthropologist 96:3 (September 1994): 524–529. Reproduced by permission of the American Anthropological Association from the 1981 Proceedings of the American Ethnological Society.

ed by deans who invest primarily in traditional departments. Ironically, graduate students not yet released from their indentured servitude often feel oppressed by cultural studies agendas, which they regard as the new hegemony. Yet the new hegemony, not unlike the notion of a liberal arts education, seems to have as many definitions as it has definers.

These observations can, perhaps, be reduced to the following proposition: Cultural Studies refers to a multistranded intellectual movement that places cultural analysis in the context of social formations, seeing society and culture as historical processes rather than frozen artifacts, emphasizing the inextricable relations between culture and power, and calling attention to social inequalities—thus always making a committed call for democratization. This

"Anthropologists have lost their monopoly on the concept of culture, and in the process the concept itself has been transformed."

movement has an oppositional history but now dominates the intellectual action at the site where a number of disciplines reproduce themselves—that is, among graduate students. At the same time one finds few departments or programs where faculty appointments can be made directly in cultural studies. Faculty members who do cultural studies are thus required to pass muster both in departmentally based disciplines and in their freely chosen interdisciplinarity. Unlike, say, American Studies, interdisciplinary cultural studies lacks the annual rites of intensification that reflect and produce the status of true disciplines, such as the present scene [the M.L.A. Convention] which derives from and annually re-creates the Modern Language Association as a corporate body. For all the intellectual excitement generated by the cultural studies movement, its material base seems pretty flimsy compared with that of established departments.

In an effort to define and position this broad-based intellectual movement with more precision, let me propose a pair of genealogies, which imply a broad project for cultural studies. The first genealogy traces my probably not unrepresentative history of beginning to do cultural studies. The site for this beginning was the emergent invisible university of reading groups where overworked faculty members tried to renew themselves through intellectual conversation rather than departmentally based talk about budgets and graduate programs. In the late 1970s, I participated in a new group at Stanford called the interpretation seminar. Participants came primarily from the law school, literary humanities, and anthropology. We got off to a fast start by reading and then meeting with French philosopher Michel Foucault. By the mid–1980s, however, the seminar was subverted by its own success; it became too big to be much more than a performance arena.

At that point, some nine years ago, a rebel group unwittingly became part of a larger trend and formed a cultural studies seminar. In order to promote

good discussion, the new group suppressed its democratic impulses and resolved to remain small. In reaction to the cultural elitism so prevalent at the time in literary studies the group decided to read broadly: not only imaginative literature, but also popular culture, social theory, political economy, and works written by people of color both in the United States and in the Third World. The group has read books and screened videos on authoritarianism and the state, the Middle East, South Africa, official state and informal ethnic nationalisms, Los Angeles, the Philippines, displacement and transnationalism, and the politics of affirmative action and multiculturalism. The group has also sponsored graduate student reading groups, worked on teach-ins with local activists during the Gulf War, and organized a conference on Culture and the Crisis of the National. Yet the group has not been able to institutionalize itself beyond the level of the reading group.

The second genealogy for cultural studies is more generic. It begins with Raymond Williams, E. P. Thompson, and Antonio Gramsci as representative cultural Marxist thinkers whose work retains an analysis of political economy and a concern with human emancipation alongside an understanding of culture, ideology, and human agency. In this context, culture is laced with power, and power is shaped by culture. Subsequent links in this genealogy include the reconceptualizations required by the emergence of gender, race, and sexuality as analytical concepts deriving from social movements of feminists and their allies, members of historically subordinated, racialized groups and their allies, and gays and lesbians and their allies. Such a genealogy problematizes previously taken-for-granted monolithic social unities. Once one notices that forms of subordination can intersect, say, in a working-class lesbian Chicana, neither women, Chicanos, lesbians, nor the working class can appear as homogeneous as they did before. How and to what extent do the various forms of oppression coincide, collide, and diverge? What are their social bases and their possibilities of alliance? These are not the only valuable agendas for cultural studies, but they are prominent among mine.

Let me now speak, first, as an anthropologist and, then, as a Chicano anthropologist. The present audience would probably be surprised to hear the reactions to cultural studies voiced by senior anthropologists. One often hears laments about exclusion: "They've shut us out," "We're being silenced," and the like. Humanists most broadly and literary critics in particular play the villain in these melodramas (as they do in not unrelated anthropological melodramas about multiculturalism). Yes, literary scholars, whatever their self-perceptions, are the all-powerful, hegemonic, exclusionary group. Despite all the talk about interdisciplinarity, a large number of senior anthropologists feel that cultural studies is just another name for literary studies. They feel downright bad because they have not been invited to the party.

The feelings of exclusion predictably engender other recognizable feelings: "If I can't come to the party, then I'm going to take my toys and go home." In public discourse, such feelings usually are encoded as something like: "Cultural studies does nothing that anthropology hasn't already done long

ago. These literary critics would do well to read Franz Boas or to take an intro-
ductory anthropology course." Now there is a grain of truth in the anthropolo-
gist's lament. An introductory anthropology course would probably do rela-
tively little damage. And one could probably learn that culture in the
anthropological sense (how many literary scholars sneer as they say "culture
in the anthropological sense"?) is neither high nor low; it is all-pervasive.
Mediation is the keyword here. Rather than being a separate domain, like icing
on a cake, culture in this sense mediates all human conduct. It has to do with
everyday life; material, economic, and institutional realms; politics, romance,
religion, and spirituality. To perceive cultural dimensions one need only ask:
Could things human be otherwise? Compare with Nuer politics, Balinese
romance, Navaho religion, and Huichol spirituality. Now explore the tacit and
explicit assumptions that guide local social relations and institutional forms.

Not unlike sociologist Max Weber's *Protestant Ethic*, where a moral code
governing the restricted realm of monastic life moved into the broadest reach-
es of civil society and market relations, the anthropological concept of culture
has moved from the seemingly esoteric domains of small-scale hinterland soci-
eties with relatively low levels of technology into the world of advanced capi-
talism with its invasive commodification and its global political economies
that reach in milliseconds from Manhattan to Tokyo and in maxiseconds from
Cooperstown to Minatitlán. It has been applied to contexts that range from
modern British subcultures and Renaissance self-fashioning to international
relations and contemporary music in the African diaspora. In other words, it
has diffused from anthropology to literary studies, law, social history, commu-
nication, business, media studies, and more.

Not unlike the faculty seminar on interpretation discussed a moment ago,
and much as any diffusionist would have predicted, the traditional anthropo-
logical concept of culture has undergone a number of metamorphoses in the
exhilarating borrowing and lending propelled by its success as a hot commod-
ity. Indeed, the rapid diffusion of the anthropological notion has led some to
worry that in today's intellectual climate all that is solid melts into cultural
studies. As gender, sexuality, and racism come to be widely redefined as social
and historical constructs, cultural studies faces the analytical difficulty of
attending, say, to racism as a historically changing cultural construct without
losing touch with the actual violence, whether physical, verbal, or institution-
al, inflicted upon living human beings through systemic white supremacy.

Anthropologists have lost their monopoly on the concept of culture, and in
the process the concept itself has been transformed. It no longer seems possi-
ble to study culture as an objectified thing or as a self-enclosed, coherent, pat-
terned field of meaning. (In literary studies, the "New Critics," whose trea-
sured self-contained texts have undergone a parallel fate, no doubt can
empathize with the anthropologist's lament.) Instead of studying an object in
the world (that is, the culture), social analysts investigate processes of media-
tion through which meanings are selected and organized in complex fields
that literary theorist Mary Louise Pratt has called contact zones [see Pratt's

"Arts of the Contact Zone" in this book]. In contact zones, social relations are often unequal, and people may speak different languages or the same language with different inflections, meanings, or purposes. An elementary school teacher who tells students to beware of strangers would do well to pause and wonder what strangers look like to six-year-olds. A New York sociologist who says national debates require civility should not be surprised when a Chicano academic asks instead for mutual *respeto* because, for him, civility appears to be an ordeal—yet another imposition of coercive Anglo conformity.

It should come as no surprise that anthropology has to remake itself, and that certain senior scholars feel bereft and nostalgic for disciplines as they were in simpler, more comfortable times. Yet both anthropology and cultural studies have gained. New objects of study come into view as anthropologists talk about arenas of interaction among members of different cultures, in the increasingly obsolete traditional anthropological sense. Graduate students can work in widespread multicultural contact zones rather than continuing to survey islands seeking that rare niche inhabited by an intact whole culture. At once inspired by and inspiring work in cultural studies, younger anthropologists have increasingly turned their gaze to the United States, where, one writer estimates, the past dozen years have seen twice as much anthropological research as was done in the entire previous history of the discipline. The intellectual labor of such researchers can contribute to activist interventions in the ongoing process of democratizing this nation's major institutions, including universities and colleges. This shift in conditions of possibility reveals that the traditional anthropological concept of separate and equal cultures has little to offer when diversity resides inside a single classroom or in a single decision-making room rather than in (one room, one culture) in separate and usually not-so-equal rooms. In related cases, with different and as yet little recognized implications, certain characteristics attributed uniquely to the metropolitan postmodern condition have been found to apply with equal ease to hinterland groups in Kalimantan and elsewhere whose daily lives are being redescribed with the benefit of recent work in cultural studies.

Now let me speak as a Chicano anthropologist. Here one finds less lamentation and more anxiety about cultural studies. If senior anthropologists feel that the discipline's crown jewel has been ripped off by cultural studies, faculty and students in ethnic studies programs often feel that cultural studies is an only slightly disguised effort to restore white male authority in areas where ethnic studies programs have a chance of speaking with some authority. If certain majority scholars distance themselves from cultural studies by saying that it is nothing more than ethnic studies writ large, certain minority scholars counter that the covert agenda of cultural studies is to allow white authority to co-opt ethnic studies programs.

Consider the *Chronicle of Higher Education*'s recent praise songs of insightful, moderate, and sensible Canadian philosopher Charles Taylor's writings on multiculturalism. What happened to bell hooks, Charles Lawrence, Gloria Anzaldúa, Cornel West, Mari Matsuda, Gerald López, Norma Alarcón,

Houston Baker, Michelle Wallace, Gerald Vizenor, Patricia Williams, Henry Louis Gates, Jr., and Paula Gunn Allen? Lest there be any confusion, let me emphasize that the story on Taylor's writings poses problems of reception, not of production. I do not think that it takes one to know one. Taylor's work is valuable; it makes significant contributions to a discussion as vexed as it is significant for this nation's future. The problem resides not in the inclusion of Taylor (his inclusion is welcome) but in the neglect of other prominent voices and the general tone of "in Taylor we've finally got what we've all been waiting for, an alternative to Afrocentrism." Is this an academic version of the return of the great white hope? Didn't Joe Louis put that one to rest? The anxiety in ethnic studies programs is that their work on diversity; educational democracy; race; white supremacy; intersections of gender, race, and sexuality; the politics of culture; histories of segregation and civil rights movements; movements for economic democracy; and the critical issues of housing, health care, jobs, and education will be appropriated by conferences with all-white panels of experts organized by the all-white chief executive officers of cultural studies programs.

Although I share certain anxieties of people in ethnic studies, I remain hopeful—at least on Mondays, Wednesdays, and Fridays. Universities need both ethnic studies *and* cultural studies. Ethnic studies programs both analyze and excavate oppositional traditions whose very existence has been lost to the established disciplines. Can intellectuals in the United States afford to lose touch with such traditions? Far from fostering simple separatist agendas, students and faculty who participate in ethnic studies programs become articulate about distinctive issues and projects that they can bring to mainstream courses in clear and persuasive ways. Cultural studies courses in particular allow an opportunity to place contributions from ethnic studies in mainstream, often prestigious settings. Both ethnic studies and cultural studies can, in principle, work out mutually beneficial programs, especially if minority students and faculty work in both arenas. All parties involved should be vigilant about the present moment's lawlike tendency for white authority to surface and attempt to claim a monopoly status rather than entering more egalitarian forms of dialogue.

Cultural studies requires diversity in order to carry out its projects. The diversity is in part disciplinary. It would be absurd for a rebel band of literary scholars to corner the market on interdisciplinarity, though it has been tried, and the would-be emperors cannot always be counted on to notice their new clothes. A course on anthropology and history, for example, should be co-taught by at least one of each, an anthropologist and a historian. Similarly, when theorists who speak the purest forms of Heidegger, Derrida, and Foucault turn their metropolitan gazes to Juan Rulfo, Zora Neale Hurston, and Rigoberta Menchú, they would do well to engage in dialogue with speakers of the local languages and knowers of the local histories. Such collaborations require and should produce knowledge built in tension between global and local regimes.

Those with serious commitments to cultural studies would do well to ask

over and over: "Who is in the room?" Affirmative action for representation by
different disciplines, proponents of global theory versus local area studies, and
the more usual gender, race, and sexuality issues do not mean quotas and
obligatory slot filling. They do mean changing search procedures so that new
names come into view. Once the process has changed, the results can change
without risk of inferior products. And one should ask for results, both in terms
of greater inclusion and high quality. That the one Chicano we invited turned
us down is not an excuse. In certain cases, the qualities sought may shift, so
that teachers of multicultural courses could be delighted to find an able clas-
sicist who also knows Caribbean literature; but these shifts involve changing
criteria of excellence, not lowering standards.

Changing search procedures to get appropriate qualified people in the
room should apply to conference panels, academic committees, reading
groups, classroom teaching, authors assigned in courses, and authors cited in
talks, published articles, and books. Of course men should speak about women
and vice versa, but would an all-male panel speak about women? Should an
all-white edited collection address issues of race or multiculturalism? How
often should all-straight, all-white panels talk about AIDS? There are differ-
ences between speaking as an X, discussing with an X, and talking about an X.

Realizing the goals of diversity will produce misunderstandings and rancor,
especially in periods of transition; it will make intellectual life less comfortable
than in the past. Scholars given to local concerns, for example, can be fierce-
ly combative toward poachers and outright hostile to anything called theory.
Certain theorists, on the other hand, can be remarkably resistant to bringing
theory together with practice, particular narratives of experience, and other
forms of local knowledge. In these and other dialogues, however, the projects
of cultural studies will most probably benefit from being subjected to wider
and more demanding perspectives.

Cultural studies entrepreneurs would do well to borrow and invent new
forms of collaboration among teachers, students, researchers, and conference
organizers. Collective work in *equipos* goes against the grain of highly individ-
ualistic official university life in the United States, but the invisible university
of reading groups may provide inspiration for the kinds of models sought.
Other countries have worked in highly productive ways with workshops and
related extramural institutional forms of doing intellectual labor. Need the for-
mal academy and intellectual life coincide? It may be that the presently inter-
stitial status of cultural studies can be developed to its long-term advantage
with organized research units, programs, and reading groups. Perhaps nonaca-
demic intellectuals can more systematically be brought into the dialogue in
the hope of working toward the creation of a more public intellectual life in
this country. Concerns with social justice and human emancipation could
well govern both the intellectual production and the human composition of
such working groups.

Cultural studies has brought anxiety to a number of anthropologists. It also
has brought opportunities for creative internal remaking. At a theoretical level,

the discipline could remake itself in order to consider not only separate cultures in separate rooms but also multiple cultures in the same room. At a practical level, it could increasingly diversify itself along lines of gender, race, and sexual orientation by changing graduate admissions and hiring practices.

The opportunities for external remaking arouse the predictable anxieties of shifting from a small to a large pond. Yet anthropologists can offer long experience with the concept of culture. Losing a monopoly need not be such a bad thing; maybe there is something to be gained from working in more rough-and-tumble arenas where the anthropological notion of culture is a key ground for conflict and misunderstanding, as well as the subject of innovative transformations brought by fresh applications and the remolding of familiar terms. Anthropologists have much to offer in developing egalitarian multicultural collaborations, both within and beyond the walls of academe. As full citizens of their institutions of higher education, more anthropologists could interrupt their lamentations, knock on closed doors, and insist on being included rather than waiting for the gilded invitation.

Note

1. The proceedings of this large scholarly meeting on "Cultural Studies Now and in the Future," held in 1990 at the University of Illinois, were published in *Cultural Studies*, Lawrence Grossberg et al., ed., (New York: Routledge, 1992).

It's All Academic

Culture Wars
in the Everyday Life
of the University

Editor's Introduction

The Struggle for the Academy

The essays in the preceding section of this book introduce a broad range of contemporary approaches to culture—the competing notions of culture implied by the various emerging schools of cultural studies, by divergent forms of mass-culture criticism, by anthropologists or by literary critics. The essays in this section show how the university has become a prime site where such theories and visions of culture struggle for dominance and are enacted in everyday life practice. Far from being isolated "ivory tower" retreats, colleges today have become major focuses of public and mass media attention as front-line battlegrounds in the ongoing "culture wars." Now each seemingly small-scale, local decision about funding, class size, teaching style, course book lists, staffing, admissions, scheduling, architecture, and so on can be seen to speak for or to contest crucial tendencies in the global economy and in global politics.

But if in the late 1960s and early 1970s universities emerged as the main laboratories for progressive cultural experiments that then had repercussions in many areas of North American life, in the 1980s and 1990s the academy has clearly become a major site for powerful movements of cultural retrenchment. Consider the cumulative effect of these recent and ongoing developments: the radical and rapid downsizing and reorganization of campuses in response to intensified economic constraints on all institutions; the increasing number of long, angry, and debilitating strikes by teaching assistants, support staff, dining hall workers, and professors; the re-emergence of crucial battles over affirmative action in hiring and admissions; skyrocketing tuitions, which further limit access to many schools for large numbers of students, along with the corresponding transformation of those schools that are still "open" and public into prison-like containment areas for minorities and poor whites; the fever pitch of uncomprehending voices in largely symbolic battles about the "canon" to be taught in many departments; the wide publicity now given to right-wing attempts to discipline and impoverish cultural institutions by attacking all academics for their perceived "cultural relativism"; and so on. All of these ominous signs across the cultural landscape of the 1990s suggest that this movement of retrenchment will only intensify in coming years, and that the struggle for the academy may become *the* major cultural issue before the end of the century.

The first essay in this section, "Disciplining the University," takes us back for a close-up analysis of changes in university life on one campus during the first stirrings of this movement of cultural retrenchment. But this look at cultural politics at Stanford University in the early 1980s is not simply presented as an exercise in localist nostalgia, an intriguing glimpse into life in a far-gone era; the hope is that this essay might spur new analysis. Each reader is urged to test this vision against his or her own analysis of the dynamics of everyday practices and

tendencies in the terrain of his or her own university scene. It is imperative that we begin to analyze the implications of today's culture wars in the academy, and such analysis must not be divorced from history. The Stanford case study presented here may help to provide some such larger historical perspective as we look at particular institutions today; indeed, on a great many fronts this case study is sadly prophetic of movements that would come to frame and constrain life in academia today: the redefinition of the curriculum; the stress on a highly structured professionalism for both students and faculty; the new emphasis on bureaucratic, impersonal administrative style along with heavy-handed displays of raw authoritarian power; and the crucial move away from knowledge as life-enhancing activity and toward "seeing knowledge as expertise aimed at producing hierarchies of authority." But this Stanford case study may also stand as a model of a kind of critical enterprise that now needs urgently to be revived. One major sign of the triumph of these tendencies toward the disciplining of the university is that the irreverence, irony, and outspoken resistance found in *TABLOID*'s 1980s study of the Stanford situation is almost unheard of today. Since then, the space for critical intellectual practice has dramatically narrowed and been subjected even further to all manner of policing—much of it under the guise of "the new professionalism."

In her introductory essay to this volume, Jean Franco finds "Disciplining the University" to be perhaps the most significant of *TABLOID*'s position papers because it reflects the group's final recognition of the importance of its institutional base—and the recognition that this institutional base is not an unreal idyll detached from the dynamics of the surrounding culture but, on the contrary, can be seen to be crucially embedded in those larger dynamics, a key site for basic struggles over central cultural questions. Noting that Stanford's ongoing relationship with the Reagan machine made it "an especially apt place to look at how that machine operates when it gets the upper hand," the *TABLOID* writers began to ask how the pattern of large and small changes observed on campus could be symptomatic of global changes "in the relationship between the university, business, and the state, changes that tend to eliminate much of the looseness and the space for diversity that academics have counted upon in the past."

Recent work by several *TABLOID*-related writers has continued to stress the global resonances of developments in university life. Rey Chow's essay "The Age of the World Target" shows how tendencies toward the "disciplining" of our academic knowledge (especially in fields such as "area studies") are intimately related to the "strategic logic" of Cold War military vision—a vision that has had dramatically expanded repercussions even in the post-Cold War period, shaping the very modes of our production of knowledge: "The United States has been conducting war on the basis of a certain kind of knowledge production, and producing knowledge on the basis of war." In a similar way, Mary Louise Pratt's retrospective look at the history of Stanford debates about its Western Culture course requirement—"Arts of the Contact Zone," in this volume—stresses how this local struggle must be seen as related to a pattern

of increasing challenges to educational democracy across North America, and then offers the outline of an ambitious alternative to such regressive, monolithic visions of education, of literacy, of classroom dynamics, and of culture. The final essay in this section, Dana Polan's "Professors," undertakes a wide-ranging survey of mass cultural representations of academics and academia (from *The Nutty Professor* to *Animal House* to *Irreconcilable Differences*) in order to emphasize that the contemporary culture wars must be seen as a series of struggles taking place simultaneously in the university and in the larger society—at all levels of culture:

> From the clichés that precede the professor into the classroom to the larger codes of mass communication, no site of knowledge production is unshaped by conventions, disembodied from public image and representation. The need for the intellectual, then, is not to imagine that there is some pristine space of pure pedagogy nor to act as if knowledge is so important in and of itself that it forces such a space into being. . . . There is a battle being fought over the possible place for the academic in today's world. . . . Unless we look at mass cultural image and framing in the literacy debate, we will lose the battle.

This series of essays urges us to recognize, then, that the issues involved in our everyday university affairs are anything but "all academic."

Disciplining the University

How Universities Became
Prime Battlegrounds in the
Reagan Revolution

The *TABLOID* Collective

Bright and early one morning in November 1980, a member of the *TABLOID* Collective in search of some Latin American newspapers entered the one building at Stanford University where such items are kept, the Hoover Institution for the Study of War, Revolution, and Peace. There was a party on. The usually somber tower (affectionately known as Hoover's Last Erection) was jumpin' and stompin'. As the 'BLOID headed for the basement newspaper room, a pair of ecstatic anticommunists, arms about each other's suited shoulders, passed by beaming, "Which do you want, Commerce or the State Department?" A sign on the exit door read: "Last one to leave for Washington turn out the lights." The Reagan era had arrived, and at Stanford it was going to be a very special experience.

Two years later, when we sat down to plan *TABLOID* 8, the idea came up to do an article in this issue on "Resistance Under Reagan." This seemed a topical subject for which we expected to find an abundance of material. After all, Reagan's first two years in office had provoked more than enough motivation for militant opposition, especially around the problems and issues of unemployment, health care, the environment, education, social services, military spending, nuclear proliferation, and so on. However, when we looked around, we wound up being surprised at how little conscientious resistance there was, given the degree to which the Reagan policies had torpedoed people's lives. With the important exception of the antinuke movement, little in the way of organized resistance had emerged on a national or even regional scale. At the level of everyday life, enormous energy and creativity were going into survival tactics—how to cope with losing your job, how to live out of a car, where to go

This collectively written "position paper" appeared in
TABLOID 8 (winter 1984): 1–20.

to start over from scratch—but very little into the question of how to fight back.

Needless to say, all this greatly disturbed us, and made us begin to wonder about the nature of resistance under the current administration. Was it possible to organize collective action against the restrictive practices of institutions in the '80s? How did people see their personal interests in relation both to the people they work with and to the larger social groups of which they are a part? Was there some new sort of "social logic" in play which isolated people and encouraged them to overlook their potential solidarity with those around them?

At the same time we were posing these questions in a general way, some of us in the *TABLOID* collective were experiencing our own version of

"Many people must be noticing in their day-to-day contexts that displays of raw power are becoming increasingly acceptable and even admirable. Many people must be experiencing the heightened sense of unreality and disorientation that seems to characterize these times, and that fosters lack of resistance. It's not only in universities that people have the feeling that the 'real world' is somewhere else."

Reaganitis in the place where we worked, namely Stanford University. The disease seemed to spread as a lurking paranoia, located mainly at the level of particular instances and individuals—with one person being denied tenure there, another being denied funding here. Each of us could list examples of things we had seen change during the Reagan period, and each of us had seen our personal relations with the university alter drastically. But somehow the changes seemed to occur as a bombardment of individual instances against which there was no clear opportunity for marshaling collective resistance. We decided that exploring further the specifics of our own situation might lead us toward more general understanding of the workings of change and the difficulties of resistance under Reagan. In the late spring, we held a small public forum on the subject. What we heard from other people there was particularly helpful as we tried to connect transformations at levels of institutional policy with changes in everyday practices and experience.

Life in Reagan's Backyard:
In Search of the Real World

For several reasons, our findings seemed worth sharing with *TABLOID*'s readers. At first, Stanford University might seem an unusual place to ask the kinds

of questions we were posing. Known as a bastion of conservatism, a citadel for the new technocracy and a country club for the privileged children of America's elite, such a place seems utterly removed from what is "really" going on for most people. And in many ways, it is. But there are ways in which Stanford's privateness and privilege makes it an especially revealing vantage point from which to study change under Reagan. For example, Stanford's long-standing ties with the electronics industry (Hewlett and Packard are alumni; the transistor was invented here), and its tremendous resources in electronics, computers, and artificial intelligence make it a particularly interesting (and interested) site for both private and public defense work. Militarization under Reagan has been very much in evidence here. Thanks to Stanford, Silicon Valley and Moffet Field military base, $3.9 billion in military money flowed into Santa Clara County last year, the highest per capita rate in the nation.

Stanford's hard science resources are obviously of particular interest to the purveyors of militarization. But its ideology- and propaganda-producing apparatuses are equally sought after these days. We refer, in particular, to the intimate relation between the Reagan political machine and the Hoover Institution for the Study of War, Revolution, and Peace. Since its founding in 1919 for the purpose of demonstrating "the evils of the doctrines of Karl Marx," the Hoover has been one of the most conspicuous upholders of the far right in foreign and domestic policy. But with the recent rise of the new right, the Hoover became more prosperous than before, more dogmatically right wing than before, and more aggressive about asserting its power over other sectors of the university. At the same time, the Hoover's Dr. Strangeloves began receiving ever more serious treatment in the national press, and in fact suddenly seemed to find op-ed pages and newstalk shows clamoring to broadcast their opinions to the world. The Hoover seemed to be the place where Reagan policy was being forged. Philip Habib was only one of a whole group of guys who took temporary leaves from lucrative positions at the Hoover and fancy houses on campus to follow Reagan's call to Washington. The Hoover's director, Glen Campbell, was named chairman of the Intelligence Oversight Board; Senior Fellow Martin Anderson became a Reagan policy development assistant; Richard Allen became national security adviser. Over 30 fellows, former fellows, and associates of the Hoover Institution (including Rita Ricardo Campbell and Milton Friedman) have held posts in the Reagan administration, and that doesn't even include George Shultz, whose appointment is in the Business School. Ronnie himself was made an honorary Hoover fellow several years ago, when he donated his gubernatorial papers to the Institution. And as early as two years ago, Reagan announced the Hoover as his first choice for the location of a new complex to include his Presidential Library along with a Ronald Reagan Museum and a Ronald Reagan Institute for Public Affairs—all to be run by the Hoover. When the first whispers of faculty opposition to such a complex arose—voicing a fear that partisan powers would thus gain further dominance in the university's academic affairs—the Reaganites immediately

brought out their big guns, trying to make this a national controversy with hysterical *Wall Street Journal and New York Times* editorials and op-ed pieces (by Fellows Milton Friedman, Peter Duignan [a major apologist for South African apartheid] and others) passionately denying the Hoover's political partisanship in cascades of red-baiting rhetoric warning of the rise of "dissident bands" of "academic terrorists" and "Marxists" seeking to "revolutionize American politics and government." The vehemence of this response, and the sheer amount of national press these minor goings-on received, suggest that a good deal is at stake here for the Reagan machine, and that Stanford, or at least its Hoover tower, has a very special place in the dreams of the far right. This ongoing relationship with the Reagan political machine, then, makes Stanford an especially apt place to look at how that machine operates when it gets the upper hand.

At the same time as we were trying to be aware of Stanford's peculiarities, we were also convinced that a good deal of what we were seeing around us was representative of what was "really" happening in other contexts as well. We knew that many people, for instance, were encountering an increasingly authoritarian atmosphere in their workplaces and in their dealings with institutions. Many people must be noticing in their day-to-day contexts that displays of raw power are becoming increasingly acceptable and even admirable. Many people must be experiencing the heightened sense of unreality and disorientation that seems to characterize these times, and that fosters lack of resistance. It's not only in universities that people have the feeling that the "real world" is somewhere else.

In examining our own situations, we wanted to make connections among all of the forms of retrenchment we and many others were experiencing in our day-to-day lives and in our personal relations to the university, and to connect all these up with large-scale political and social changes happening elsewhere. We began to ask how one might link together politically based changes in things like the research priorities of funding agencies, with internal changes in intellectual fashions inside particular disciplines; with changes in hiring and promotion practices (if not policies); with changes in microlevel institutional practices like exam systems, course requirements, classroom methods, even memo writing; with changes in the everyday aspects of university life—ways of working, of organizing leisure, handling health, and so on. We began to ask what kinds of things political machines and elected governments might need universities for, and what relationships the current administration and Reagan machine in particular were trying to construct with universities (especially elite private ones). We began to think about the widespread atmosphere of unreality and helplessness, the practices involved in sustaining it, the points at which it tends to break down, and the ways it can be actively combated.

What the Hell Is Going on Here?

From Ronald Reagan, universities and academics don't get no respect at all. His anti-intellectualism was notorious long before he became president.

When he was state governor, beating up on the University of California was one of his favorite pastimes (a hobby inherited by his current clone, George Deukmejian). The rumor that Ronnie has not read a book since high school is perfectly believable. As president, his contempt for learning and what you could call working knowledge is brought home to us every day as one ignoramus after another is appointed to administrative positions of high responsibility. Confirmation hearings become comedies of error as appointee after appointee proudly declares he knows nothing about the world in general and even less about the job he is about to take on. Reagan manages to find people who don't even know enough to do the easy jobs. The floor-wax millionaire who was appointed ambassador to Britain, for example, turned out to be so ignorant and inexperienced that the British government itself was driven to request his recall, after no one in Washington thought it necessary. It ought to have been an embarrassing incident, except that Reagan showed no signs of embarrassment.

The White House doesn't look much better than the diplomatic corps. No one has forgotten William Clark at his confirmation hearings as head of the National Security Council declaring that it was okay that he didn't know the names of the prime ministers of South Africa and Zimbabwe because he had moral vision, and that's all you needed to do the job. The point of reference here is obviously Jimmy Carter. He had a moral vision, but he also stayed up nights reading everything he could get his hands on. He operated on the firm belief that the world was perfectly comprehensible to anyone who kept informed. But Carter burned himself out, and he became increasingly indecisive the more enmeshed in things he became. People got scared of chaos. The contrast with this Carter antecedent helps explain what people find reassuring about Reagan and his inner circle. The Reaganites don't set great store either in working hard or in knowing things. They treat governing as fundamentally a *managerial* task, and politics as a public relations task. Precisely because they operate with complete contempt for knowledge and facts, they appear to be be displaying a good deal of decisiveness and determination.

Though contempt for knowledge and learning is a hallmark of Reaganism and the new right in general, Ronnie does have his uses for universities and academics. Indeed, in ways that are paradoxical only on the surface, the ties between government and universities have become thicker and more intense under Reagan than ever before. For starters, universities are the places where the technology and know-how for militarization can be produced. Second, they are places where consciousness gets produced, where values can be transmitted, in this case values supportive of right-wing authoritarianism. Third, they can be sources of legitimation for government activities, producing "experts" who will legitimize policies and go to bat for the administration in public or congressional debates. When we looked around ourselves at Stanford, we saw the university's resources being marshaled in all these ways, producing conspicuous changes in every sector of the institution.

Experience and Expertise: Redefining Study within the University

The most significant changes for us were linked with a shift toward seeing knowledge as expertise aimed at producing hierarchies of authority, and away from knowledge as life-enhancing activity emerging from and feeding into lived experience.

One way of identifying such changes is to ask the economic question: How does the university justify the expenditure of money for its operations? In what ways does it establish its authority and legitimacy as an institution? During the late 1960s and early 1970s, these questions evoked answers directed at the connection between the university and its surrounding community. The university was an important force because it could link up with social currents that affected large numbers of people who never set foot on a campus. Change had been in the direction of increasing democratization of education and knowledge. Subjective, lived experience was granted increasing authority as a form of knowledge and as a point of departure for intellectual activity. Educational programs were reorganized to make them more "relevant." Women's studies, black studies, Chicano studies, health care and human biology programs, and a variety of other interdisciplinary projects were started in an attempt to break down the barriers both within the university—between the humanities and the sciences, between different disciplines—and within the community. The legitimacy of minority studies programs resided in the recognition that the life experience of large sectors of the population was not feeding into the academy's project of constructing the society's self-image.

Students were no longer required to take courses in Great Works of Western Culture, since these were no longer seen to represent their interests in their own lives. An atmosphere of relative freedom was sought, which allowed (and even encouraged) individuals to make connections between their personal experience and their course of study.

Today, academic accountability is formulated less and less in terms of "relevance" to the social experience of individuals and more and more in terms of the expertise it produces. Often this focus on expertise comes across as pragmatism, as a turn "back to basics." Courses are being designed specifically to help students get jobs. English departments teach more and more scientific and business writing; economics departments double the number of accounting courses they offer; foreign language teaching is severing its connection with culture, and replacing it with "German for business majors."

The Battle over Western Culture: First Shots in the Canon Debates and Culture Wars

But hand in hand with this new pragmatics and this privileging of expertise comes an apparent return to the decidedly unpragmatic idea of the university as an ivory tower, the diligent protector of the Great Works, the storehouse for

cultural capital. At Stanford this shift in ideology has been quite explicit. Of course what attracted the most attention was the sudden, wholesale reinstatement, in 1980, of a Western Culture requirement, with its built-in imperialist and ethnocentrist views of world history. Various subsequent efforts to revise or reorganize this requirement led to years of nasty, uninformed (and ongoing) debate as hosts of ambitious conservative commentators sought to make their reputations by focusing the glare of the national media's spotlights on the question of "threats to Western Culture at Stanford" and making this particular curricular discussion a "defining moment" in the framing of the so-called culture wars.

[Some of these first shots in the "canon wars" at Stanford were fired by William Bennett, the chairman of the National Endowment for the Humanities who later became Reagan's secretary of education. Having emerged as America's culture cop in these early Battles of the Books, Bennett would go on to to try to discipline the nation's teachers, programmers at PBS, and a whole slew of emerging pop-culture voices; the fear of diversity and of increasing cultural pluralism first expressed in these debates about college curricula would later emerge in Bennett's more shrill (and even more cynically symbolic) attacks on Gangsta Rap, TV talk shows, and so on — all attempts to keep the base idea of culture wars on the mass media agenda. Conservatives claim to be excited by free market models and deregulation in all areas, and have been especially harsh in applying such ideas through dramatic cuts in government funding for the arts and humanities, asserting that truly worthy artworks should find their own paying audiences to sustain them in a free market left to express its popular tastes. So it is especially strange to find intellectual policemen such as Bennett so profoundly worried about a deregulated American culture, and so deeply anxious that Plato, Chaucer, Milton, and Shakespeare might lose their readerships in truly deregulated departments of English or humanities. But the basic impulse in all of Bennett's attempts at disciplinary intervention is toward limiting the voices that are seen to make up our cultural heritage, and also limiting the voices that are allowed to share in and meditate upon this heritage. Defining rigid lists of Great Books for the Western Mind, Bennett sought to silence new voices that had begun to appear on university syllabi; urging radically reduced funding for education (and therefore greatly escalating tuition costs), he also significantly restricted access to classrooms and resources — limiting the pool of available heirs to his Western heritage in ways that anticipated and fed into a major movement in mid-1990s university life: the backlash against affirmative action in admissions. And Bennett's own most lasting legacy — the war on drugs, which he helped initiate as Reagan's drug czar — functioned as a cultural silencer in similar ways: its major outcome has simply been to take a huge number of young black males out of normal social circulation — and place them in the hands of prisons and the legal system.]

It is important to see these Western Culture or Western Civilization requirements — the "Plato to NATO" courses that were reinstituted as part of

the core curriculum at so many North American universities since the early 1980s—as one of the main forms in which the humanities collude in the disciplining of the university. This requirement, usually involving a one-year course built around a set list of Great Books, justifies itself in terms of teaching young people values and traditions, giving them historical knowledge they can use in making sense of the present. But in fact it works as much in the opposite direction. The Great Books format (Homer this week, Aeschylus next week, Plato after that, and so on through the greatest hits of Virgil, Augustine, and Dante) actually teaches students to alienate questions of value and meaning from the realities of ongoing social, material, and institutional life. How else can you cover the Enlightenment to the present in the last ten weeks? Western Civ anchors cultural knowledge and cultural investigation in the past in an alienated way—in the mythical intellectual utopia of the classics—rather than in a present, daily personal production of history. Would-be culture cops such as Bennett seem unaware of crucial differences between American notions of culture and those of Matthew Arnold. American culture—at least that aspect of it that is spoken for by those like Emerson—has always been shaped by a much more mobile and progressive sense of cultural practices than this. It is less focused on the worship of fixed, hardened cultural products in the past than on the celebration of culture as an ongoing, creative life process.

Western Civilization programs universalize questions of value and meaning (What Is the Essence of *Man*?), thereby achieving coherence at the price of dehistoricizing philosophical, moral, and political thinking. Particular periods of history tend to be presented as monolithic—the Greeks and Romans, the Renaissance, the Victorians. This in turn encourages students to look solely at historically dominant ideologies as the ones that count, or as the only ones that exist, thereby ignoring or rendering invisible alternative currents that have always been present in every era. Once these periods, as represented by the intellectual "high points" of the authors selected for study, have been strung together, students are left with the impression that they have grasped the essence of what is pointedly presented as *their* finest cultural heritage, without ever really having been forced to examine the complexities, contradictions, and omissions inherent in the concept of *a* Western civilization.

[For a retrospective survey of these Western Culture debates at Stanford, defining alternatives to such monolithic models of culture, of education, of literacy, and of classroom dynamics, see Mary Louise Pratt's "Arts of the Contact Zone" in this volume.]

The Professionalization of Power: Redefining the Role of Knowledge in Society

What seemed to be happening, then, was a move toward redefining study within the university. The role that knowledge was to play in the society at large was being recast so that it no longer needed to be tied to anyone's experi-

ence. Rather, knowledge was being reconceived as expertise, and universities as places for creating experts or authorities. Such a conception of knowledge is by no means new in universities. But what is new for us now is the swiftness and sureness with which this conception has taken the initiative, and how it connects with the current rise in militarism and authoritarianism.

In an article in *Mother Jones*, Hugh Drummond refers to the contemporary stress on expertise as "the professionalization of power." Drummond argues that what we are now seeing is a social shift toward

> the professionalization of power in which control is increasingly taken by various credentialed elites who translate the common property of daily life into esoteric matter under their jurisdictions. They develop exclusive guilds protected by licensing and they invent arcane languages to confuse the obvious. Childbirth is by doctors, divorce by lawyers and teaching by tenured educators. Knowledge, in this contemporary social order, comes from "researchers." The research establishment is the last and best-protected residence of patriarchal hegemony. It defines "correct ideas" and "correct ways of thinking." It does not tolerate criticism. (*Mother Jones*, [Sept/Oct 1983]: 46).

Reaganism did not, of course, create the research establishment. But under Reagan, we are seeing an increasingly intense effort on the part of the government to cash in on this establishment, at the expense of other kinds of knowledge production with other, more democratic goals.

It is no coincidence that some of the most effective efforts to protest Reagan's policies are precisely those that reaffirm the importance and validity of lived experience. During the first shock of the recession, newspapers and magazines were full of articles on what it is like to be unemployed, to suddenly have no money, and so on. Against Reagan's militarization, formulated in terms of numbers of missiles and warheads, the scientific and medical community has tried to sketch out a picture of what the lived experience of nuclear war is like. This tactic was initiated by the Physicians for Social Responsibility, and was recently used with great effect by a group of scientists led by Paul Ehrlich (of Stanford, mind you) who were exploring the environmental impact of so-called limited nuclear war. It is an interesting phenomenon: scientists and doctors speaking with medical and scientific authority but in the discourse of lived experience.

All societies have socially organized ways for producing and distributing knowledge, and in all societies the knowledge produced participates in organizing the society. What counts as knowledge in a group is determined in part by the group, on the basis of shared assumptions, which are always subject to change. Moreover, as Michel Foucault has taught us, all knowledge is created in the context of and in relation to particular sets of power relations—there is no knowledge without power and no power without knowledge. When a society undergoes a major political and economic realignment, as this one has been for the past three years, its ways of producing knowledge (and consciousness) will change, and so will the apparatuses whereby knowledge is created

to legitimize particular relations of power. A democratization both brings about and consists of a democratization of education—any new class empowered politically will also get empowered intellectually. But what we are seeing here now is the reverse—a process of mass disempowerment and intellectual disenfranchisement. On the one hand the effect (if not the goal) is to create citizens with minimal critical capacities and minimal confidence in their own thought. (If you don't think it's working, look at support for the Grenada invasion.) On the other hand, the objective is to appropriate the country's knowledge-producing resources to the ends of U.S. world dominance. In what follows, we look further at the specifics of how these projects are shaping up and where they are meeting resistance. The discussion looks both at the specifics of Stanford and at broader developments in academic disciplines and policies.

About Money

At a time when California's state university system is deteriorating rapidly and the state and community college systems are suffering truly crippling cutbacks, Stanford is doing very well financially. Salaries are among the highest in the nation, and the campus is full of new buildings, gift sculptures, towers and fountains. There is lots of money coming in, and it is coming from different places in different packaging than before. In particular, in both public and privately funded research, there has been a move away from free-ranging "basic research" (that is, research not oriented toward instrumental goals) and toward less speculative research oriented toward producing specific products or solving specific problems.

Several aspects of this shift are examined in a *New York Times Magazine* article by Katherine Bouton (September 11, 1983) that looks into the precedent-setting case of Harvard biologist Howard Goodman and the huge German pharmaceutical company Hoechst A.G. In an arrangement that represents an entirely new degree of industry direction in academic research, Goodman received a grant of $70 million for ten years of unrestricted biomedical research, on the condition that Hoechst get exclusive rights to anything potentially marketable that he turns up. According to Bouton, the agreement has triggered a flood of new industry money into biomedical research—money that is ultimately oriented mainly toward profit making, sometimes toward specific marketable inventions. Such developments are particularly ominous in the biomedical area, where profit-making activity is so often at odds with the legitimate goal of producing health. As it happens, Bouton quotes the president of Stanford's teaching hospital as being critical of such research-industry relationships. On the other hand, Stanford has sprouted in the past year at least three new research centers funded by corporate money and with agreements about possible marketable products that might result. Genetic engineering became big business the minute it was invented. Already Stanford's Technology Licensing Office has licensed more than seventy companies doing work with recombinant DNA and collects $2

million a year from patents it licenses for the faculty members who make up these companies. That sum can only increase, and with it Stanford's financial interest in product-oriented research.

The other expanding funder these days is of course the military, which is likewise extending its interests to new fields of research. According to one Stanford engineer, the field of robotics is currently being taken over by military funding (aimed at military applications) after having traditionally been a nonmilitary field. A Stanford geneticist was recently contacted by the military shortly after losing his NIH funding. When Stanford's president reported this month (to the Los Angeles Rotary Club) that since 1968 Stanford had seen a 40 percent decline in federal funds for non-defense research, one could only speculate about the flip side of the story—the increase in funds for defense research, especially in the last three or four years.

The episode that really focused attention on the issue of military funding at Stanford was the concerted effort last spring by the military to involve a lab connected with Stanford's linear accelerator in nuclear weapons research for the first time. The effort was vehemently protested by a majority of the accelerator employees, many of whom had come there to work precisely because of its policy against doing weapons-related research. Under intense pressure from Lawrence Livermore Labs in Berkeley and Los Alamos Labs in New Mexico, the weapons research was forced on the Stanford lab, with a few compromises relocating the most explicitly bomb-oriented tests elsewhere.

These increases in defense funding, in collaboration with private industry, and in nonspeculative, goal-directed research are perhaps the most readily observable effects of Reagan policies in the university. They should not be regarded as trivial changes—they are fundamental ones, without precedent in American academic history, and they lead toward fundamental changes in the relationship between the university, business, and the state, changes that tend to eliminate much of the looseness and space for diversity that academics have counted on in the past. These spaces and this movement are what "academic freedom" consists of at this time in history.

About Advanced Study

Besides sculptures and fountains, one of the conspicuous ways of spending money these days at Stanford is by establishing centers for advanced study in a variety of fields. Among the new arrivals are a new Soviet Studies Center, a Center for the Study of Language and Information, a Center for Biotechnology Research, a Center for Integrated Systems (the last three with direct private industry funding). Even the ever-suspect humanities have been offered an opportunity to participate in this new phase: there is a new Chicano Research Center and a new Humanities Center. This tendency to expand at the level of so-called "advanced study"—research not connected to teaching—is an obvious result of the increased focus on knowledge as expertise directly connected either with formulating and endorsing government policy or with producing

commercially profitable products. Such a focus orients education toward the production of elite teams of experts, rather than toward democratically distributed mass instruction. These advanced study centers also represent a centralization of resources, a move to further concentrate expertise, notably in the elite private universities. Over the past three years Stanford's hiring practices have shifted toward buying expensive, established "stars" from other elite schools or from impoverished state ones, and away from making experimental appointments at lower levels.

An even more extreme effort at centralization of expertise came to light last spring when an article in *The Nation* exposed an effort by Stanford political scientist Robert Ward (a Hoover Fellow and head of Stanford's Center for Research in International Studies) to consolidate all international studies research in the country into a single network under an umbrella-style organization. His ambitious dream-scheme would establish a single centralized directorate (a National Security Council, serving the interests of and including important members from the CIA, the Pentagon, the State Department, etc.), which would reorganize funding in order to control and direct as much scholarly work in international relations as possible. The council would, of course, only sponsor what Ward calls "policy-relevant research," and the CIA and the Pentagon would be the first to see any new data from these studies. The project was presented as an act of patriotism, in which scholars would join together "to protect and advance the national interests of the United States in the international community," writes Ward. Many foreign governments are already wary of CIA connections when any American scholar turns up, but under Ward's plan, such links would be a given, and would quite likely close some countries to American researchers altogether.

Ward's plan is an example of a clear effort on the part of the political right to consolidate a base for itself in academia, one to be oriented toward direct participation in government and not toward anything like neutral or general — let alone critical — research. *The Nation*'s Andrew Kopkind argues that Ward's plan must be understood in terms of the Vietnam era. The plan, he says, is "a brazen proposal to re-establish the shameful intimacy between the theoreticians and the practitioners of foreign policy that provided the intellectual basis for the disaster of Vietnam, and that was broken at the war's end" (*The Nation*, June 25, 1983). Another Stanford political scientist saw the proposal as "a way of controlling dissent by centralizing the flow of money and shutting off the kind of independent and highly critical scholarship that is going on now" (*Stanford Daily*, October 25, 1983).

Ward approached the presidents of the ten major research universities in the country and found himself welcomed by some but rebuffed by others. The presidents of Yale and Princeton were appalled, as were the heads of some think tanks. But the outrageous, out-of-the-ballpark proposal is a familiar bargaining tactic of this administration, used to achieve some less outrageous but still utterly outrageous "compromises" (only $100 million in military aid for El Salvador — a mere half of what was asked for!). It is unclear what the final result

of this effort will be, but Kopkind warns, "We could wake up one morning soon to find that the national security apparatus in the White House and in academia has taken command of international studies in the land."

The biggest irony of all is that if this government did succeed in engaging more bright young faculty in policy-oriented research, it would have only minimal interest in or use for their ideas. Many of Reagan's policies can stand solidly only on a thick foundation of total ignorance. How, for example, could an in-depth study of conditions in El Salvador fit into this administration's purely black and white scheme? Why would it care to know about the breadth, fervor, and actual politics of the European antinuke movement? What use would it have for knowledge of Grenada's recent history (or even its geography, for that matter—nobody even told the Marines where the beaches were). As *The Nation* notes, "The only worthwhile research about Central America and the Caribbean Basin would show the stupidity and brutal inefficacy of American-based counter-revolution." And in fact many research specialists who are brought into this centralizing administration find themselves reporting to superiors who are ignorant of or rabidly hostile to the very fields they are responsible for.

On Policy Research

Increasing orientation toward policy making and "pragmatism" is also one of the changes taking place within particular academic disciplines, especially the social sciences (i.e., psychology, sociology, anthropology, political science). In these domains you find an increase in research money for policy-oriented research, and an increase in support for the "hard science" end of these disciplines, the end where knowledge is produced in the form of quantifiable "results" rather than in supposedly "softer" forms like speculation, contemplation, experienced impressions and the like. Not to mention theory, which is in nearly every case equated with dangerous radicalism.

In psychology and psychiatry, biochemical and neurophysiological work have gained new priority, with a parallel movement in therapeutic practice toward drug intervention. At the famed Langley-Porter Psychiatric Institute last spring an effort began to replace the current director, a Freudian, with a biological specialist. The public-policy implications of such a trend are clear. If you don't care about abstractions like quality of life, it is much cheaper to drug people and put them back on the street than to work through their difficulties and support them institutionally while you are at it. What you need is research and experts to find what drugs work best and to argue for the effectiveness of such a policy once it's been decided on. One *TABLOID* friend, a psychiatric social worker, reports his case load has been increased over the past two years to the point that he can't be much more than a legal drug pusher.

Stanford has seen some analogous shifts in other disciplines. In linguistics, an emphasis on sociolinguistics (the study of language in its social context) has been displaced by a new focus on abstract formal linguistics, with funding links

to the computer and artificial intelligence industry. Four new appointments in formal linguistics were made in 1983, and a Center for the Study of Language and Information was founded, to be administered by the Institute for Mathematical Studies in the Social Sciences. In anthropology, at Stanford and elsewhere, the move is away from "soft" fields such as symbolic and cultural anthropology, toward "hard" ones such as archaeology, medical and biological anthropology, and sociobiology. (Sociobiology is the particularly frightening development here.) Again, a policy orientation is clear, since medical and biological studies are more likely to produce pragmatic recommendations either about what kinds of aid and intervention we should be giving to Them (Them is what anthropology studies), or about what kinds of things They could be giving us.

The Trickle-Down Theory of Administrative Style

One of the ways political identity is constructed these days in the mass media is through what you could call "administrative style." Presidents get associated with particular ways of doing things. Each is read as legitimizing and valorizing certain sets of administrative and interpersonal practices, just as each gets identified with sets of leisure practices (the Presidential Lifestyle). The president and his helpers by no means control the construction of these social and administrative identities—the dominant portrait of Reagan opulence has always been a critical one; and Carter's temperate humility wore thin much earlier than he might have wished. The presidential style is not just a propaganda device, but a way of registering or reading change.

The aspect we are interested in here, however, is the way these presidential styles seem to "trickle down," reproducing themselves in other sectors of the society. This trickle is pretty obvious in the spheres of consumption and leisure. Ronnie and Nancy make it all right to like nice things, and Richard Nixon liberated scores of Americans by legitimizing ketchup on cottage cheese. But the trickle down also happens with administrative style—ways of handling power, relating power and knowledge, working with institutions. And this is one of the first things we noticed when we started to look at how Stanford had transformed itself in the image of Ronald Reagan.

Take the fox-in-the-henhouse technique, for example. This is Reagan's preferred, but not always successful, device for handling democratic welfare institutions. Rather than trying to dismantle them or even reform them publicly, Reagan pays public lip service to them while working to create the conditions by which they will collapse from within or actually reverse their direction. The most famous instance is of course the one that failed—Ann Gorsuch's charge to turn the EPA into an apparatus for overriding the laws it was set up to enforce. Then there is James Watt the antienvironmentalist appointed to protect the interior, the many "antidesegregationists" appointed to the civil rights commission, the antiabortionists in jobs charged with upholding abortion laws, the openly hostile appointees to the Department of Education, and so on.

In a less openly aggressive variant of this, social institutions and programs are left in place but deprived of the funds to do the tasks they have been charged with. They then stagger along until they collapse on their own. (The entire public education system may be an example of this.)

One might have expected such practices to reproduce themselves at other levels of government—it was no surprise in California, for example, to see Governor Deukmejian appoint the state's biggest water users to the Water Commission. But it took a little longer to realize the same style was turning up in institutional relations all over the place. In universities, for instance, many minority studies programs have found themselves newly in the grip of the fox-in-the-henhouse technique. At Stanford, ethnic studies programs have not been overtly dismantled, as many feared, but the availability of faculty to run them and teach in them is being allowed or encouraged to decrease. In a number of cases, departments targeted to make minority or affirmative action appointments simply fail to do so, often arguing that there are no minority candidates available whose credentials meet the department's needs. No means exist for raising the obvious question of whether departments are defining their needs in ways that exclude the kind of work minority scholars and women are likely to be doing. At the same time, barrages of new course and distribution requirements are absorbing faculty energies that might otherwise go into interdisciplinary work. More important, such requirements are undermining the student constituencies of minority studies programs, whose offerings (of course) rarely fulfill the requirements.

Following this pattern, Stanford's fledgling program in feminist studies has been left in existence, but the feminist faculty has been decimated by firings, departures, and accidents. Losses have not been replaced; work on the program is unrewarded or even stigmatized, creating conditions in which it is difficult for a critical mass to coalesce. Of the considerable energy there is behind feminist studies, much has had to go into fighting battles that only a few years ago were thought to have been won, and raising consciousnesses that only a few years ago gave every sign of having been raised. The nationally publicized tenure battle of feminist historian Estelle Freedman, for instance, ought never to have been necessary, and probably would not have been five years ago. Fortunately that battle was won, and the feminist studies program is likely to survive. And there are even more general signs these days that opposition to the new academic conservatism is asserting itself in bureaucratic contexts if not on the streets or in the press.

Then there is plain old authoritarianism, which has trickled down in a much more general way. When we at *TABLOID* started adding up our complaints, we found ourselves surrounded with everyday instances where well-established democratic process had suddenly been suspended, and matters that had once been settled through discussion and consensus were now being dictated. In several departments, for instance, attempts were made to change graduate exam systems without the customary student participation, and sometimes without even collective faculty participation. In hiring, the old-boy

system started reasserting itself unexpectedly here and there. Last spring, the entire humanities and science faculty was stunned when several drastic alterations in the tenure system were announced by the administration, without warning and without a syllable of input from faculty. The running joke was that now we actually had to start reading memos from the dean's office in order to know what was going on.

Predictably, many of the changes being thus dictated from above were changes that reduced autonomy and increased surveillance of those below. In one department, a new exam system shifted emphasis from work on topics of the student's choice to questions assigned by faculty; in another, graduate students were provided with a set list of "Acceptable Books" for their oral exams; in yet another, a new policy attempted to take away students' control over the composition of their doctoral committees. For the first time, a curriculum oversight committee was set up at the dean's level to monitor each department's curriculum and establish curriculum policies. It was only in adding up such microlevel changes that you could see the impact of the big shifts in power relations that were occurring.

Managerial Style; or, How to Abolish Content

Besides authoritarianism, one of the most conspicuous traits of the Reagan administrative style is its tendency to treat all tasks as managerial, and all problems as either bureaucratic problems or image problems. Nothing is a matter of content. This tendency became apparent as soon as Reagan began making Cabinet appointments. Knowledge about a given area of government was clearly not considered a qualification for a post—administrative skill and blind loyalty were. So we have seen the same Reagan buddies playing musical chairs round and round the Cabinet. Policies are regarded as verbal and statistical constructs unattached to material realities. U.N. Ambassador Jean Kirkpatrick's mindless distinction between authoritarian and totalitarian regimes was advanced as a purely verbal construct which, because of its lack of content, could uphold equally well any policy whatsoever. This is a very effective way of subverting debate—if the terms of discussion are emptied of content, there is no way to discuss content. When people complain that chemical dumps are causing them to get cancer, and demand the government do something about it, the government does: it announces a new verbal construct—the "acceptable level of mortality"—and the problem dissolves. In order to cut off people's food stamps and medical care, poverty is redefined and the meaningless category of the "truly needy" invented. When that category gets too full, Budget Chief Stockman invents another one—a new way of defining the "true rate of poverty." Questions about people's actual quality of life, and the actual effects of the policies, are excluded from the discussion.

The administration itself never addresses the questions of whether racism and sexism are problems the society should overcome, whether the administration is upholding them or fighting them; what it addresses is the question of

whether the Hispanics are mad at them or not; whether women voters will vote for them or not. When questions of content do come up, the administration tries to dodge them by shifting the terms of the discussion. So it wants to discuss its activities in Central America only in terms of whether the declared policy objective is to bring down the Sandinistas or only to keep them from helping the Salvadorans. What it won't discuss is what is happening to people, what life is like in the region, what it ought to be like, what effects the American presence is having there.

This strategy has been working, but it works only insofar as the administration controls the terms in which things are discussed. So far it has been able to do this only by continually shifting those terms, so the opposition has to scramble just to keep up, and the public gives up on trying to remember even from one day to the next. Think how many different ways you heard the White House describe the Grenada invasion even as it was going on. It was an invasion, a rescue mission, a surgical operation, a preventive attack, a policing operation, and so forth. Lately, it has also been increasingly necessary to muzzle the press altogether (as in Grenada) in order to prevent alternative rhetorics from consolidating themselves. But they may do so yet—the key way to resist this contentless managerial discourse is somehow to gain some control over the terms of discussion.

Reagan's strategy of posing (i.e., containing) issues solely as questions of management and public relations has meant that, to a significant extent, resistance to Reagan's initiatives is concentrating at the level of bureaucracy. People are only too right to feel that mass popular resistance has incredibly little impact on this administration, that the struggle is all happening in Washington at levels of bureaucracy that seem impossibly remote. The two biggest demonstrations in the history of this country have happened under Reagan, and their memory lasted barely a week. On the other hand, what finally brought James Watt down was the threat of a Senate resolution condemning him. And it looks as though Congress is going to rescue the Civil Rights Commission by legislative means. People outside Washington are learning bureaucratic forms of resistance too. At local levels, nuclear freeze initiatives are proving to be effective political stands along with demonstrations. At Stanford, damned if a group of students didn't follow the trend and sue the Hoover Institution.

Alienation, Unreality, Helplessness and Other Discomforts

Life at Stanford has always had an air of unreality about it, a feeling of not being in the world but being off in some tiny overprotected corner of it— Stanford students are routinely driven crazy by this atmosphere. But in thinking about how this atmosphere had intensified in the past few years, we realized that people all over the place are experiencing a sense of unreality these

days, a sense of being cornered and unable to get in touch with what is really going on, let alone influence it. One of the things contributing to this sense is undoubtedly the administration's concerted refusal to acknowledge popular sentiment and mass political movements, and its refusal to listen to criticism or even pretend to take it seriously. One genuinely wonders whether it knows we exist.

A sense of unreality comes too from having to confront daily the fact that one's leaders are operating with a view of the world completely different from the one we thought most people here had come to share. Hence the jolts people experience when Watt makes overtly racist remarks in public forums, or when William Clark seems genuinely to believe the Soviets want to invade Central America, or when senators sincerely propose a limited nuclear strike in retaliation for the Korean jetliner incident, or when Jesse Helms starts a campaign against Martin Luther King's birthday as a national holiday, or when Reagan's advisers deluge Barbara Honegger with sexist abuse. In democracies, leaders are supposed to represent common understandings of the electorate. When they so drastically don't, people get very disoriented indeed, and life seems muffled, confused, and unreal. There is no other way to deal with scenes like James Watt in a cowboy suit riding off into the sunset after giving his resignation speech.

At Stanford, local events have likewise called forth the same "this-can't-be-happening-here" response. Like the case a few months ago when the head of obstetrics and gynecology at the Medical School wrote a resident a letter about how unprofessional and inconvenient it was for her to have gotten pregnant while still in training (to be an obstetrician, mind you). Fortunately, the student protested and released the letter, and a storm of criticism and reprimands rained down on the offender. Equally ludicrous was the response last spring to the faculty request for a review of the Hoover Institution's status in relation to the rest of the university. As we noted earlier, even this mild, moderate petition unleashed in response a typically Reaganesque barrage of rude, loud, vicious editorial-page rants (in the national press, which had by this time put itself fully in the service of this administration), associating anyone who even raised questions about the Hoover with the Sandinistas, the Salvadoran guerrillas, Marxists, and so on — rallying the last of the faithful to defend the ramparts against those infamous "dissident bands" of "academic terrorists."

The Politics of Insincerity

Another factor contributing to the general disorientation is the Reagan administration's unprecedented practice of using contradiction, overt deception, and insincerity as routine political and administrative tools. With the Reagan camp, deception and ignorance work together, and you often can't be sure which one you're up against. This point is raised in a recent book by Gail Macoll and Mark Green called *There He Goes Again: Ronald Reagan's Reign*

of Error, which concludes that "No modern president has engaged in so consistent a pattern of misspeaking on such a wide range of subjects and shown no sense of remorse."

As we mentioned earlier, people trying to make sense of things now have to confront constant, drastic shifts in rhetoric, and constant, drastic gaps between what the White House says and what it does or hopes to do. One week the White House proposes that the U.N. disband or move to Moscow, the next week Reagan is there himself making an arms reduction speech—but Americans don't know how to interpret the speech, because no one thinks Reagan really wants to reduce arms. It was treated as a matter of course for Reagan to make up a blatantly implausible excuse for canceling his trip to the Philippines. Why, one wonders, not give a believable one, even if it were equally insincere?

Critics of the administration are baffled not just by why Reaganites do this, but more importantly by why it seems to work. Jean Kirkpatrick can't have expected to convince anybody with her distinction between authoritarian and totalitarian governments, so why make it? Especially if one were going to abandon it right away? Why try to argue that there is a Soviet threat in Central America if you know there isn't and don't intend to stick to the argument anyway? What is gained by arguing one day that your policy is not to overthrow the Nicaraguan government and asserting the next day that it is? Why do such ways of doing not produce a complete collapse of national and international confidence in this administration?

To some extent, of course, they have, especially internationally. But it is also true that these raw and arbitrary displays of power, by their very rawness and assertiveness, give an impression that things are under control—an iron-fisted control that will brook no opposition and be swayed by nothing. Again you have to see these tactics against the background of Carter's tolerance and indecisiveness and the threat of chaos they raised for many people. It is against this background that Reagan's abrupt decision to replace James Watt with the hideously unqualified William Clark was widely received as an example of decisiveness and strong leadership. Once that guy makes up his mind, he doesn't even talk to his own advisers.

The politics of insincerity have trickled down from Washington too. At Stanford, we thought lovingly of James Watt when we received an administration report on new hirings for 1983 which glowed that a "significant number" of women were included among the new hirees. The significant number turned out to be three out of more than thirty appointments, exactly one woman at each of the three ranks. The number of minority appointments was "insignificant" (i.e., 0). We thought of the White House last spring, when the faculty senate charged the board of trustees to set up an impartial committee of from five to twenty persons to reassess the relationship of the Hoover Institution to the rest of the university. What the board of trustees proceeded to do was to set up a committee of five people, of whom three were members of the Hoover Board of Overseers, and charge this "impartial" group with reviewing the Hoover-Stanford ties in hopes of strengthening them.

There is no question that this tolerance for inconsistency and insincerity make effective opposition difficult. It means dialogue, debate, and all the traditional democratic practices for advocating dissenting views and forging compromises break down. On the other hand, this reliance on the lie and this anti-democratic bent underlie what may be the weakest point of the Reagan administrative style: its inability to deal with dissent. The Reagan-style response to criticism is knee-jerk hysteria. Outpourings of invective, group libel, threats, and name callings can be provoked at the drop of a hat, and they have a great potential for backfiring. James Watt was perhaps the paradigm example, but, as the Barbara Honegger case showed us, there are plenty more hysterics in the woodwork. Reagan himself can be made to lose his cool at the drop of a hat, and it very early became necessary to protect him from this possibility. Under pressure, neither he nor his friends conceal their true colors very well.

Epilogue

1984 is not likely to be a very good year, and the ones after that—when the fruits of Reagan's astronomical budget deficits are being reaped—are not going to be either. It sets one to thinking about another grim time and place: Germany in 1936, when Walter Benjamin published his famous essay "The Work of Art in an Age of Mechanical Reproduction." Already (long before TV), Benjamin was talking about the way mass media and the developing star system were going to determine political life in the future. Film, he says, will have as much of an impact on political life and institutions as it has on live theater:

> The present crisis of the bourgeois democracies comprises a crisis of the conditions which determine the public presentation of the rulers. Democracies exhibit a member of government directly and personally before the nation's representatives. Parliament is his public. [In contrast,] since the innovations of camera and recording equipment make it possible for the orator to become audible and visible to an unlimited number of persons, the presentation of the man of politics before camera and recording equipment becomes paramount. Parliaments, as much as theaters, are deserted. Radio and film not only affect the function of the professional actor, but likewise the function of those who also exhibit themselves before this mechanical equipment, those who govern. . . . The trend is toward establishing controllable and transferable skills under certain social conditions. This results in a new selection, a selection *before the equipment* from which the star and dictator emerge victorious. (Walter Benjamin, *Illuminations*, NY: Schocken, 1969, 247)

There is no question that Ronald Reagan was selected before the equipment, and that, as a star and a dictator, he has emerged victorious. And there is no question that we are confronting what Benjamin in that essay calls the "estheticization of politics" (241). In Benjamin's view, such an estheticization flows inevitably toward war: "War and war only can set a goal for mass movements on the largest scale while respecting the traditional property system"

(ibid.). The immediate challenge that faces us in 1984 is to try to prevent the re-election of the dictator-star, and to live through the awful aftermath of his regime. The longer and larger challenge will be to assess the transformation of political life and political consciousness that culminated in a Ronald Reagan, and to find ways to create a political consciousness that will use "the equipment" and its products in a different way. And what happens in universities will be important to this process. We must be skeptical of ivory tower ideologies that place universities outside the real world. If there's one thing life under Ronnie has taught us, it's that.

Arts of the
Contact Zone

Mary Louise Pratt

Whenever the subject of literacy comes up, what often first pops into my mind is a conversation I overheard eight years ago between my son Sam and his best friend, Willie, aged six and seven respectively: "Why don't you trade me Many Trails for Carl Yats . . . Yesits . . . Yastrum-scrum." "That's not how you say it, dummy, it's Carl Yes . . . Yes . . . oh, I don't know." Sam and Willie had just discovered baseball cards. Many Trails was their decoding, with the help of first-grade English phonics, of the name Manny Trillo. The name they were quite rightly stumped on was Carl Yastrzemski. That was the first time I remembered seeing them put their incipient literacy to their own use, and I was of course thrilled.

Sam and Willie learned a lot about phonics that year by trying to decipher surnames on baseball cards, and a lot about cities, states, heights, weights, places of birth, stages of life. In the years that followed, I watched Sam apply his arithmetic skills to working out batting averages and subtracting retirement years from rookie years; I watched him develop senses of patterning and order by arranging and rearranging his cards for hours on end, and aesthetic judgment by comparing different photos, different series, layouts, and color schemes. American geography and history took shape in his mind through baseball cards. Much of his social life revolved around trading them, and he learned about exchange, fairness, trust, the importance of processes as opposed to results, what it means to get cheated, taken advantage of, even robbed. Baseball cards were the medium of his economic life too. Nowhere better to learn the power and arbitrariness of money, the absolute divorce between use

First presented at the Responsibilities for Literacy conference in Pittsburgh, in September 1990, this essay then appeared in Profession (1991): 33–40. Reprinted by permission of the Modern Language Association of America.

value and exchange value, notions of long- and short-term investment, the possibility of personal values that are independent of market values.

Baseball cards meant baseball card shows, where there was much to be learned about adult worlds as well. And baseball cards opened the door to baseball books, shelves and shelves of encyclopedias, magazines, histories, biographies, novels, books of jokes, anecdotes, cartoons, even poems. Sam learned the history of American racism and the struggle against it through baseball; he saw the depression and two world wars from behind home plate. He learned the meaning of commodified labor, what it means for one's body and talents to be owned and dispensed by another. He knows something about Japan, Taiwan, Cuba, and Central America and how men and boys do things there.

"Contact zones are social spaces where cultures meet, clash, and grapple with each other, often in contexts of highly asymmetrical relations of power."

Through the history and experience of baseball stadiums he thought about architecture, light, wind, topography, meteorology, and the dynamics of public space. He learned the meaning of expertise, of knowing about something well enough that you can start a conversation with a stranger and feel sure of holding your own. Even with an adult—especially with an adult. Throughout his preadolescent years, baseball history was Sam's luminous point of contact with grown-ups, his lifeline to caring. And, of course, all this time he was also playing baseball, struggling his way through the stages of the local Little League system, lucky enough to be a pretty good player, loving the game and coming to know deeply his strengths and weaknesses.

Literacy began for Sam with the newly pronounceable names on the picture cards and brought him what has been easily the broadest, most varied, most enduring, and most integrated experience of his thirteen-year life. Like many parents, I was delighted to see schooling give Sam the tools with which to find and open all these doors. At the same time I found it unforgivable that schooling itself gave him nothing remotely as meaningful to do, let alone anything that would actually take him beyond the referential, masculinist ethos of baseball and its lore.

However, I was not invited here to speak as a parent, nor as an expert on literacy. I was asked to speak as an MLA member working in the elite academy. In that capacity my contribution is undoubtedly supposed to be abstract, irrelevant, and anchored outside the real world. I wouldn't dream of disappointing anyone. I propose immediately to head back several centuries to a text that has a few points in common with baseball cards and raises thoughts about what Tony Sarmiento, in his comments to the conference, called new visions of literacy. In 1908 a Peruvianist named Richard Pietschmann was exploring in the Danish Royal Archive in Copenhagen and came across a manuscript. It was dated in the city of Cuzco in Peru, in the year 1613, some forty years after the

final fall of the Inca empire to the Spanish and signed with an unmistakably Andean indigenous name: Felipe Guaman Poma de Ayala. Written in a mixture of Quechua and ungrammatical, expressive Spanish, the manuscript was a letter addressed by an unknown but apparently literate Andean to King Philip III of Spain. What stunned Pietschmann was that the letter was twelve hundred pages long. There were almost eight hundred pages of written text and four hundred of captioned line drawings. It was titled *The First New Chronicle and Good Government*. No one knew (or knows) how the manuscript got to the library in Copenhagen or how long it has been there. No one, it appeared, had ever bothered to read it or figured out how. Quechua was not thought of as a written language in 1908, nor Andean culture as a literate culture.

Pietschmann prepared a paper on his find, which he presented in London in 1912, a year after the rediscovery of Machu Picchu by Hiram Bingham. Reception, by an international congress of Americanists, was apparently confused. It took twenty-five years for a facsimile edition of the work to appear, in Paris. It was not till the late 1970s, as positivist reading habits gave way to interpretive studies and colonial elitisms to postcolonial pluralisms, that Western scholars found ways of reading Guaman Poma's *New Chronicle and Good Government* as the extraordinary intercultural tour de force that it was. The letter got there, only 350 years too late, a miracle and a terrible tragedy.

I propose to say a few more words about this erstwhile unreadable text, in order to lay out some thoughts about writing and literacy in what I like to call the *contact zones*. I use this term to refer to social spaces where cultures meet, clash, and grapple with each other, often in contexts of highly asymmetrical relations of power, such as colonialism, slavery, or their aftermaths as they are lived out in many parts of the world today. Eventually I will use the term to reconsider the models of community that many of us rely on in teaching and theorizing and that are under challenge today. But first a little more about Guaman Poma's giant letter to Philip III.

Insofar as anything is known about him at all, Guaman Poma exemplified the sociocultural complexities produced by conquest and empire. He was an indigenous Andean who claimed noble Inca descent and who had adopted (at least in some sense) Christianity. He may have worked in the Spanish colonial administration as an interpreter, scribe, or assistant to a Spanish tax collector — as a mediator, in short. He says he learned to write from his half brother, a mestizo whose Spanish father had given him access to religious education.

Guaman Poma's letter to the king is written in two languages (Spanish and Quechua) and two parts. The first is called the *Nueva corónica* ("New Chronicle"). The title is important. The chronicle of course was the main writing apparatus through which the Spanish represented their American conquests to themselves. It constituted one of the main official discourses. In writing a "new chronicle," Guaman Poma took over the official Spanish genre for his own ends. Those ends were, roughly, to construct a new picture of the world, a picture of a Christian world with Andean rather than European peoples at the

center of it—Cuzco, not Jerusalem. In the *New Chronicle* Guaman Poma begins by rewriting the Christian history of the world from Adam and Eve, incorporating the Amerindians into it as offspring of one of the sons of Noah. He identifies five ages of Christian history that he links in parallel with the five ages of canonical Andean history—separate but equal trajectories that diverge with Noah and reintersect not with Columbus but with Saint Bartholomew, who is claimed to have preceded Columbus in the Americas. In a couple of hundred pages, Guaman Poma constructs a veritable encyclopedia of Inca and pre-Inca history, customs, laws, social forms, public offices, and dynastic leaders. The depictions resemble European manners and customs description, but also reproduce the meticulous detail with which knowledge in Inca society was stored on *quipus* and in the oral memories of elders.

Guaman Poma's *New Chronicle* is an instance of what I have proposed to call an *autoethnographic* text, by which I mean a text in which people undertake to describe themselves in ways that engage with representations others have made of them. Thus if ethnographic texts are those in which European metropolitan subjects represent to themselves their others (usually their conquered others), autoethnographic texts are representations that the so-defined others construct *in response to* or in dialogue with those texts. Autoethnographic texts are not, then, what are usually thought of as autochthonous forms of expression of self-representation (as the Andean *quipus* were). Rather they involve a selective collaboration with and appropriation of idioms of the metropolis or the conqueror. These are merged or infiltrated to varying degrees with indigenous idioms to create self-representations intended to intervene in metropolitan modes of understanding. Autoethnographic works are often addressed to both metropolitan audiences and the speaker's own community. Their reception is thus highly indeterminate. Such texts often constitute a marginalized group's point of entry into the dominant circuits of print culture. It is interesting to think, for example, of American slave autobiography in its autoethnographic dimensions, which in some respects distinguish it from Euramerican autobiographical tradition. The concept might help explain why some of the earliest published writing by Chicanos took the form of folkloric manners and customs sketches written in English and published in English-language newspapers or folklore magazines (see Treviño). Autoethnographic representation often involves concrete collaborations between people, as between literate ex-slaves and abolitionist intellectuals, or between Guaman Poma and the Inca elders who were his informants. Often, as in Guaman Poma, it involves more than one language. In recent decades autoethnography, critique, and resistance have reconnected with writing in a contemporary creation of the contact zone, the *testimonio*.

Guaman Poma's *New Chronicle* ends with a revisionist account of the Spanish conquest, which, he argues, should have been a peaceful encounter of equals with the potential for benefiting both, but for the mindless greed of the Spanish. He parodies Spanish history. Following contact with the Incas, he writes, "In all Castille, there was a great commotion. All day and at night in

their dreams the Spaniards were saying "Yndias, yndias, oro, plata, oro, plata del Piru" ("Indies, Indies, gold, silver, gold, silver from Peru"). The Spanish, he writes, brought nothing of value to share with the Andeans, nothing but armor and guns "con la codicia de oro, plata, oro y plata, yndias, a las Yndias, Piru" ("with the lust for gold, silver, gold and silver, Indies, the Indies, Peru") (372). I quote these words as an example of a conquered subject using the conqueror's language to construct a parodic, oppositional representation of the conqueror's own speech. Guaman Poma mirrors back to the Spanish (in their language, which is alien to him) an image of themselves that they often suppress and will therefore surely recognize. Such are the dynamics of language, writing, and representation in contact zones.

The second half of the epistle continues the critique. It is titled *Buen gobierno y justicia* ("Good Government and Justice") and combines a description of colonial society in the Andean region with a passionate denunciation of Spanish exploitation and abuse. (These, at the time he was writing, were decimating the population of the Andes at a genocidal rate. In fact, the potential loss of the labor force became a main cause for reform of the system.) Guaman Poma's most implacable hostility is provoked by the clergy, followed by the dreaded *corregidores*, or colonial overseers. He also praises good works, Christian habits, and just men where he finds them, and offers at length his views as to what constitutes "good government and justice." The Indies, he argues, should be administered through a collaboration of Inca and Spanish elites. The epistle ends with an imaginary question-and-answer session in which, in a reversal of hierarchy, the king is depicted asking Guaman Poma questions about how to reform the empire—a dialogue imagined across the many lines that divide the Andean scribe from the imperial monarch, and in which the subordinated subject single-handedly gives himself authority in the colonizer's language and verbal repertoire. In a way, it worked—this extraordinary text did get written—but in a way it did not, for the letter never reached its addressee.

To grasp the import of Guaman Poma's project, one needs to keep in mind that the Incas had no system of writing. Their huge empire is said to be the only known instance of a full-blown bureaucratic state society built and administered without writing. Guaman Poma constructs his text by appropriating and adapting pieces of the representational repertoire of the invaders. He does not simply imitate or reproduce it; he selects and adapts it along Andean lines to express (bilingually, mind you) Andean interests and aspirations. Ethnographers have used the term *transculturation* to describe processes whereby members of subordinated or marginal groups select and invent from materials transmitted by a dominant or metropolitan culture. The term, originally coined by Cuban sociologist Fernando Ortiz in the 1940s, aimed to replace overly reductive concepts of acculturation and assimilation used to characterize culture under conquest. While subordinate peoples do not usually control what emanates from the dominant culture, they do determine to varying extents what gets absorbed into their own and what it gets used for.

Transculturation, like autoethnography, is a phenomenon of the contact zone.

As scholars have realized only relatively recently, the transcultural character of Guaman Poma's text is intricately apparent in its visual as well as its written component. The genre of the four hundred line drawings is European — there seems to have been no tradition of representational drawing among the Incas — but in their execution they deploy specifically Andean systems of spatial symbolism that express Andean values and aspirations.[1]

In one figure, for instance, Adam is depicted on the left-hand side below the sun, while Eve is on the right-hand side below the moon, and slightly lower than Adam. The two are divided by the diagonal of Adam's digging stick. In Andean spatial symbolism, the diagonal descending from the sun marks the basic line of power and authority dividing upper from lower, male from female, dominant from subordinate. In another figure, the Inca appears in the same position as Adam, with the Spaniard opposite, and the two at the same height. In a third figure, depicting Spanish abuses of power, the symbolic pattern is reversed. The Spaniard is in a high position indicating dominance, but on the "wrong" (right-hand) side. The diagonals of his lance and that of the servant doing the flogging mark out a line of illegitimate, though real, power. The Andean figures continue to occupy the left-hand side of the picture, but clearly as victims. Guaman Poma wrote that the Spanish conquest had produced "un mundo al reves" ("a world in reverse").

In sum, Guaman Poma's text is truly a product of the contact zone. If one thinks of cultures or literatures as discrete, coherently structured, monolingual edifices, Guaman Poma's text, and indeed any autoethnographic work, appears anomalous or chaotic — as it apparently did to the European scholars Pietschmann spoke to in 1912. If one does not think of cultures this way, then Guaman Poma's text is simply heterogeneous, as the Andean region was itself and remains today. Such a text is heterogenous on the reception end as well as the production end: it will read very differently to people in different positions in the contact zone. Because it deploys European and Andean systems of meaning making, the letter necessarily means differently to bilingual Spanish-Quechua speakers and to monolingual speakers in either language; the drawings mean differently to monocultural readers, Spanish or Andean, and to bicultural readers responding to the Andean symbolic structures embodied in European genres.

In the Andes in the early 1600s there existed a literate public with considerable intercultural competence and degrees of bilingualism. Unfortunately, such a community did not exist in the Spanish court with which Guaman Poma was trying to make contact. It is interesting to note that in the same year Guaman Poma sent off his letter, a text by another Peruvian was adopted in official circles in Spain as the canonical Christian mediation between the Spanish conquest and Inca history. It was another huge encyclopedic work, titled the *Royal Commentaries of the Incas*, written, tellingly, by a mestizo, Inca Garcilaso de la Vega. Like the mestizo half brother who taught Guaman Poma to read and write, Inca Garcilaso was the son of an Inca princess and a Spanish

official, and had lived in Spain since he was seventeen. Though he too spoke Quechua, his book is written in eloquent, standard Spanish, without illustrations. While Guaman Poma's life's work sat somewhere unread, the *Royal Commentaries* was edited and re-edited in Spain and the New World, a mediation that coded the Andean past and present in ways thought unthreatening to colonial hierarchy.[2] The textual hierarchy persists: the *Royal Commentaries* today remains a staple item on Ph.D. reading lists in Spanish, while the *New Chronicle and Good Government*, despite the ready availability of several fine editions, is not. However, though Guaman Poma's text did not reach its destination, the transcultural currents of expression it exemplifies continued to evolve in the Andes, as they still do, less in writing than in storytelling, ritual, song, dance-drama, painting and sculpture, dress, textile art, forms of governance, religious belief, and many other vernacular art forms. All express the effects of long-term contact and intractable, unequal conflict.

Autoethnography, transculturation, critique, collaboration, bilingualism, mediation, parody, denunciation, imaginary dialogue, vernacular expression—these are some of the literate arts of the contact zone. Miscomprehension, incomprehension, dead letters, unread masterpieces, absolute heterogeneity of meaning—these are some of the perils of writing in the contact zone. They all live among us today in the transnationalized metropolis of the United States and are becoming more widely visible, more pressing, and, like Guaman Poma's text, more decipherable to those who once would have ignored them in defense of a stable, centered sense of knowledge and reality.

Contact and Community

The idea of the contact zone is intended in part to contrast with ideas of community that underlie much of the thinking about language, communication, and culture that gets done in the academy. A couple of years ago, thinking about the linguistic theories I knew, I tried to make sense of a utopian quality that often seemed to characterize social analyses of language by the academy. Languages were seen as living in "speech communities," and these tended to be theorized as discrete, self-defined, coherent entities, held together by a homogeneous competence or grammar shared identically and equally among all the members. This abstract idea of the speech community seemed to reflect, among other things, the utopian way modern nations conceive of themselves as what Benedict Anderson calls "imagined communities."[3] In a book of that title, Anderson observes that with the possible exception of what he calls "primordial villages," human communities exist as *imagined* entities in which people "will never know most of their fellow-members, meet them or even hear of them, yet in the minds of each lives the image of their communion."

"Communities are distinguished," he goes on to say, "not by their falsity/genuineness, but by *the style in which they are imagined*" (15; emphasis mine). Anderson proposes three features that characterize the style in which the mod-

ern nation is imagined. First, it is imagined as *limited* by "finite, if elastic, boundaries"; second, it is imagined as *sovereign*; and, third, it is imagined as *fraternal*, "a deep, horizontal comradeship" for which millions of people are prepared "not so much to kill as willingly to die" (15). As the image suggests, the nation-community is embodied metonymically in the finite, sovereign, fraternal figure of the citizen-soldier.

Anderson argues that European bourgeoisies were distinguished by their ability to "achieve solidarity on an essentially imagined basis" (74) on a scale far greater than that of elites of other times and places. Writing and literacy play a central role in this argument. Anderson maintains, as have others, that the main instrument that made bourgeois nation-building projects possible was print capitalism. The commercial circulation of books in the various European vernaculars, he argues, was what first created the invisible networks that would eventually constitute the literate elites and those they ruled as nations. (Estimates are that 180 million books were put into circulation in Europe between the years 1500 and 1600 alone.)

Now obviously this style of imagining of modern nations, as Anderson describes it, is strongly utopian, embodying such values as equality, fraternity, and liberty, which the societies often profess but systematically fail to realize. The prototype of the modern nation as imagined community was, it seemed to me, mirrored in ways people thought about language and the speech community. Many commentators have pointed out how modern views of language as code and competence assume a unified and homogeneous social world in which language exists as a shared patrimony—as a device, precisely, for imagining community. An image of a universally shared literacy is also part of the picture. The prototypical manifestation of language is generally taken to be the speech of individual adult native speakers face-to-face (as in Saussure's famous diagram) in monolingual, even monodialectal situations—in short, the most homogeneous case linguistically and socially. The same goes for written communication. Now one could certainly imagine a theory that assumed different things—that argued, for instance, that the most revealing speech situation for understanding language was one involving a gathering of people each of whom spoke two languages and understood a third and held only one language in common with any of the others. What you choose to define as normative depends on what workings of language you want to see, or want to see first.

In keeping with autonomous, fraternal models of community, analyses of language use commonly assume that principles of cooperation and shared understanding are normally in effect. Descriptions of interactions between people in conversation, classrooms, medical and bureaucratic settings readily take it for granted that the situation is governed by a single set of rules or norms shared by all participants. The analysis focuses then on how those rules produce or fail to produce an orderly, coherent exchange. Models involving games and moves are often used to describe interactions. Despite whatever conflicts or systematic social differences might be in play, it is assumed that all

participants are engaged in the same game and that the game is the same for all players. Often it is. But of course often it is not, as, for example, when speakers are from different classes or cultures, or one party is exercising authority and another is submitting to it or questioning it. Last year one of my children moved to a new elementary school that had more open classrooms and more flexible curricula than the conventional school he started out in. A few days into the term, I asked him what it was like at the new school. "Well," he said, "they're a lot nicer, and they have a lot less rules. But know *why* they're nicer?" "Why?" I asked. "So you'll obey all the rules they don't have," he replied. This is a very coherent analysis with considerable elegance and explanatory power, but probably not the one his teacher would have given.

When linguistic (or literate) interaction is described in terms of orderliness, games, moves, or scripts, usually only legitimate moves are actually named as part of the system, where legitimacy is defined from the point of view of the party in authority—regardless of what other parties might see themselves as doing. Teacher-pupil language, for example, tends to be described almost entirely from the point of view of the teacher and teaching, not from the point of view of pupils and pupiling (the word doesn't even exist, though the thing certainly does). If a classroom is analyzed as a social world unified and homogenized with respect to the teacher, whatever students do other than what the teacher specifies is invisible or anomalous to the analysis. This can be true in practice as well. On several occasions my fourth grader, the one busy obeying all the rules they didn't have, was given writing assignments that took the form of answering a series of questions to build up a paragraph. These questions often asked him to identify with the interests of those in power over him—parents, teachers, doctors, public authorities. He invariably sought ways to resist or subvert these assignments. One assignment, for instance, called for imagining "a helpful invention." The students were asked to write single-sentence responses to the following questions:

What kind of invention would help you?
How would it help you?
Why would you need it?
What would it look like?
Would other people be able to use it also?
What would be an invention to help your teacher?
What would be an invention to help your parents?

Manuel's reply read as follows:

A GRATE ADVENTCHIN

Some inventchins are GRATE!!!!!!!!!! My inventchin would be a shot that would put every thing you learn at school in your brain. It would help me by letting me graduate right now!! I would need it because it would let me play with my freinds, go on vacachin and, do fun a lot more. It would look like a regular shot. Ather

peaple would use to. This inventchin would help my teacher parents get away from a lot of work. I think a shot like this would be GRATE!

Despite the spelling, the assignment received the usual star to indicate the task had been fulfilled in an acceptable way. No recognition was offered, however, of the humor, the attempt to be critical or contestatory, to parody the structures of authority. On that score, Manuel's luck was only slightly better than Guaman Poma's. What is the place of unsolicited oppositional discourse, parody, resistance, critique in the imagined classroom community? Are teachers supposed to feel that their teaching has been most successful when they have eliminated such things and unified the social world, probably in their own image? Who wins when we do that? Who loses?

Such questions may be hypothetical, because in the United States in the 1990s, many teachers find themselves less and less able to do that even if they want to. The composition of the national collectivity is changing and so are the styles, as Anderson put it, in which it is being imagined. In the 1980s in many nation-states, imagined national syntheses that had retained hegemonic force began to dissolve. Internal social groups with histories and lifeways different from the official ones began insisting on those histories and lifeways *as part of their citizenship*, as the very mode of their membership in the national collectivity. In their dialogues with dominant institutions, many groups began asserting a rhetoric of belonging that made demands beyond those of representation and basic rights granted from above. In universities we started to hear, "I don't just want you to let me be here, I want to belong here; this institution should belong to me as much as it does to anyone else." Institutions have responded with, among other things, rhetorics of diversity and multiculturalism whose import at this moment is up for grabs across the ideological spectrum.

These shifts are being lived out by everyone working in education today, and everyone is challenged by them in one way or another. Those of us committed to educational democracy are particularly challenged as that notion finds itself besieged on the public agenda. Many of those who govern us display, openly, their interest in a quiescent, ignorant, manipulable electorate. Even as an ideal, the concept of an enlightened citizenry seems to have disappeared from the national imagination.

A couple of years ago the university where I work went through an intense and wrenching debate over a narrowly defined Western culture requirement that had been instituted there in 1980. It kept boiling down to a debate over the ideas of national patrimony, cultural citizenship, and imagined community. In the end, the requirement was transformed into a much more broadly defined course called Cultures, Ideas, Values.[4] In the context of the change, a new course was designed that centered on the Americas and the multiple cultural histories (including European ones) that have intersected here. As you can imagine, the course attracted a very diverse group of students. The classroom functioned not like a homogeneous community or a horizontal alliance but like a contact zone. Every single text we read stood in specific historical rela-

tionships to the students in the class, but the range and variety of historical relationships in play were enormous. Everybody had a stake in nearly everything we read, but the range and kind of stakes varied widely.

It was the most exciting teaching we had ever done, and also the hardest. We were struck, for example, at how anomalous the formal lecture became in a contact zone (who can forget Atahuallpa throwing down the Bible because it would not speak to him?). The lecturer's traditional (imagined) task—unifying the world in the class's eyes by means of a monologue that rings equally coherent, revealing, and true for all, forging an ad hoc community, homogeneous with respect to one's own words—became not only impossible but anomalous and unimaginable. Instead, one had to work in the knowledge that whatever one said was going to be systematically received in radically heterogenous ways that we were neither able nor entitled to prescribe.

The very nature of the course put ideas and identities on the line. All the students in the class had the experience, for example, of hearing their culture discussed and objectified in ways that horrified them; all the students saw their roots traced back to legacies of both glory and shame; all the students experienced face-to-face the ignorance and incomprehension, and occasionally the hostility, of others. In the absence of community values and the hope of synthesis, it was easy to forget the positives; the fact, for instance, that kinds of marginalization once taken for granted were gone. Virtually every student was having the experience of seeing the world described with him or her in it. Along with rage, incomprehension, and pain, there were exhilarating moments of wonder and revelation, mutual understanding, and new wisdom—the joys of the contact zone. The sufferings and revelations were, at different moments to be sure, experienced by every student. No one was excluded, and no one was safe.

The fact that no one was safe made all of us involved in the course appreciate the importance of what we came to call "safe houses." We used the term to refer to social and intellectual spaces where groups can constitute themselves as horizontal, homogeneous, sovereign communities with high degrees of trust, shared understandings, temporary protection from legacies of oppression. This is why, as we realized, multicultural curricula should not seek to replace ethnic or women's studies, for example. Where there are legacies of subordination, groups need places for healing and mutual recognition, safe houses in which to construct shared understandings, knowledges, claims on the world that they can then bring into the contact zone.

Meanwhile, our job in the Americas course remains to figure out how to make that crossroads the best site for learning that it can be. We are looking for the pedagogical arts of the contact zone. These will include, we are sure, exercises in storytelling and in identifying with the ideas, interests, histories, and attitudes of others; experiments in transculturation and collaborative work and in the arts of critique, parody, and comparison (including unseemly comparisons between elite and vernacular cultural forms); the redemption of the oral; ways for people to uncover, confront and reflect on suppressed aspects of

history (including their own histories), ways to move *into and out of* rhetorics of authenticity; ground rules for communication across lines of difference and hierarchy that go beyond politeness but maintain mutual respect; a systematic approach to the all-important concept of *cultural mediation*. These arts were in play in every room at the extraordinary Pittsburgh conference on literacy. I learned a lot about them there, and I am thankful.

Works Cited

Adorno, Rolena. *Guaman Poma de Ayala: Writing and Resistance in Colonial Peru.* Austin: University of Texas Press, 1986.

Anderson, Benedict. *Imagined Communities: Reflections on the Origins and Spread of Nationalism.* London: Verso, 1984.

Garcilaso de la Vega, El Inca. *Royal Commentaries of the Incas.* 1613. Austin: University of Texas Press, 1966.

Guaman Poma de Ayala, Felipe. *El primer nueva corónica y buen gobierno.* Manuscript. Ed. John Murra and Rolena Adorno. Mexico: Siglo XXI, 1980.

Pratt, Mary Louise. "Linguistic Utopias." *The Linguistics of Writing.* Ed. Nigel Fabb et al. Manchester: Manchester University Press, 1987, 48–66.

Treviño, Gloria. "Cultural Ambivalence in Early Chicano Prose Fiction." Diss. Stanford University, 1985.

Notes

1. For an introduction in English to these and other aspects of Guaman Poma's work, see Rolena Adorno. Adorno and Mercedes Lopez-Baralt pioneered the study of Andean symbolic systems in Guaman Poma.

2. It is far from clear that the *Royal Commentaries* was as benign as the Spanish seemed to assume. The book certainly played a role in maintaining the identity and aspirations of indigenous elites in the Andes. In the mid-eighteenth century, a new edition of the *Royal Commentaries* was suppressed by Spanish authorities because its preface included a prophecy by Sir Walter Raleigh that the English would invade Peru and restore the Inca monarchy.

3. The discussion of community here is summarized from my essay "Linguistic Utopias."

4. For information about this program and the contents of courses taught in it, write Program in Cultures, Ideas, Values (CIV), Stanford University, Stanford, CA 94305.

Professors

Dana Polan

By all biographical accounts, Christian Gauss of Princeton was a riveting professor and, later, an energizing dean. The tributes to him toward the end of his life and after his death attest with impressive regularity to the talents of a man for whom pedagogy assumed especially the form of a radiant inspiration. Here the activity of learning is less an attaining of specific ideas than a full and effective captivation by aura. The language of the tributes is a physical, even sensuous one. For his student, Edmund Wilson, for example, Gauss cut through the artificialities of rhetoric to offer up the things to be learned in their full presence: "Such an incident [Rousseau's discovery of the Academy of Dijon essay competition] Gauss made memorable, invested with reverberating significance, by a series of incisive strokes that involved no embroidery, or dramatics. It was, in fact, as if the glamor of legend, the grandeur of history, had evaporated and left him [Rousseau] exposed to our passing gaze. . . . In the same way, [Gauss] made us *feel* the pathos" (Wilson 1952, 10).

But this recurring description of Gauss as a teacher of immediacy sits significantly with another image in the writing about him: in his role as conveyer of a learning onto which he imposes no specific contents, a figure who lets us feel the aura of historical events or characters, Gauss is repeatedly described as a modest figure of mediation who relays a knowledge that he alone can bring to life but that does not originate with him. At the same time, though, accounts of Christian Gauss emphasize his imposing presence. Wilson's description, for instance, stresses both Gauss's presence *and* his self-effacing surrender to a higher moral truth: "[T]he very uniformity of his candid tone, his unhurried pace and his scrupulous precision, with his slightly drawling intonations, made a kind of neutral medium in which everything in the world seemed soluble" (6).

This essay first appeared in Discourse 16.1 (Fall 1993): 28–49. Reprinted here by permission of the author.

For another student, R. P. Blackmur, this mediating quality gave Gauss membership in a special community of "men" for whom specific acts of transmission take value as an art of resistance to the mediocrities and dogmatisms of history:

> It seems to me there has always been a representative race of men which, understanding what is desperate and fanatic, has itself stood for what is anonymous and random. It is by the example of that race that we understand the excesses of great men and of mass movements; it is by contact with that race that we gain the impulse and borrow the courage to keep up what is human in us and make that our enterprise. If we feel the touch, we know by the warmth of it what it is we have to do. That

"Another powerful cultural representation: the professor as particularly vulnerable to the vagaries of existence. As figures who are unaware of the nature of their embodiment or who relate to their embodiment in theatrical or inauthentic ways, professors find their bodies escaping them, giving in to dangerous influences. Jerry Lewis's _The Nutty Professor_ is nothing as much as a cataloguing of the temptations and malleabilities of the flesh."

> touch—that contact—is the only human resource by which we get at the force which underlies our own desperations and fanaticisms and makes us seem fit to survive. Christian Gauss belongs to that race; he affords that touch or contact; he represents what keeps us going; and he stands at the head of what he represents because he knows what it is that he represents, but knows also that he cannot, if he is to transmit it to others, commit himself to any one form of it as necessarily superior to any other form of it. He knows that he represents not a doctrine of life but the condition of living. (341–42)

Now I hope it won't be in any way assumed that I am setting out to impugn the reputation of this obviously important figure in the history of American education and, more specifically, in American literary studies if I suggest that the discourse on Gauss gains much of its force from its investments in a number of evident ideological representations. Most obviously, Gauss is positioned as part of that gentlemanly tradition of criticism that Gerald Graff and others have seen as in battle with the rise of a professionalist ethos in criticism (Graff 1987). Content of instruction is seen to matter less than a taking on of a whole way of life, an ethos. Significantly, while many of the commentators on Gauss wonder why the job of dean appealed to him, they also suggest a continuity with the earlier work of Gauss as professor of letters: in both jobs, an emphasis

on imparting knowledge and guidance to gentlemen undergraduates, and a devaluation of the research work of the graduate school, seem central.

For the gentlemanly tradition, education is not research, it is not science, it is a radiant influence of spirit, of humanity. It is a contentless knowledge or, rather, in opposition to the content-neutral knowledge of democratic pragmatic education, it needs no specific content since each new act of learning is to be based on an already common content of classic gentility. Gauss, who named his dog "Baudelaire" and his son "Dante," is pictured as a man for whom the classics are lived existentially and are so much a part of the humanist's being-in-the-world that they can be taken for granted. Such classic gentility is what one begins from, spontaneously, naturally, immediately. As Marjorie Hope Nicholson mentions in her tribute, her colleagues thought "common sense" was Gauss's most salient characteristic (1948, 340).

This enabling base of gentlemanliness can nonetheless give rise to specific political preferences, specific programs and practices. Indeed, it is the very extent to which each belief seems to spring naturally from a core of common sense that allows Gauss to slide from letters to politics easily, gracefully. Although he toyed with the idea of socialism, he rejected it in favor of the values of religion and nationhood. He wrote diplomatic history against German character and in support of the war policies of Woodrow Wilson, his former president at Princeton (Gauss 1919). At the end of his life in the Cold War 1950s, he championed the teaching of religion in the university as, among other things, a way of combating what he saw as the dogmatic savagery of communism (Gauss 1951).

But what interests me here are not simply the specific ties that might be made between the gentlemanly tradition and any particular politics of American diplomacy; what I would like to stress is the outline of a general ideology constructed in the very notion of education as discovery and transmission. At this level, as Gerald Graff notes, the research tradition and the gentlemanly tradition cease to appear as rivals because both adhere to a faith in the presence of truth but differ in their sense of where such truth is located and what methods or non-methods could discover or uncover it. Through its various manifestations, its various schools, the job of education is imagined as an activity of retrieval and transmission: "lux et veritas," as the official motto of several universities would have it—the finding of truth *and* the luminous radiation of that truth. Emile Zola gives us a condensation of this transmissive notion of education in his 1902 novel *Vérité* in the character of the schoolteacher Marc Froment, whose very name—from wheat—suggests learning as an act of fertilization, a sowing of seeds of truth in the minds of students:

> There was a measure of heroism in his deed and he accomplished it with simplicity, out of enthusiasm for the good work he was undertaking. The highest role, the noblest, in a young democracy is that of the primary schoolteacher, so poor, so despised, who is entrusted with the education of the humble and who is to make of them the future happy citizens, the builders of the City of Justice and Peace. His

mission suddenly became clear to him: his apostolate of truth, his passion to pene-
trate the positive truth, to proclaim it loudly, to teach it to everyone. (Qtd. in
Brombert 1961, 68–69)

Simplifying, we might suggest that the humanist theory of education starts
from a simple epistemological premise. One version of this theory is dissected
in Richard Rorty's *Philosophy and the Mirror of Nature*: truths exist as objects
in nature, and subjects come from without to know those truths through trans-
parent media of discovery, and these knowing subjects enable others to know
truth through pedagogic transmission. The university will inflect this model by
inserting the knower into a social universe. The goal of knowing is not simply
to *acquire* but to *give* to others—to profess; and the spirit of collegiality—of col-
legeness—exists so that the quest for truth becomes a group quest. This is the
central inflection given to philosophy today by Jürgen Habermas, for whom
our productive, purposive relations to the world have achieved a stability, even
inertia, but for whom our communicative relations to each other still can bear
rational reconstruction so that investigation will become communal, an act of
open dialogue.

Components of this philosophy of knowledge have come under attack—in
new approaches to science, for example. Thus, Donna Haraway's *Primate
Visions*, on the discipline of primatology, argues the ways in which dynamics
of gender have as a consequence that the relations of knowing subjects to their
disciplinary objects is never immediate, transparent, uninflected by desire,
phantasy, myth. In a complementary gesture, Stanley Aronowitz argues in
Science as Power that, although partially heuristic, the Habermasian separation
of purposive action from communicative action can tend to reify scientific
method even as it promises an opening up of dialogue among scientists. And
recent work on the sociology of science, such as Latour-Woolgar's *Laboratory
Life*, suggests that the intersubjective relation of scientist to scientist is not
so much an activity of rational communication as of rivalry, competitiveness,
a trading of pure knowing for glories of reputation and personal accomplish-
ment.

In an article in *Social Text* on Habermas's notion of the public sphere, I sug-
gest that for all its attractiveness as the promise of a way to rebuild humanistic
inquiry, Habermas's model limits itself by its recourse to a very standard con-
ception of the mass media and its role in communication (1990). This con-
ception begins by defining a sphere of pure, open, rational communication,
and then sees the media as invading after the fact as artificialities, deceptions,
false coverings (as in the title of Edward Said's book on media and the Orient,
*Covering Islam: How the Media and the Experts Determine How We See the
Rest of the World*).

I would argue, though, that to start with a before/after conception of the
media in the analysis of knowledge production may be to ignore ways in which
the very elements of knowledge and university investigation are not merely
mediated, but mediatized from the start, rendered as images, made into spec-

tacles, good (or bad) show. The transmission model of knowledge assumes the teacher to be a medium, a vessel, for a knowledge that passes through intact, or even enhanced if the teacher is gripping and engaging enough. But for many students, the teacher is not a conduit to a knowledge that exists elsewhere: the teacher is an image, a *cliché* in the sense both of stereotype but also of photographic imprinting that freezes knowledge in the seeming evidence of a look, where the image predetermines what the person means to us. Professors don't come into class as pure figures of a knowledge that simply passes through them. The medium is the message, and the image of the professor often matters more than the ideas of the lesson. Given that the professor is a figure in the media, he/she cannot be a purely neutral medium.

The notion of knower as pure subject and as pure professor assumes a certain disembodiment of the person. What the professor is as a body is almost irrelevant to what the professor can convey as mind. As Hazard Adams puts it in *The Academic Tribes*, "In this vision, the faculty member is a pure presence, rather than a being-in-the-world" (36). But the Heideggerean or Sartrean terminology here should alert us to the ways in which the philosophy of disembodiment is also an embodiment and one enabling a binary ideology that maps mind/body splits onto social dialectics such as male/female, popular culture/high culture, aristocracy/democracy. One interesting example of the sexual dimensions of the professor's being-in-the-world shows up significantly in Edmund Wilson's own *private* musings on Christian Gauss. In the 1920s, Wilson has long since graduated from Princeton and is beginning to make a name for himself in the literary world. While his public pronouncements represent Gauss as a virtually disembodied force of a pure and disinterested learning, Wilson's private musings render the professor, as so much student culture about professors does, as fully embodied. Writing a love poem to the woman he is passionately involved with, Edna St. Vincent Millay, Wilson cannot, however, prevent a homosocial subtext from emerging:

Princeton fell away
And there seemed to be nothing real
Among intangible shadows,
Except a light here and there, a light I had known of old
And your flame [that is, Millay's] in New York
That that cruelty did but feed.
I sat in a bare room
Talking to Christian Gauss
And watching his clear green eyes, as hard and as fine as gems;
I heard him speak of books and politics and people,
With his incredible learning and his cloudless mind,
But he was really talking of life . . .
And I thought of him, as I have always done, as a short stocky naked man
Holding an impossible post
At the edge of an abyss,

With bleak and uncontrollable storms
Crashing about him. . . .
I was already swearing again an oath I had many times sworn already:
That, so long as I should live, I should honor nothing but Gauss
With his back against the rock,—
But, while I swore, your bitter beauty
Filled the room,
And I saw it was you who were standing
Against the rock. . . . (*The Twenties* 62–63)

To maintain the transmission model, professors have had to imagine them-selves as other than in the world: the material world is little but their object of study, and they move in a realm that is other—ethereal, ideational. From the start, for example, the American university is caught in a debate between the practical and the spiritual, which is also a debate about bodies and the seduc-tions of the physical. Not surprisingly, the antipragmatist bent of the gentle-manly tradition quickly turns into an antidemocratic tendency that can even invoke myths of British spirit against American physicalness. A 1934 article in *Harpers*, "Don't Shoot the Professors! Why the Government Needs Them," by Jonathan Mitchell, is explicit in this respect. Running against an anti-intellec-tual tradition that would see the entrance of intellectuals into politics as a prob-lem, Mitchell argues that the problem of politics is politicians. Rooted too much in the physicality of day-to-day issues, politicians can't lift themselves up to a higher, neutral position. Such elevation is the prerogative of two groups especially: the aristocratic clique of British civil servants and the spiritual clique of American intellectuals who should take the aristocracy as their model.

> [In British civil servants,] the impartial arbitration of the government between war-ring private factions is personified. . . . The British civil servant, at his best, comes from one of the English country families, landowners since the conquest. . . . They are outside and above the economic and cultural conflicts. Because of their birth, they are above social ambitions. . . . We have in America no hereditary land-owning class from which to recruit our New Deal civil service. Our nearest equivalent are the college professors. Like the country families of England and the petty East Prussian nobility, the professors are in a sense above the preoccupations and the temptations of the rest of us. More and more, college professors must go to Washington until, in the future, we shall succeed in building a professional American civil service, supported by its own loyalties and traditions. (748–49)

In passing, I might note that even as late as the 1950s, such a rhetoric of a return to British aristocratic models is being used to describe the mission of *American* universities: in his 1950 address to the Newcomen Society, a society concerned to reiterate the British cultural roots of things American, Indiana University President Herman B. Wells speaks of Indiana University as "part of our rich English heritage" and applauds the ways an emphasis on culture

pulled the budding university away from its "savage origins" in the Indian lands (Wells 1952, 9).

But if intellectual self-representation endlessly imagines knowledge and the knower together as transcending the brute physicality of the everyday world, that world itself endlessly imagines intellectual culture as physical, as embodied, although often embodied in what to the intellectuals would no doubt seem wrong or woefully inadequate ways. Professors often imagine that they are ignored by the nonacademic world. What professors call anti-intellectualism they imagine as working according to a model of repression in which knowledge is not given its say; but, borrowing from Foucault, we might argue that production, rather than repression, is a better model for public discourse on the professor. Professors are in fact endlessly represented, endlessly figured, and that representation and that figuration may work according to tightly coherent patterns.

It's interesting to note, then, that if the gentlemanly scholars, writers, and judges think of Christian Gauss as an effective radiator of knowledge and of his Princeton as a neutral or enhancing site for this activity, a very different Gauss and a very different Princeton were being constructed in everyday student culture and in popular representations of that culture. Here, Gauss is not simply a disembodied conduit to knowledge; in this popular culture, he is given a body, and one in which he is imagined to be fully implicated in the weighty problems and the material desires of the everyday world.

We should remember that the gentlemanly tradition itself was actually a bit more complicated than I've suggested up to now. The cultivation of gentlemanliness could be achieved by intellectual improvement, but there was also frequently the sense that learning was the least important aspect of college life, that real gentlemanliness was more a matter of social interaction with one's peers (and future business contacts) than academic communion with the souls of dead thinkers. Indeed, the very emphasis in the philosophy on contentless, spiritual education ran the risks of making specific patterns of formal education irrelevant. One dimension of this split between the official pedagogy of the university and a more abstract cultivation of gentlemanliness is captured by Judge Harold Medina's 1955 *Reader's Digest* tribute to Gauss as "The Most Unforgettable Character I've Met": "Gauss attracted me as he attracted everyone, and I sensed at once that he had something to impart which was infinitely more important than the courses he taught. It was many years after I left college before I realized what it was: he had taught me how to think" (161).

This declaration can seem the ultimate defense of the values of a disembodied knowledge that doesn't even need the supports of the classroom to cast its spell. But, especially at a place like Princeton with its tradition then of undergraduate rowdiness, it can easily slide in the opposite direction to a defense of those aspects of student life not at all under the sway of the classroom—toward a notion that classroom pedagogy is the least important aspect of an education, that the real goal of university life is for one to have a good time, and, perhaps in so doing, build good gentlemanly contacts useful later

on. Significantly, in one of Gauss's most famous works on education, *Through College on Nothing a Year*, which represents Gauss's conversations with a working-class student, we receive a very different view of the function of the university from the one that the tributes to Gauss offered. As Gauss's interlocutor puts it at the end of the book, "This place has been one grand recreation and this campus comes as near being a utopia as anything I have ever seen. . . . I got a great deal out of it. Most of it didn't come in the way I expected. It didn't come from books. To me the greatest thing was learning how to talk and deal with my fellow men and the opportunity I have had of meeting fellows from all walks of life and all parts of the country" (168). Not surprisingly perhaps, the narrator of *Through College on Nothing a Year* starts college with the goal of becoming a teacher himself but, after four years of Princeton, he drops that to go into big business. The Ivy League gentleman school is not out to educate; it has as its function to groom a power elite for its inevitable success.

Significantly, Gauss himself becomes an object of popular cultural representation in this conception of the enjoyable university. In this representation Gauss becomes the embodied figure of the harried dean. Here, Gauss is fully in the world, a world of elite college students out for all the fun that elite universities have to offer and taking teachers and administrators alike as little more than weighty blockages to the students' quest for pleasure. In Edward Hope Coffey's novel *She Loves Me Not* (1933), made into a Broadway play and then into a Paramount motion picture, Gauss is Dean Mercer, whose daughter falls for a Princeton undergrad who is hiding a showgirl who has been an eyewitness to a gangland slaying.[1] Here Princeton undergraduate life is a zany whirlwind of fun—one student memorizes his textbook by tap dancing the lines—where school is a chance for love and adventure. Mercer is a weighty figure of pure resistance who wants to block the expression of fun-filled energy for no reason except that that's what deans do: disconnected from the life of learning, the dean has become a stock figure, a stereotype, a foil. And if many '30s intellectuals began to feel that New Deal America would give them a new, even aristocratic role in politics, *She Loves Me Not* returns to the stereotype of the academic as fully unfit for the political life. Mercer expels the cavorting students and is immediately assailed by public and political opinion—for example, a Senator Gray who makes a public speech in which he declares, "Perhaps I am prejudiced in my sympathies, but we have learned here in Washington to place very little faith in the judgments of college professors" (117). In this popular culture representation, Mercer/Gauss is fully in-the-world: as a fully embodied figure, he finds his resistance to fun—for example, to the marriage of his daughter to the partying hero—worn down as he is punched, menaced by gangsters, kidnapped, tied up, framed by photos of a showgirl crawling all over him, and finally knocked unconscious when, in a publicity stunt, the showgirl, now a Hollywood starlet, jumps out of a second-story dorm window onto him.

As knowing subjects, professors are potentially able to take any object and

make it an object *of study*. But they rarely have examined their own objectification or, if they do so, they conduct their inquiry at the level of gossip or at the level of an economics cut off from cultural analysis (so, for example, most of the letters from professors to the *Milwaukee Journal Magazine* about its excerpts from Charles Sykes's *Profscam* simply note that few professors are paid astronomical salaries; very few consider or confront Sykes's critiques of what they do for their salaries).

Even the discourse of recent years on postmodern culture is, as a discourse *on*, easily assimilated back into a retrieval-transmission model in which the professor's own role is supposed to be a disembodied one. Professors imagine themselves above a postmodern world that they set out to know when in fact they may well be immediately part of that world, one of its representations, an object themselves of discourse. For example, while there is a long-running history of representations of professors and intellectual activity, one very striking phenomenon of recent years is how not only intellectual figures but also their concepts can enter into popular discourse. Thus, the film semiotician who might want to gain knowledge over contemporary popular cinema might discover that he/she is already known by that cinema, already reduced to a cliché of the new brand of hip humanities professor, as in *Irreconcilable Differences*, where Ryan O'Neal plays a professor of film semiotics and author of a book on postwar American cinema. How can one imagine a scholarly discourse on music television as postmodern culture when MTV has a show called "Postmodern MTV"? How can one accuse the film *The Eyes of Laura Mars* of sleekly seductive sexism when the film includes an overbearing intellectualist character who already does just that? If, as we're fond of saying, postmodernism involves a blurring of genres, a breakdown of the boundaries of high and low, we also have to realize that one way this has occurred is by a breakdown of the limits between popular knowledge and intellectual knowledge. There is nothing (even the cultural critic him/herself) that cannot become an image in today's popular culture; there is no knowledge that can remain a pure application of ideas to a sphere of popular cultural life external to itself.

There have often been professors, for example, in film and popular fiction, but in recent years we've seen the rise of a new, savvy popular culture that can also represent the sorts of concepts that previously would have stayed in the university. For example, the scandal around Paul de Man has led to versions of deconstruction (and, by a weird guilt by association, New Historicism) appearing in mass media magazines (and on TV shows—*Class of '96* had a Great Books professor pressured into resigning because of his youthful affiliation with a right-winger). It is almost irrelevant whether or not the journals get the concepts right, although significantly most professors who mock such mass media representations pitch their critiques at this level of rightness or wrongness. Right or wrong, the media presentation has the power to become the public perception of the concept in question. And, I would suggest, the fact that some of the public summaries are incomprehensible can also be effective in shaping popular consciousness; such summaries can simply confirm the

impression that university debate is itself incomprehensible, that it is an out-
pouring of words about nothing whatsoever.

One way to think about this might be to imagine professors as a subculture.
What would it mean to treat professors as subcultural? As with any subculture,
the members of the academic subculture have typical and often ritualistic
ways of dress, modes of behavior, patterns of speech, techniques of inclusion
and exclusion, or rituals for entrance into the subculture.

But then, we might note the multiplicity of ways this subculture interacts
with the culture at large. On the one hand, there is a resistance through ritual
which, if not as pronounced as that of, say, punks or skinheads, nonetheless fol-
lows many of the same procedures of trying to make meaning out of style. The
notion of meaning in style implies that subcultural activity becomes dialogical:
the ideas consciously expressed have meaning, but there is also a second and
separate level of meaning in the style with which they are expressed. This dial-
ogism seems particularly apparent in academia where what one says—as a
teacher, as a lecturer, as a public figure—may be less important than the style
with which one says it. It has been suggested, for example, that one model for
academic encounter with the external world might be that of Leo Strauss in his
famous *Persecution and the Art of Writing*. For Strauss, philosophy in the world
is frequently pushed toward a double language that says one thing esoterically
but another thing exoterically. Academic jargon would become important,
then, not so much for the communication it enables among members of the
subculture but for the communication it blocks between the subculture and
the world at large. But another sort of subcultural response would operate not
by emphasizing the difference of the professor from the world but by working
all the more intensely to situate him/her as a figure of that world. For example,
against an older image of the professor as anonymous droning figure, certain
professors have tried to construct an image of the professor as stylish performer,
intensely embodied in the spectacle of a fashionable presence. Jane Gallop,
for example, has become noted for conference talks where style constructs a
semiotic meaning independent to a large degree of any meaning within the
words of the talk. For Gallop, evidently, the mind-body split is to be countered
by an intense insistence on the professor as bodied image, as on the cover of
her book, *Thinking Through the Body*, where we see Gallop giving birth to her
child. Similarly, some male professors have tried to counter the image of the
academic as anonymous drudge by a careful attention to style and flash that
even gets reported on as a virtual fashion statement (see, for instance, the var-
ious accounts in public media such as the *New York Times* highlighting the
flashy presence of critic Andrew Ross).

The limitation, though, of the presentation of professorial self in everyday
life as flashy self is that it is not so much an oppositional image as one that
everyday culture already assumes for the professor. One danger of Dick
Hebdige's emphasis on resistant style is that it tends to see the achieving of dis-
tinctive style as subversive in and of itself. Influenced by Julia Kristeva and *Tel
Quel* poetics, Hebdige all too often assumes an easy and direct connection

between formal innovation and political effect. Once he accepts the premise that the subculture is within a larger culture, he tends to ignore how that larger culture might be producing or enframing or representing to its own ends the stylistic flourishes of the subculture. Perhaps the relation of dominant culture and resistant subculture should be seen less as a dialectic or a dialogism than, à la Foucault, as a spiral of power where dominant and resistant play off each other, producing each other, upping the ante on each other.

In the case of the woman professor, for example, there are already codified styles that may constrain what one can do to make style meaningful in any resistant way. David Mamet's film *House of Games* is revealing in this respect for the ways it encloses its female intellectual between two very sharply defined models—the cold, self-denying woman whose nature is marked by the drab style of her severe black-and-white outfits, and the pleasure-seeking woman she becomes at the end, the transformation marked by the entrance of color into her clothing choice. (*House of Games* is significant also since the woman is not in fact a professor but a professional, a psychiatrist. Yet numerous friends and colleagues cited it to me as an example of a professor film. The fact that such a confusion can occur—even though we see the woman's mentor, a professor who is alive and vital—is what intrigues me.) As written and directed by Mamet, the film can imagine such a transition from drab to stylish only as a descent into evil and neurosis, the woman at the end having become murderer and kleptomaniac.

Similarly, one can wonder if the new flashy look for male academics challenges popular conceptions or simply plays into them. There is, for instance, a long-running image of the male professor, a professor of English especially, as a seducer of young women (see, among others, *Animal House, D.O.A.*, the TV movie *Murder 101*, or the episode of *Quantum Leap* in which Sam is embodied in a drunken, pipe-toting English professor who goes after coeds). The flashy look for today's academic may not signal a new relation to knowledge but may run the risk of saying the same old thing in public representation: namely, that the professor's relation to knowledge is perhaps inauthentic and an alibi for suspicious desires.

The stylish look is an anticipated look. Men and women in this conception are already embodied with a being-in-the-world. Think, for example, of *Back to School*, in which the English professor, played by Sally Kellerman, appears as an intense presence: in her first scene in the film, the professor strides onto a stage in a vibrant red dress and begins throatily to read that famous speech of female sensuality, the Molly Bloom soliloquy.

But the performing professor who makes style a meaning runs a greater risk of simply confirming a general suspicion in popular culture that professorial activity is a sham, a game. Now this may seem paradoxical; we often assume that anti-intellectualism condemns intellectuals for being serious. But it seems to me that what is condemned or criticized is not so much seriousness as a wasteful, pretentious seriousness applied to something that seems insubstantial. The professor appears as a figure of duplicity, an actor who mimics the real

seriousness of everyday life. The professor is then someone who can shift roles, who can become anyone but without any real commitment to anything. Take, for example, a plot summary of a 1946 film, *She Wrote the Book*: Prim calculus professor Joan Davis is asked to impersonate the dean's wife who has written a steamy bestseller called *Always Lulu* that she's afraid to promote. Davis goes to New York to begin the publicity tour, but a knock on the head scrambles her memory, and she now believes that she's led the lascivious life the book describes.

Professors are in the Real but they are in it unreally. In some cases, the professor is seen as using this ability to play roles to his/her own advantage (see, for instance, Robert Reeve's Professor Thomas detective series where Thomas can become so effective a gumshoe because he is not really rooted in his identity as a professor and can drop the academic trappings at a moment's notice). In other cases, the idea that to be a professor is to take on a superficial role can lead to a representation of the professor him/herself wracked by a guilt over his/her inauthenticity. For example, Nan Weaver, the professor heroine of Valerie Miner's novel, *Murder in the English Department*, "often . . . wondered why they had hired her, forgetting the critical acclaim her books had received. Self-effacement came too easily. That's why she wanted this tenure. It was more than job security. It was a passport. . . . Nan sometimes worried that Marjorie and the other students could tell she wasn't smart. . . . Although she was a professor at one of the best American universities, she still didn't feel like a scholar. She felt like a fraud." Indeed, for Jean-Paul Sartre, in his *Plea for Intellectuals*, the intellectual is fundamentally vulnerable to either bad faith or doubt about authenticity, caught as he/she is between the intellectual's function as critic of society and his/her recruitment as engineer for that society: intellectuals lead double lives that encourage guilt.

There are several popular versions of this image of professorial superficiality, of the professor who can adopt any identity whatsoever, including the identity of professor, with ease and with little effect on an integrity of inner self. First, the professor as someone who was unsure of his/her goals and opted for an academic career arbitrarily ("those who can, do; those who can't, teach"). For example, in the made-for-TV movie, *Secret Life of a Student*, about a student in love with her marine biology teacher, the professor (Barry Bostwick) always seems to be looking for something, needing something (represented by lots of glances directed off-screen); he will admit to his lover-student (Kathryn Harrold) that he really only went into marine biology to be able to be near the beach, and his passage through academia is a search for a reality as stable as that of resplendent nature. Significantly, this notion of the academic career as something one can take on and off like a set of clothes, like a surface style, has an important manifestation even as far back as the Middle Ages in the anecdote of the Inconstant Scholar who goes from academia to business to farming to the military to law and so on and so on, and finds no way of life satisfying (scholarship, he claims, demands too little sleep, too much bad food, and too much thinking).[2]

A second variation suggests that to be a professor is to be fake, but that beneath every fake academic there is a real person just waiting for the chance to burst out. For women, this usually means embodiment as a sexual figure: for example, the professor of classical music (played by Maureen O'Hara) in the 1946 film *Do You Love Me?* who learns how to like jazz and how to let down her hair and have a good time. For men, the rediscovery of self is an uncovering of a fundamental masculinity, a process rendered in stunning immediacy in *Indiana Jones and the Last Crusade*, in which the professor escapes from his office hours to find mysterious men waiting for him outside to plunge him into adventure. Significantly, when Indiana Jones becomes himself and casts off the bonds of academic bad faith, he achieves an integrity that suddenly is found to be lacking in much of the outside world. Although he forms bonds of pure trust with a group of select friends (including his dad), no one else can be trusted: for example, the beautiful woman he encounters is a figure of bad faith, a dangerous performer.

In 1988's *D.O.A.*, a film about a professor murdered because of the university's insistence on "publish or perish," the return to authentic self takes on intensely existential dimensions. Dexter Cornell (Dennis Quaid) has been living an empty, deadened life, the life of the professor caught in the web of words. A conversation with his estranged wife suggests how the artificialities of academic procedure have substituted for real living:

> Wife: You are so smart, and you don't have the faintest idea what I'm talking about. If you'd have only talked to me.
> Dexter: Talk? I talk all day, every day. It's what I do.
> Wife: No, it's ironic banter. It's not intimacy.

For Dexter, having been fatally poisoned shows that he could matter. Although he had earlier mocked the idea that he could be a target for murder—"Yeah, my Mark Twain lecture drove some student into a homocidal rage. . . . Nobody tries to kill an English professor. We just don't inspire that kind of passion"— by the end of the film he is able to see that *as men* English professors can inspire lots of passion.

In a third variation, there is the notion of the professor as a deliberate con artist by nature, using reputation to exploit people: for example, the narrator of Don DeLillo's *White Noise* is the founder of the field of Hitler studies even though he has hidden the fact that he does not know the German language; he is one of the few professors on campus to wear full academic regalia as a way of gaining people's confidence through inescapable aura. In the TV soap opera *All My Children*, a college professor, Langley Wallingford, seduced the infamous Phoebe Tyler by promising to use his historical art to trace her genealogical tree and establish her aristocratic origins; after Phoebe married Langley, it was revealed that he was really a carny performer named Lenny Wlasuk. Perhaps the extreme is Anthony Lejeune's intensely right-wing novel, *Professor in Peril*, where an Oxford classicist is recruited by a British intelligence service to see if a Soviet participant in a philology conference is really a professor or a

spy. There's a strong indication in *Professor in Peril* that the boundary between the two is not so solid—professors and spies are both potentially masters of deceit—and even though the Soviet turns out honestly to be a professor, another professor, Oxford's Emily Bryant, turns out to be a Soviet mole. As the hero-narrator says, "In theory I wasn't surprised to find a spy in Oxford. . . . Nor was I surprised that Emily Bryant should be the spy. She was a classic type: clever but unloved and unlovable, therefore vulnerable" (170).

The notion that professors are in the real world, but only awkwardly or improperly or inadequately so, feeds into another powerful cultural representation: the professor as particularly vulnerable to the vagaries of existence. As figures who are unaware of the nature of their embodiment or who relate to their embodiment in theatrical or inauthentic ways, professors find their bodies escaping them, giving into dangerous influences. Jerry Lewis's *The Nutty Professor* is nothing as much as a cataloguing of the temptations and malleabilities of the flesh: for example, for this professor, weight lifting leaves him with elongated arms; the desire to be seductive leads him to transform his body through chemicals. *The Nutty Professor* also invokes a very common image: professors as figures who can't hold their liquor. For example, in *Young Ideas, She's Working Her Way Through College* (with Ronald Reagan as the vulnerable college professor), *The Male Animal*, and *Educating Rita*, professors turn to hard liquor as a way of bringing out a fundamental masculinity, and the result is disastrous. In *D.O.A.*, indeed, it's the professor's binge of alcohol-drenched existential doubt that leads to his fatal poisoning. Interestingly, in contrast, professor culture—its own gossip, for example—is often fascinated by the amount certain professors are supposed to be able to drink without it showing. In Amanda Cross's *In the Last Analysis*, for instance, professor-detective Kate Fansler goes to a faculty party devoted to nothing ideational: "When members of this department got together, they never discussed anything but department politics, the exigencies of the teaching schedule, the insufficiencies of the administration and the peculiarities—moral, physical, psychological, and sexual—of certain absent members. . . . Several aspects of the gathering surprised Kate not at all. One was the amount of alcoholic stimulation which members of the academic profession could withstand. They were by no means constant drinkers, but as members of an underpaid profession, they drank whenever they got the chance" (100).

The topic of professors' relation to drink may seem a mere epiphenomenon to a real and serious public role and responsibility of the intellectual, but it seems to me that these anecdotal representations have their symptomatic importance. First, there is the professorial self-representation. Professors frequently imagine themselves as above influence, transcendent to the vulnerabilities of the flesh. But, significantly, where it has been a tradition within academic culture to imagine the *nonacademic* everyday world as made up of masses open to each and every influence, it is precisely popular culture that imagines the professor as a wishy-washy, vulnerable figure blown in any direction by any influence. Whether it be susceptibility to drink or to politics or to

abstract and unreal ideas or to corruptive influences, the professor is the figure of inconstancy, of self-betrayal. Indeed, this is what Julien Benda specifically saw as the treason of the intellectuals: their pretense to being above the world really enables them all the more often to become corrupted by the world in a way that ordinary people, more familiar with the range of temptations, resist.

In the present moment, talking about the appearance of the professor is not an eccentric, trivial, impertinent activity. As we know from books such as *Profscam* or *Tenured Radicals* or *Killing the Spirit*, a battle is being fought over the possible place for the academic in today's world. This battle has moved beyond the words on the pages of largely unreadable and unread books like Bloom's *Closing of the American Mind* to the mass media, and discussion around it has already begun to influence policy. For example, as an article in the *Chronicle of Higher Education* (April 16, 1989) notes, many private foundations are rethinking their granting priorities in relation to literacy and canon debates.

Though I do believe that those of us who object to the new critiques of academia have certainly to present alternate contents and deal with the ideas of the debate—to take just one example, we need to work more to show that the Bloom position and the Hirsch position, so often lumped together, are quite different—I also think we lose the battle from the start if we don't also examine the style of debate, the way we come off as images, as professorial show. One influencing factor in this is the role of journalism, which seems to me to be increasingly taking on an adversarial role vis-à-vis professors. Scott Heller of the *Chronicle of High Education* has suggested that this may have something to do with feelings of competitiveness as to who are the last intellectuals today—professors or journalists. And an article by David Ignatius in the *Washington Post* (March 11, 1990) suggests that such a rivalry may indeed be operative: Ignatius reacts virulently against professors who try to write short pieces for public media and recommends very explicitly that they stay in their proper place—in academic journals, monographs, and so on.

As I say, unless we look at the role of image and framing in the literacy and canon debate, we will lose the battle. But I should clarify that two separate battles are going on, even if they blur in someone like Sykes (*Profscam*). One is a battle between a philosophy of traditional higher education and a new cultural theory, a battle in which questions of the canon become central; the other battle is between academics and nonacademic workers—in which questions of professorial salary, teaching loads, and so on become central. As I say, these blur in Sykes; he condemns the university and then calls for the teaching of the canon, a move that I imagine actually has very little resonance for the nonacademic for whom the rest of the book may be appealing. The point is that for many viewers of the debate within popular culture, neither Bloom *nor* his opponents are outside a shared set of cultural images of all professors, whether in defense of the canon or not. Gerald Graff's continued call to "teach the conflicts" as a way to solve current crises and stultifications in the human-

ities seems to me to underestimate two aspects of the public image of profes-
sorial debate. First, as Graff himself notes in *Beyond the Culture Wars*, both the
language of the humanistic tradition and the language of new theory can
appear alien to popular culture; second, much of popular culture already
assumes that engaging in endless and worthless debate is what professors do
anyway, so that airing one more debate isn't really going to accomplish much.

A marvelous demonstration of this latter point occurs in the episode of
Oprah titled "How Dumb Are We?" (October 15, 1990) in which Graff and
Allan Bloom debated canons and common cores of knowledge. Although the
show is obviously structured to play Bloom and Graff off against each other in
the culture wars, one senses through the course of the hour a shifting of power
alignments by which it comes to be both professors together who are put in
opposition to Oprah and to the nonacademic public. On the one hand, Oprah
clearly demonstrates that she is in charge of the hour, directing the professors'
interventions, determining when they can talk (and for how long)—in a stun-
ning moment, she cuts Bloom off in midquotation and chastizes him in tones
one would use with a little child—and raising objections to both men so that
she comes off as occupying a position of truth beyond the partialities of either
of them (Oprah, the last intellectual?).

On the other hand, the initial presentation of the two professors as figures
of intellect, the covers of the books splayed across the screen in dissolves that
move back and forth between the authors' faces and their oeuvres, might seem
to set up one form of intellectual separation—the intellectual as authority fig-
ure who is situated above the ordinary world (and indeed, the two men are up
on a stage while Oprah wanders among the crowd below and beyond)—but
quickly another less haughty form of separation takes over. The two men
become squabbling figures of excessive verbosity, each and both together
unable to connect up to a world that frames professors per se as figures of
wasted verbal effort.

Two moments here are particularly uncanny and symptomatic. In response
to a young woman's question, Bloom argues that there is a need to distinguish
the value of Aristotle from the value of Elvis (and Bloom uses only the first
name), and says that if the distinction cannot be made, "we might as well just
close up shop." Graff toughly asks him who the "we" is (and the toughness
itself seems an escalating response to a prior attack by Bloom on Graff's
upbringing). The two men begin to talk over each other's words and, at the
same time, in the effort to make themselves heard and to score their points
more toughly, they begin to talk more loudly and more aggressively. The
image shifts to a woman in the audience who has risen to ask a question. She
tries once, but the men's squabble continues. Finally, she appears to give up,
and opens and closes her mouth and opens and closes her mouth in quick suc-
cession as if mimicking or mocking these professors who are so caught up in
endless debate that their outpouring of words seems to block out any awareness
of the larger world around them.

The other moment is even more striking. It comes at the end of the show

after all the time each of the two men has spent distinguishing his position from the other's (in often virulent, aggressive ways) and trying to show how his position is dramatically pertinent to the interests of the world at large. Each man has tried to show that he has important things to say, things that matter. Suddenly, though, a woman gets up and, with a hand gesture that sweeps across both men, demands, "Who cares about any of this stuff?" She suggests that life is difficult enough with the ordinary cares of bill paying and check-book balancing without having to live also under the pressures of having to read more. Before either man can answer, or say why one should care about *any* position in a debate that at least some of the audience seems to consider "merely academic," Oprah announces that they are out of time. Abruptly, the show ends. Once again, the inevitable codes of mass media reassert themselves and show that they are a frame that is indifferent to any content contained within, a frame generally invincible to attempts by the enframed content to make a cognitive difference. The vibrant and violent confrontation of the two academics has led not to adjudication of intellectual truth-claims about the world, but to a good show, a good spectacle.

There may be no way around such enframings. From the clichés that precede the professor into the classroom to the larger codes of mass communication, no site of knowledge production is unshaped by conventions, disembodied from public image and representation. The need for the intellectual, then, is not to imagine that there is some pristine space of pure pedagogy nor to act as if knowledge is so important in and of itself that it forces such a space into being. The need, rather, is for intellectuals to begin to reflect upon their own embodiment, to understand how knowledge, their own knowledge, is fully situated, and how to build from the givens of their situation a responsible and attentive pedagogy.

Notes

1. For this paper, I had access only to the 1934 stage version cowritten by Coffey and Howard Lindsay.
2. For discussion, see Gabriel.

References

Adams, Hazard. *The Academic Tribes*. New York: Liveright, 1976.

Aronowitz, Stanley. *Science as Power: Discourse and Ideology in Modern Society*. Minneapolis: Univeristy of Minnesota Press, 1988.

Blackmur, R. P. "Christian Gauss and the Everlasting Job." *American Scholar* 17.3 (1948): 341–43.

Brombert, Victor. *The Intellectual Hero: Studies in the French Novel, 1880–1955*. Philadelphia: Lippincott, 1961.

Coffey, Edward, and Howard Lindsay. *She Loves Me Not*. New York: Samuel French, 1934.

Cross, Amanda. *In the Last Analysis*. New York: Avon, 1964.

Gabriel, Astrik L. "The Source of the Anecdote of the Inconstant Scholar." *Classica et mediaevalia* 19 (1958): 152–76.

Gallop, Jane. *Thinking Through the Body*. New York: Columbia University Press, 1988.

Gauss, Christian. *Through College on Nothing a Year, Literally Recorded From a Student's Story*. New York: Scribner's, 1915.

———. *Why We Went to War*. New York: Scribner's, 1919.

———. "Religion and Higher Education in America." *The Teaching of Religion in American Higher Education*. Ed. Christian Gauss. New York: Ronald Press, 1951, 1–19.

Graff, Gerald. *Professing Literature: An Institutional History*. Chicago: University of Chicago Press, 1987.

———. *Beyond the Culture Wars*. New York: Norton, 1992.

Haraway, Donna. *Primate Visions: Gender, Race, and Nature in the World of Modern Science*. New York: Routledge, 1989.

Hebdige, Dick. *Subculture: The Meaning of Style*. New York: Methuen, 1979.

Latour, Bruno, and Steve Woolgar. *Laboratory Life: The Social Construction of Scientific Facts*. Beverly Hills: Sage, 1979.

Lejeune, Anthony. *Professor in Peril*. New York: Doubleday, 1988.

Medina, Harold. "The Most Unforgettable Character I've Met." *Reader's Digest* (June 1955): 161–64.

Mitchell, Hadley. "Don't Shoot the Professors! Why the Government Needs Them." *Harpers* (May 1934): 740–49.

Nicholson, Marjorie. "True Wayfaring Christian." *American Scholar* 17.3 (1948): 338–41.

Polan, Dana. "The Public's Fear." Review of *Structural Transformations of the Public Sphere* by Jürgen Habermas. *Social Text* 25/26 (1990): 260–66.

Rorty, Richard. *Philosophy and the Mirror of Nature*. Princeton: Princeton University Press, 1979.

Said, Edward W. *Covering Islam: How the Media and the Experts Determine How We See the Rest of the World*. New York: Pantheon, 1981.

Strauss, Leo. *Persecution and the Art of Writing*. Glencoe, IL: Free, 1952.

Sykes, Charles. *Profscam: Professors and the Demise of the Higher Education*. New York: Kampmann, 1980.

Wells, Herman B. *A Man, An Institution, and An Era*. New York: Newcomen Society, 1952.

Wilson, Edmund. "Christian Gauss as a Teacher of Literature." *The Shores of Light: A Literary Chronicle of the Twenties and Thirties*. New York: Farrar, 1952.

———. *The Twenties*. Ed. Leon Edel. New York: Farrar, 1975.

The Age of the World Target

On the Fiftieth Anniversary
of the Dropping of the
Atomic Bomb

Rey Chow

"They did not want to risk wasting the precious weapon, and
decided that it must be dropped visually and not by radar."
 —Barton J. Bernstein, "The Atomic Bombings Reconsidered"[1]

For most people who know something about the United States' intervention in
the Second World War, there is one image that predominates and seemingly
preempts the rest: the dropping of the atomic bomb on Hiroshima and
Nagasaki, pictorialized in the now familiar image of the mushroom cloud,
with effects of radiation and devastation of human life on a scale never before
imaginable.[2] Alternatively, we can also say that our knowledge about what hap-
pened to Hiroshima and Nagasaki is inseparable from the image of the mush-
room cloud. As knowledge, "Hiroshima" and "Nagasaki" come to us inevitably
as representation and, specifically, as a picture. Moreover, it is not a picture in
the older sense of a mimetic replication of reality; rather it has become in itself
a sign of terror, a kind of gigantic demonstration with us, the spectators, as the
potential target.

For someone such as myself, who grew up among survivors of China's war
against Japan in the period 1937–45—the "Eight-Year War," as it is still called
among the Chinese—the image of the atomic bomb has always stood as a sig-
nifier for another kind of violence, another type of erasure. As a child, I was far
more accustomed to hearing about Japanese atrocities against Chinese men
and women during the war than I was to hearing about U.S. atrocities against

This essay was originally presented at the NEH Summer
Institute on Remembering American Wars in Asia, the
University of Montana, 1995. It will be published in the
Institute volume, Remembering American Wars in Asia,
ed. Philip West et al., forthcoming.

Japan. Among the stories of the war was how the arrival of the Americans brought relief, peace, and victory for China; however hard the times were, it was a moment of "liberation." As I grow older, this kind of knowledge gathered from oral narratives persists in my mind not as proof of historical accuracy but rather as a kind of dissonance, an emotional effect that becomes noticeable because it falls outside the articulations generated by the overpowering image of the mushroom cloud. It is as if the sheer magnitude of destruction unleashed by the bombs demolished not only entire populations but also the memories and histories of tragedies that had led up to that apocalyptic moment, the memories and histories of those who had been brutalized, kidnapped, raped, and slaughtered in the same war by other forces.[3] To this day many people in

"We participate in war's virtualization of the world as we use—without thinking—TV monitors, remote controls, computer interfaces, and other digital devices that fill the spaces of everyday life."

Japan still passionately deny the war crimes committed by the Japanese military in East and Southeast Asia, and the label "Japanese" is hardly ever as culturally stigmatized as, say, the label "German," which for many is still a straightforward synonym for "Nazi" and "fascist."[4]

I have two concerns in this paper. The first has to do with the significance of the atomic bomb as part of a global culture in which everything has become visual representation and "virtual" reality. The second has to do with the racial politics of knowledge production, which bears crucial ideological connections to the dropping of the atomic bomb.

Seeing Is Destroying

As a journalist recently commented, the bombs that fell on the two Japanese cities in August 1945 ended any pretense of equality between the United States and Japan. It was, he writes, "as if a steel battleship had appeared at Trafalgar, effortlessly and ruthlessly destroying the wooden enemy fleet. There was absolutely no contest."[5] Passages such as this rightly point to the fundamental shift of the technological scale and definition of the war, but what remains to be articulated is the political and ideological significance of this shift.

From a purely scientific perspective, the atomic bomb was, of course, the most advanced invention of the time. Like all scientific inventions, it had to be tested in order to have its effectiveness verified. It was no accident that the United States chose as its laboratory, its site of experimentation, a largely civilian rather than military space, since the former, with a much higher population density, was far more susceptible to demonstrating the upper ranges of the bomb's spectacular potential.[6] The mundane civilian space in the early hours

of the morning, with ordinary people beginning their daily routines, offered the promise of numerical satisfaction, of a destruction whose portent defied the imagination. Such civilian spaces had to have been previously untouched by U.S. weaponry so as to offer the highest possible accuracy for the postwar evaluations of the bombing experiments.[7] The fact that Christians and U.S. prisoners of war were in such spaces, which therefore were not purely Japanese or "enemy" territories, did not seem to matter. And destroying one city was not enough: since the United States had two bombs, one uranium (which was simple and gunlike, and nicknamed Little Boy) and the other plutonium (which worked with the complex and uncertain means of assembly known as the implosion design, and was nicknamed Fat Man),[8] both had to be tested to see which one should continue to be produced in the future.[9] After the more "primitive" uranium bomb was dropped on Hiroshima, the more elaborate, plutonium one was dropped on Nagasaki a few days later.[10]

There are many ways in which the development of modern science, with its refined criteria for conceptualization, calculation, objectification, and experimentation, led up to these moments of explosion through what Michael S. Sherry calls "technological fanaticism."[11] But what was remarkable in the nuclear blast was not merely the complexity of scientific understanding,[12] but the manner in which science—in this case, the sophisticated speculations about the relationships among energy, mass, speed, and light—was itself put at the service of a kind of representation whose power resides not in its difficulty but in its brevity and visibility. In a flash, the formula $E=mc^2$, which summarizes Einstein's theory of relativity and from which the bomb was derived, captured the magnitude of the bomb's destructive potential: one plane plus one bomb = minus one Japanese city. Was the formula a metaphor for the blinding flash of the atomic explosion itself, or vice versa?

Precisely because the various units of measurement must be carefully selected for such a formula to be even approximately correct, and precisely because, at the same time, such exactitude is incomprehensible and irrelevant to the lay person, $E=mc^2$ exists far more as an image and a slogan than as substance, and far more as a political than as a scientific act. If the scientific accuracy and verifiability of this formula remain uncertain to this day, it was nonetheless a supremely effective weapon of persuasion and propaganda. The speed of light is supposed to be a maximum, the fastest anything could possibly travel. The speed of light *squared* is thus clearly and easily perceived as a very large multiplier. Because of its visual representability and simplicity, the formula successfully conveyed the important message that one little bomb could create a whole lot of terror and that one airplane was enough to destroy an entire nation's willingness to resist. It seized the imagination, most crucially, of the *non-scientist*, such as the U.S. president who consented to dropping the bombs on Hiroshima and Nagasaki.[13]

I should make clear that what I am suggesting is not simply that "science" was replaced by a visual gimmick, that the "real thing" was replaced by a mere representation. Instead, it is that the dropping of the bombs marked the pivot

of the progress of science, a pivot that was to continue its impact on all aspects of human life long after the Second World War was over. Science has, in modernity, reached the paradoxical point whereby it is simultaneously advanced and reduced. Having progressed far beyond the comprehension of nonspecialists and with complexities that challenge even the imagination of specialists, science is meanwhile *experienced* daily as the practically useful, in the form of small, simple, matter-of-fact operations that the lay person can manipulate at his/her fingertips. Our daily uses of the telephone, the computer, e-mail, and other types of equipment are examples of this paradoxical situation of "scientific advancement," in which the portentous disappears into the mundane, the effortless, and the intangible.[14] We perform these daily operations with ease, oblivious to the theories and experiments that made them possible. Little do we think of the affinity between these daily operations and a disaster such as the atomic holocaust. To confront that affinity is to confront the terror that is the basis of our everyday life.

The gigantic impact of the explosion literally expressed itself—as if without effort—in a neat little formula that anyone could recall and invoke. An epochal destruction based on the speed of light became, for the ordinary person, an instantly visible, graspable, portable thing, like a control button at his command. The logic of the ending of this particular war was hence encapsulated in the formulaic elegance of "$E=mc^2$": The most rarefied knowledge of science became miniaturized and transmissible, and thus *democratized* as a weapon of attack.

From a military perspective, the mushroom cloud signals the summation of a history of military advancement and invention that has gone hand in hand with the development of representational technologies, in particular the technologies of seeing. As Paul Virilio asserts, "For men at war, the function of the weapon is the function of the eye."[15] Virilio argues time and again in his work that close affinities exist between war and vision. Because military fields were increasingly reconfigured as fields of visual perception, preparations for war were increasingly indistinguishable from preparations for making a film: "The Americans prepared future operations in the Pacific," Virilio writes, "by sending in film-makers who were supposed to look as though they were on a location-finding mission, taking aerial views for future film production."[16]

In the well-known essay "The Age of the World Picture," Martin Heidegger argues that in the age of modern technology, the world has become a "world picture." However, he adds, this "does not mean a picture of the world but the world conceived and grasped as a picture."[17] By this, Heidegger means that seeing and objectification have become so indispensable in the age of modern technology that "conceiving" and "grasping" the world is now an act inseparable from visuality. Supplementing Heidegger, we may say that in the age of bombing, the world has been transformed into—is essentially conceived and grasped as—a target. To conceive of the world as a target is to conceive of it as an object to be destroyed. As W. J. Perry, a former U.S. undersecretary of state

for defense, said: "If I had to sum up current thinking on precision missiles and saturation weaponry in a single sentence, I'd put it like this: once you can see the target, you can expect to destroy it."[18] Increasingly, war would mean the production of maximal visibility and illumination for the purpose of maximal destruction. It follows that the superior method of guaranteeing efficient destruction through visibility during the Second World War was aerial bombing, which the United States continued even after Japan had made a conditional surrender.[19]

If the dropping of the atomic bomb created "deterrence," as many continue to believe to this day, what is the nature of deterrence? (We can ask the same question about "security," "defense," "protection," and other similar concepts.) The atomic bomb did not simply stop the war; it also stopped the war by escalating and democratizing violence to a hitherto unheard-of scale. What succeeded in "deterring" the war was an ultimate (am)munition; destruction was now outdone by destruction itself. The elimination of physical warring activities had the effect not of bringing war to an end but instead of promoting and accelerating terrorism, and importantly, the terrorism of so-called "deterrent" weaponry. The mushroom cloud, therefore, is also the image of *this* transfer, this blurring of the boundary between war and peace. The transfer ushered in the new age of relativity and virtuality, an age in which powers of terror are indistinguishable from powers of "deterrence," and technologies of war indissociable from practices of peace. These new forces of relativity and virtuality are summarized in the following passages from Virilio:

> There is no war, then, without representation, no sophisticated weaponry without psychological mystification. Weapons are tools not just of destruction but also of perception—that is to say, stimulants that make themselves felt through chemical, neurological processes in the sense organs and the central nervous system, affecting human reactions and even the perceptual identification and differentiation of objects.
>
> By demonstrating that they would not recoil from a civilian holocaust, the Americans triggered in the minds of the enemy that *information explosion* which Einstein, towards the end of his life, thought to be as formidable as the atomic blast itself.
>
> Even when weapons are not employed, they are active elements of ideological conquest.[20]

This merging of war and representation, war technology and peacetime technology, has brought about a number of changes.

First, the visual rules and boundaries of war altered. While battles in the olden days tended to be fought with a clear demarcation of battlefronts versus civilian spaces, the aerial bomb, for instance, by its positioning in the skies, its intrusion into spaces that used to be off-limits to soldiers, and its distance from the enemies (a distance which made it impossible for the enemies to fight back), destroyed once and for all those classic visual boundaries that used to define battle. Second, with the transformation of the skies into war zones from

which to attack, war was no longer a matter simply of armament or of competing projectile weaponry; rather it became redefined as a matter of the logistics of perception, with seeing as its foremost function, its foremost means of preemptive combat.

Third, in yet a different way, the preemptiveness of seeing as a means of destruction continues to operate as such even after the war. Insofar as the image of the atomic blast serves as a peacetime weapon to mobilize against war, it more or less precludes other types of representation. *Nuclear* danger becomes the predominant target against which peace coalitions aim their efforts, while the equally disastrous effects caused by chemical and biological weapons (nerve gases such as sarin and bacteria such as anthrax) seldom receive the same kind of extended public consideration. Because of the overwhelming effect of the continual imaging of the mushroom cloud, the world responds to the nuclear blast as if by mimicry, by making the nuclear horror its predominant point of identification and attack, and by being oblivious to other forms of damage to the ecosphere that have not attained the same level of *visibility*.

The World Becomes Virtual

The dropping of the atomic bomb effected what Michel Foucault would call a major shift in *epistemes*, a fundamental change in the organization, production, and circulation of knowledge.[21] War after the atomic bomb would no longer be the physical, mechanical struggles between combative oppositional groups, but would more and more come to resemble collaborations in the logistics of perception between *partners* who occupy relative, but always mutually related, positions.[22] As in the case of the competition between the United States and the Soviet Union for several decades, war was more and more to be fought in virtuality, as an exchange of defensive positionings, a mutually coordinated routine of upping the potential for war, a race for the deterrent. Warring in virtuality meant competing with the enemy for the stockpiling, rather than actual use, of preclusively horrifying weaponry. To terrorize the other, one specializes in representation, in the means of display and exhibition. As Virilio writes, "A war of pictures and sounds is replacing the war of objects (projectiles and missiles)."[23] In the name of arms reduction and limitation, the SALT and START agreements served to promote, improve, and multiply armament for both the United States and the Soviet Union, which were, strictly speaking, allies rather than adversaries in the "star wars" (Strategic Defense Initiative).

Moreover, war would exist from now on as an agenda that is infinitely self-referential: "War" represents not other types of struggles and conflicts—what in history classes are studied as "causes"—but "war" itself. From its previous conventional, negative signification as a blockade, an inevitable but regretted interruption of the continuity that is "normal life," war shifts to a new level of force. It has become not the cessation of normality, but rather, the very defin-

ition of normality itself. The space and time of war are no longer segregated in the form of an other; instead, they operate from within the here and now, as the internal logic of the here and now. From being negative blockade to being normal routine, war becomes the positive mechanism, momentum, and condition of possibility of society, creating a hegemonic social space through powers of visibility and control.

It is important to note that the normativization of war and war technology also takes place among—perhaps especially among—the defeated. As John W. Dower writes, in Japan, deficiency in science and technology was singled out as the chief reason for defeat, and the atomic bomb was seen simultaneously as "a symbol of the terror of nuclear war and the promise of science."[24] Because it was forbidden to advance in militarism, postwar Japan specialized in the promotion of science and technology for "peace" and for the consolidation of a "democratic" society. Instead of bombs and missiles, Japan became one of the world's leading producers of cars, cameras, computers, and other kinds of "high tech" equipment.[25] With Honda, Toyota, Nissan, Hitachi, Toshiba, Sony, Sanyo, Nikon, Mitsubishi, and their likes becoming household names throughout the world, the "victim" of the war rises again and rejoins the "victor" in a new competition, the competition in bombarding the world with a different type of implosion: information.[26]

With the preemptiveness of seeing-as-destruction and the normativization of technology-as-information, thus, comes the great epistemic shift, which has been gradually occurring with the onset of speed technologies, and which finally *virtualizes* the world. As a condition that is no longer separable from civilian life, war is thoroughly absorbed into the fabric of our daily communications—our informational channels, our entertainment media, our machinery for speech and expression. We participate in war's virtualization of the world as we use—without thinking—TV monitors, remote controls, computer interfaces, and other digital devices that fill the spaces of everyday life. We no longer notice the terrorism of, say, watching news episodes of the most violent bloodshed on television while having dinner, nor are we shocked by the juxtaposition of TV commercials with reports of mass slaughters that are happening on another continent. Our consumption of war, bloodshed, and violence through our communication technologies is on a par with our consumption of various forms of merchandise.

There is, furthermore, another side to the virtualization of the world that most of us do not experience but that is even more alarming: when a war does occur, such as the Gulf War of 1991, the ubiquitous virtualization of everyday life means that war can no longer be fought without the skills of video games. The aerial bombing of Iraq meant that the world was divided into an above and a below in accordance with the privilege of access to the virtual world. Up above in the sky, war was a matter of maneuvers across the video screen by U.S. soldiers who had been accustomed as teenagers to playing videogames at home; below, war remained tied to the body, to hard work, to the random disasters falling from the heavens. For the U.S. men of combat, the elitism and

aggressiveness of panoramic vision went hand in hand with distant control and the instant destruction of others; for the women and children of Iraq, life became more and more precarious—immaterial in the sense of a readiness for total demolition at any moment.[27]

The Orbit of Self and Other

Among the most important elements in war, writes Karl von Clausewitz, are the "moral elements."[28] From the United States's point of view, this phrase does not seem at all ironic. The bombings of Hiroshima and Nagasaki, for instance, were considered pacific acts, acts that were meant to save lives and save civilization in a world threatened by German Nazism. (Though, by the time the bombs were dropped in Japan, Germany had already surrendered.) Even today, some of the most educated, scientifically knowledgeable members of U.S. society continue to believe that the atomic bomb was the best way to terminate the hostilities.[29] And, while the media in the United States are quick to join the media elsewhere in reporting the controversies over Japan's refusal to apologize for its war crimes in Asia or over France's belatedness in apologizing for the Vichy Government's persecution of the Jews, no U.S. head of state has ever visited Hiroshima or Nagasaki, or expressed regret for the nuclear holocaust.[30] In this—the perpetual conviction and self-legitimation of its own superiority, leadership, and moral virtue—lies perhaps the most deeply ingrained connection between the dropping of the atomic bombs and the foundation myth of the United States as a nation, as well as all its subsequent interventions in nationalist struggles in Asia, Latin America, and the Middle East.[31]

In the decades since 1945, whether in dealing with the Soviet Union, the People's Republic of China, Korea, Vietnam, countries in Central America, or during the Gulf War, the United States has been conducting war on the basis of a certain kind of knowledge production, and producing knowledge on the basis of war. War and knowledge enable and foster each other primarily through the collective fantasizing of some "foreign" or "alien" body, usually communist or Moslem, that poses danger to the "self" and to the "eye" that is the nation. Once the monstrosity of this foreign body is firmly established in the national consciousness, the United States feels it has no choice but war.[32] War, then, is acted out as a moral *obligation* to expel an imagined dangerous otherness from the United States's self-conception as the global custodian of freedom and democracy. Put in a different way, the "moral element," insofar as it produces knowledge about the "self" and "other"—and hence "eye" and "target"—as such, justifies war by its very logic. Conversely, the violence of war, once begun, fixes the other in its attributed monstrosity and confirms the idealized image of the self.

In this regard, the racist stereotyping of the Japanese during the Second World War—not only by U.S. military personnel but also by social and behavioral scientists—was simply a flagrant example of an ongoing ideological

mechanism that had accompanied Western treatments of non-Western "others" for centuries. In the hands of academics such as Geoffrey Gorer, writes John W. Dower, the notion that was collectively and "objectively" formed about the Japanese was that they were "a clinically compulsive and probably collectively neurotic people, whose lives were governed by ritual and 'situational ethics,' wracked with insecurity, and swollen with deep, dark currents of repressed resentment and aggression."[33] At the same time, as Dower cautions:

> The Japanese, so "unique" in the rhetoric of World War Two, were actually saddled with racial stereotypes that Europeans and Americans had applied to nonwhites for centuries: during the conquest of the New World, the slave trade, the Indian wars in the United States, the agitation against Chinese immigrants in America, the colonization of Asia and Africa, the U.S. conquest of the Philippines at the turn of the century. These were stereotypes, moreover, which had been strongly reinforced by nineteenth-century Western science.
>
> In the final analysis, in fact, these favored idioms denoting superiority and inferiority transcended race and represented formulaic expressions of Self and Other in general.[34]

The moralistic divide between "self" and "other" constitutes the production of knowledge during the U.S. occupation of Japan after the Second World War as well. As Monica Braw writes, in the years immediately after 1945, the risk that the United States would be regarded as barbaric and inhumane was carefully monitored, in the main by cutting off Japan from the rest of the world through the ban on travel, control of private mail, and censorship of research, mass media information, and other kinds of communication. The entire Occupation policy was permeated by the view that "the United States was not to be accused; guilt was only for Japan":[35]

> As the Occupation of Japan started, the atmosphere was military. Japan was a defeated enemy that must be subdued. The Japanese should be taught their place in the world: as a defeated nation, Japan had no status and was entitled to no respect. People should be made to realize that any catastrophe that had befallen them was of their own making. Until they had repented, they were suspect. If they wanted to release information about the atomic bombings of Hiroshima and Nagasaki, it could only be for the wrong reasons, such as accusing the United States of inhumanity. Thus this information was suppressed.[36]

As in the scenario of aerial bombing, the elitist and aggressive panoramic "vision" in which the other is beheld means that the sufferings of the other matter much less than the transcendent aspirations of the self. And, despite being the products of a particular culture's technological fanaticism, such transcendent aspirations are typically expressed in the form of selfless universalisms. As Sherry puts it, "The reality of Hiroshima and Nagasaki seemed less important than the bomb's effect on 'mankind's destiny,' on 'humanity's choice,' on 'what is happening to men's minds,' and on hopes (now often extravagantly revived) to achieve world government."[37]

Once the relations between war, racism, and knowledge production are underlined in these terms, it is no longer possible to assume, as many still do, that the recognizable features of modern war—its impersonality, coercion, and deliberate cruelty—are "divergences" from the "antipathy" to violence and to conflict that characterize the modern world.[38] Instead, it would be incumbent upon us to realize that the pursuit of war—with its use of violence—and the pursuit of peace—with its cultivation of knowledge—are the obverse and reverse of the same coin, the coin that I have been calling "the age of the world target." Rather than being irreconcilable opposites, war and peace are coexisting, collaborative functions in the continuum of a virtualized world. More crucially still, only the privileged nations of the world can afford to wage war and preach peace at one and the same time. As Sherry writes, "The United States had different resources with which to be fanatical: resources allowing it to take the lives of others more than its own, ones whose accompanying rhetoric of technique disguised the will to destroy."[39] From this it follows that, if indeed political and military acts of cruelty are not unique to the United States—a point that is all too easy to substantiate—what is nonetheless remarkable is the manner in which such acts are, in the United States, usually cloaked in the form of enlightenment and virtue, in the form of an aspiration simultaneously toward technological perfection and the pursuit of peace. In a country where political leaders are always held accountable for their decisions by an electorate, violence simply cannot—as it can in totalitarian countries—exist in the raw. Even the most violent acts must be adorned with a benign, rational story.

It is, then, in the light of such interlocking relations among war, racism, and knowledge production that we may make the following comments about "area studies," that academic establishment which crystallizes the connection between the epistemic targeting of the world and the "humane" practices of peacetime learning.[40]

As its name suggests, "area studies" as a mode of knowledge production is, strictly speaking, military in its origins. Even though the study of the history, languages, and literatures of, for instance, Far Eastern cultures existed well before the Second World War (in what Edward Said would term the old Orientalist tradition), the rigorous systematization of such study under the rubric of special "areas" was a postwar and North American phenomenon. The areas that needed to be studied were those that, in the aftermath of the Second World War, when the United States competed with the Soviet Union for the power to rule and/or destroy the world, required continued, specialized super*vision*. Thus countries of East Asia, Southeast Asia, Eastern Europe, Latin America, and the Middle East took on the significance of "target fields"—as fields of information retrieval and dissemination that were necessary for the United States's continual political and ideological hegemony. The "scientific" and "objective" production of knowledge about these "other" cultures during peacetime—often under the modest claims of fact gathering and documentation—became the institutional practice that substantiated and elaborated the militaristic conception of the world as target.[41] In other words,

despite the claims about the apolitical and disinterested nature of the pursuits of higher learning, activities undertaken under the rubric of area studies, such as language training, historiography, anthropology, economics, political science, and so forth, are fully inscribed in the politics and ideology of war. To that extent, the disciplining, research, and development of so-called academic information are part and parcel of a *strategic* logic.

If the production of knowledge in area studies (with its vocabulary of aims and goals, research, data, analysis, experimentation, and verification) in fact shares the same scientific and military premises as war, is it a surprise that it is doomed to fail in its avowed attempts to "know" the other cultures? Can knowledge that is derived from the same bases as war put an end to the violence of warfare, or is such knowledge not simply warfare's accomplice, destined to destroy rather than preserve the forms of lives at which it aims its focus?

As long as knowledge is produced in a self-referential manner, as a circuit of targeting or *getting* the other that ultimately consolidates the omnipotence and omnipresence of the "self" and "eye" that is the United States, the other will have no choice but remain just that—a target whose existence justifies only one thing, its destruction by the bomber. As long as the focus of our study of Asia remains the United States, and as long as this focus is not accompanied by knowledge of what is simultaneously happening elsewhere, such study would ultimately confirm once again the already self-referential function of virtual worlding that was unleashed by the dropping of the atomic bomb, with the United States always being the bomber and other cultures being the military and information target fields. In this manner, events whose historicity does not fall into the orbit of the atomic bomb—such as the Chinese reactions to the war from the anti-Japanese point of view that I alluded to at the beginning of this essay—would never receive the attention that is due to them. "Knowledge" would lead only to further silence and the silencing of diverse experiences.

The truth of the continual targeting of the world as the fundamental form of knowledge production is, as I already suggested, xenophobia, the inability to handle the otherness of the other beyond the orbit that is the bomber's own visual path. For the xenophobe, every effort must be made to sustain and secure this orbit—that is, by keeping the place of the other-as-target always filled. Hence, with the end of the Cold War and the disappearance of the former Soviet Union, the United States by necessity seeks other substitutes for war. As has often been pointed out, drugs, poverty, and illegal immigrants have since become the new targets. They, like the communists and the Muslims, now occupy the place of that ultimate danger which must be "deterred" at all costs.

Even then, xenophobia can backfire. When the anxiety about the United States's loss of control over its own target fields—and by implication its own boundaries—becomes overwhelming, bombing takes as its target the United States itself. This is so because, we remember, bombing the other was the

means to end the war, the violence to stop violence, and, most important of all, the method to confirm moral virtue. Why, then, when the United States is perceived to be threatened and weakened by incompetent leadership, should bombing not be the technique of choice for correcting the United States itself? And so, in spite of all the racist conspiracy suspicions quickly raised about "foreigners" in the bombing of the federal office building in Oklahoma City on April 19, 1995, U.S. militiamen were arrested in the case. Spurred by a moral determination to set things right, the targeting of "others" turned into the targeting of innocent American men, women, and children, with a violence that erupted from within the heart of the country. The worst domestic terrorist incident in U.S. history,[42] the bombing in Oklahoma City took place with the force of an emblem. The vicious circle of "the world as target" had returned to its point of origin.[43]

Notes

1. Barton J. Bernstein, "The Atomic Bombings Reconsidered," *Foreign Affairs* 74.1 (January/February 1995): 140.
2. For an account of the immediate consequences of the dropping of the bombs in Hiroshima, see John Hersey, *Hiroshima* (New York: Alfred A. Knopf, 1946). (Hersey's account was first published in *The New Yorker*, 31 August 1946. An excerpt from the account was reprinted on the 50th anniversary of the end of the War in *The New Yorker*, 31 July 1995, pp. 65–67.) For accounts of the censorship of information about the atomic bomb in the aftermath of the Second World War, see Monica Braw, *The Atomic Bomb Suppressed: American Censorship in Occupied Japan* (Armonk, NY and London: M. E. Sharpe, 1991), especially chapters 1, 2, 8, 9, 10.
3. "To the majority of Japanese, Hiroshima is the supreme symbol of the Pacific War. All the suffering of the Japanese people is encapsulated in that almost sacred word: Hiroshima." Ian Buruma, *The Wages of Guilt: Memories of War in Germany and Japan* (New York: Farrar Straus Giroux, 1994). Buruma criticizes the manner in which Hiroshima has become the exclusive sacred icon of martyred innocence and visions of apocalypse in Japan, often in total isolation from the rest of the history of the war. In this process of sanctifying Hiroshima, he writes, what has been forgotten is the city's status as a center of military operations during Japan's period of active aggression against other countries, such as China. "At the time of the bombing, Hiroshima was the base of the Second General Headquarters of the Imperial Army (the First was in Tokyo)" (p. 106). Buruma offers accounts of the Rape of Nanjing and the varied postwar Japanese reactions to Japanese war crimes; see Parts 2 and 3 of his book. See also John W. Dower, "The Bombed: Hiroshimas and Nagasakis in Japanese Memory," *Diplomatic History* 19:2 (Spring 1995) 275–95. Dower writes: "Hiroshima and Nagasaki became icons of Japanese suffering—perverse national treasures, of a sort, capable of fixating Japanese memory of the war on what had happened to Japan and simultaneously blotting out recollection of the Japanese victimization of others. Remembering Hiroshima and Nagasaki, that is, easily became a way of forgetting Nanjing, Bataan, the Burma-

Siam railway, Manila, and the countless Japanese atrocities these and other place names signified to non-Japanese" (281).

4. See Buruma, *The Wages of Guilt*, for comparative accounts of the significance of Hiroshima and Auschwitz. Kentaro Awaya has argued that the stigmatizing of Japan, though different from that of Germany, is widely felt within Japanese discussions, including the Diet itself. See Awaya's essay "Controversies Surrounding the Pacific War: The Tokyo Trials," presented at the NEH Summer Institute on Remembering American Wars in Asia, University of Montana, Missoula, 1995.

5. "The Mushroom Cloud Over Art," *The Economist* (25 February 1995): 87–88.

6 The testing of the plutonium bomb on July 16, 1945, at the Trinity site in New Mexico was in the main a concept test: what was tested was the nuclear device but not the precise delivering mechanisms or the blast effects on a real target. "Between Trinity and Hiroshima, the bomb remained [to the scientists] a kind of awesome abstraction, now tested to be sure, but not yet imaginable as a weapon of war." Michael S. Sherry, *The Rise of American Air Power: The Creation of Armageddon* (New Haven, CT and London: Yale University Press, 1987), 343. In his notes, Sherry appends information on calculations that were made at Trinity about possible hazards to occupying personnel (notes 112 and 113, p. 417).

7. For an account of the shift among U.S. military decision makers from the older morality of not killing noncombatants to the emerging morality of total war, see Barton J. Bernstein, "The Atomic Bombings Reconsidered," pp. 135–52. Murray Sayle writes that the moral line of not bombing civilians was in fact already crossed with the bombing of Dresden in February 1944; see his essay "Letter from Hiroshima: Did the Bomb End the War?" *The New Yorker* (31 July 1995): 40–64. For a long and detailed history of the events leading up to the use of the atomic bomb, including the major scientific and political figures involved, see Richard Rhodes, *The Making of the Atomic Bomb* (New York: Simon and Schuster, 1986).

8. The gender politics of the naming of the bombs is noted by Sherry as follows: "Dominated by men, Western science has aspired to unlock the secrets of the natural world. Often its practitioners have also sought immortality through escape from that world, a world so often associated with women and femininity. By their colloquial language, the men at Los Alamos hinted at such aspirations. . . . Femininity was weakness, masculinity was the power to transcend nature and its mortal reality. If these men entertained a male fantasy of ultimate potency, it was perhaps not coincidence that they gave their bombs masculine names (Fat Man, Little Boy)" (*The Rise of American Air Power*, pp. 202–3). By contrast, crews often gave their own bombers feminine names since such bombers were regarded as "the symbolic repository of feminine forces of unpredictable nature which men could not control" (*The Rise of American Air Power*, p. 215).

9. For a personal account of these events, see Philip Morrison, "Recollections of a Nuclear War," *Scientific American* 273.2 (August 1995): 42–46. A neutron engineer, Morrison was one of the many physicists enlisted to work on the Manhattan Project in Chicago and Los Alamos.

10. See Hersey, *Hiroshima*, pp. 107–8. Buruma: "There was . . . something . . . which is not often mentioned: the Nagasaki bomb exploded right over the area where outcasts and Christians lived" (*The Wages of Guilt*, p. 100). See also Evan Thomas, "Why We Did It," *Newsweek* (24 July 1995), 28: "If there was little debate over the moral rights and wrongs of atomizing Hiroshima, there was even less over Nagasaki; indeed, no debate at all. The operation was left to [General Leslie R.]

Groves, who was eager to show that an implosion bomb, which cost $400 million to develop, could work as well as the trigger-type bomb that had destroyed Hiroshima. Exploding over the largest Roman Catholic cathedral in the Far East, the Nagasaki bomb killed an additional 70,000 people. The victims included as many Allied prisoners of war as Japanese soldiers—about 250."

11. See Sherry, *The Rise of American Air Power*, especially Chapters 8 and 9, pp. 219–300.

12. For detailed philosophical reflections on science and modernity, see, for instance, Martin Heidegger's *The Question Concerning Technology and Other Essays*, translated and with an introduction by William Lovitt (New York: Harper Colophon Books, 1977).

13. "According to President Truman, on his part the decision to use the atomic bomb was taken without any second thoughts." Braw, *The Atomic Bomb Suppressed*, p. 138. Braw's source is Harry S. Truman, *Memoirs: Year of Decisions* I (Garden City, N.Y.: Doubleday, 1955–56), p. 302. Sayle writes, "No one ever made a positive decision to drop the bomb on Hiroshima, only a negative one: not to interfere with a process that had begun years before, in very different circumstances. Truman later described it as 'not any decision that you had to worry about,' but a decision implies a choice, and Truman never contemplated, or even heard suggested, any delay, or any alternative to the bomb's use on a Japanese city" ("Letter from Hiroshima," 54). See also Osborn Elliott, "Eyewitness," *Newsweek* (24 July 1995) 30: "Harry Truman . . . buried any qualms he might have had. At a press conference in 1947 he told reporters, 'I didn't have any doubts at the time.' He said the decision had saved 250,000 American lives. In later years Truman would raise the number of lives saved to half a million or a million. 'I'd do it again,' Truman said in 1956. In 1965, seven years before he died, he repeated that he 'would not hesitate' to drop the A-bomb." For a detailed account of the decision-making process (by top military personnel and scientists as well as Truman) that led up to the dropping of the bombs, see Bernstein, "The Atomic Bombings Reconsidered."

14. This is the situation Heidegger is referring to in a passage such as this: "Everywhere and in the most varied forms and disguises the gigantic is making its appearance. In so doing, it evidences itself simultaneously in the tendency toward the increasingly small. We have only to think of numbers in atomic physics. The gigantic presses forward in a form that actually seems to make it disappear—in the annihilation of great distances by the airplane, in the setting before us of foreign and remote worlds in their everydayness, which is produced at random through radio by a flick of the hand." Heidegger, *The Question Concerning Technology*, p. 135. Elsewhere, I have discussed in greater detail the manner in which modern technology, which is aimed at facilitating global "communication" in the broadest sense of the word, has paradoxically led to the increasing intangibility and, for some, the disappearance, of the material world. See Chapter VIII, "Media, Matter, Migrants," *Writing Diaspora: Tactics of Intervention in Contemporary Cultural Studies* (Bloomington and Indianapolis: Indiana University Press, 1993).

15. Paul Virilio, *War and Cinema: The Logistics of Perception* (1984), trans. Patrick Camiller (New York and London: Verso, 1989), 20. Virilio's other works, in particular *Pure War* (with Sylvère Lotringer), trans. Mark Polizzotti (New York: Semiotext(e), 1983), are also germane.

16. Virilio, *The Vision Machine* (1988), trans. Julie Rose (Bloomington and Indianapolis: Indiana University Press, 1994), 49.

17. Heidegger, *The Question Concerning Technology*, p. 129.
18. Quoted in Virilio, *War and Cinema*, p. 4.
19. "On August 10, the day after the Nagasaki bombing, when Truman realized the magnitude of the mass killing and the Japanese offered a conditional surrender requiring continuation of the emperor, the president told his cabinet that he did not want to kill any more women and children. . . . After two atomic bombings, the horror of mass death had forcefully hit the president, and he was willing to return partway to the older morality—civilians might be protected from the A-bombs. But he continued to sanction the heavy conventional bombing of Japan's cities, with the deadly toll that napalm, incendiaries, and other bombs produced. Between August 10 and August 14—the war's last day, on which about 1,000 American planes bombed Japanese cities, some delivering their deadly cargo after Japan announced its surrender—the United States probably killed more than 15,000 Japanese." Bernstein, "The Atomic Bombings Reconsidered," pp. 147–48. In *The Rise of American Air Power*, Sherry argues that the United States's aerial attacks on Japan stemmed from strategic and emotional reasons: "The ultimate fury of American aerial devastation came against Japan not because it was more fanatical, but because it was relatively weaker. Germany's strength and tenacity gave the Allies little choice but to resort to invasion because Germany would not surrender without it. It was the relative ease of attacking Japan by air that tempted Americans into the fullest use of air power. As an image, Japan's fanaticism was real enough in the minds of many Americans. But it served mainly to justify a course of bombing rooted in strategic circumstances and the emotional need for vengeance" (p. 246).
20. Virilio, *War and Cinema*, p. 6; emphasis in the original.
21. See Michel Foucault, *The Order of Things: An Archaeology of the Human Sciences* (London: Tavistock Publications, 1970). Foucault means by "episteme" not simply a concept or an idea but a particular relation between "reality" and representation, a relation that produces knowledge (i.e., that exists as a condition for the possibility of knowledge) and shifts with different historical periods.
22. Ironically, this partnership attests to what Freud, in the famous exchange with Einstein, discusses as the ambivalence of war, which for him advanced as much as threatened civilization. See the section "Why War?" (1932/33) in *The Standard Edition of the Complete Psychological Works of Sigmund Freud*, vol. xxii (London: Hogarth Press, 1964), pp. 197–215.
23. Virilio, *War and Cinema*, p. 4.
24. Dower, "The Bombed," p. 7.
25. Dower points out that Japan's conversion to nonmilitary manufacturing activities in the postwar years was greatly facilitated by its previously diverse and sophisticated wartime technology. See the chapter "The Useful War" in his *Japan in War and Peace: Selected Essays* (New York: The New Press, 1993), in particular pp. 14–16.
26. Notably, Japan's rise to economic power triggers in the United States a new rhetoric of anxiety and hostility—a rhetoric that, Dower argues, is rooted in the racist attitudes toward Japan in the Second World War. See his discussion of this point in *War without Mercy: Race and Power in the Pacific War* (New York: Pantheon Books, 1986), 311–17. I will discuss the relations between racism and postwar knowledge production in the pages that follow.
27. See Sherry, *The Rise of American Air Power*, pp. 204–18, for an account of the *dis-*

tance from the enemy that occurs both because of the nature of air combat and because of the demands of aviation that arise outside combat. In the history of air war, airmen were conditioned to "see themselves as an elite for whom performance of professional skills—a mastery of technique—was more important than engaging an enemy. Before they went into combat and again when they came out of it, powerful factors of class, education, and policy strengthened their status and their elite image" (p. 213).

28. Karl von Clausewitz, *On War*, edited and translated by Michael Howard and Peter Paret (Princeton: Princeton University Press, 1976), 184. See also Book 1, Chapter 3, "On Military Genius" (pp. 100–12) for more extended discussions.

29. Buruma reports that at a United Nations Conference on Disarmament Issues in Hiroshima in July 1992, "An American Harvard professor argued that the Hiroshima bombing 'ended World War II and saved a million Japanese lives.' He also added that the horror of this event had helped to prevent nuclear wars ever since, and thus in effect Hiroshima and Nagasaki saved millions more lives" (*The Wages of Guilt*, p. 105). See also the account by Mary Palevsky Granados, "The Bomb 50 Years Later: The Tough Question Will Always Remain," *Los Angeles Times Magazine* (25 June 1995): 10–11, 28–30. Granados was shocked to hear Hans Bethe, the man who was the head of the Los Alamos Lab's Theoretical Physics Division during the time of the war and "who has been called America's most influential advocate of nuclear disarmament," emphatically confirm that "the first use of nuclear armaments was necessary and correct" (p. 28).

30. Richard Nixon visited Hiroshima in 1964, four years before he became president, and Jimmy Carter visited Hiroshima during the late 1980s, on one of his many trips to Japan after he had left office. Neither expressed regret for what was done by the United States during the war. In April 1995, Bill Clinton declared that the United States did not owe Japan an apology for using the atomic bombs and that Truman had made the right decision "based on the facts he had before him." See Robert Jay Lifton and Greg Mitchell, *Hiroshima in America: Fifty Years of Denial* (New York: Grosset/Putnam, 1995), 211–22.

31. It should be pointed out, however, that despite the massive destructions over the decades, attitudes toward the United States in some of these areas remain ambivalent rather than straightforwardly hostile. For instance, in a country that was devastated by U.S. military forces such as Vietnam, there is, ironically, widespread welcome of the return of the Americans today.

32. See Jacqueline Rose's persuasive discussion of this point in "'Why War?,'" the first chapter of *Why War?—Psychoanalysis, Politics, and the Return to Melanie Klein* (Oxford, England and Cambridge, MA: Blackwell, 1993), 15–40.

33. Dower, *War without Mercy*, p. 127. Besides Gorer, the notable scientists who studied the Japanese national character listed by Dower include Margaret Mead, Gregory Bateson, Ruth Benedict, Clyde Kluckhohn, and Alexander Leighton (p. 119). Of course, these scientists did not come to the same conclusions.

34. Dower, *War without Mercy*, p. 10.

35. Braw, *The Atomic Bomb Suppressed*, p. 142.

36. Braw, *The Atomic Bomb Suppressed*, p. 151. Notably, such suppression of information took place *even as Supreme Commander Douglas MacArthur publicly emphasized the virtues of the freedom of the press and freedom of speech.* (MacArthur issued a Directive for the Freedom of Speech and Freedom of the Press in Tokyo on September 10, 1945, and reimposed censorship on the Japanese

press on September 18.) From being simply a routine military undertaking that was negative in its function, censorship was transformed into a positive, essential tool, a tool that would assist in the virtuous task of helping Japan emerge from defeat as a democratic, peace-loving nation. See pp. 143–56 of Braw's book for an extended discussion.

37. Sherry, *The Rise of American Air Power*, p. 351.
38. See, for instance, the discussion of the "inhuman face of war" in John Keegan, *The Face of Battle* (London: Jonathan Cape, 1976), pp. 319–34.
39. Sherry, *The Rise of American Air Power*, p. 253.
40. The most controversial argument on this connection remains that of Edward Said's *Orientalism* (New York: Pantheon Books, 1978).
41. I shall not repeat arguments that I have already made elsewhere about the politics of Asian studies in American universities. Interested readers are asked to see my discussions in Chapters I and VI of *Writing Diaspora*.
42. See the exclusive prison interview with the prime suspect, Timothy McVeigh, in David H. Hackworth and Peter Annin, "The Suspect Speaks Out," *Newsweek* (July 3, 1995): 23–26.
43. I am very grateful to Beth Bailey, David Farber, James A. Fujii, Austin Meredith, and Susan Neel for their valuable contributions to this essay. Conversations with them not only helped me revise my arguments but also directed me to crucial references on a topic on which I had not done previous research. My thanks also go to Jackie Hiltz and Peter Gibian for their constructive editing comments and suggestions.

Mass Media I

Film and Television

Another World?

Daytime Television and Women's Work in the Home

Tania Modleski

In his book *Television: Technology and Cultural Form*, Raymond Williams suggests that the shifts in television programming from one type of show to another and from part of a show to a commercial should not be seen as "interruptions"—of a mood, of a story—but as parts of a whole. What at first appear to be discrete programming units in fact interrelate in profound and complex ways. Williams uses the term "flow" to describe this interaction of various programmings with each other and with commercials. "The fact of flow," he says, defines the "central television experience."[1]

I would like to examine the flow of daytime television, the way, particularly, soap operas, quiz shows, and commercials interrelate. More specifically, I want to look at how the flow of these programs connects to the work of women in the home. As the ladies' magazines never tire of telling us, this work involves a variety of tasks and requires a wide range of abilities. Moreover, this work tends to be very different from men's work. As Nancy Chodorow describes it:

> Women's activities in the home involve continuous connection to and concern about children and attunement to adult masculine needs, both of which require connection to, rather than separateness from, others. The work of maintenance and reproduction is . . . repetitive and routine . . . and does not involve specified sequence or progression. By contrast, work in the labor force—"men's work"—is more likely to be contractual, to be more specifically delimited, and to contain a notion of defined progression and product.[2]

One of the chief differences between daytime television and nighttime programming is that the former appears to be participatory in a way that the latter

This essay first appeared in TABLOID 4 (summer 1981):
18–24. For an extended analysis of some of these issues,
see Chapter 4 of Tania Modleski's Loving with a Vengeance:
Mass-Produced Fantasies for Women (New York: Routledge,
1990).

almost never is; it stresses, in other words, "connection to rather than separation from others." This is obviously the case with quiz shows and talk shows such as *Phil Donahue*. But it is also true of soap operas. For example, on soap operas, action is less important than *reaction* and *interaction*, which is one reason fans keep insisting on soap opera's "realism," although critics continually delight in pointing out the absurdity of its content. Despite the numerous murders, kidnappings, blackmail attempts, emergency operations, amnesia attacks, etc., that are routine occurrences on soap operas, anyone who has followed one for however brief a time knows that these events are not important in themselves; they merely serve as occasions for characters to get together and have prolonged, involved, intensely emotional discussions with each other.

"Daytime television plays a part in habituating women to interruption, distraction, and spasmodic toil; its flow reinforces the very principal of interruptability crucial to the proper functioning of women in the home."

Furthermore, audiences are much more likely to become intimately involved with soap opera characters and to experience them as equals than they are the characters on nighttime programs. A comparison with *Dallas*, the popular nighttime serial, is instructive. There the characters are highly glamorized, the difference between their world and that of the average viewer could not be greater, and the difference is continually emphasized. On soap operas, by contrast, glamour and wealth are played down. Characters are attractive *enough* so that their looks are not distracting, well off *enough* so that, as in a Henry James novel, they can worry about more exciting problems than inflation at the market. But glamour and wealth are *not* preoccupations as they are on *Dallas*. Obviously, the soap opera world is in *reality* no more like the average spectator's than the world of *Dallas*; yet the characters and the settings all connote averageness. This accounts for the fans' frequent contention that soap opera characters are just like them—whereas *no* one is likely to make such a claim about the Ewing family on *Dallas*. The consequent blurring of the boundaries between fantasy and life that sometimes occurs (as, for example, when fans write letters to the "characters," giving them advice about their problems) suggests that the psychological fusion which Chodorow says is experienced by the wife/mother applies in these instances to the *viewer's* experience of the characters.

This last observation would seem to lend support to Luce Irigaray's thesis that identification is an inadequate term for describing women's pleasure. As film critics have pointed out, "Cinematic identification presupposes the security of the modality 'as if.'"[3] Soap operas tend, more than any other form, to break down the distance required for the proper working of identification. But rather than seeing these cases as pathological instances of *over*-identification

(as in the case of the boy who stabbed a woman in the shower after seeing *Psycho*),[4] I would argue that they point to a different *kind* of relationship between spectator and characters, one that can be described in the words of Irigaray as "nearness": "a nearness so close that any identification of one or the other is impossible."[5] The viewer does not *become* the characters (like the boy in the *Psycho* case) but rather relates to them as intimates, as extensions of her world. Speaking of woman's rediscovery of herself, Irigaray writes, "It is a sort of universe in expansion for which no limits could be fixed and which, for all that, would not be incoherence."[6] I need not belabor the similarities between this description and soap opera as a form. But I mention it because I believe it is crucial to understand how women's popular culture speaks to women's pleasure at the same time that it puts it in the service of patriarchy, keeps it working for the good of the family.

Television also plays on women's fears that they are not near *enough* to those around them. Consider the happy ending of the well-known television commercial: Wife: "Why didn't you *tell* me you like Stove-Top Stuffing with chicken?" Husband: "You never asked me." So, it seems, women must play guessing games, be mind readers. Is it then merely accidental that several popular television quiz shows emphasize mind reading over the possession of correct answers? I'm referring to programs that have contestants guess the responses of a studio audience or a poll of people, such programs as *The Match Game, Card Sharks*, and *Family Feud*. In a perceptive article in *Screen Education*, John Tulloch argues that quiz shows on British television present a reified view of knowledge which is current in the culture at large.[7] Increasingly, daytime quiz shows on American television relate not so much to any particular view of knowledge as to a desire to overcome one's *exclusion* from knowledge, from the thoughts and feelings of others. Answers are no longer right or wrong in any "objective" sense; contestants are rewarded when they correctly guess what *other people* think.

Questions about what is on other people's minds provide many of the enigmas of soap operas as well as of other popular feminine narratives. In Gothic Romances, for example, the solution to the mystery lies less in the intellectual process of detection—following external clues to determine who provided the corpse, how, and with what motive—than in guessing what the aloof, attractive, enigmatic male is thinking and feeling. In soap opera, characters spend an inordinate amount of time trying to find out what is "bothering" another character. Soap operas may be excessively wordy, as Horace Newcomb has pointed out, but this wordiness is built around deep silences.[8] Characters talk and speculate endlessly about why other characters are *not* talking.

Furthermore, it is not only the characters on soap operas who are impelled to fathom the secrets of other people's minds; the constant, even claustrophobic use of close-up shots stimulates the audience to do likewise. Often *only* the audience is privileged to witness the characters' expressions, which are complex and intricately coded, signifying triumph, bitterness, despair, confusion—the entire emotional register, in fact. Soap operas contrast sharply with other

popular forms aimed at masculine visual pleasure, which is often centered on the fragmentation and fetishization of the female body. In the most popular feminine visual art, it is easy to forget that characters even *have* bodies, so insistently are close-ups of faces employed. One critic significantly remarks, "A face in close-up is what before the age of film only a lover or a mother ever saw."[9] Soap operas appear to be the one visual art that activates the gaze of the mother—but in order to provoke anxiety (an anxiety never allayed by narrative closure) about the welfare of others. Close-ups provide the spectator with training in "reading" other people, in being sensitive to their (unspoken) feelings at any given moment.

This openness to the needs and desires of others is, of course, one of the primary functions of the woman in the home. The wife and mother, who is excluded from participation in the larger world in which her husband and children move, must nevertheless be attuned to the effects of this world upon her family. Moreover, although her family cannot be bothered with the details of *her* world, with making such "trivial" decisions as whether to have stuffing or potatoes with dinner, such decisions nevertheless affect her family's attitudes and moods, and it is well for her to be able to anticipate desires which remain unuttered, perhaps even unthought. Thus, the enigmas of a significant number of commercials, as in the one quoted above, center around the wife's anxiety about what her husband or children will think of one of her little changes in menu or the running of the household. She waits in suspense as her husband takes the first forkful of his meal, or breathlessly looks on as he selects a clean shirt, wondering if he will notice just how clean and fresh it is. Of course, he *does* notice, as she ecstatically exclaims. This last example seems to come very close to subverting its own project—the project of many commercials of showing the immense rewards of being a housewife. To me, it announces a little too clearly how extraordinary it is when family members pay the least attention to all the work the woman in the home does for them. It is worth noting that in the many commercials in which a man tests a woman—for example gives her a new medicine to reduce tension—there is never any anxiety involved. He is absolutely certain what brand will please her. Men, it appears, don't have to try to "read" women; they already *know* them and fully understand their needs.

But if it is the responsibility of the woman in the home to be sensitive to the feelings of her family, this job is further complicated by the fact that she must often deal with several people with different, perhaps conflicting moods; and, further, she must be prepared to drop what she is doing in order to cope with various conflicts and problems the moment they arise. Unlike most workers in the labor force, the housewife must beware of concentrating her energies exclusively on one task—otherwise, the dinner could burn, or the baby could crack its skull (as happened once on a soap opera when a villainess became so absorbed in a love encounter that she forgot to keep an eye on her child). The housewife functions, as many creative women have sadly realized, by distraction. Tillie Olsen writes, in *Silences*, "More than in any other human rela-

tionship, overwhelmingly more, motherhood means being instantly interrupt-able, responsive, responsible. . . . It is distraction, not meditation, that becomes habitual; interruption, not continuity; spasmodic, not constant toil."[10] Daytime television plays a part in habituating women to interruption, distrac-tion, and spasmodic toil. Here I must take issue with Raymond Williams, who rejects the notion that television programs and commercials may be seen as interruptions. Indeed, I would argue that the flow of daytime television rein-forces the very principle of interruptability crucial to the proper functioning of women in the home. In other words, what Williams calls "the central televi-sion experience" is a profoundly *decentering* experience.

"The art of being off center," wrote Walter Benjamin in an essay on Baudelaire, "in which the little man could acquire training in places like the Fun Fair, flourished concomitantly with unemployment."[11] Daytime televi-sion programs, most obviously soap operas, also provide training in "the art of being off center" (and we should note in passing that it is probably no accident that the nighttime soap opera *Dallas* and its offshoots and imitators flourished in a period of economic crisis and rising unemployment). The housewife, of course, is in one sense, like the little man at the Fun Fair, unemployed, but in another sense she is perpetually employed—like the soap opera plots that never come to any closure, her work is never done. Moreover, as I have said, her duties are split among a variety of domestic and familial tasks, and her tele-vision programs keep her from desiring a focused existence by involving her in the pleasures of a fragmented life.

The multiple plot lines of soap operas, for example, keep women interested in a number of characters and their various fates simultaneously. When one plot threatens to become too absorbing, it is interrupted, and another story line is resumed, or a commercial is aired. Interruptions within the soap opera die-gesis are both annoying and pleasurable; if we are torn away from one absorb-ing story, we at least have the relief of picking up the thread of an unfinished one. Commercials, of course, present the housewife with mini-problems and their resolutions, so after witnessing all the agonizingly hopeless dilemmas pre-sented on soap operas, the spectator has the satisfaction of seeing *something* cleaned up, even if only a stained shirt or a dirty floor.

Although daytime commercials and soap operas are set overwhelmingly within the home, the two views of the home seem antithetical, for the chief concerns of the commercials are precisely the ones soap operas censor out. The soggy diapers, yellow wax buildup and carpet smells constituting the world of daytime television ads are rejected by soap operas in favor of "Another World," as the very title of one soap opera announces, a world in which char-acters deal only with "large" problems of human existence: crime, love, death, and dying. But this antithesis embodies a deep truth about the way women function in (or, more accurately, around) culture as both moral and spiritual guides and household drudges: now one, now the other, moving back and forth between the extremes, but obviously finding them difficult to reconcile.

Similarly, the violent mood swings the spectator undergoes in switching

from quiz shows to soap operas also constitute a kind of interruption, just as the housewife is required to endure monotonous, repetitive work but to be able to switch instantly and on demand from her role as a kind of bed-making, dishwashing automaton to a large, sympathizing consciousness. It must be stressed that although nighttime television certainly offers shifts in mood, notably from comedy to drama, these shifts are not nearly as extreme as in day-time programming. Quiz shows present the spectator with the same game, played and replayed frantically day after day, with each game a self-contained unit, crowned by climactic success or failure. Soap operas, by contrast, end-lessly defer resolutions and climaxes and undercut the very notion of success by continually demonstrating that happiness for all is an unattainable goal: one person's triumph is another person's bitter disappointment.

Not only this, but the forms of pacing on these two types of programs are at opposite extremes. On quiz shows contestants invariably operate under severe time pressure. If the answer is not given in thirty seconds, a most unpleasant sounding buzzer, rather like an alarm clock or an oven timer, forces the issue: time is up, your answer please. Whereas quiz shows operate on the speed-up principle, compressing time into tight limits, soap operas slow down the action and expand time to an extent never seen on nighttime television (not even on such shows as *Dallas*). Soap opera time coincides with or is actually slower than "real" time, and, moreover, throughout the years, the lengths of the pro-grams themselves have been expanding. If the two kinds of time embodied by these two types of programs reflect the fact that the housewife must both race *against* time (in completing her daily chores) and *make* time (to be receptive to the demands on her attention made by her family), on a deeper level they are not as divergent as they appear. Speaking of games of chance, in which "starting all over again is the regulative idea," Benjamin relates the gambler's psychological experience of time to that of the man who works for wages. For both, it is "time in hell, the province of those who are not allowed to com-plete anything they have started."[12] The desire for instant gratification, says Benjamin, is the result of modern man's having been cheated out of his expe-rience. But gratification instantaneously awarded (as in games of chance) or gratification infinitely postponed (as in soap operas) both suggest the depriva-tion of experience, a deprivation inflicted not only on those who work for wages, but obviously also pertaining to those who work at repetitive tasks for *no* tangible rewards, but rather for the gratification of others.

The formal properties of daytime television thus accord closely with the rhythms of women's work in the home. Individual soap operas and the flow of various programs and commercials tend to make repetition, interruption, and distraction pleasurable. But we can go even further and note that for women viewers reception itself often takes place in a state of distraction. According to Benjamin, "reception in a state of distraction . . . finds in the film its true means of exercise."[13] But now that we have television we can see that it goes beyond film in this respect, or at least the daytime programs do. For the con-sumption of most films as well as of nighttime programs in some ways recapit-

ulates the work situation in the factory or office: the viewer is physically passive, immobilized, and all his or her attention is focused on the screen. Even the most allegedly "mindless" program requires a fairly strong degree of concentration if its plot is to make sense. But because the housewife's "leisure" time is not so strongly demarcated, her entertainment must often be consumed on the job. As the authors of *The Complete Soap Opera Book* tell us:

> The typical fan was assumed to be trotting about her daily chores with her mop in hand, duster in the other, cooking, tending babies, answering telephones. Thus occupied, she might not be able to bring her full powers of concentration to bear on *Backstage Wife*.[14]

This accounts, in part, for the "realistic" feel of soap operas. The script writers, anticipating the housewife's distracted state, are careful to repeat important elements of the story several times. Thus, if two characters are involved in a confrontation that is supposed to mark a final break in their relationship, that same confrontation must be repeated, with minor variations, a few times, in order to make sure the viewer gets the point. "Clean breaks"—surely a supreme fiction—are impossible on soap operas. Quiz shows, too, are obviously aimed at the distracted viewer who, if she misses one game because she is cleaning out the bathroom sink, can easily pick up on the next one ten minutes later.

Benjamin, writing of film, invoked architecture as the traditional art most closely resembling the new one in the kinds of response they elicit. Both are mastered to some extent in a state of distraction; that is, both are appropriated "not so much by attention as by habit."[15] It is interesting to recall in this connection the Dadaist Eric Satie's concept of furniture music, which would be absorbed while people went about their business or chatted with each other. Television is the literalization of the metaphor of furniture art, but it must be stressed that this art is more than simply background noise in the way, for example, that muzak is; daytime programs, especially soap operas, are intensely meaningful to many women, as a conversation with any fan will immediately confirm. Moreover, as I have tried to show, their rhythms interact in complex ways with the rhythms of women's life and work in the home.

Ironically, critics of television untiringly accuse its viewers of indulging in escapism. In other words, both high art critics and politically oriented critics, though motivated by vastly different concerns, unite in condemning daytime television for *distracting* the housewife from her real situation. My point has been that the housewife's routine is itself most centrally characterized as a mode of existence-in-distraction; a distracted or distractible frame of mind is crucial to a housewife's efficient functioning *in* her real situation, and at this level television and its so-called distractions, along with the particular forms they take, are intimately bound up with women's work.

Notes

1. Raymond Williams, *Television: Technology and Cultural Form* (New York: Schocken, 1975) 95.
2. Nancy Chodorow, *The Reproduction of Mothering: Psychoanalysis and the Sociology of Gender* (Berkeley: University of California Press, 1978) 179.
3. Mary Ann Doane, "Misrecognition and Identity," *Cine-Tracts* 3:3 (Fall 1980): 25.
4. Doane refers to James Naremore's discussion of this incident in *Film Guide to Psycho* (Bloomington: Indiana University Press, 1973) 72.
5. Luce Irigaray, "Ce sexe qui n'en est pas un," in Elaine Marks and Isabelle Courtivron, eds., *New French Feminisms* (Amherst: University of Massachusetts Press, 1980) 104–5.
6. Irigaray, 104.
7. John Tulloch, "Gradgrind's Heirs—The Quiz and the Presentation of 'Knowledge' by British Television," *Screen Education* 19 (Summer 1976): 3–13.
8. Horace Newcomb, *T.V.: The Most Popular Art* (New York: Anchor, 1974) 168–9.
9. Dennis Porter, "Soap Time: Thoughts on a Commodity Art Form," *College English* 38:8 (April 1977): 786.
10. Tillie Olsen, *Silences* (New York: Dell, 1979) 18–19.
11. Walter Benjamin, "On Some Motifs in Baudelaire," in *Illuminations*, trans. Harry Zohn, ed. Hannah Arendt (New York: Schocken, 1969) 176.
12. Benjamin, "On Some Motifs in Baudelaire," 179.
13. Benjamin, "The Work of Art in the Age of Mechanical Reproduction," in *Illuminations*, 240.
14. Madeleine Edmondson and David Rounds, *From Mary Noble to Mary Hartman: The Complete Soap Opera Book* (New York: Stein and Day, 1976) 46–47.
15. Benjamin, "The Work of Art," 239–40.

Eros and Syphilization

The Contemporary Horror Film

Dana Polan

In the 1950s film *It, the Terror from Beyond Space*, everything conspires to assert the Otherness of the monster—its complete and irrevocable difference from everything that the film upholds as the decent everyday world, the world of ostensibly average men and women. Sneaking aboard a spacecraft returning to Earth, the monster stands as a force of pure and complete menace, an irrationality that attacks without motivation and even without goal (other than simply to realize the sheer desire to attack). The film draws a moral bar between two ways of life—its images of a normal way of life versus a destructive, malevolent one—and suggests that this bar is of necessity inevitable, eternal, and unbreakable.

Even the title suggests the difference of the monster by turning it into a mere thing, an "It." Not accidentally, many '50s monster titles imply the monster's membership in a community of the nonhuman: *The Blob, Them!, The Creature From the Black Lagoon, The Thing*.[1] The extreme threat of the monster here allows no possibility of communication with it, of mediation between the two worlds; consequently, the films suggest that the only way to deal with that which is monstrous is through reactive forces of high violence (in order: rifles, grenades, high voltage, atomic radiation). Rare exceptions, early in the '50s, would be such films as *The Day the Earth Stood Still* and *Red Planet Mars*, but even the latter film tells of the benevolence of Martians only to still find monstrosity—in this case, in the Soviet regime and in fugitive Nazis. Generally, the '50s monster film argues that the desire to deal with the monster through anything other than violence is a sign of misguided (i.e., in the

This essay first appeared in TABLOID 5 *(winter 1982):*
31–34. A revised version subsequently appeared in Barry
Grant, ed., Planks of Reason: Essays on the Horror Film
(Metuchen, NJ: Scarecrow, 1984), 201–211. Revised version
reprinted here by permission of the author.

films' terms, liberal) weakness, a woefully inadequate and self-dooming gesture. In many '50s monster films (e.g., *War of the Worlds*) there is a character, often a priest, whose attitude toward the monsters is, "Let us try to reason with them." Several seconds later that character will be a smoldering pile of ashes in consequence of his belief that monsters share anything, such as rationality and humanism, with human beings.

Part of the significance of the "new" horror films—those turn-of-the-1980s films that mark a crucial shift towards a new paradigm still dominant in contemporary works—lies in the way they reject or problematize this simple moral binary opposition to suggest that horror is not something from out there, something strange, marginal, ex-centric, the mark of a force from elsewhere, the in-

"The 1950's horror film deals with oppression—monsters as pure exteriority outside the realm of the human—while in the new horror films that oppression may finally be only another guise for repression: that is, the very act of constituting another is ultimately a refusal to recognize something about the self."

human. With an unrelenting insistence, this new generation of horror films—those original turn-of-the-1980s works and their multiple, numbered sequels continuing on into the 1990s—now suggests that the horror is not merely among us, but rather part of us, caused by us. These films do often continue the older concern with monstrosity as a realm of incommunicability, of dangerous silences, but they see the failure to communicate as an inherent *part of the human realm itself*, not something that assails humanity from an elsewhere. The films look at current modes of everyday life and see that life itself as a source and embodiment of the monstrous; the break-up of older forms of social relations seems to incite attack, seems to direct a virtually inward-directed wrath. Already dissolute, the quotidian world here brings about its own further dissolution.

In *The Howling I* (1981), for example, a husband and wife have trouble with their sex life ("we're just out of sync," the wife complains), and several seconds later the husband slips out to turn into a werewolf and rut with a female werewolf; the succession of the scenes sets up a logic of implication and causation that suggests that the problem of the marriage somehow encourages the unleashing of beastly elements (and the husband is reading *You Can't Go Home Again* just before the transformation). In *Halloween I* (1978) and *Slumber Party Massacre I* (1982), boys and girls who play around get murdered by the maniac while the virginal heroine survives—evidently because she refuses what the films picture as a kind of moral decadence. Even as seemingly classical a monster film as *Alligator I* (1980), which echoes the '50s film *Them!*

and its images of mutant creatures living in the L.A. sewers, implies our own responsibility for the monstrous. A freak of industrial waste (such as the mutant in *Prophecy* (1979) or the monster family in *The Hills Have Eyes*), the alligator stands for a kind of return of the repressed as society's destructive forces turn against the engendering society itself (and with a melodramatic sense of justice, the monster's greatest attack is directed against a lawn party of the man whose chemical company caused the mutation in the first place). As close as *Alligator* may be to the '50s film, it is also not that far from the new-era horror film *It's Alive I* (1974), which completes the metaphoric use of the L.A. sewers by turning the classical horror film into a modern "family romance."

In *It's Alive*, the sewer becomes the place for the father's recognition and acceptance of his mutant baby. Here, the sewer is no longer some mysterious, other place but literally a sign of the repressed (the sewer is where you cast off things you don't want); also a sign, therefore, of the act of repression. Here we might invoke a distinction that Robin Wood makes between "oppression" and "repression"; whereas oppression enacts the crushing of alien elements, of that which is ostensibly different, repression involves the crushing of internal qualities, of those aspects of the self (whether individual or social) that one would like to banish or disavow.[2] In this sense, the '50s film deals with oppression — monsters as pure exteriority outside the realm of the human — while in the new horror films oppression may finally be only another guise for repression: that is, the very act of constituting another is ultimately a refusal to recognize something about the self. In this sense, if the tanks and machine guns and jets of *Them!*, blasting away at ant holes and sewer hideouts, seem to indicate a full-scale war with full-scale enemies (war, that is, as oppression), in contrast, the images of helmeted policemen (coupled with the fact that they are policemen — civil servants — and not military personnel) in *It's Alive* can serve as a sign of domestic warfare, an attempted repression. For example, a scene of police storming an L.A. bungalow where the baby has been reported seems iconographically quite reminiscent of the (in)famous S.W.A.T. team attack on, and destruction of, an S.L.A. hideout in L.A. Similarly, the opening of *Dawn of the Dead* (1979) maps the horror film onto images of inner-city rebellion as S.W.A.T. members have to battle a ghetto community so organically bound together that it refuses to give up its relatives even though they have turned into zombies. Such images of an everyday life run through by urban and suburban violence seem a fitting commentary on dissent in the '60s and '70s, showing how an earlier mythology of consensus (for example, Daniel Bell's declaration at the end of the '50s that America had reached an End of Ideology, so that disagreement could only be aberrant or un-American)[3] could sustain itself only by a conscious self-ignorance, the election of some regions as monstrous turning out by the '70s to be the dominant system's grappling with its own monstrosity.

The new 1980s films argue that in some sense we partake of the monstrous, that in some way our lives are leading to the breakdown of traditional society. A few of the films, such as *Wolfen* (1981), view this breakdown as a progressive

necessity; with its opening scene of an attack on a rich politician, *Wolfen's* story of killer wolves menacing Manhattan from the concrete jungle of the South Bronx is an explicit comment on, and critique of, the very kind of ghettoizing and marginalizing that occurs when the dominant ideology equates same/different with good/monstrous. This is not to imply, though, that a film like *Wolfen* is progressive; indeed, its answer to the problems of class seems to be no less problematic — a set of appeals to romanticized visions of a new communal work coupled, without any sense of the inappropriateness on the film's part of such a coupling, to a mystique of the lone brooder-hero (Albert Finney as *angst*-ridden cop) and a simultaneous affirmation of the heterosexual couple as basic social unit.

With a nostalgia that in some films can fuel a conservatism (as in *Poltergeist I*'s (1982) invocation of the good, old family as haven in a heartless world), many of the new films suggest that in our devotion to the now, to the modern, we have created an agonistic and antagonistic culture of narcissism and have lost something that held us together, something that gave our lives a sustaining cohesion and "value." The flip side of nostalgia will show up in such films as a discontent with, a suspicion of, the new as decadent, malevolent, morally inadequate. For example, *The Howling* begins with a reporter discovering a man (who is actually a werewolf) in a sex shop, and so suggests a connection between moral decadence and monstrosity — the man's werewolf transformation occurring as a porno film plays in the background. Even more extreme in its fear of, and recoil from, the lifestyles of today, *They Came From Within* (1975) views our world as doomed because of its internal libidinal energies. Chronicling the attack of sluglike parasites on an apartment complex, *They Came From Within* constantly shifts its attention from the menace the parasites cause to attacks by the people who have the parasites within them: the shifts imply ultimately that the people themselves, in their very lifestyles, are already parasitic, and that the parasite creatures are themselves no more than enabling devices that bring to the surface a latent condition of the modern human being. To put it bluntly (as a scientist of the film does when he refers to the parasites as "combination aphrodisiac and venereal disease"), the parasites are the outbreak of libido, of the id as destructive desire against all the restraints of established order and propriety. The parasites strengthen sexual drives, and the film views this process with revulsion, picturing female desire, incest, homosexuality, rape, and adultery as equivalent forms of evil, of what the film imagines as a fundamental challenge to the very security of human life.

With an opening credit sequence that shows a publicity film for the apartment complex and emphasizes the pleasures of the place, *They Came From Within* implies that the new hedonistic society, the so-called "me" generation attitude, is responsible for the decline of the West. It is this hedonism that is monstrous; the attack of the parasites does no more than speed up an inevitable process. Where an earlier film such as the first version of *Invasion of the Body Snatchers* (1956) saw sleep, lifelessness, and lack of emotion as the evils that endanger modern society, the new horror films view emotion,

energy, and especially libidinal vitality as the sources of social breakdown (significantly, the remake of *Invasion* (1978) keeps the original motif of sleep but maps it onto images of maladjustment, problems in relationships, romantic alienation). Emotion, rather than its absence, becomes something that one must steel one's self against, through a disciplining of the body (both personal and social). The hero-doctor in *They Came From Within* seems to hang on as long as he does because of his basic coldness, an absolutely blasé professionalism that shows up even in the eyebrows that never arch, even when the situation would seem to have reached an extreme of horror.

The new horror films vary from each other in a number of details, but the majority seem to rely on a concept of an evil apocalypse that grows from within the social order, the threat of our own potential monstrosity as an ultimate challenge to, and test of, the stuff of which society is made. The politics of each film relates in a large degree to the ways—both in terms of its *mise-en-scène* and generic elements—it reacts to this apocalypse and to the possibilities of salvation. A great number of the films, for example, seem to work under the pressure of a nihilism, a hopelessness. For instance, in *The Howling*, there is no way finally to stop the onslaught of werewolves; the last scene shows how the werewolves are no longer kept at the margins of society in the woods (where they could prey only on rich narcissists out for therapy) but now have invaded the city (and a working-class bar), which is too benumbed by the media to react. In *The Texas Chainsaw Massacre I* (1974), there is nothing rational or calculated that the young bourgeois woman, Sally, can do to escape the onslaught of the chainsaw-toting Leatherface; when she does escape, it is by pure accident, and so the film suggests that one's defense against horror is finally subject to the forces of an arbitrary fate.

Such hopelessness reigns especially when the monster is explicitly shown to be an inevitable part of everyday life or human nature. In this respect, it is interesting to note what happens in the recent films to those figures that the '50s horror film used as signs of power and efficacy—doctors and scientists. In the most optimistic of these earlier films, the doctor or scientist is literally the source of solutions to monstrous ills as he (and the use of the male pronoun tends to be accurate here) calmly and rationally plugs away at a cure or ultimate weapon in the sanctity of his laboratory. Even films that show the scientist to be the cause of monstrosity (for example, *I Was a Teenage Werewolf*, where it is a mad doctor's injections that turn the teenager into a werewolf) suggest that it is not science that is at fault, but only an unfortunate misuse of science. Many films, such as *I Was a Teenage Werewolf*, give the mad scientist a sane, protesting partner, as if to suggest how the mad scientist could equally have made the choice to use his talents for good. In contrast, the newer films suggest that if horror has all-too-human origins, the physical sciences can have little diagnostic or curative power; they are quite simply out of their league. New horror films either eliminate the scientist figure altogether or they emphasize his inconsequentiality. For example, ecology monster films such as *Prophecy* (1979) might seem like the '50s films about monsters unleashed by

radiation, but they remove the sources of horror from the specificity of the scientific laboratory or the barren wasteland (for example, the North Pole of *The Beast from 20,000 Fathoms* [1953]) to suggest that horror now can break out anywhere and everywhere: mutations can occur in the Canadian woods (*Prophecy*) or in the L.A. sewers (*Alligator*) or in an L.A. hospital (*It's Alive*). Some films show the scientist causing the monster but, in contrast to the '50s film, with no intention to do so; unlike the mad scientist of *I Was a Teenage Werewolf*, the young chemical researcher of *Alligator* doesn't know that his chemical wastes are causing mutations. Significantly, even social scientists, especially psychologists, are shown to be ineffective in their attempts to gain control of an elusive horror. Thus, for example, the psychiatrist-therapists of *The Howling* and *The Brood* (1979) fail in their attempts to normalize monsters and so are killed off. Science is no longer a potential knowledge, an accomplishment, a savior; it has become a mere irrelevance or even a positive danger. Significantly, the heroes of the new horror films are rarely doctors or scientists (and even the hero of *They Came From Within* does little *as a doctor* once the parasites start attacking) but professionals of public order: soldiers (*The Crazies* [1975]), government agents (*The Fury* [1978] and *Swamp Thing* [1982], with its karate-chopping intelligence agent heroine), or, most often, cops (*Wolfen, Alligator, Q* [1982], *Dawn of the Dead, The Car*). Representative in this respect is *Jaws*'s (1975) demonstration of the intellectual marine biologist's ultimate worthlessness (and even, perhaps, cowardice) against the ordinary cop's efficiency with a simple tool, a rifle (and, as if to strengthen the image of the ordinary law enforcer's worth, the film eliminates the novel's affair between the biologist and the cop's wife).

In those cases where the horror film narrative refuses complete nihilism and draws back from an attitude of pure cynicism to suggest a way out, the position it retreats to is often that of militarism or fascism or aggressive professionalism (for which the cop is the "ideal" hero). The solution of violent counterattack to the horror of apocalypse would seem to derive from the modern horror film's fear of modernity's fall, of society's corruption of itself through eros, through an ostensible dissociation of sensibility that is also, in these films' terms, a dissociation of an older, organic society. See, for example, the scene in *The Texas Chainsaw Massacre* where the brother and sister, Sally and Franklyn, face each other in filial anger and disgust across the width of the screen—the distance suggesting the alienation in the heart of family relations—just before Leatherface goes at them with the chainsaw. The solution that the film narratives seem to promote, then, is a kind of *forced* organicism, with a strong professional group forming itself to come in and remove the apocalyptic threat. In *Night of the Living Dead*, deer hunters become zombie hunters, and gleefully and professionally wipe out the living dead (and, by accident, the hero); this celebration of violent might and right becomes even more orgiastic in *Dawn of the Dead*, where the zombie-infested shopping mall receives a counterattack by a S.W.A.T. team that happily knocks off the zombies (and a motorcycle gang) as if it were all a game. As Tony Williams's analy-

sis of *Assault on Precinct 13* (1976) suggests, the distance from the Hawksian adventure of male camaraderie, to the almost vigilantelike violence of the new crime film, to the new horror film is not that great.[4]

To be sure, the '50s monster film seems to deal with a growth of organic society; indeed, many of the plots revolve around the ways that the monstrous attack makes the hero and heroine fall in love (see, for example, *It*, *The Terror from Beyond Space*, *Them!*, and *War of the Worlds*).[5] But the difference lies precisely in that emphasis in the '50s film on love as the cause of organicism; with few exceptions (e.g., *Alligator*), even those modern horror films that would seem closest to the '50s films in their plot of an inhuman menace attacking the human way of life nonetheless start with already-formed couples and then chronicle the tensions and internalized aggression that attack by the monster causes in the heterosexual unit (see, for example, the couples in *Dawn of the Dead*, *The Howling*, *The Brood*, *Invasion of the Body Snatchers*). Good relationships will either turn bad or their very goodness will seem to invite destruction; thus, many films show the tragic death of one of the couple, as in *American Werewolf in London* (1981) or *The Crazies* (1975). Another option (which begins, perhaps, with the teaming up of Lila Crane and Sam Loomis in *Psycho*) is to show male and female meeting arbitrarily because of the attack but forming no alliance of love, which is the situation of the protagonists in both *Night of the Living Dead* (1968) and *Scanners I* (1981), for example. In all these cases, there seems to be a disavowal or even refusal of a mythology of love's redemptive powers, of what Raymond Bellour has called the Oedipal trajectory of classic American cinema.[6]

All too often, though, the films disavow an ideology of romance only to substitute an equally problematic ideology of discipline and denial, a faith in cold pragmatism as the only way of life able to survive in the modern world. If the monsters are symptomatic expressions of libido and uncontrol, the answer — or so the force of reaction implies — is to make violence, the ruthless obliteration of the monsters, erotic in its own right, thereby stealing from the monsters the very energy that sustains them. In *Dawn of the Dead*, for example, the consuming power of the monsters (who ravenously eat flesh) becomes analogous to their earlier power as commodity consumers (one of the S.W.A.T. team members suggests that the zombies return to the shopping mall because of what it meant to them once); in response, the protagonists become consumers in their own right and meet the consumptive destruction of the zombies with a destruction that is of an equally intense sort. Robin Wood's observation — that watching *The Texas Chainsaw Massacre* "with a large, half-stoned youth audience who cheered and applauded every one of Leatherface's outrages against their representatives on the screen, was a terrifying experience"[7] — has its contrasting complement in the audiences for *Dawn of the Dead*, who cheer each triumph of the forces of authority against the forces of destruction. The gunshot explosions of heads, shoulders, torsos, and so on, outdo the zombie attack in terms of engrossing spectacle.[8]

This creation and exploitation of a thrill of violence to ends supportive of

violent authority suggests that any nomination of the horror film as a progressive genre, simply because it depicts certain limitations of dominant society, would be wrong in missing the ways a critique of certain aspects of domination may itself derive from the other equally dominating aspects of that same society. (For example, in the 1960s, a critique of racism often came from a position of imputed male power, as in Eldridge Cleaver's infamous declaration that black power could be achieved through the rape of white women. Even the nihilism that Robin Wood so correctly finds in the horror film[9] is not always progressive; one must examine what the historical options are for where the nihilism can lead. Echoing Andrew Britton's declaration, in *The American Nightmare*, that "the return of the repressed isn't clearly distinguished from the return of repression,"[10] we might suggest that, as a disdain for the conditions of the present, nihilism can easily fuel desires for regression as well as progress. Indeed, history would seem to suggest that nihilism is an attitude that can lead in opposing directions in different historical contexts; cultural despair has often made those who despair desirous of a force like fascism as a drastic but disciplined and disciplining promise of solution to cultural ills.[11]

At their political worst, the new-style horror films can serve as justification for vigilante violence. At their best, they can serve as a critique of the very ideological justifications by which contemporary society sustains itself. What is revealing in this respect about the end of, say, *Alligator*, is the way it brings together these conflicting impulses. Fired from the police to consequently become that sort of lone hero so central to American mythology, the main character rejects authority's ineffectual ways of dealing with the monster. Against a romantic myth embodied by the big-game hunter the authorities hire to shoot down the alligator, the hero shows that, à la *Jaws*, the ordinary shnook can make a go of it, can prove his own worth. He blows the alligator to bits with dynamite and the film ends. But at least two excesses remain. First, to blow up the alligator the hero must also blow up an entire city street (and almost blow up an innocent bystander in the process); the destruction of disorder may have to make a necessary detour through a destruction of order. Second, the film ends with a track into the sewer to show a baby alligator about to be mutated by industrial waste, thereby once again showing the inevitable problems of a society based on contradictions.

Notes

1. In this paper, I make little or no distinction between horror and monster films, finding in both forms versions of the formula that, as Robin Wood argues, underlies narratives of menace: "Normality is threatened by the Monster." See Robin Wood's introduction to *The American Nightmare: Essays on the Horror Film* (Toronto: Festival of Festivals, 1979), p. 14 and passim. As I hope my analysis will suggest, a quick separation of films into airtight genres may miss the filiations, interchanges and resonances between genres.

2. See Wood, *The American Nightmare*, p. 8 and passim.

3. See Daniel Bell, *The End of Ideology: On the Exhaustion of Political Ideas in the Fifties* (Glencoe, IL: The Free Press, 1960).

4. Tony Williams, "Assault on Precinct 13: The Mechanics of Repression," in *The American Nightmare*, 67–73.

5. On the centrality of the love story to the '50s horror/monster film, see Margaret Tarrat, "Monsters from the Id," in Barry K. Grant, ed., *Film Genre: Theory and Criticism* (Metuchen, NJ: Scarecrow Press, 1977), pp. 161–81.

6. See, especially, "Alternation, Segmentation, Hypnosis: Interview with Janet Bergstrom," *Camera Obscura* 3–4 (Summer 1979): 87–100.

7. Wood, *The American Nightmare*, p. 22.

8. When I went to see *Dawn* three white youths, who had obviously seen the film before, stood around in the men's room before the start of the film talking with gleeful anticipation of "that scene where the S.W.A.T. guy blows the nigger's head off."

9. Wood, *The American Nightmare*, passim.

10. Andrew Britton, "The Devil, Probably: The Symbolism of Evil," in *The American Nightmare*, p. 41.

11. For an analysis of the ties between despair and conservatism, see Fritz Stern, *The Politics of Cultural Despair: A Study in the Rise of Germanic Ideology* (Berkeley: University of California Press, 1961).

Mass Media II

Dialogue on the Airwaves—
Talk Radio and Talk TV

Editor's Introduction

Talk Media Take Center Stage

Today, we're beginning to get used to a public culture of "All Talk! All the Time!" Peculiarly American modes of dialogue—combining "talk" and "show" in hybrid forms that develop the traditionally private and intimate mode of conversation for the public uses of mass instruction and mass entertainment—have now become the basis for many of the most dominant and pervasive forms of mass cultural spectacle. The "public sphere" for current political discussion, for example, is now the sort of mass media "town meeting" hosted by a Larry King or an Arsenio Hall; political candidates, even presidential hopefuls, now find that their campaigns are made or broken in the give-and-take of such quasi-interactive and quasi-spontaneous "talk show" spectacles. In 1992, Bill Clinton—the "all talk, all the time" president—gained significant advantage over George Bush by playing saxophone during his chats with Arsenio, and by walking into the audience during campaign debates, thus turning these events (usually a tired series of monologues from "talking heads" at their lecterns) into "Donahue"-like rap sessions for the sharing of pain and problems before huge mass audiences. Characteristically, once in office, he asked the National Endowment for the Humanities to keep such talk going through its major new initiative, a "National Conversation on American Pluralism and Identity." And if Clinton is thus well-suited to the mode of confession and exhibitionism and victim-speak that is currently such an attraction on talk TV, the Republican right for its part has been able to mine the paranoid style of talk radio as a site of enormous public power. Making talk radio into a new sort of "bully pulpit," a Rush Limbaugh could emerge as in effect the leader of the opposition, using disinformation and rhetorical bullying to mobilize whole armies of unthinking "ditto-heads" to simulate "grass roots" support for any cause he and other Republican Party leaders choose as their focus.

But this major transformation in the functioning of the North American "public sphere" is really a very recent development. It is only in the past fifteen years that a broad-based explosion in "airwaves dialogue" has made mass media forms that were once among the most humble and marginal—talk radio, talk TV, "talk shows," "newstalk," and so on—absolutely central in so many areas of our public life. In the early 1980s, several members of the TABLOID group found themselves both fascinated and horrified as they began to observe and analyze the first stirrings of developments that would lead to this talk media revolution. "Where we were used to hearing static 'talking heads' handing down The Word in monologue—talking at us—we are increasingly faced with a wild multiplicity of voices in dialogue, arguing about that Word—talking all around us," writes Peter Gibian in "Newspeak Meets Newstalk," a wide-ranging survey of both the progressive potential in and the problems raised by the many parallel forms of "airwaves dialogue" that seemed to be developing

simultaneously in various media. Soon after Walter Cronkite retired from his seat of authority in the network newsroom, Ted Koppel's *Nightline* emerged to make current events debate into a gladiatorial combat and a major late-night attraction, McNeil-Lehrer began framing dinner-hour news as a series of panel discussions, weekend "meet the press" and "week in review" shows were redesigned to give fuller play to clashes of opinions and to the "witty repartee" (i.e., extreme opinions, presented in a food-fight atmosphere) of reporters now emerging as media "personalities"—and in general all news programming moved closer and closer to newstalk. At the same time during this formative period, daytime TV was beginning to be dominated by newly dynamic talk-show modes—mass media forums for group psychodrama, verbal conscious-ness raising and public confession—being developed by Phil Donahue and Oprah Winfrey, while on AM radio the entire programming day suddenly began to be taken over by an astonishing proliferation of other sorts of wild-and-woolly airwaves dialogue. Now talk radio could wake us up with sensationalis-tic collisions of extreme opinions on morning shows ("Don't miss today's insults!"); take us through the day with call-in info-discussions for increasingly specialized interest groups (sports talk, car talk, garden talk, money talk); bring us an airwaves feeling of "home space" by offering chat sessions in the increas-ingly diverse languages of specific political or ethnic identity groups; titillate us after dinner with sex talk—the mass media alternative to a romantic evening date—or with other forms of "self help" talk involving strange mass media transformations of the intimacies of psychoanalytic dialogue or of the church's confessional; and then keep us up through late-night loneliness by serving as a forum for all the other crazies out there, giving new public voice to call-in rants of pent-up frustration, paranoia, or hysteria.

In its full flowering today, this "talk media explosion" presents us with a sit-uation full of paradoxes and contradictions. Though private, face-to-face con-versation between people seems on the verge of dying out in our high-speed, high-tech culture—and while many observers find that Americans seem now to be sadly limited by their lack of a language for intimate personal expres-sion—we are witnessing a boom in new forms of public dialogue which make a simulation of impromptu and revealing personal talk the basis for mass media spectacle. If sportstalk or newstalk or ethnictalk shows do seem to bring together close-knit communities of speakers and listeners who tune in to their talk group almost daily, we are always also aware that these "airwaves commu-nities" are virtual communities, formed of the most desperately atomized and alienated of people—with each caller and listener actually sitting alone in a car or a bar or at home. (And perhaps the same could be said for the "chat groups" or "cyber-salons" now proliferating on the Internet: though we can celebrate these wonderful new possibilities for the establishment of previously impossi-ble forms of global association, at the same time the sense of collectivity and commonality here becomes highly mediated, attenuated, impersonalized, strat-ified, impoverished.)

Visiting the United States in the 1830s, Tocqueville found boosterish and

speechifying Americans so full of partisan opinions that they seemed unable to engage in true conversation: "An American cannot converse; but he can certainly orate. He speaks to you as if he were addressing a meeting."[1] But the proliferation of voices and of openings for discussion in the various talk media today does not seem to have brought much improvement in the ability of a North American citizenry to open into dialogue with "other" voices expressing other visions. "We have lost our talent for conversation," observes legal theorist Stephen Carter,

> What argument is about today is waiting for your chance to show the other fellow that he is an idiot. Nobody says anymore what is a vital part of my creed: "I may disagree with what you say but I'll fight to the death for your right to say it." Instead, people say, "I disagree with what you say and you're a monster for having said it."[2]

While our mass media forums may have us talking more, then, actual dialogic interchange seems to be becoming dangerously rare, and many of the tendencies in 1990s "airwaves dialogues" seem only to exacerbate this sad situation. This is especially true of talk radio as it has been transformed by far-right voices such as Rush Limbaugh, G. Gordon Liddy, or Pat Buchanan, with its careful screening out of divergent voices and difficult questions; its increased stress on inflexible partisanship and demagogic, "mad as hell" invective; its ratings-driven urge toward expression of more and more shocking and sensationalistic opinions; its conscious use of the talk forum as a divisive force defining firm boundaries between "us" and "them"; and its need to please these aroused, lynch-mob crowds of supporters through more and more vicious and violent scapegoating of all those outside or opposed to the group—"Death penalty to this! Death penalty to that! Line 'em up and shoot 'em!"

In an increasingly pluralistic and multicultural world, though, we cannot (and should not) always avoid encounters with divergent voices. Mary Louise Pratt's "Arts of the Contact Zone," in this volume, proposes an alternative, genuinely dialogic model for understanding and taking advantage of the sites of meetings between cultures: "*Contact zones* are social spaces where cultures meet, clash, and grapple with each other, often in contexts of highly asymmetrical relations of power." But though we can imagine an ideal talk show that would frame itself as such a "contact zone," the "arts" that might help us to define heterogeneous public sites in which truly divergent voices could meet, exchange, and at least agree to disagree seem to be lacking in today's "talk media." These days, each time a well-intentioned government or network makes another attempt to set up a "cross-country dialogue" or a multivoiced "town meeting on the air," the main result is a spectacular shouting match between rival speechmakers, either rudely interrupting one another or talking over one another at cross purposes—providing us with yet another example of the collapse of contemporary possibilities for public conversation.

For Jürgen Habermas, who defined the perhaps utopian post-Enlightenment ideal of a modern "public sphere" in which citizens could meet as equals for free and rational discussion about civic issues, the advent of the television talk

show seemed the clearest evidence that such a site for collective dialogue is no longer available today: "The world fashioned by the mass media is a public sphere in appearance only."[3] But here again we must recognize that the contemporary talk media in fact speak for multiple and contradictory impulses. The TABLOID essays reprinted in this volume take "airwaves dialogue" as a classic example of the way in which mass cultural phenomena can tap into and speak for profound popular energies and desires, while also often channeling those energies and desires in unproductive, repressive or regressive directions. Analyzing the actual moment-by-moment workings of specific mass media conversations, Jean Franco and Mary Louise Pratt find a special fascination in highlighting the central place here of irrationality, of rude displays of arbitrary force, of struggles for power between divergent voices in situations of marked inequality, and show how foregrounding the dynamic of struggle inherent in the dialogue form and stressing inevitable moments of breakdown in the coherence of mass media talk can bring out a great potential here for new expression of popular resistance and liberation.

Of course any trend toward an expansion in forms of public dialogue can at first seem to have great liberatory potential; it seems to suggest an opening of the mass media for grass-roots debate, for pluralistic freedom, for participatory citizenship in the "conversation of the culture." And certainly one of the great attractions of talk radio, talk TV and the panel-discussion news shows is the way they have in fact worked to give new speaking parts to a whole array of divergent voices that had rarely been heard before—allowing at least some public representation to life experiences that had long been silenced, excluded, closeted, or simply ignored. Ellen Willis, for example, hails the populist potential in this democratization of the airwaves for its challenge to the would-be "elite authorites," pundits and schoolmarms on the left or the right who (following William Bennett) have now begun to attempt a censorious crackdown on the "people's pleasures" offered by Ricki Lake, Sally Jessy Raphael, et al.: "On talk shows, whatever their drawbacks, the proles get to talk."[4] This invasion of the realm of the spokesmen and experts is also celebrated by the C.U.N.Y. Mass Media Group: "the new talk shows . . . problematize the distinction between expert and audience, professional authority and layperson." Making conversation into a working-class street fight, the Morton Downey Jr. show at least provides a new forum for the voices of disenfranchised young white men: "Downey is trash television because he trashes middle-class university- and business-based expertise." In the C.U.N.Y. analysis, the Phil Donahue show— the first to put the "public" as studio audience in an active, protagonist's role by giving it voice and bringing it onto a spotlit center stage—must be recognized as having broken the ground for a crucial transformation in the discursive practices of our mass media public sphere.[5]

The essays presented here share this exhilaration with the ideal possibilities of the new talk media, but then also focus on a series of troubling questions about the current situation. Gibian's "Newspeak Meets Newstalk" asks: Has the boom in media dialogue in fact opened new avenues of democratic debate,

or has it finally become simply a new form of spectacle, simulating the process of political participation without enacting it? Does this change in discursive practices correlate with any decentralization in actual decision making? Has the introduction of some new voices involved any actual broadening (to the left or even to the center) in the range of views heard on the mainstream media? Has a newly active "public" begun to challenge the role of professional pundits, or has the boom in dialogue forms in fact led to a major consolidation of the power of a small group of opinion makers: talk show hosts and "star" reporters usually strongly connected to the political establishment? While the explosion of interest in the "talk media" certainly reflects a deep-seated popular desire for more fully active and democratic participation in public life, it may also finally stand as a gauge not of an increase in actual popular power but of the people's strongly felt powerlessness, voicelessness, and isolation.

Jean Franco's related concerns about the more ominous implications of these new talk media are developed through a close analysis of the dialogic interactions in one talk media form: call-in radio. In "Hello, You're on the Air," Franco calls up examples from her large collection of taped radio dialogues to describe the fluctuating dynamics of interchanges between callers and hosts as revealing, small-scale models of the fluctuating dynamics of "ideology at work" in a dysfunctional public sphere. Studying the mobile "economy" of social energies in these radio sessions, Franco shows how rude interruptions and brush-offs by radio hosts mirror the isolation and indifference of the larger marketplace, and how scapegoating mechanisms—the constant need to police the shifting boundaries of "sanity" and "normalcy" by excluding all voices and ideas that can be branded as "extreme" or "crazy"—play on a strong urge to belong among isolated callers. Never simply logical arguments or rational discussions, then, these late-night talk radio dialogues operate as irrational tools for the enforcement of group-think conformity.

Mary Louise Pratt's "No, She Really Loves Eggs" moves in even closer, applying techniques of "conversation analysis" to study, phrase by phrase, word by word, all that is involved in the micropractices and micropolitics of talk radio exchanges between callers and hosts. This sort of close, attentive analysis of the actual dynamics of specific talk media dialogues is much too rarely undertaken, and Pratt shows that it can have surprising results—defining a mode of study that really begins to capture the mingling of fascination, hilarity, and horror that is the talk radio experience for most callers and listeners. While the framing structure of call-in radio shows may dictate grossly oppressive relations between an authoritarian "emperor host" and a "supplicant caller," in its micropractices radio talk emerges as a highly mobile realm of improvisatory experiment, heterogeneity, randomness and disorder, and for Pratt this *lack* of fixity or cohesiveness offers some unexpected openings for new voices and new powers in spite of (and perhaps *because* of) the rude and ruthless rule of the talk show hosts.

Tracing the emergence of the forerunners of today's talk show forms, the essays presented here raise questions rather than provide answers. And now

that the talk media have taken center stage in our public life, these questions must be raised with a new urgency. Quite remarkably, the talk media explosion remains one of the great unexplored phenomena in contemporary mass culture; it has received almost no serious, sustained analysis since the formative period of the early 1980s. The following writings, then, are offered not as solutions but as provocative beginnings—raising questions, testing approaches, and framing a call for future analysis.

Notes

1. Alexis de Tocqueville, *Democracy in America*, ed. Richard D. Heffner (New York: New American Library, 1956), p. 109.
2. Stephen Carter, "Toward a Culture of Conversation," *Yale Alumni Magazine* 58:5 (March 1995): 29.
3. Jürgen Habermas, *The Structural Transformation of the Public Sphere*, Trans. Thomas Burger with Frederick Lawrence (Cambridge, MA: MIT Press, 1989), p. 171.
4. Ellen Willis, "Bring in the Noise," *The Nation* (1 April 1996): 23.
5. Paolo Carpagnano et al., "Chatter in the Age of Electronic Reproduction: Talk Television and the 'Public Mind,'" in *The Phantom Public Sphere*, ed. Bruce Robbins (Minneapolis: University of Minnesota Press, 1993), pp. 96, 118–19.

Newspeak Meets Newstalk

The Boom in Airwaves Dialogue

Peter Gibian

We can see now that Cronkite's departure represented more than the
end of an era. He represented the end of a certain way of broadcasting
the news.
 (Senior producer, network news, 1982)

Like the head of Orpheus (which sang in a new way after his body was
ritually dismembered and dispersed), our media's "talking head" (a tech-
term for the visually boring format that shows only a single speaking
face) seems to be dissolving, shattering, singing in a new mode.

He was a Monument in that desert with the silence far off; like the
godhead in a crypt ... he almost confiscated the right to express himself
from anyone who thinks, holds forth, and recounts ... and I believe that
[those other voices] waited respectfully for this giant ... to disappear, in
order to break away. The whole language ... is breaking loose, with a free
separation into a thousand simple elements.
 (S. Mallarmé, "Crise de vers," 1896)

Good place to get some thinking done
 (Talking Heads)

Maybe we're just starting to "hear things" in a buzz of airwaves overdose—too
much mass media, too closely observed, for too long—but ... these days we've
begun to sense a change in the way our tubes are speaking to us. Where we

This essay first appeared in TABLOID 7 *(winter 1983):*
14–26.

were used to static "talking heads" handing down The Word in monologue—
talking at us—we are increasingly hearing a wild multiplicity of voices, of
tones, of stances in dialogue, fighting for the floor, arguing about that Word—
talking all around us. Benign high priest Walter Cronkite's vacated seat of
authority seems to have been invaded by a murmuring Babel of tongues; the
calm old temple of truth seems to have become a brassy sort of bazaar, loud
with the sounds of competing cries.

What we're picking up here seem to be larger reverberations of what *Time*
and *Newsweek* have been celebrating as a "newstalk explosion," a "media
gabfest"—but on second thought the discovery leaves us as bewildered as
enthusiastic. Who would have believed, a few years ago, that the call-in talk

**"Monologue and dialogue cannot be so clearly, generically
distinguished in every case: one person can speak for many
views in many voices, and many people can speak for one
view in a single voice."**

show and the news-issue debate—the most raw, humble, primitive forms on
the air—would blossom forth as the hottest media formats for the 1980s, the
models for a wide range of programming now reaching us twenty-four hours a
day? And who can foresee where the audience hunger for voices in dialogue
may lead?

At first view, the potential here can be exhilarating to even the most cynical
among us. The boom in airwaves dialogue seems a wish fulfillment of some
deep idealism we all share—and that may begin to explain the sudden, sweep-
ing success of these new talk media forms. When network producers now talk
about "open-line broadcasting," "reality broadcasting," or about going "one on
one" with "provocative questions" from the "voices of the people," they know
we'll perk up: "The talk show format is a blue-chip format," says one station
manager (*Business Week*, June 15, 1981). When they title shows *Your Turn* and
People Talking Back, they know they're tapping into a strong audience
demand: as one CBC head put it, "Now the fashion is for a town-meeting sort
of journalism" (*Maclean's*, January 29, 1979).

But is the "newstalk explosion," then, just a surface change in format fash-
ions, a repackaging of the same old product, or is this a deeper trend, respond-
ing to major new directions in audience interest? Is America becoming again,
as it was in the early 1800s, a nation of talkers and stump orators, where excited
political debate is the biggest show in town, in the barroom, in the media—or
is this whole movement about as real as *Real People*?

Promises, Promises: A Debate About Dialogue

If the eruption of media dialogue was a turn-of-the-decade phenomenon, with

its first surge coming in the banner years 1979–80, maybe now we've had time to step back from the excitement of the initial promise, to take a closer look at the actual achievements after a few years of practice.

Certainly the change we sensed then was not illusory; some wide-ranging shift *is* taking place and should be noted. In the case studies that follow—surveying newstalk and call-in shows, TV courtrooms and sportscasts, interview forums and debates—we'll find a common movement: from one voice to many voices; from media-trained "pro" performers to at least a sprinkling of lay voices; from listener-as-student (passive at a lecture) to listener-as-eavesdropper (tuning in to the back-and-forth of other people's discussions, challenged to make a choice between these positions, or to call in with a personal response).

Of course any such trend toward dialogue easily touches a soft spot in our democratic hearts: it seems to open the media for grass-roots debate, for participatory citizenship in "town meetings of the air," for pluralistic freedom in the conversation of our culture. Some newstalk producers use these phrases; they talk about "the old democratic spirit of radio days," and want to recapture the excitement of radio's early boom years: the stunning impact of new direct access to live common voices from around the nation. So here our long-held populist ideal—the Studs Terkel oral history of real lives—would meet the technological dream of an open society based on a global system of interactive media. For most Americans, any mention of the word "dialogue" conjures the vision of a free, rational, nonauthoritarian mode of decision making. In fact, we usually use the phrase "open a dialogue" as a hopeful shorthand meaning "arrive at a solution."

But the phenomenon is not so clear-cut. With call-in and newstalk shows, the opening into media dialogues is not in itself a solution—though it may offer some rich starting points. The very term "dialogue" can be problematic at second glance. For one thing, monologue and dialogue cannot be so clearly, generically distinguished in every case: one person can speak for many views in many voices; and, as we will see in the following case studies, many people can speak for one view in a single voice. And Michel Foucault suggests another paradox in conversation. In his histories of psychoanalytic dialogues and of our discussions of sexuality, Foucault stresses the point that *more talk does not necessarily mean more freedom*: the more subjects we open to dialogue, the more areas of our lives we open to management, restructuring, and control—while at the same time we also multiply the possible points of resistance to that control. Is the 1980s turn to media dialogue an opening for new decentralized personal resistance and expression, or will it simply relocate older mechanisms of power in more subtle, personal, and localized arenas?

The dialogue form is not inherently a means of *avoiding* the power, dominance, and authority of monologue. In fact, it gains its interest and its charge as it brings these issues of power to the foreground, as it *enacts* them, so that we become more keenly attuned to their operation: in the verbal ebb and flow, we're very conscious of who has the floor, who asks the questions, who sets the vocabulary, the tone, the issues; who interrupts, who is silenced or excluded;

who gains through the irrational attractions of style, charisma, voice quality, media training; who feels the strong pull of conformity and consensus, the fear of ostracization; and so on.

If any decline in authority is implied in the 1980s rise of airwaves dialogue, it would seem to reflect a widespread loss of confidence in the "experts" whose predictions have failed so often in these chaotic times, and in the newspeak officers whose words have so often been contradicted by events. These days everyone has an opinion and wants to get it on the air; no voice can make any special claim to truth or insight. And so each question is now met by a panel of diverse interpreters in what seems an endless series of personal responses, even of personal languages. In such a context, any assertion of authority that *is* made is clearly a result not of rational persuasion but of rude force.

But does the striking garrulity of 1980s America, this sudden proliferation of talk and of opinions, correlate with any simultaneous increase in popular political power? With any decentralization of actual decision making? With any increase in voting? With any greater group knowledge of the issues? With any actual broadening of the range of views to be heard on mainstream media? With any new access for voices of opposition? With any increasing sense of closeness or understanding or intimacy among the speakers and listeners? With any evidence of improvements in peoples' abilities to communicate with one another in other areas of social life?

The NO answer that most observers would probably give to all of these questions suggests some of the ambiguity and complexity of this bizarre media shift. It is an eerie situation: we get a paradoxical picture of an imperial White House in unprecedented silence, refusing any dialogue with Congress, with the press, or with the voters, surrounded by an unprecedented talkativeness in an outpouring of airwaves opinions—voices which apprently carry as much weight as the air they travel on. The talk show is "a fabulous forum for people who feel somewhat impotent," observes one big-city news director (*Newsweek*, October 29, 1979). The newstalk explosion, then, may be a gauge not of popular power but of powerlessness and isolation, of the felt *need* for some new "forum." Does media dialogue open new avenues of democratic debate—or does it simply simulate the process of political participation without enacting it?

News issue debate clearly has a strong allure; several programmers think of it almost as an opiate. "People are becoming information junkies," says Michael Jackson, host of a hit four-hour morning talk show in Los Angeles. But the addictive attachment seems to be primarily to a particular show or station: "Once people listen, they tend to stay hooked," notes one station manager, happy with the audience loyalty that makes newstalk so attractive to advertisers (*Business Week*, June 15, 1981). So here a paradoxical picture arises of a close-knit airwaves community somehow formed of the most alienated and atomized of listeners—each alone in a car or living room. What do loyalty to a station or obsession with news information mean in other areas of people's lives?

All of these giant questions call for a closer look at the dynamics of specific shows. A quick sketch-survey of examples from the media mainstream may concretize some of the problems and the potential in this intriguing new field.

Where It All Started: Ted Koppel's "Iran Show"

The surprising success of ABC News Nightline was the spur to many of the recent changes in television formats. Ever since our strange obsession with the long-running "Iran Show" (so nicknamed because it was born as a "special report" discussion of the Iran crisis, but then stayed on as a fixture as that crisis continued, and the audience remained loyal), this Ted Koppel news-talk program has been giving Johnny Carson a run for the money at the 11:30 P.M. slot. Perhaps these two shows aren't totally dissimilar, but many people have been lured away from the rehearsed and rehashed Hollywood gossip and promos of The Tonight Show to a new kind of talk, surprised to find a more compelling electricity in news-issue debate, in a sort of television diplomacy where the issues are not solved, the speakers are not in agreement, and the speeches are not preplanned. Nightline brings us in for the moments when buzzwords and set pieces are unsettled. The tough question—quickly turning self-contradictions back on the speakers, getting beneath their guard, making them think on their feet—is the Koppel specialty that gives these dialogues their charge. In sudden flare-ups, sidestep maneuvers and head-to-head exchanges, we test the powers of articulation in speakers who are not professional performers (or at least are not entertainers). Though the attraction here has something in common with sports (in a contest of verbal gladiators) and with that of entertainment (the glamor of spotlights and popular recognition, the charisma of presentational style), the stakes here add something very different: a sense that history is not only being reported but is being made, that our agenda for the future is being set. We've learned a lot about how to listen to interviews with politicians (what they answer and what they don't; what's in the silences and between the lines) and on Nightline we begin to root for the advocate who'll puncture and probe. We're newly attuned to the soft points in official newspeak with a faint hope that they may be challenged; we place new value in the spokesperson who, suddenly granted a few unexpected minutes of airtime, eyes blinking under spotlights and pressure, can make our points with persuasive power. Maybe we move closer to becoming that spokesperson ourselves.

Nightline seems to be riding the crest of a large media movement from entertainment to news—a trend to the treatment of news as entertainment (and a trend making P.R. media training essential for more and more people: not only for actors and politicians, but for athletes, doctors, teachers, fire chiefs . . . anyone who wants to be spokesperson for anything). This high-tech entertainment gloss severely limits the openness of the Nightline debate. Serious foreign diplomats who stumble over English phrases will seem weak and silly next to slick, shallow Hollywood-style TV journalists delivering canned

speeches with great flair; and any speaker who lacks performing experience faces the same sort of problem. Not everyone speaks the *Nightline* common language with equal fluency. To succeed in this forum a speaker must make himself over; he must become an entertainer (photogenic, smooth); he must speak strong English (a significant exclusion of foreigners and many Americans), and to be convincing he should develop the very special media version of "good old American" speech: not too intellectual, highfalutin' or abstract; not too angry or "fanatical"; not too boring or earnest; and so on. So it will be rare that the alternative views of those out of power, without media training, will be able to match the overwhelmingly conservative slate of ABC interviewers and panelists, with their distinct home field advantage. But still, the very fact that some new voices are now getting occasional first tries before a large public is a hidden benefit of the dialogue format—which thrives on controversy and so must seek out opposition.

Donahue: The Lure of Group Psychodrama

And *Nightline* is certainly not alone in this boom in dialogue/controversy. While Koppel's debates are invading Carson's old night-hour territory, Phil Donahue's wild-and-woolly discussion sessions (a more open forum than *Nightline*) have taken a firm hold in the midmorning, which had been the realm of game shows and soaps. Mining the heat of debate engagements and disagreements, women's issues, and spontaneous eruptions from a loud, active and (significantly) now very visible audience (with even call-in viewers becoming part of the show)—all the live, raw elements that had been ignored by earlier daytime small-talk shows—Donahue brought a populist crusading fervor to the format, a passion that could transform current-events chatter into a sort of group psychodrama. In newstalk's boom year of 1979, Donahue's nonnetwork morning show actually passed Carson in the ratings. ABC recognized the continued attraction of Donahue's form, and its relation to their own newstalk experiments, when in the fall of 1982 they brought him in for a new nightly version of his show, *The Last Word*, to follow the *Nightline* debates. So the pioneers have been brought together in the scramble for claims in television's new frontier—the wide-open field created by the expansion of late-night programming and the shift to news-issue formats in those hours. Making Koppel and Donahue a team, ABC wants to stake out a large parcel of the old Carson domain; but their hold is sure to be challenged soon by many other snooze-news talk teams now in formation.

TV Sports and the *Crowd Effect*: To the Verbal Arena

Even television sports programming now involves a strong infusion of these new talk elements. To a degree that amazes those of us who remember the spare single-announcer game format and the advent of the earliest postgame

interviews, the action of each athletic event is now surrounded by a widening frame of debates and question sessions. Because ABC's Roone Arledge presided over many of these decisive format experiments in both sportscasting and news (recognizing his success with sports, the network shifted Arledge a few years ago to revitalize their news), it is not surprising that these fields are developing along parallel lines, moving closer together—so that Nightline has the feel of a heavyweight boxing match while big weekend games become big "news," on the same pages with battles between nations.

Shows such as Howard Cosell's Sportsbeat point up the way that attention can shift completely to a verbal "arena" where our sports heroes fight it out in words, and where sports is inevitably linked with political issues: nationalistic maneuvering and terrorism at the Olympics or Wimbledon, player strikes in baseball and football, player-owner disputes, strategy debates, and so on. And even if our first love is the sports action itself, we have to admit a fascination with the talk that has become its frame: we always stay or even lean closer to hear how an embattled player articulates his position; how an owner can react to defeat; how a tired, elated boxer speaks about his showing, or brags about his future. (Ali, especially, made talk and controversy one of the key parts of the "fight.") Even the increasing corps of voice-over announcers during games has become self-consciously "dialogic" for most events (most clearly with the "party" feel of Monday Night Football), so now we watch each game to a continuous verbal background hum—from a striking diversity of voices: contrasting attitudes (some singing, some joking, some pontificating), various specialities, and even the widest possible range of national, racial, and regional accents. (As a sign of how far we've gone in this direction, we are shocked when we get an occasional feed of a British broadcast of a tennis match or soccer game and are met with long expanses of silence.) Sometimes these TV sports conversations, sideline interviews, retorts, cheers, and comments are quite successful as a small simulacrum of the atmosphere of a larger live crowd—we can almost feel that we're squished in on a tight bench with a loud, diverse, and even at times knowledgeable bunch of fans.

More and more, we seem to turn to the airwaves for our communal experiences with large groups of people. Maybe the multiplicity of voices reporting today's sports reflects an urge to experience that wild crowd feeling without sacrificing the safety and comforts of the private home—bringing the full life of the stadium back to the armchair in the den, re-creating it in a verbal arena. Certainly the many sports-talk programs currently on call-in radio point to another way that dialogue about sports can form a new sort of airwaves community—and to the way that the importance of the sports event can fade before the demands of talk and of community. Some people really open up only when they can meet others on the common ground of sports talk. Sports-talk shows in the mass media, then, build strong bonds of intimacy as they bring trivia nuts and barroom debaters together in a new forum for which there has apparently been a great need.

The Frames Take Center Stage: TV News and Round Tables

Of course, the verbal forum has been developing in many other areas at the same time. The most obvious and basic expansion of media talk has come with the general boom in newstalk and news magazine programs on both radio and TV. Before and after workdays, in the full range of commuter periods, and through a lengthy bedtime, the old news slots have been growing and growing. Shows that were "frames" to other programming have almost usurped the entire schedule, to the point that sometimes on AM radio, music seems to have been given over totally to a nonstop flow of words: more and more, we hear, "All Talk, All the Time." Now whole radio and television networks are devoted solely to varieties of newstalk, testifying to our voracious new appetite for voices in dialogue.

When AM radio stations found that FM (offering better sound quality) had taken over music audiences, they made a desperate switch to the spoken word as their domain—and found themselves with a surprisingly hot product. By 1979–80, network executives were convinced, and ordered large-scale conversions to talk. "Radio's self-help era" began with the hiring of psychics, psychologists, real estate experts, sex therapists, auto mechanics, and so on, to lead endless discussion sessions with an expanding and avid audience. In the same years, cable TV systems were challenging the three old networks with twenty-four-hour programming, forcing the networks to battle back with a strong stress on newstalk. By 1982, this "video information boom" had all three networks offering twenty-four-hour broadcasting—with news shows (including many varieties of late-night newstalk) for nearly half of those hours.

The half-hour dinnertime TV news shows, both national and local, reflect the larger trend to dialogue in subtle format shifts: they try to use their satellite screens to set up long-distance "conversations"; anchorpeople now ask questions of their field reporters to try to attempt some live spontaneity after the set spiel is over; correspondents don't just accept each other's monologues but try to talk between reports, joking or challenging facts, asking for up-to-the-minute personal evaluations ("but what is the mood there now?"). Such attempts to bring some give-and-take to the "talking heads" news headline format are often ridiculously feeble and shallow; they simply point up more clearly the limits of that rigid form. The weekend interview shows (such as *Meet the Press*) offer more room for change in this direction, and they have been changed and greatly expanded. We see that, for example, ABC's program now places the guest who is "facing the nation" right in among the circle of wisecracking, fast-talking journalists, allowing more interruptions and challenges, avoiding set speeches in favor of conversation—and then finally inviting more newspeople (for what is supposed to be a more diverse range of viewpoints) in for what is aptly called a "Free-for-all Discussion" after the guest "authority" is gone. The newest element of the weekend format, these "Free-for-all" periods allow for strong disagreements, irreverent repartee, and more extreme opinions in

the wilder, less polite form of dialogue that comes as a brief holiday release after the "respected visitor" has left the room. These periods are a clear sign of the times.

A Celebration of the Telephone: "As It Happens"

The granddaddy of all of today's experiments in airwaves dialogue, satellite conversation, call-in radio, etc., may be the Canadian Public Radio broadcast "As It Happens," which Americans can hear in all its refreshing simplicity on our PBS radio. While it is the acknowledged model for many of the newest programs—NPR's "All Things Considered" is just one of many clones, and NPR's popular "Car Talk" actually has very much its interest and atmosphere—"As It Happens" achieved its impact by returning to the oldest roots of talk radio: it wants to bring back the plain thrill that kept the first radio listeners leaning into their crackly sets for new close contact with a diverse range of national and international voices; and, like other more recent CBC specials, it is clearly modeled on the old "open-line" shows for farmers (such as "Farm Forum" and "Citizen's Forum") that not long ago served as a sort of folksy town meeting on the sparsely populated prairies. "As It Happens" is a celebration of the telephone, and of the global network of lines that now mean that a reporter who is nosy, pushy, and resourceful enough can talk to anyone in the world. Unlike call-*in* shows, which usually gather the voices of localized listeners, "As It Happens" works many unbelievable feats of call-*out* radio: during the late 1970s Beirut crisis, for example, its reporters called the PLO headquarters, the State Department, and also just a randomly chosen bar in West Beirut, and then talked to whomever first picked up the phone. Avoiding direct news-event summaries and official newspeak non-statements, "As It Happens" reporters seek out a variety of voices, firsthand or off-the-cuff responses, and can be humorous, irreverent, or confrontational in drawing speakers out. The show seems, in fact, to stress vocal diversity, regional humor and accents, and local color over the global headlines. The reporters are as likely to speak with a Montana farmer about his new buffalo-chip ashtrays as with an economist about his indicators on the depression. The final honor, though, goes not to any individual but to the radio-phone lines themselves, the system that links all those distinct regions to help us talk as a larger community.

People's Court and the Trend to "Reality Programming"

A much more primitive, raw access to the life stories of nonperformers, to lay voices, comes with the "live" broadcast of actual small-claims trials, as on *People's Court*. Produced by the same man who gave us *This Is Your Life* (the *Real People* of the 1950s), *People's Court* began in 1981 as part of that fall's obsession with what is called "reality programming" (producing a whole barrage of shows with the words "People" or "Real" in their titles; and the NBC

pilot *Wedding Day*—actual marriages performed to game-show-style fanfare). But this show was distinguished by its tough approach to such material, and by its strong emphasis on talk. *People's Court* seems to want to prepare average Americans for an era in which more and more aspects of life involve litigation, to teach them how to litigate for themselves. It's really sort of a streetwise message, too, warning inarticulate people that they need to learn to tell their stories, to speak up for their interests; it's a verbal battleground out there, and he who stumbles over his words will stumble in life. The final refrain is always: "Don't you take the law into your own hands; you take them to court"—with the implication that to take them to court *is* the best way to take the law into your own hands, to manipulate it to your needs.

Of course, any court scene has authoritarian overtones, but the judge here is placed in a bizarre role like that of a call-in radio host. So *People's Court* becomes a funny example of what happens to "authority" when it enters the arena of conversation, of how that "authority" is compromised or transformed by even the most bald and basic introduction of vocal multiplicity, of nonprofessional speakers in dialogue. The judge here is close to the litigant/storytellers. He talks their jargon and pushes for more easy, conversational exchanges. He chats familiarly, he jokes, and when he *does* admonish, it's in a blunt, personal street voice. This authority enters into persuasion and dialogue, with a haggling tone like that of the New York street signs that read: "Littering is filthy and selfish so don't do it." (To resolve all argumentative complexity in an impersonal decision, the judge has to leave the room during an ad break; he has to break away from his old self, into silence, before he can conjure up his magic final Word.)

But while the judge appears to be trying to teach people about "evidence," about how to narrate convincingly, about the fact that justice is based not on some abstract truth but on persuasive power and probability, the large television audience for this new kind of show is more interested in the original life stories and voices than in their resolution into legal dicta. Like listeners to the call-in show "Now Is That True?" (see an analysis of this show in Mary Louise Pratt's essay, "No, She Really Loves Eggs," in this volume), we are more interested in the color and power of the "performances" than in their final truths, and in the complexity and ambiguity—the untidy back and forth—of everyday life problems than in any one-sided reductive judgment. It may be misleading to ask us to wish that, if we would get our arguments and evidence together, they will be heard and justice served. But it is not a bad idea to get our arguments together, and on dialogue shows such as *People's Court* at least they are *heard*.

Letters to the Editor: The Future?

People's Court and the *Donahue* show until recently were as close as mainstream television came to a call-in radio feel. (*Donahue* actually does take calls; some local TV programs now highlight dial-in access; *PBS Latenight*

appears now to be having a great success in attracting viewers to its national late-night call-in sessions; and ABC's new *The Last Word* is hoping to get on that bandwagon.) But the expansion of dialogue forms may also open other avenues for other new voices that want to be heard. Maybe one day, for example, the realm of the rebuttal to a station's editorials could become a lively segment after the news. It seems unlikely that stations would welcome a larger response to their lip-service invitations to air "opposing views from responsible parties," but then again . . . if technically proficient and innovative opponents were to break down the boring, anachronistic, rigor-mortis "talking head" format with powerful new forms of argument (and with speakers who give the impression of being alive), the stations' management teams might be gratified to find a burst of audience interest in what was certainly the sleepiest part of their schedule. No matter what their ideology, program managers find it hard to argue against ratings. If a true, ongoing, back-and-forth of views emerged in "news editorial" segments, these thirty-second spots might become as much of a draw as the letters to the editor, which are often the most vital and first-read parts of a magazine or newspaper.

As Richard Ohmann pointed out during a visit to *TABLOID*, another potential opening for new voices in media debate is the space given over to free "public service announcements" required on each channel. These spots need not be monopolized, as they are now, by the Ad Council, whose distinct ideological line is disseminated in tepid, beer-run ads; some explorers are beginning to try to distribute alternative PSAs. And if these examples of possible new directions seem odd, limited, unlikely to lead anywhere, remember: all the other examples of the eruption of airwaves dialogue show that stranger things have happened; other equally lifeless genres and segments have only lately become newly vital.

So You Think You've Got Troubles: Retorts ad Absurdum

No mass media genre stays the same for long. Even the strange process of quickie proliferation and rip-off imitation often leads to unexpected new turns. Some very recent dialogue formats have shown again the bizarre tendency of mercurial popular forms to develop as their own best retort, or their own *reductio ad absurdum*.

One show, for example, was so uncanny and hilarious that we can't quite believe we really saw it. (It may be a brilliantly crafted and acted comedy sketch rather than a pure live show, but it certainly does exist—we've even seen it in rerun). It reflects all the talk-show elements, but as they might appear in a carnival's distorting mirror. Titled *So You Think You've Got Troubles*, this program parodies our age's "self-help" radio by placing caricatured call-in talk intimacy in a jazzy game-show setting. The role of talk-show host is taken by a ventriloquist and his dummy, whose weird internal debates call up unsettling images of the dissolution of identity. The host here does not stand apart in

imperial detachment from his show's dialogue but, on the contrary, becomes in his squabbles with his dummy a model of the self *as* dialogue—as a dialogue full of misunderstandings, rebellions, and rude retorts. The show's mode has permeated him to the core. After all the puppet's smart back talk and wordplay, it's not clear who's the "dummy" or who's in control. The puppet's blunt remarks seem to spring up like an irrepressible jack-in-the-box from the host's id; but his rudeness is also only a slight exaggeration of the wild, irrational comments heard everyday from the hosts on talk radio and talk TV.

Guests on this program—in a caricature of the "I am a victim" mode of "top this" confessional coming to the fore in some daytime TV talk shows—narrate their troubles to this host and to a panel of experts who reflect the dissolution of authoritative expertise with the rise of dialogue forms. The solutions of the three experts—a minister, a pop-psychology counselor, and a handwriting analyst—are simply juxtaposed: no one knows best. And in fact the guest is not asked to choose what seems personally the best solution to his or her problem but, in a move very indicative of the final message of many airwaves dialogues, gets prizes for guessing which solution the studio *audience* liked most—for falling in with the only authority left: the majority consensus.

On the particular show we saw, the tales of trouble of the day's two contestant/guests also cut to the heart of some other issues we've seen as central to all talk shows: the problematic confusions of public and private domains, the mixing of "real people" and media professionals. One woman—called a man-hating "Supreme Amazon" by the dummy—feels superior to everyone but is afraid to leave her house. In wonderful paradoxes, she then goes on national TV to speak about her fear of crowds, and she inflates her ego by this public recital of her private weakness. The second contestant's trouble is that he's a Ronald Reagan lookalike (again the dialogue comes upon problems of self-doubling). This man is a lay person whose life has been invaded by the demands of media performance. His wife wants him to stop, but he can't go home again. So he steps into the spotlights once again to make a polished, moving presentation of his strange case. . .

Last Laugh on *The Last Word*

Not all the revealing moments in recent airwaves dialogues are so self-conscious, so scripted, or so out of the way. Most arise out of unintentional mistakes or sudden, unusual challenges that set everything on edge and send the medium back for a closer look at itself. (Mary Louise Pratt's essay, "No, She Really Loves Eggs," in this volume, finds that the breakdowns and excesses of call-in radio hosts create openings for charged new expression.) These are the moments most of us wait for.

The very rough, unsuccessful beginnings of *The Last Word*, for example, have often been interesting for their failures, exposing the limits of the dialogue form. The attempt here to do a whole *Donahue* show in less than fifteen minutes makes for a better parody than could be done on *Saturday Night Live*.

In this helter-skelter, speeded-up version, the guest's issues-oriented discussion is almost completely crowded out by interruptions and rudeness, and audience participation becomes perfunctory at best (making us wonder why they even bother to cart all those people into the studio). The chosen topics exploit a *National Enquirer* sensationalism that had always been latent in the morning *Donahue* show, and Donahue becomes an eerie caricature of himself: the wild rush makes him exaggerate his hyper and histrionic movements across the floor, his melodramatic theatricality, and his self-righteousness; wielding his mike in manic romps through the studio, he appears power-mad, dangerous.

Then, on the second part of *The Last Word*, Greg Jackson's mass-audience call-in format has its own problems. Actual phone calls with viewers here are few and empty (callers can only ask questions) because the lip-service goals of treating serious issues and hearing from listeners are given over to fawning interest in media-trained stars. (This was clear in the first week, when the show had a nuclear freeze debate—between Paul Newman and Charlton Heston.)

But on the day after the elections, when Jane Fonda and Tom Hayden were the guests, these aspects of Jackson's show were challenged so effectively that the story made the next day's papers. This was one of those moments when the dialogue form worked; it became a real struggle, and the format itself became the subject in question. Of course these two were invited because of their celebrity status, but they worked well as a team—one a star, one a "real person" with issues on his mind—to use and to subvert the "double" demands of media dialogue. Each time Jackson asked one of his crass questions about money and movie stars, Fonda would interrupt him with laughter and ask why the media were so stuck on such yellow-journalism topics—thus opening a space for Hayden to go on at unusual length, in unpolished earnestness, about ideas on his agenda. So Fonda used her photogenic appeal, her ease with the camera, her star status, to ridicule the dialogue format for its preoccupation with those very qualities. And later newspaper reports revealed that the pair had used another weapon to disarm the interviewer: they'd come close to walking off the set in midshow. The equivalent of hanging up on a talk-radio host, this is the strongest card that can be played against a rigid format that gives the host such overwhelming power. Sometimes we're glad to see a reporter challenge a politician who ducks his questions, but Hayden and Fonda stressed the other side of the media dialogue, the ways in which the questioner's role can also be oppressive: he alone chooses the issues, sets the tone, implies the perspective. By the end of this particular show, Hayden had turned the tables. Now he was the one asking the questions, and for once the host had to respond. Jackson was asked about the rigidity and shallowness of his format, and then about his career and life goals. In a rare access of genuine talk, this "Last Word" ended with a movingly candid and confessional host musing about his age, his thwarted aspirations, and the problems of being a media professional. While this episode pointed up the poverty of airwaves dialogue, it also exposed and exploited rich points of resistance inherent in this new media form.

A Phase of Dispersion: Raising Questions for the Future

What do we make, finally, of our era's proliferation of forms of airwaves dialogue? Well, first of all, it reminds us again that many longtime media critics are not really looking at—or are not participating in—what they are trying to describe. At several media conferences where the *TABLOID* group has appeared as a sort of "panel," we've been startled to hear some "experts" still talking about the airwaves as a monolith sending us propagandistic messages in monologue, talking at us, manipulating us like puppets, or about television as a boob tube that stifles audience thought, eliminating all choice and leaving no room for response. These same voices usually also repeat the old clichés about a few lookalike networks monopolizing the air—when actually we're beginning to see the emergence of a multiplicity of specialized cable channels that will challenge the old giants, and the first growth of interactive video mechanisms that may soon allow much more viewer choice and make each TV set capable of much more active response. Clearly the airwaves themselves are entering a phase of dispersion, becoming a sort of bazaar, opening into a free-for-all of voices competing for our interests. And though this may well be only a transitional phase, heralding some new and more ominous consolidation, the old vocabulary of monolithic determinism is plainly inadequate to deal with such developments.

The same is true for the format of individual shows. When we are looking at movements toward dialogue in a broad range of current programming, the old diatribes about oppressive one-way monologue are not enough—they don't begin to approach the actual dynamics of these complex media forms. *TABLOID* can offer no pat answers to replace those tired truisms; we're only just beginning to explore this intriguing area. But perhaps, at this point, as steps toward a more adequate response, we might offer a series of questions we continue to ask ourselves—questions that reflect our own inner debate on these issues.

Most basically, we wonder, for the individual shows as for the airwaves themselves, whether the opening into a multiplicity of voices will mean greater freedom or a new consolidation? In what senses is this airwaves dialogue an "open form"? Is there something inherent in conversational structure that situates an "eavesdropping" listener in a less passive role, allowing more entries for active mental or vocal participation, more freedom of thought? And does the mainstream media dialogue in fact give access to a wider range of views, or does it merely give a surface sense of openness and diversity to the same old spectrum of opinions? (How free is an ABC "Free-for-all" discussion when the slate of guests includes only rabid-to-moderate conservatives? Why is the most ideologically conservative network the leader in many areas of experiment with dialogue? What difference does the token racial or sexual diversity of local news anchor teams really make?)

Are the primitive dialogue forms surveyed here the first murmurs of a Studs

Terkel oral history dream come true, a newly democratic and pluralistic involvement of the true "voices of America," or is this just a fad of repackaging? And how have the voices of "nonperformers" fared in these public, broadcast conversations? How much power does a lone call-in voice have against a loud host with an itchy finger on the cutoff button? When newstalk becomes big media entertainment, can stumbling, sincere, and emotional novices stand up against the smooth style of performer-hosts, journalists, and politicians? What will media access *do* to these voices that have been silent for so long? Will they be warped, stifled, or compromised in these confrontations in the spotlight? And what changes or accommodations can they or should they make, to take advantage of these newly proffered chances for *power in articulation?*

All of these questions call for a closer look at how specific talk shows on TV and radio work. We need to follow the experiences of speakers and of listeners, moment by moment, through a variety of conversation structures. And the interactions *between* speakers, or *between* diverse speakers and an active unaligned audience, can of course be much more sensitively gauged through models that come out of "conversation analysis"—based in sociology, discourse theory, and some schools of literary and philosophical study that stress the dynamics of dialogue—rather than through a concentration on monologue.

Afterword

The Silent White House—A Contrast and Frame

It is interesting to note in closing that the Reagan camp has staked out a position solidly against the grain of these movements toward a more "free-for-all" talk format. Once again, the Cowboy Communicator is fighting a Last Stand for something out of a rather distant past.

Clearly, the dialogue is Reagan's Achilles heel, and the press conference is his nightmare enemy. He has given significantly fewer press conferences than any recent presidents; in fact, one of his first acts once he was in power was to make revealing alterations in the press conference format: he sought to tame reporters by ordering them to be seated, and then established a separate imperial entrance for himself, increasing his symbolic distance from what had previously seemed to be a somewhat raucous, bustling marketplace of ideas. He now preselects the questioners, in order to silence the undignified bazaar-like screaming for recognition that used to come after each answer, to avoid the spontaneity and diversity of real audience response, and thus to reward reporters who have asked friendly questions in the past. Compared to the crowd of standing, shoving newspeople that surrounded Carter as he emerged from among them, the Reagan press corps is closer to a military corps—in dress review. With assigned reporters asking assigned questions surrounded by reverent silence, these sessions now have the feel of a rubber-stamp regal audience.

Reagan was supposed to be a folksy populist, but this new press format sets him up as a Sun King: his emphasis is on courtly decorum and "the proper respect," on taming the wild diversity of voices out there, on standing above them. Though he is supposed to be against "regulation" (of course we all know he only wanted government "off the backs" of big businesses and property owners), Reagan's impulse in the verbal realm was immediately to strengthen the Laws and Rules of Order, to silence and control any opposition. And though he was supposed to be a "great communicator," he has proved unable to speak without his Teleprompter or his note cards, and the biggest fear of his strategists and packagers has always been that he might one day get drawn into conversational exchange and depart from his canned speeches—that he might one day really talk.

Because they have denied dialogue, and thus bottled up voices that feel a mounting pressure to speak, the Reagan camp has been met with an unusual number of rude, loud, unexpected interruptions in its controlled format. But the press rarely reports the content of these outbursts, focusing rather on the lack of manners and respect shown by these "guests"—they've apparently taken quickly to the strange and anachronistic etiquette dictated by the silent Reagan White House.

Hello, You're on the Air

Talk Radio's Fluctuating Economy, Community, and Ideology

Jean Franco

The new media are egalitarian in structure. Anyone can take part in them by a simple switching process. . . . Potentially, the new media do away with all the educational privileges and thereby with the cultural monopoly of the bourgeois intelligentsia. This is one of the reasons for the intelligentsia's resentment against the new industry.

 (Hans Magnus Enzenberger, "Constituents of a Theory of the Media," *The Consciousness Industry*)

Do the media's various genres and formats, which divide up "the public" into fragments and partition off different areas of knowledge, do anything other than reproduce social divisions intrinsic to bourgeois society?

 (Armand Mattelart, *Mass Media, Ideologies and the Revolutionary Movement*)

Critics who believe that the media have deprived people of their voice often imagine an alternative of magical mass participation. The "people" will be transformed into cultural producers. No longer passive receivers of media messages, they will busy themselves in nonstop communication. Curiously these critics don't hear what is within earshot or pay attention to a form of participation that already exists—the radio talk show.

You're on the air.

Compared to the lavish attention given to television, radio has attracted very little comment, and talk shows practically none at all. Yet there's hardly a minute of the day when you can't call into some program or other to ask for advice, give advice, make a public confession or talk about yourself and the

This essay first appeared in TABLOID 5 *(winter 1982):* 15–23.

government. Ronald Reagan called a talk show in Texas when he wanted to give his economic policy an airing. In *Private Benjamin* Goldie Hawn phones into a talk show for advice and gets recruited into the Army. Do you want to set someone straight on the ERA, or tell the caller before last what you think of his damn fool ideas? Do you want to tell someone about the funny thing that happened on the way to your honeymoon or get advice about acne? Call in. You might have to wait for an hour and a half before you get on the air, and you have to go through a producer who screens what you have to say—all of which rules out the spontaneous overflow of powerful feeling, but is good for slow burners and patient watchers in the night. Let's face it, there's a hell of lot of us around.

"At a moment when political decisions are increasingly being reserved for the experts, the talk show remains one area in which it is legitimate and good to have opinions even when you know nothing at all about whatever it is you're talking about."

The whole country is blanketed with talk. There are hundreds of talk shows going on at any moment in the United States, some of them for twenty-four hours a day. You'd need a thousand years to get a balanced view of it all. Radio talk is as varied as talk itself.

> KGO's midnight-to-dawn audience outdistances most other stations' overall performance. What does that mean to you as an advertiser? I'll tell you. Our listeners tonight are your customers tomorrow. If you enjoy playing "Everything Is Coming Up Roses" on the cash register, this is the place to write the music. (Russ Coughlan, KGO, San Francisco)

Radio talk defies statistics, too. How can you tell who's listening or when? Or how many? Listeners are always changing, always on the move, always being cut off or switching stations. After all, talk shows came in during the '60s at the height of television prime-time compulsive watching when radio was supposed to curl up and die. Instead radio reached places that television couldn't get to— the inside of cars, the workbench, the counter—and many of the best talk shows were late at night when television had closed down or was showing old movies. If there's a classic place for listening to talk shows, it is driving long distances at night, or when you're waiting for the traffic lights to change at rush hour.

OK. The light's red, you're waiting for the green arrow, and here's someone calling in to KGO worried, of all things, about *dichotomies*.

> Now to my belief, dichotomies began in the Garden of Eden. As a Believer, I have

decided that nuclear bombs and dichotomies, although scientific, they're not good, Russ.

Anyway, have a nice day tomorrow.

As you wait in the supermarket, you hear an anxious voice from a transistor.

No, that's the problem. Poland's not allowed in.

Oh, OK.

No, no, no. That's the whole point—that Poland's not allowed in. We should quit playing politics with people's lives.

Commercial Break

Snatches of rap. This kind of listening appeals to those of us who creep after tour groups in museums, eavesdropping on their conversations. It's the ear's equivalent to the keyhole. It's rap rhythm. You can almost dance to it. Rap records use heated-up talk shows. And they're better than muzak.

Rap snatches are like subauditory appetizers that make you ready for a whole show. That's when you sit down and listen to the people who call in. You begin to recognize regulars who have preferences for certain talk shows and the patience to hold the line at 2 A.M. In public broadcasting call-ins, all the callers seem to be regulars, thus enhancing the impression of a cozy club. But the true talk-show audience is composed of invalids, insomniacs, and verbal exhibitionists such as the people who call Bill Bassett in San Diego with their sex talk. Bill's gravelly voice has the effect of making every conversation into a seduction scene.

Haven't we talked before?

No, this is my first time.

You don't sound terrified at all, my darling. Are you married, pumpkin?

Listening to Bill Bassett is like hearing public confession, and he does not fail to remind his listeners that they can be heard all over southern California. Callers give their first names (which can easily be fictional), but they also have both the anonymity of the confessional and the publicity of an exhibitionist.

The regulars are mostly night people. On KGO in the Bay Area, there is a dividing line between day shows and night shows. Day shows are often advice shows. The hosts invite guests. X-spurts, as one woman caller called them: "X is an unknown quantity, and spurt is simply a drip under pressure." Well, so the X-spurts—astrologers, psychics, human relations counselors, politicians, and sex therapists, but also vets, real estate agents, carpenters, and car repairmen—attract a lot of calls. But this kind of show simply duplicates the communication of knowledge in society at large, carrying out the transmission and acquisition of techniques that enable people to deal with cars, manage bank

accounts and human relations, preferably by using the same devices. The rules for all categories are the same: look after your property, give it a regular check-up, proceed in an orderly way, and don't rush into anything without taking professional advice.

The real talk show, however, is quite different. It is a free-flow affair with Jim Eason or Russ Coughlan quoting something they read in the paper or sounding off about bureaucracy or the medfly. The calls come rolling in the minute their shift starts. This is public opinion in the raw, the absolute contrast to the "expert." And best of all, it is mostly political talk. At a moment when political decisions are increasingly being reserved for the experts (e.g., MX missile sites), the talk show remains one area in which it is legitimate and good to have opinions even when you know nothing at all about whatever it is you're talking about.

Keep on jogging, I'll be back . . .

Commercial Break

"You're a mature adult lady, and I can tell that by your voice." (Russ Coughlan on KGO)

The talk show recognizes the supremacy of the expert, then, but at the same time and especially at night, it also accommodates that public opinion that just floats around without any party or institution to accommodate it. Opinion is, by definition, not informed or specialized, and information must not be allowed to get in its way. Whereas conversation with the expert is unequal — the caller is asking for guidance — the free-flow talk show starts from the assumption that everyone is entitled to an opinion. The host must give the impression that other people's opinions are as legitimate as his own. He can't lecture from an obvious position of superiority; he can only argue from sources that are available to everybody — newspapers, television, radio news. So at the very least, talk shows are good ways of gauging what opinions are around at any time. Of course there is endless confusion and misquotation. That is why the predominant tone of the talk-show host (almost invariably male in the political talk shows) is emphatic and assertive, especially when he is on shaky ground. Talk shows are not about hard facts. They are about holding and defending opinions. What you are testing when you call is not the truth of your information, the validity of experience, or even your grasp on reality, but the ability to hold your own. That's why the talk show host can't afford to be consistent. If the callers are against gun control, he leans toward it. Russ Coughlan believes as a matter of principle in going whichever way the wind blows:

> It has a lot to do with societal pressures at the time, and I think what society ought to do and what we ought to do is to adjust to whatever the condition is at the time. There might be a lot of times we ought to be right-wing. There might be a lot of times when you say, "I have a Barry Goldwater attitude to that thing, and we ought to go in with 8 million bombers," and then there's another time when you're going

to say, "What! You're going to take food from poor people!" And what we can't do is to get so constricted in our thinking that we're not able to change as the condition of the time changes.

Women rarely host political talk shows, perhaps because they often tend to be too deferential to the listeners. You have to be both patient and abrasive to make it work. KGO in the Bay Area runs twenty-four hours of talk, much of it free flow, and has a regular team that includes Owen Spann, Jim Eason, Ray Taliaferro, and Russ Coughlan. They each have their different styles. Eason is the bullyboy, a "quasi-libertarian" according to his own description of himself. Taliaferro is a more liberal counterpart, but inclined to be too brusque with callers: "Thank you so much for your call" is out of his mouth even before the listener has caught a breath. Russ, on the other hand, lets talkers go on and on. He's on the night shift from 11 till 1 A.M., when lonely people begin to feel their loneliness.

> I don't make a million and a half a year like that phony left-fielder for the Yankees who catches three fly balls a night. I sit here three hours a night, five nights a week — fifteen hours, listening to you insane people talk to me.

Commercial Break

The host has advantages over the listeners. He has a producer who screens calls. He can use a bleeper to eliminate obscenities. He has a sheaf of newsclips to back up whatever line he wants to plug on that particular show. But the important thing is that his information comes from sources that are available to everybody — newspapers, popular TV shows, and radio news flashes. If you have ever had the feeling that the left is out of touch with what people think, you should listen to one of the talk shows — precisely because they are a barometer not of the accuracy or detail of public information, but of the mobile grounds of common knowledge. Here, for instance, is Russ brazening out his ignorance of Irish history with a caller with an Irish accent who has challenged him to explain what he means when he says that there are two IRAs:

> Well the IRA was originally formed to fight, as I recall, the Black and Tans during the Black and Tan times of the English in Ireland. They were a revolutionary organization to fight that kind of oppression by the British. The IRA grew and grew and all of a sudden in the later years as more young people came into it with different political ideas there was an arm or group of people within the IRA that were Marxists, avowed Marxists because they wanted a revolution, you know, because of their Marxist attitudes and not because of the original idea that the IRA was formed for. And on the basis of that the IRA withdrew from that militant group and formed the provisional IRA and a Marxist group which is the IRA which is running around throwing the bombs and starving themselves to death in prison are based upon the Marxist lot.

Well, of course this is quite wrong as history. It has more the air of a fairy tale. The IRA, like Jack's beanstalk, just grew and grew and grew. And Russ has mixed up the non-Marxist left, which has a militant wing (the Provos), with quite a different group, the INLA, the Irish National Liberation Army.

The point of all this is not to show that the talk show host is mistaken — you could spend a lifetime correcting just one evening's errors — but rather to show how this demonstrates the workings of "common knowledge" (i.e., the knowledge that is going around at any given time). In this case Russ has got it all from a current best seller: Claire Sterling's *The Terrorist Network*. The caller is able to counter with two best sellers of his own that give the IRA view of things.

A persistent caller with special knowledge can get the better of the host in this way, but it is often a slender victory, especially for people with strong ideological convictions. One of the purposes of the talk show is a constant and ever-fluctuating sifting process whereby such people are labeled as crazies and others, in contrast, are made to feel safely "inside." Those on the inside agree to exchange opinions, unlike those crazy people who suddenly become Marxists and then go around throwing bombs and starving themselves to death.

Keep on jogging, I'll be right back.

Commercial Break

If you support the right, the natural tendency is for the other extreme, the far left, to come into power, and by and large they're just as bad or even worse than what they got rid of. By and large, it seems to me, what we should be doing and not just in El Salvador, but in any other troubled nations, nations with whom we have dealings, is to try and encourage people who are more towards the center, who are more moderate. (Russ Coughlan)

You're really crazy. You're all fired up and going crazy. (Russ Coughlan)

Opinions, like the stock market but unlike "rigid ideologies," fluctuate. The market is, indeed, the economic model on which the talk shows are based. Hence the worst transgression is for the consumer to sabotage the system by refusing payment or by slamming down the phone. A caller admitting that she had to declare bankruptcy in order not to lose her home during a spell of unemployment brought on an outburst of denunciation, for it was considered a transgression of the whole market system, and as such had to be proved immoral:

Big business in not *bad* business, guys. They're getting stuck a lot. . . . Come on, if you owe, you owe. That never changes. If I was in a craps game, in the Army, and one of you guys owed me, you owed me.

Business, Russ explains, is there to keep things moving:

What we deal with in television and radio is moving goods and services, and what

makes the economy of the United States is moving goods and services, and that isn't moving goods and services to people who are going to stick you. And I tell you that's what the free enterprise system is about, so don't condemn us because we advertise. And our advertisers are good guys; they give you value for whatever it is.

The talk show is like the economy because it keeps things moving. It mustn't stick or, worse, get stuck. That's why it follows rules that are rather different from those of everyday conversation. In everyday conversation there are implicit conventions for when it is appropriate to intervene or change the subject, and for when the ball can be passed from one speaker to the next. But the talk-show rules are quite different because one speaker (the host) has so much power. Moreover, the impression of movement can be kept up only by constant interruptions—"Hey, Phil, I've got to run, thanks for your call"—which are made necessary by commercial breaks, by news and weather reports, as well as by the host's sense of when a caller has had his or her two cents' worth. ("Thank you for letting me put in my two cents' worth," says a caller to Ray Taliaferro.) Because only the host has the right to interrupt, the power in a talk show is quite unequally divided, just as the power between business and the customer is unequally divided. The callers' only defense in this situation, especially if they hold an unpopular position, is to hang up—only to expose themselves to instant condemnation. A woman who accused Russ of being a pharisee and immediately slammed down the phone, for instance, evoked the following diatribe:

> What I'd like to ask is "What is her morality?" Don't bring up a lot of obtuse kinds of conditions to talk about whether we should pay our bills or not. Come on. What we are talking about, we're not talking about that. And that terrible moral lady who hung up. I'd like to ask where *her* morals are. Her morals are probably only talking about people who have difficulties, not doing anything about it.

Commercial Break

You know you are really lucky to live in California. Your lifestyle is the envy of people all over the country. One of your favorite pastimes is showing your bodies around the beach and around the pool, and your only problem is having a little too much body to show off. Well, that's where the Diet Center comes in. . . . (Ad on KGO)

Russ Coughlan once compared the individual's relation to society to a marriage in which people can change as long as they're loyal to one another: "If we accept the hard line on things and never change from that then we're divorcing ourselves, or not being married to the situation that society is." But unlike marriage, speakers in talk shows cannot talk to one another, only to the host, who, far from acting as a marriage broker, must keep the extremes apart, disconnect them. One night a supporter of the Nicaraguan revolution calls in, and Russ responds by rejecting his entire statement as propaganda. Any coun-

try that doesn't have the confidence of business, he says, must have something wrong with it. A little later a former mercenary in Nicaragua calls in, and Russ leans the other way. The purpose is not to let these people begin an argument with one another, but rather to let them demonstrate, by their very extremes, the pluralism of the talk show.

The paradox is that to keep the show moving, some extremists are needed. That's what makes people listen and get indignant and call back. Indignation is one indication of the strength of opinions (even if they're always fluctuating). Now in a not very subtle way, talk shows are always drawing boundaries between what is crazy and what is good normal American. Because talk-show hosts differ among themselves and because these boundaries are always changing, the line between crazy and interesting is often pretty tenuous. In fact, what has been fascinating over the last few months has been to observe how the pious liberal morality that won instant approval some time back now has become downright eccentric, a "bleeding heart" morality.

Jim Eason is adept at putting his listeners into the crazy camp. During the hostage crisis, a program regular called and wanted to send the shah back in order to ward off the threat of a third world war:

> **Eason:** I am telling you, if you send him back to Iran you are a firm believer in capital punishment without a trial.
> **Caller:** Not without a trial.
> **E:** One point at a time now. You have never heard me advocate capital punishment without a trial?
> **C:** They say they'll give him a trial.
> **E:** Listen, the ayatollah says no trial. He'll be killed.
> **C:** I want to ask you one more question. Would you have us keep the shah and involve us in a third world war?
> **E:** Let me ask you a question in return.

At this point the caller puts down the phone, a tactic that nearly always sends the talk-show host into a frenzy. Jim Eason goes into a long monologue about sending the shah back "to be killed":

> Now that's a radical stance, and it's a profoundly un-American stance. We don't believe that just because someone calls himself the head of the Islamic world, just because he wants the shah killed and his family killed and all of the other people killed, we don't believe that in this country—it is foreign to the American way. However, there are a couple of folks apparently who are so concerned about the forty-nine hostages that they are willing to have someone killed, a sacrificial lamb [i.e., the shah!]. Let them kill him to get our forty-nine people back. I say to hell with that! I would say send him back, but he's not going to get a fair trial, he's going to get killed probably as soon as he steps off the plane. You hear people advocate not only capital punishment but murder. Apparently some folks favor that. I just think you ought to remember though that last May 13 that Ayatollah said it the way it is and for that reason I'm saying don't send the shah back, never, never, never send the

shah back because if you do, you have his *blood on your hands*. Now if you're will-
ing to accept that, if you say, well on certain occasions we are happy to deliver him
over to be killed, fine, that means someone like the last caller in the '30s and '40s
when Jews were trying to escape to this country would say pack up and send them
back. No trial is necessary. I don't think we ought to say that.

Somehow, here, in a strange Middle Eastern crossing—so characteristic of the
shifting, blurry, out-of-control sort of opinion making in radio talk—the shah
mutates into the Jews fleeing Hitler, and the "bleeding heart," afraid of a third
world war, suddenly becomes responsible for the holocaust. Still, there are
holocausts and there are holocausts:

Eason: I don't care if the shah was the worst mass murderer in history, surpassing
Hitler and Mao Tse Tung, you don't grab our embassy.

The problem with Eason's tirades is that there is always some crazy out
there who can go over his limits. During the Iran hostage crisis, he got this
helpful suggestion from a caller:

Caller: Just give them seventy-two hours and launch all sixty-four fleet ballistic mis-
siles and just totally annihilate them. Our people are not going to make it out.
There's no way those forty-nine people are going to get out, I think.
Eason: Well, I think they will if the United States crawls on its hands and kisses
Khomeini's feet and bargains and gives him everything he wants, we'll get those
forty-nine people out.
C: Right. Now this is the straw that broke the camel's back. This has been going on
for too long. Just push the button, no American lives lost and totally annihilate them
if we have to.
E: Well, that's a little further than—than I am willing to go.
C: Well, it'd make an ideal refugee camp for the Cambodian refugees.

Thank you so much for calling.

Commercial Break

Hullo, Line 2, speak up or forever hold thy . . .
. . . Good to talk to you, crazy.

Listening to talk shows, you soon realize that being American is a source of
anxiety. The very pluralism of the talk show (and even the constant interrup-
tion, the coitus interruptus) practically guarantees this anxiety. Someone is
always being labeled a crazy. For instance, ERA supporters, "with all their
stomping and screaming and their anti-Phyllis Schlafly attitude. . . ." In part
this arises from the talk-show structure itself. Callers are always on their own,
or at least they never mention having someone else with them. They are on the
air to exhibit themselves and their views. Yet at the same time there is often a

nostalgia for community, for solidarity, which can only be thwarted. This anxiety often becomes crystallized around the issue of who belongs to the community. A worried caller asks Russ about a Datsun ad showing a Native American (described as a creepy-looking guy) buying red, white, and blue Datsuns for his reservation. Surely that's un-American. But no, Russ doesn't agree. A lot of people make money selling Datsuns, and making money can't be un-American.

The labeling of certain callers as crazies is a way of drawing a line around community. It is always a fluctuating, tenuous line so that people constantly need to inquire about it (rather like the weather). Yesterday's in group is tomorrow's candidate for the booby hatch. It is in fact a prime example of how people are constituted as subjects by feeling themselves to be hailed by a mode of address that implicitly excludes others—as "crazy," or "foreign," or whatever. (We adult, mature people . . .) In other words, the talk show lets us see ideology at work. At the same time it destroys once and for all the notion that ideology is a monolithic or unchanging thing. On the contrary, it is as fluctuating as a hi-fi needle. However, it also shows how hard the feeling of exclusion is on people and how anxious they are to get back on track—which is the strong card of any dominant ideology.

Yet even in the limited sphere in which it can operate today, the talk show has tremendous potential. We can detect this as soon as some topic arises or event occurs in which the callers have more authority than the host; when, that is, people draw on the authority of their own experience; when their opinions are no longer based on newspaper stories and television ads. At the end of August, a gas leak in San Francisco released dangerous PCB fumes into office buildings in a downtown area. The authorities acted in a typical cover-up, "no danger to health" fashion. A caller not only told it like it was, but at the same time revealed what cannot help being thrust to the fore—the system's total indifference to human beings:

> **Caller:** One o'clock, I think it was when a hysterical voice came over the loudspeaker saying, practically screaming, to evacuate the building, don't use the elevators, so we all went out and there was no announcement not to smoke, just go down the stairs and as we got down lower and lower, the gas got thicker and thicker. It was just filled with gas, the stairway.
> **Coughlan:** Could you smell the gas?
> **Caller:** Oh, it was terrible. It was terrible. It was really just filled with gas, but there was no announcement at any time, not to smoke. In my office, on the ninth floor many people smoke. It's my understanding that the building could have blown at that time.

The disembodied voice that doesn't give these people essential information reveals the chaos behind the appearance of a system. The chaos is confirmed by the caller when he goes to work the next day, now extremely suspicious of the bosses. His headache is so bad he can't work.

Caller: It's my opinion that those filters are full of PCB, and no one has changed them. The PCB is splattered all over that side there, the windows are all coated.

The system is quite indifferent to people; that much has become clear. In a sense, the talk show's dynamic arises out of this very indifference. The indifference represented here by that intercom voice-of-the-system that "makes no announcement" even about crucial issues of life and health in a crisis moment highlights a desperate need for *some* personal contact out there. But it's also the irony of the situation that the talk show—except on special occasions—only *personalizes* that very indifference. And that, after all, is the function of the host.

Hey Sorry, I've got to run . . .

Why couldn't you build a little community somewhere like that? (Russ Coughlan, on Disneyland)

No, She Really Loves Eggs

Fighting It Out on
Call-In Radio

Mary Louise Pratt

With some important exceptions like the telephone and still photography, mass media since their beginnings have been overwhelmingly organized in such a way that the "mass" of people (i.e., us) participate mainly as receptors and hardly ever as transmitters. And since the beginning, it has been recognized that this organization is not a technological necessity, but a political and social development. Bertolt Brecht recognized this fact in the 1920s when he wrote his essay "Theory of Radio." There Brecht remarked:

> Radio must be changed from a means of distribution to a means of communication. Radio could be the most wonderful means of communication imaginable in public life, a huge linked system—that is to say, it would be such if it were capable not only of transmitting but of receiving, of allowing the listener not only to hear but to speak, and did not isolate him but brought him into contact. Unrealizable in this social system, realizable in another, these proposals, which are, after all, only the natural consequences of technical development, help towards the propagation and shaping of that *other* system.

In a very limited and distorted way, aspects of Brecht's vision for two-way media communication do get realized "in this social system." Ironically, for instance, it is the forces of commodity capitalism themselves that have seized on the market potential of small-scale media equipment such as CBs, tape recorders, intercoms, video cameras, or personal computers, which are capable of both production and reception (witness the practice of using tapes in lieu of personal letters). In turn, it is partly because of people's new expertise with such devices that we find large-scale mass media moving toward dialogic and participatory formats in place of traditional monologic ones (see Peter Gibian's article on this phenomenon in this book).

This essay first appeared in TABLOID 7 (winter 1983): 27–37.

Call-in radio was one of the earliest instances of a two-way participatory format in the mass media, no doubt partly because radio is among the oldest of the media. We can hardly say this development has made radio "the most wonderful means of communication imaginable in public life," as Brecht put it, but we do need to ask what exactly is being accomplished in this shift. The assumption—the one *TABLOID* makes all the time—is that whatever utopias one envisions, the media in their present state must be taken seriously. As Hans Magnus Enzensberger puts it,

> The electronic media do not owe their irresistible power to any sleight-of-hand, but to the elemental power of deep social needs which come through even in the pre-

"There are instances in call-in radio where heterogeneity and

disorder are fostered, and where, within the fixed hierarchy

of the emperor-host and supplicant caller, possibilities for

testing and challenging discourses emerge."

> sent depraved form of these media. (*The Consciousness Industry* [N.Y.: Seabury Press, 1974] 111).

Building on Jean Franco's article on call-in radio (also in this book), these remarks are an attempt both to look closely at the "depravity" of communication in call-in radio shows, and to ask what social needs are addressed through such shows, and what emancipatory potential can be found there.

As Peter Gibian argues, the call-in format makes radio into a space where a multiplicity of voices and discourses can meet, interact, combine, and recombine in ways that can be scripted only minimally. Call-in radio introduces heterogeneity and considerable disorder and unpredictability into the univocal seat of the disc jockey or newscaster. Plus, those heterogeneous voices are those of nonprofessional, nonspecialist nonexperts. It is foolish, of course, to think of heterogeneity, disorder, and spontaneity as inherently beneficial or emancipatory. Indeed, in many instances of the call-in format, univocal authority is retained, as on advice shows where the lay speakers are heard only in the constrained role of supplicant seeking the wisdom of Dr. Hippocrates, Bert Bertolero the Dirt Gardener, or Joe Carcione the Greengrocer. Here prevailing structures of authority are maintained, and all that is gained is the minimally liberatory pleasure of experiencing the texture of the spontaneous human voice. There are other instances, within the "depravity," where the heterogeneity and disorder are exploited and fostered, and where, within the fixed hierarchy of the emperor-host and the supplicant-caller, possibilities for testing and challenging discourses emerge. Needless to say, in mainstream radio especially, such possibilities are circumscribed in such a way as to virtually rule out any possibility of their becoming politically productive. (Most noticeably, as Jean Franco points out, the callers have no way to talk to each other.)

Nevertheless, such cases bear examining. One small example is a program called "Now is That True?" run by Ron Owens on KGO Talk Radio in San Francisco.

This bizarre program invites people to call in and tell narratives of personal experience. At the end of your narrative, you ask the question "Now is That True?" and the host and whoever his guest is have the task of deciding whether or not they believe your story. They take a few moments to discuss the "evidence" of its truth or falsehood—plausibility, spontaneity, the significance of hesitations or repetitions, causal coherence, vividness of detail, and so forth—and they arrive at a judgment: the story was either true or false. The caller then tells them whether they have judged correctly.

Clearly this game foregrounds a point of slippage or even contradiction within the speech genre of the personal narrative. The slippage arises from the conflicting demands of performance and truthfulness. True stories don't always make the best stories, and vice versa. The general rule calling for truthfulness in speech is particularly fragile in the case of the personal narrative, because the truthfulness of such stories cannot be verified, whereas their success as performances can be verified on the spot and duly rewarded. In fact there are reasons to see truthfulness as likely to decrease in proportion to the success of performance. The radio game undertakes not to resolve this discrepancy, but merely to *pretend to attempt* to resolve it, by trying out ways of deriving judgments of truthfulness from performance factors (such as spontaneity, use of detail, etc.). The attempt is totally insincere, however, for it is obviously doomed from the start. The judges will be right some of the time and wrong some of the time. And of course, apart from the reliability of *their* judgments, the whole exercise is completely void because the storytellers themselves reveal whether their story was "in fact" true or false. There is no more reason to believe this pronouncement than there was to believe the story in the first place.

"Now is That True?" thus calls into jeopardy two related but not identical hierarchies. First, the hierarchy of the host (keeper of the airwaves) over the caller (the supplicant) is partially reversed. The caller is given the authority to determine the correctness of the host's interpretive effort. Moreover, since the callers initiate the narratives, they are in uninterruptable control both of the topic of discourse and of the floor for the duration of their narrative. This is a major concession on public media. Secondly, the prevailing hierarchy valuing truthfulness in speech over performance is called into question. The game acknowledges that hierarchy, but does not accept it. The whole point is to interrupt it, to explore its vulnerability and limitations.

The least scripted form of call-in radio is the late-night rap-and-opinion show that we all love to hate. Many people, middle-class intellectuals especially, cannot stand to listen to these shows because they find intolerable not only the predictability of the content, but above all the level of verbal disorder and violence—the incredible rudeness, abrasiveness, and intolerance of the hosts, the

authoritarianism and arbitrariness with which they wield their buttons, cutting off this speaker or that, changing their position for the sake of winning an argument, distorting people's positions, making blatantly false claims, and seemingly resisting at every turn the very differences of opinion on which the vitality of the program obviously depends. Critics of such shows often attach their antagonism to the right-wing politics of the hosts, but this is an oversimplification. In the following excerpt, for instance, the host is relatively liberal, arguing here for the legalization of marijuana, against the arms race, and for the compensation of Agent Orange victims. The caller is a person who agrees with him on all these issues, and is moreover very polite and cooperative. Nevertheless she is treated badly. Here is the opening exchange (C=caller, H=Host):

> **C:** I was just driving home, and I heard uh uh a man talking—this is back to marijuana for a moment—
>
> **H:** Yes.
>
> **C:** But I'll give you a bridge—talking about the need to do something about this dangerous thing that affects you know ten million people, because it's bad it's even worth arresting a few. And I wondered if you couldn't draw a parallel to some of the other very dangerous, more obviously dangerous things like (pause) the nuclear arms race.
>
> **H:** (noncommittally) Mhm. Oh, by the way, you know I, I'm glad you've brought it up. I've talked about it with a couple of guys in the last hour, but once again, last night I talked about this quite a bit, but once again I really want to pat uh Archbishop Quinn on the back. He was, he gave a very wonderful statement today. As a matter of fact it rather surprised his parishioners there at St. Mary's Cathedral here in San Francisco. And they gave him a standing ovation, and that was the first time that he'd gotten an ovation for a sermon.
>
> **C:** (noncommittally) That's wonderful.
>
> **H:** Very much so. And so I too just want to pat him on the back again . . .

There are two voices working at once within the host's speech here. On the one hand he complies with rules calling for feedback to reinforce an interlocutor (e.g., his "mhm") and, at the same time, the intonation clearly signals dismissal of what the woman is saying. Then he suddenly preempts the floor and drastically changes the topic, while attributing the change to the caller ("I'm glad *you* brought it up"). In return, the caller's feedback becomes lukewarm. As the exchange proceeds, the host becomes more and more dismissive:

> **C:** I have another thing I just wanted to say in the Agent Orange thing. I'm glad to hear on your program that the vets are going to be treated, but every time that issue comes up it occurs to me that no one has ever said (voice trembling) if it could have hurt the soldiers that were administering it, what in the name of God did it do to the Vietnamese in the countryside?
>
> **H:** Oh sure, oh sure. Yes. You're absolutely right.
>
> **C:** We never think of that anymore. And you know (tearfully) whenever anyone says

Vietnam now, um, people are being resentful of the poor people who come here.
H: Mhm.
C: And are trying to live.
H: Yeah, you're quite right, yeah.
C: But enough of this.
H: Hey, well, cheer up and get some sleep. Line nine, you're on the air.

The host's enthusiastic agreement with the caller's Agent Orange point simultaneously trivializes what she is saying. He seems to accept her beliefs but not the emotion with which she holds them. Likewise, the ending on the one hand complies with the rules for closing conversations—he does not just hang up on her. But, at the same time, the closure is a putdown. Quite gratuitously he tells the caller to go to sleep; that is, to remove herself from verbal life altogether, presumably until she can get herself under control.

For reasons of some ideological interest, almost all the work that linguists have done on conversation focuses overwhelmingly on the factors that produce coherence, harmony, orderliness, and symmetry in speech exchanges (one basic concept is called the Cooperative Principle, for instance). Applied to the exchange just quoted, such approaches would capture only one of the voices at work there. They would be able to characterize that conversation insofar as it was orderly, symmetrical, cooperative, and polite. To the degree that it is antagonistic, inequitable, and oppressive, it would simply be labeled as deviant and left at that. This somewhat utopian stress on harmony and symmetry in conversation is particularly unhelpful in the study of language and power relations, where you are often looking at how struggle, disruption, instability, and change are produced and worked out in speech exchanges.

In their book *The Material Word* (London: Routledge, 1980), British linguists David Silverman and Brian Torode identify what they call antiauthoritarian or emancipatory practices in everyday speech. According to them, in virtually any speech exchange, you find a multiplicity of voices (or subject positions), both within the speech of individual participants and between them. Much of the shape and dynamics of speech exchange consists in the ongoing and unpredictable interplay among these voices. What Silverman and Torode particularly focus on are the means by which participants in a speech exchange, intervene, and try to transform an established or ongoing discourse and make it do something else, make it serve ends or needs other than those for which it was initiated. In the rest of this article, using some of Silverman and Torode's ideas, I look at four instances where callers use the specific openings of the talk-show space to try to disrupt or interrupt the discourse established by the host-authority and try to redirect or transform the talk exchange. Not all the attempts are successful; none of them could be called socially or politically productive in any significant way. Indeed, all are what Enzensberger would call "depraved."

First, an exchange from the same show already quoted. The topic is marijuana, but simultaneously what is going on is a battle about cooperativeness and politeness in speech. The caller, in a completely paradoxical maneuver, tries in his opening to impose the rules of polite conversation on the exchange—which serves only to bring down on him all the irrational wrath the host can muster:

C: Hi, uh, Ray, this is Charlie, uh, I'm calling, uh, to offer a little bit of opposition to what you say about marijuana. I hope you're a little more courteous with me than you have been to others, that, uh, substantially disagree with you. Uh, I don't know why you have to be that way. Certainly Owen Spann, or Ron Owens, or Jim Easton, uh. . . .

H: Sir, just make your point. You don't have to run down the roster of talk-show hosts here. Just make your point.

C: OK, uh, first of all you say that there are ten million users in California.

H: Yeah, that is what NORML says, sir.

C: I don't agree with that.

H: All right, fine, you don't . . . what . . . how do you . . . where do you base your information?

C: Well, I base my information on the fact that I don't live in an ivory tower, number one, and I don't know one person that uses it.

H: OK, fine. So you know about uh two or three hundred people all told, so you know two or three hundred people who don't use it.

C: No, I'm not trying to generalize in particular, but I'll use some of your own language last night. You said you know some things and you feel some things.

H: Sure, sure.

C: I feel that ten million people do not use it, and you don't know that ten million are.

H: (angrily) Sir, sir, ten million is not my figure, I didn't say that . . .

In this exchange, the caller tries to juxtapose to the established voice of the host another voice which he proposes the host should adopt or enter into as well. The host rejects the proposal by literally interrupting the new voice with its opposite, that is, by rudely refusing to be polite. The caller then very astutely tries to bring the host into his speech by using some of the host's own words, about knowing and feeling. These terms keep recurring as the conversation develops. In the exchange that comes next, the host flies into what sounds like an irrational rage with no bearing on anything, but if you listen, you hear that he is challenging in a very precise way the terms under which the caller is trying to conduct the exchange. Here, the caller has proposed that rewards be offered to people who turn in marijuana growers:

H: I see, so you'd have some kind of a little, uh, a quasi-vigilante effort.

C: I don't think that constitutes a quasi-vigilante effort.

H: Well, of course it does. Vigilantism is where you have citizens doing what they can to enforce the law.

C: Well I, I, I don't agree with that.

H: (angrily) Well, sir, look it up in the dictionary, don't . . . Quit trying to be polite and keep saying, "Ray, I don't agree with this, I don't agree with that," just so you can be disagreeable. It's all right for you to agree with me on some things, it really is. I'm a very nice person; it really is all right. I mean you're going to be able to hold your head up in Santa Clara County area if your friends and your wife and your loved ones know that you agree with Ray Taliaferro. You don't have to keep saying, "I don't agree with that" simply to be disagreeable.

C: Ray, I don't agree that that's vigilantism in the sense that we normally think of it.

H: That's right, in the sense that we normally think of it . . .

In this outburst, what you hear is the host transforming the caller's phrase *don't agree* into the phrase *be disagreeable*, which he then equates with *be polite*. *Polite disagreement* is thus labeled *disagreeable*. This is the particular way in which the host here overlays the caller's voice with his own.

In the end of this long exchange, in order to close the conversation, the host does adopt some of the caller's terms, notably the difference the caller draws between opinion (feeling) and knowledge. But as you can see, the host gives himself the last word:

H: . . . way to stop it. This law is unenforceable, and your plan will not work (pause) in my opinion.

C: OK, well, that's your opinion, of course.

H: Well, of course, of course, and it's your opinion that it is. Now, sir, have you been treated fairly?

C: Have I been treated fairly?

H: Yes.

C: I haven't said that I wasn't being treated fairly.

H: No, no, you started to castigate the way that this program is handled at the beginning of your remarks in comparing it with other programs and so forth and you want to be sure that you were treated fairly. So my final question to you is have you been treated fairly?

C: I would like to answer it this way, that I was listening to your program and I. . . .

H: Oh, sir, sir, hey hey hey, listen buster, simply say yeah or nay, have you been treated fairly?

C: I will not say yeah or nay.

H: Thank you very much (cuts off caller). He agrees he's been treated fairly (laughter).

Here we get another substitution just like the earlier one with *don't agree* and *be disagreeable*. In this case, the caller's original demand to be treated *courteously* has been changed to a question of being treated *fairly*. The caller tries to reject this transformation. The host then becomes both rude and unfair, cutting the caller off and then absorbing him wholesale into the host's own voice by saying, "He *agrees* he's been treated *fairly*" —which of course is a blatant lie, one no listener would miss.

How are we to explain the verbal violence so characteristic of these talk-show exchanges, especially the defensiveness and provocativeness of the hosts? It all seems so uncalled for — especially in the light of the immense power differential between host and caller. The hosts already have far greater control over topic and over turn taking. Why would they want also to have the privilege of operating outside the politeness and cooperativeness rules, while the callers do not? Callers who are rude are unceremoniously cut off, or can be if the host desires. Perhaps more puzzling is why people call in and agree to be treated this way. And why other people choose to listen to it. Thus overall: Why has this form developed in this way?

What I would like to suggest is that in a perverse or, as Enzensberger might say, a "depraved" way, the host's rudeness and authoritarianism, while creating certain kinds of oppressive closure, also create openings where voices excluded from or devalued by polite conversation can appear with minimal social jeopardy. Crudely put, the host is already making such an ass of himself that you are not likely to do any worse. A space is cleared. It is the role played by the fool at court — the person who by violating taboos creates a verbal space at the seat of power where voices other than the voice of authority can make themselves heard. (Only on the talk show, the fool and the king are the same person.)

This space is important, because, of course, the rules of polite conversation produce not only certain shapes of speech, but also immense silences. It is these silences the talk-show host mines, and that is partly why people call in, and seem blithely willing to submit to the king-fool. And that is partly why people listen, too. It isn't just for the content, that's for sure.

In the exchange last quoted, what took place was an attempt by a caller to impose a discourse. The attempt, we saw, ended in an unresolved confrontation. In the next example, there is a victory of sorts, though at first it sounds like a pathetic defeat. The caller is an elderly woman from Spokane who wants to thank the host for playing all her old favorites on last night's show:

H: Well . . . yeah, yeah, that's you, come on into the telephone.
C: Hello?
H: (childlike voice) Yes, hello.
C: This is Lisa Jane.
H: Hello, Lisa Jane, where are you?
C: (childlike voice) Spokane, Washington.
H: Oh, that's very nice, have we talked before?
C: No.
H: Well, then, that's twenty-five million points, Lisa.
C: It's also my budget for the week for food.
H: Really? This telephone call.
C: Sure, I'm on the pension.
H: Oh, my gosh.
C: Now, do you wanna know what happened last night?
H: I sure do.

C: You flaked me out of my skull with that music.

H: I'm gonna do it again tonight.

C: You know what? I've been sitting here waiting for this show, but you know I've been married forty years to the greatest guy, but he went and died just before (pause) we were celebrating. But, every tune you played was exactly what we danced to and loved to, and every time it came on I just shuddered, and I was through sweating it out, and I said I'm gonna sit here and wait all day and all night to talk to you and tell you just how much I appreciate just how great you did.

H: OK, hold it just a moment, sweetheart, we've got a traffic advisory.

In an absolutely stunning putdown, the host interrupts this poignant self-disclosure of love and grief for a traffic advisory. He does not want to deal with these personal feelings, and personhood and feelings subsequently (and consequently) become the center of the exchange that follows. Again in this opening, you can hear the multiplicity of voices. The host's first greeting is that of adult to adult, his second of adult to child. The caller dutifully adopts this child voice into her own speech, but at the same time counters it by juxtaposing the host's childish game (twenty-five million points for new long-distance callers) with the material fact that she is devoting her food budget to this conversation.

As the exchange moves on, an astonishing thing happens. The host and the traffic reporter (T) together try to cover over the tale of woe that Lisa has introduced:

T: Traffic is proceeding quite normally north on Doyle Drive and across the Golden Gate Bridge.

H: I love to hear you talk that way, Bob.

T: Well, I'm glad to report something happy, Al.

H: OK, so it's open and I thank you very much for that, Bob, and when you come down at the break later I have a thing I want to play for you and reminisce a bit about some ole remote band days, OK?

T: What time's that gonna be, Al?

H: Anytime you can get down here.

T: All right.

H: Even between news'd be fine.

T: I'll see you in a bit.

H: OK, bye.

The traffic reporter is glad to introduce some *happy* news (as opposed to the caller's sad news—this word *happy* will recur), and the host *loves* to hear *him* talk that way (as opposed to the way the caller is talking). Then the host tries to substitute the traffic man for Lisa, by offering to play *him* some of his favorite oldies. Meanwhile, the caller's food budget is draining away, and here's what happens (assume for the moment that Lisa Jane's objective here is to overcome this annihilation of her and her discourse of feelings):

H: (to T) OK, bye. All right, is that all off and everything, ready to go? Good. Let me turn the page, too, and get on to something. Oh, I have to get back to that first call, is that still on line 1 up there? I'm sorry. Gee, I'm really sorry. Hello.

C: You don't have to be sorry.

H: Well, it was a news thing. Well, thanks very much for the compliment. And tonight we're gonna give a little bit more of the same thing as we go back into the Grotto. I've picked some other things.

C: Would you believe that no matter what you play, it's perfect?

H: Oh, thank you, isn't that nice. Well and you know it's a simpatico arrangement there—you like the things that I like and that makes me happy of course.

C: Know what my last name is?

H: No.

C: Collins.

H: Lisa Jane Collins?

C: Yes.

H: Oh, isn't that nice. Well, I'll tell ya Lisa, I love ya, that's all I can say.

C: And I wanna tell you something, I couldn't live without you.

H: (chuckle) Uh huh.

C: Bye, Dave.

H: Well, just stay out there. We're so happy.

I would suggest this kind of analysis: to his annihilation of her, Lisa juxtaposes complete acceptance of him—don't apologize, whatever you play is perfect. This enables or obliges him to make his first move into her emotive language, with *it's a simpatico arrangement*. Then the impersonal construction with the foreign word is at last transformed into a full-fledged *I love ya*, immediately qualified by *that's all I can say*, to let us know the host has been exhausted by this emotional effort. Meanwhile, Lisa has also recovered some of her person-hood by forcibly introducing her last name into the dialogue. The weight of this move becomes even more evident when, a moment later, she calls the host by the *wrong* first name (Dave instead of Al). In the end, as in previous examples, the host cuts her off and then absorbs her into his own discourse, by saying *we're so happy*. At the same time he distances her by telling her to *stay out there*. This returns things to square one, and the next caller can be brought in.

On the one hand, what you hear here is a terrible dehumanization. The host's overall message is clearly the "depraved" one that pensioned widows should keep their grief—and their sexuality—to themselves. But (as with Hollywood movies) it is important not to think about these exchanges solely in terms of their endings, because the endings are pretty predictable from the beginning. It is ultimately through power plays by the host that the show moves forward. It would be a mistake, then, to let the ending obscure the ways in which as the exchange is improvised, this caller successfully resists annihilation and intervenes in the prevailing discourse of the host. Having listened to

the program a lot, the caller herself knows that the ending is not what matters most. She knows she will be cut off, knows she will have to "sweat it out," as she says. It's apparently worth a week's food budget for her to take these risks. The point is not to romanticize what she does here, but it would be an equal mistake to reduce the whole thing to victims and victimizers.

The final two examples are from another genre, the call-in advice show. In this first excerpt, a psychiatric advice show, a woman calls in not to ask advice but to offer some encouragement to a previous caller. She does not try to introduce a new discourse then. What she does is try to speak the same language as the doctor, and thus transform the doctor-patient relation into a peer exchange. She is quickly put down. The context here is that this woman is very proud of having at last taken charge of her high blood pressure:

> C: (cheerfully) Hi, Dr. Perez. In regard to the lady that called a couple of calls ago about diet and so forth, I just want to share this with you. I've been treated for high blood pressure, and uh, I've been told for years that I should cut down my salt, and I was cooking for a family and um just didn't get around to it for myself until a crisis as you mentioned, um developed and my blood pressure went sky high, and I cut out salt, and I have lost about five pounds in a week as a result of this, and uh I'm going
> H: You just, this is very recent then, a week ago.
> C: Yes, uh huh, yeah, and uh I'm working to reduce my cigarette consumption, which I shouldn't be doing at all, but um it's taken a lot of discipline to do this but
> H: Ah, but I have to wonder when someone says they have high blood pressure, are there other pressures in your life that uh . . .

It is probably not a coincidence that the doctor interrupts the caller at her mention of the power of self-discipline, and reasserts the doctor's authority, which is that of knowing the realities (diseases) behind the appearances (symptoms). In response, the caller both resists and wavers:

> C: Well I think I'm a sort of a stress-ridden person, and I'm trying by, uh, oh I have a record, or a tape I should say, for deep relaxation, and um I've been doing that, and I must say I really feel a lot better. But it's like I'm trying to take control of my life.
> H: That sounds good, but let me say on this whole thing of stress things, stress reactions like high blood pressure, like ulcers, like habits that one picks up to handle the stress, there are two sides to it. One is to work on relaxing on that level, but you also have to work on what's causing you to be tense, which is like, you know, putting on a Band-aid or taking aspirin. Better example—taking aspirin, which will pull your temperature down, but you better look at what's giving you the fever.
> C: Mhmm.

Again, at the mention of self-control, the doctor chimes in. The caller's earlier active expressions—I cut out fats, I lost five pounds, and so on—are turning to inactive ones: I have a record, I am a stress-ridden person. At the same time, the caller resists the doctor's attempt to shift her back into a patient role. The doctor persists:

H: What's making you tense?

C: Mhmm, yeah. Well uh I, I really don't know, uh I mean I. . . .

H: You may want to explore that, though, you know, either yourself or with someone else.

C: Mhmm, mmhm, yeah. I raised a large family, and I'm fifty-two years old and um I mean um there certainly have been problems, as everyone else has. It just seems to be my coping mechanisms haven't been as good as they might be . . .

And it's all downhill from there. Without going into detail, what happens here is that the caller does give up the initiative and move into the subordinate patient role, depersonalizing herself so that, by the end, the "I" who was taking control of her life has reduced herself to a batch of coping mechanisms that aren't too good.

The last example is from a medical advice show, and the trick in this one is that it's the doctor on this show who wants to demystify medical authority. He does this by trying to avoid medical jargon and using a whole bevy of different voices instead. His show includes, for instance, a medical newscast and an editorial; he cracks jokes, raises nonmedical topics, and so on. The contradiction, of course, is that the attempt not to be a voice of medical authority takes the form of trying to be a master of every other voice he can find. In this sequence, for example, a caller wants to discuss his girlfriend's allergy to eggs, and the doctor ends up talking about chile relleno recipes:

C: I'm calling for my girlfriend. She, uh, she can't eat eggs. But she can eat chile rellenos and uh once in a while she can eat eggs, and she just dearly loves them, and it sorta limits my uh breakfast time with her (giggles).

H: (knowingly) Uh huh.

C: And I'm just curious is there something like . . . in a chile relleno she can eat eggs, you know, she likes that.

H: Well, now a chile relleno, if I remember right, is made with egg whites and not with the yolks of the eggs. Surprised I knew that, didn't ya?

C: Yeah, I didn't know that.

H: Yeah, so I . . . I'm gettin' . . . Chris is givin' me a look—are you sure? (laughs) Well, put it this way: I've watched chile rellenos being made . . .

Notice the way the doctor oscillates between displaying expertise ("surprised I knew that") and displaying vulnerability ("Chris is givin' me a look"). Notice how the caller keeps coming back to the fact that "she dearly loves eggs." This phrase becomes a theme in the exchange, as does the locker-room voice of sexual innuendo. After a fairly long cooking discussion, the doctor finally asks a medical question:

H: So what are the symptoms she gets?

C: Uh, well she really likes it, she enjoys an egg, but (pause) she upchucks. Afterwards, she gets real sick.

H: She gets real sick. Hmmm.

C: And she can't eat avocados, and I think Shirrif's powder too.

H: 'Cause very often . . . that's an unusual sign. Usually food sensitivities come out in other ways, you know, and very often people — I'm not saying this in her case, Art, I wouldn't be as foolish as to try and you know, diagnose it like this, but she may just have convinced herself that she doesn't like eggs and . . .

Once again the doctor offers a hypothesis but hedges its authority. As we might fear, the medical hypothesis is that it's all in her head—which is exactly the diagnosis the caller has been trying to forestall by stressing repeatedly that she *really loves* eggs. The doctor, however, insists on this hypothesis. In this next segment, he tries to back it up with new voices, first that of experimental science, and then the locker-room voice that Art introduced at the beginning. The result is a complete dehumanization of the girlfriend, which Art again rejects by reasserting her love for eggs:

H: Get some powdered eggs from the camping store and put 'em in some capsules and do a little double-blind study on your own. Have her close her eyes and feed her a few capsules and don't tell her whether she's getting the real eggs or just empty capsules, and do it three or four times because, you know, you just might be lucky, and she just might you know throw up maybe the time you really gave her the eggs, but the next day she might throw up when you give her the blank capsules just by, uh, suggestion. Uh, that's about the only way I can think of, uh, finding out, because usually, as I say, with uh food sensitivities there's other symptoms than just uh just throwing up, and listen, you know, if she gets mad atcha, you know sometimes, you know how women are, they use these things against you, make you suffer at breakfast time cause you're a bad guy, Art.

C: Oh no, she, she really loves eggs.

And again, it's all downhill from there. The doctor continues to oscillate and eventually stumbles back to the chile relleno theme. But the dehumanizing treatment of the girlfriend as either a lab animal or a sex object is stopped from within the conversation without causing either open warfare or a communicative breakdown. I'm reading this exchange, then, as what Silverman and Torode would call a successful *interruption* of the voice of medical authority. Both Art and the doctor contribute to the process. The doctor opens up their terrain for this intervention by rejecting the conventional medical stance, and he keeps it open by constantly asserting limits on his knowledge. He is playing something of the fool, in a way that Dr. Perez the psychiatrist was not. At the same time, there is a way in which the variety of voices the doctor uses are simply masking or substituting for medical authority. The way Art copes with that complex situation is to find and stick to a single voice, in fact to a single claim—*she really loves eggs*. It is a strategic choice, for this sentence states a brute fact that the medical man cannot just explain away. *She really loves eggs* requires the doctor to see the "patient" not just as a cluster of symptoms, or a case of some disorder or other, but as a subject who has pleasures and desires

that are as *real* and *dear* (she *really/dearly* loves an egg) as the symptoms medicine is supposed to isolate and treat.

Talk is by definition a domain of continuous improvisation. It consists not just of communication in the sense of information passing from one person to another; it is a domain where social relations are set up and worked out, where people are continuously negotiating their positions with respect to one another. What I have tried to do here is point up a few of the micropractices found in such negotiating, in the specific context of call-in radio. Such micropractices do not come into view if you look at conversations only as manifestations of general conventions, models, roles, or rules. They do come into view when you look at conversations as events in time, improvisatory events where social meaning and social productiveness cannot be defined in advance but are worked out as the event proceeds.

As has been argued so often in the pages of *TABLOID*, this improvisatory character is a crucial dimension of much mass culture and everyday life activity. It is a dimension that tends to be obscured by structure-oriented kinds of analysis that can only approach the dynamic of everyday life practices and interactions by first defining and isolating discrete texts or artifacts and monolithic subjects playing fixed roles.

Bodily Functions

What the Body Embodies in
a Mass Cultural Context

In the Belly of the Beast

Reagan's Body, MIAs, and the
Body Politic

Maria Damon

The obsession with retrieving the remains of U.S. soldiers from Vietnam points to a resurgence of a pattern of reifying the body politic during a crisis of political legitimation. The genuine and cross-cultural (one is tempted to use the term *ubiquitous*) concern with proper disposal of the dead can be observed in as diverse phenomena as *Antigone* on the one hand, and, on the other, recent Native-American victories in their protest against researchers' disrespectful appropriation of their ancestral remains. However, far from being a "universal" feature that operates similarly across the cultural board and around the world, care of the dead, in this case the war dead, consistently reflects and constitutes an instance of the dynamics of each culture.

In the context, therefore, of American politics in the 1980s, public phenomena such as the *Rambo* films, professional athlete Gary Gaetti's publicized fixation on the MIA/POW issue, the fetishization of presidents' bodies, and the anatomical tropes that creep into media discourse on domestic and foreign policy must be read with an eye toward our particular social situation. When an imperial power is embattled, when an economy threatens collapse, a wild scramble to salvage some kind of certainty ensues, and the physical body emerges as an icon to which ideological significance can be attached. National paranoia and a corollary self-aggrandizement both increase, and questions of boundary play themselves out on the fetishized body. The following discussion will touch not only upon the MIA phenomenon, but also upon other contemporary instances of the physicalization of the body politic and the simultaneous separation of national ideology from real bodies. Here I will note primarily the enormous publicity given to former President Reagan's health, and the way medico-physical language and imagery permeate the discourse of both foreign and domestic policy.

This essay was originally conceived for TABLOID but, when TABLOID ceased publication, it was published in Viet Nam Generation 4:3–4 (summer–fall 1992): 78–82.

What appears to be a brief digression into a twentieth-century interpretation of medieval politics of the body and bodies politic will serve to outline the primary concept informing my discussion. Historically and culturally, the United States is far from medieval Europe. In the Middle Ages, the very nascent concepts of nationalism and national leadership needed an ideology of the body to make them appear "natural"; currently, the twilight of capitalism and nationalism demands an analogous ideology, though this time around it is reactively defensive rather than actively constructive. However, the way in which the medieval constellation of ideas comes to us makes it an appropriate template against which to consider recent events. Ernst Kantorowicz, an Eastern-European Jew teaching at Berkeley during the 1940s and 1950s—and

"The 'Central America crisis,' with its coverage in the papers constantly accompanied by diagrams and maps of the isthmus, arrows and dots pointing out the capital of Nicaragua, Contra campsites in Honduras, etc., merged with the crisis in Reagan's health, complete with diagrams of the president's colon, arrows and dots highlighting the offending polyps."

then dismissed for spearheading opposition to the compulsive loyalty oath—exhaustively explored this physicalizing of politics in his "study of medieval political theology," *The King's Two Bodies*. An enormous compendium of anecdotes, images, and literary and historical detail, *The King's Two Bodies* examines the medieval and Renaissance notion of the complex and at times mystical conjunction of the ruler's natural body with his spiritual body—in other words, the body politic.

In the context of Kantorowicz's own experience as a Jew exiled from Europe during the expansion of the Third Reich, one hidden agenda in his project was to demystify the spiritually rationalized totalitarianism invested in national politics—a totalitarianism, that is, effected through conflating spiritual authority with the person of the head of state, and the integrity of the nation with racial and ideological "purity." This conflation could be said to have reached its modern apex in the symbolically charged person of Adolf Hitler, but was also resurfacing in Kantorowicz's adopted nation, the United States, in the anticommunist discourse dominating the postwar period. Kantorowicz speaks euphemistically of the German 1930s and the American 1950s as dominated by "the weirdest dogmas . . . in which political theologisms became genuine obsessions defying . . . the rudiments of human and political reason"(viii). Reconstructing medieval history in the light of mid-twentieth-century concerns, Kantorowicz illuminates the times in which he wrote, and

we in turn are not indulging in arbitrary, anachronistic comparison to apply his analysis to the 1980s.

According to this Cold War text, the fiction of the king's two bodies as it operated in medieval legal and political life was a versatile concept that could be interpreted in wildly divergent ways, depending primarily—of course—on the interests of the state. At times the two bodies were conceived of as separable. Kantorowicz quotes Edmund Plowden, the Elizabethan lawyer, who articulates seemingly contradictory positions in the same text. On the one hand,

> The King has in him two bodies, a Body natural and a Body politic. His Body natural (if it be considered in itself) is a Body mortal, subject to all Infirmities that come by Nature or Accident, to the Imbecility of Infancy or Old Age, and to the like Defects that happen to the natural Bodies of other people. But his Body politic is a Body that cannot be seen or handled, consisting of policy and government . . . and this body is utterly void of Infancy, Old Age, and other natural defects and imbecilities, which the Body natural is subject to. . . . (9)

To illustrate this version of the concept, Kantorowicz cites the case in which peasants had to pay a fee on the natural death of the king even though his kingship was considered immortal; and also the case of the English Revolution, in which the Parliament could invoke the spiritual king's leadership in taking up arms against Charles, the king's natural incarnation.

On the other hand, sometimes the two are not so sharply distinguishable. The two kings could be conflated such that they were inseparable. Plowden also states,

> [The King] has *not* a Body natural distinct and divided from the Office and Dignity royal, but a Body natural and a Body politic *together indivisible*; and these two bodies are incorporated in one Person, and make one Body and not divers, that is the Body corporate in the Body natural, *et e contra* the Body natural in the Body corporate. (9)

The perfection of the spiritual king redeemed any possible failing of the natural king—thus, for example, the infallibility and political omnipotence of child kings.

Here we might look at a modern-day American instance of the bodying forth of a state in the person of its leader, and the corollary or contradictory situation in which the person of the leader comes to embody the state. We might observe that Johnson and Nixon were each forced to step down because their conduct was not worthy of the spiritual presidency. Conversely, even Reagan's political enemies in government have played down his possible role in Contragate because he has *so successfully identified his person with the office of the president* that it is seriously feared that any condemnation of Reagan would lead to mass cynicism and public loss of faith in the presidency itself. Another more humorous and bluntly physical comparison comes to mind: the public ridicule that followed Johnson's display of his appendectomy scar stands in

neat juxtaposition with the noble cast given to Reagan's highly touted drug-test urinalysis. An acknowledgment of presidential physicality is seen as undignified in the first instance and morally praiseworthy in the second. Johnson and Nixon both served during periods of great public questioning of authority; the Reagan era, on the other hand, has been characterized on the whole by public passivity and increased state control of public institutions.

From these examples, as from Kantorowicz's examples of the English Revolution against the omnipotence of child kings, one could speculate that increased conceptual slippage between the physical body of the ruler and the body politic points toward the possibility for social change — and, conversely, that the more the two are conjoined into one static and reified whole, the more literalized metaphors of the body politic become in the person of the ruler, the more intransigent will be the state's hegemonic rule. Again, consider the example of Hitler. Ernst Kantorowicz is not the only European to point with urgency to the dangers of overinvestment in the person of a leader. Much more recently, Jochen Schulte-Sasse has written of Reagan as a supreme icon and media invention of a national ideology, who "incorporates, more than any other [cultural icon], both the cultural politics of neoconservatism and the powerful effect of high technology on culture"; later in the article, Schulte-Sasse draws parallels between the Hands Across America media event and Nazi rallies, reminding his readers that his personal history as "someone with a German background" dictates the gravity of his remarks (146).

However, this literalizing of the body politic as the leader's body is not always a simple equation. It can take the form of a compensatory relationship: faith in the strong person of the leader can salvage a threatened nation. For instance, while former President Reagan's survival of an assassination attempt, intestinal and skin cancer, and the natural vicissitudes of the aging process pointed toward his virility and even immortality, the body politic itself was, at the same time, taken to be in extreme danger. Its fragile health was seen to be hanging on the thread that is Central America. The "Central America crisis," with its coverage in the papers constantly accompanied by diagrams and maps of the isthmus, arrows and dots pointing out the capital of Nicaragua, Contra campsites in Honduras, etc., merged with the crisis in Reagan's health, complete with diagrams of the president's colon, arrows and dots highlighting the offending polyps. Although Reagan himself insisted after each trip to the hospital that he should now be seen as a person who "*had* cancer," the nation was not out of the woods yet. Continuing to play on the myth, solidified by the assassination attempt, of the double vulnerability and immortality of the ruler's body, the president projected and displaced his condition onto the international scene, continuing to warn us of the far more dangerous "cancer of communism" spreading from seemingly harmless and tiny Managua, the polyp that will kill two continents if not subjected to certain "operations." On conventional atlas maps, Central America even looks like a long and skinny, crumpled-up gut connecting two larger continents. Without *its* health intact, North and South America may become *in*continent. The consumers of these media

images were urged to show the same outpouring of concern for the welfare of the body politic as for Reagan's natural body—in fact, the one should follow from the other. If we think of these diagrams of Reagan's colon superimposed over a map of the nation, Che Guevara's observation that we who live in the United States live "in the belly of the beast" takes on a grotesque allegorical materiality.

"The presentation of Reagan's body was an important part of his performance of popularity," observes Michael Warner in a complex recent study of the imagination of the body politic in a modern public sphere (251). Indeed this dynamic shaped how the public responded to both Reagan and Bush as indestructible repositories for our national faith who, smiling and sporting Band-aids in TV appearances and on front pages, urged allegorical readings of their survival after skirmishes with facial skin cancer. Exaggerated publicity of these minor presidential problems both distracts from and is exactly analogous to the covert and *un*publicized activities supported by the United States in Central America. According to John Stockwell, the highest-ranking officer to defect from the CIA and the author of the CIA exposé *In Search of Enemies*, one form of torture used by the Contras was to peel the facial skin off of Nicaraguan peasants as their families were forced to watch.

It is of special interest to point out here that national health-care improvements were among the most successful undertakings of the Sandinista government; hence, health-care workers, hospitals and people delivering pharmaceuticals and supplies overland to remote areas were special targets of the counterinsurgency. The counterrevolutionaries' brutal and preemptive "operations" were designed to prevent isolated parts of the Nicaraguan population from realizing the health benefits of the revolution. As faith in the good health of our individual leaders becomes itself a fetish, attacks on the health of others—even of our own children, our indigent and our elderly, in the form of educational, welfare, Medicare, and Medicaid cutbacks—unavoidably accompany anticommunist vigilance and increased military spending.

In a further linguistic displacement, military enterprises are described in medical terms. The "retaliatory" air attack against Libya was repeatedly referred to as a "surgical strike," carefully aimed at excising only the undesirable elements of that country—Khadafi's fifteen-month-old daughter, for example. The precision and cleanliness we were meant to infer from the medical metaphor was both underscored and belied by TV coverage of wounded Libyan children and adults in hospital beds—as if, somehow, the U.S. armed forces had been the doctors rather than the disease, operating on them with our bombers "for their own good." After all, here they were recuperating. More recently and even more dramatically, the Persian Gulf War was touted as a clean and, again, "surgical" war—a designer war for television, as it were. Not only, we were told, were there no Iraqi casualties to speak of (literally, that is: the hundreds of thousands of Iraqis killed were not spoken about in the mainstream media); but American troops were spoken of as if they were virtually in no danger because the sophistication of their long-distance radar weaponry put

them out of range of retaliation. However, months after the war's end, though we still hear precious little about Iraqi suffering, many articles have appeared attesting to the post-traumatic stress suffered by members of the U.S. military. In this case, there were not images of Baghdad's wounded available to the general public, and news on American suffering was delayed until it could be safely dehistoricized and repackaged as a quasi-natural aftereffect of the stressful but responsible business-as-usual of a team of world-class Hippocrateses.

Accompanying the conflation of the ruler's body with the nation is a kind of national autism; the objectifying of the body politic renders that state incapable of acknowledging other states. If the country is one threatened and monolithic organism, other countries can be perceived only as either inert resources for our further survival or hostile obstacles to that survival. The United States alienates itself from other nations on the planet as it declares itself an outlaw state willing, if necessary, to "go it alone" (the phrase has been used both by the United States defending its attack on Libya and by South Africa defending its emergency measures in the face of increased international pressure to end apartheid). As State Department spokespeople issue these claims of self-sufficiency, an obsession with national boundaries and the physical integrity of the nation sets in. Replicating on the national level the anatomical ideology encouraged by the religious right, the United States is to be born again into a state of *virgo intacta*, impenetrable from without—witness the increasingly stringent immigration laws and the paramilitary role of border patrols and the INS. (In connection with this point, I'd like to mention a John Borneman article in the *Journal of Popular Culture*, tellingly titled "Emigrés as Bullets/Immigration as Penetration," which analyzes the homophobia in popular discourse surrounding the U.S. reception of the 1980s wave of Cuban immigrants.) Accompanying the terror of contamination and/or sexual penetration from without is a fear of escape from within. It's OK to leave your heart in San Francisco, but not your bones in Vietnam—actually, in light of the AIDS epidemic the former is no longer advisable either. Tourists are urged to spend their dollars on native soil rather than wasting them in ungrateful foreign nations. We are terrorized by the domestic press's accounts of terrorism against U.S. citizens foolhardy enough to leave their own shores. We could be taken hostage at any moment by foreigners characterized by a San Francisco television commentator as "creeps whose names I can't even pronounce." As long as there are Americans, or even *parts* of Americans, abroad, the American nation is not "whole."

Aside from the preoccupation with the physical condition and retrieval of the bodies of the Challenger crew, which overlapped roughly with the release of *Rambo*, MIAs and KIAs in Vietnam constitute the most dramatic version of this phenomenon. According to the government, the numbers of missing personnel in Vietnam are far less than in other American wars of this century. Captain Douglas Clarke has pointed out, in his book *The Missing Man: Politics and the MIA*, that the number of MIAs initially unaccounted for in Vietnam was 2,546, or 5 percent of the fatalities, compared to 8,406 in Korea,

or about 25 percent of all deaths, and almost 80,000 in WWII, which comprised 22 percent of fatalities. By 1978, moreover, the number of Vietnam war MIAs had been reduced to 282, an almost insignificant number in material terms (7–11). And yet the furor continues to resurface periodically, fueled by such media extravaganzas as *Rambo*. Public interest in the MIAs, from the popularity of Rambo to the ongoing grief and uncertainty of the families of the missing, makes them a symbolically charged group. This symbolism currently serves the dominant conservatism. According to this world view, the shame of Vietnam is not that we initially intervened; it is that we didn't win. Vietnam is unfinished business because there was no clear victory for the United States; the conflict can thus be seen as open-ended and unresolved. The MIA issue, especially the possibility that some of the men are still living captives who need rescue, offers the perfect opening for a re-engagement of public indignation and a chance to resettle the case. Bruce Franklin's book *MIA, or Mythmaking in America*, details the history of the post-Vietnam War MIA/POW obsession. He documents the U.S. government's initial complicity in fostering the belief in living MIAs, the role of several presidents (from Nixon through Bush) in supporting (or appearing for campaign purposes to support) the cause, and the subsequent estrangement of the government from the MIA/POW institutions (National League of Families *et al.*) and movement they created, as the latter institutions and spin-off organizations came to feel that "bureaucratic officials" in Washington were as obfuscatory and insensitive as the Vietnam government, and as repeated diplomatic and military forays into Vietnam failed to unearth or reveal any signs of Americans, living or dead.

In addition to the obvious and predominant reason for the prominence of MIA publicity, there is also a further implication that it is a sacrilege to allow American remains to rest in a Third World — and socialist — country. This is true not simply because Vietnam is a Third World socialist country, and not simply because the remains are proof of valorous service and thus their return, under the guidelines of the Geneva Convention, constitutes a way of honoring and accounting for the dead. Those 282 unaccounted-for missing people haunt us, pointing to a dispersal rather than a concentration, a threatening lack of closure not just of the war as event, but of physical boundaries. Those hypothetical ungathered bodies call our own bodies into question, and in particular, our civic and communal body, the body politic. The MIAs become the invisible kings whose spiritual bodies will be restored only through the restoration of their physical remains. Even more poignant and unsettling than the image of dead bodies is the far-fetched but gnawing possibility that some of the living MIAs — if they *are* alive — have *chosen* to stay in communist territory. If these men are not truly insane, like Kurtz in *Apocalypse Now*, their possible existence threatens our sense of ideological certitude.

As has often been observed, the Vietnam war was the first television war. Although the images were primarily those of disfigured Vietnamese rather than American bodies, television coverage offered a somewhat palpable, if still highly mediated, sense of the horrors of war. These nightly scenes of carnage

in American living rooms fueled the public indignation that eventually led to our withdrawal from the conflict. But again, through the peculiarities of the hyperreal medium of television, that sense of horror was displaced and alienated. Physical suffering was made a *spectacle for* the American public; body parts on display *became* the war. Bodies became fetishes that symbolized the war. Now, the sight of those Vietnamese bodies on television is gone, and the horrors of war become emblematized by the invocation of American bodies left in Vietnam. The indignation aroused by the sight of maimed Asian bodies is transmuted into indignation at having lost the war; the absent and imagined bodies of our countrymen stand metonymically for that loss.

Pertinent here is the Minnesota Twins's Gary Gaetti and his obsession with the MIA/POW issue. It is no accident, I think, that a professional athlete, whose sole use value in the public eye, and exchange value in his career, resides in his mortal and aging body, and whose body, moreover, is on constant public display, should choose this phantom cause as the only public work to which he will devote his energy and time. American athletes are, like soldiers, simultaneously valued and devalued as bodies in the interest of someone else's economic gain — as cannon fodder and/or images in spectacle who, when they sign on for the job, effectively relinquish their right to bodily privacy and self-determination; who can be "traded," "stationed," drug tested, drugged, and then superficially run through quick-fix treatments to get off drugs and who are otherwise deprived of free choice and movement. Behind a flimsy screen of hero worship, they are fundamentally treated as slaves. The displacement of Gaetti's concern over his own body (fetishized as intact and healthy) onto the apocryphal bodies of "forgotten servicemen" (fetishized as fragmented and ghostly) speaks poignantly to professional sports as an elaborately glamorized form of physical abuse, neglect, and exploitation. The two versions of fetishization, or course, mirror each other. Where is the "real" body Gaetti yearns for? What inner battlefield is it strewn over? What kind of care would heal it?

The imagistic splitting and displacement go on, taking form in the "weirdest . . . dogmas" and "genuine obsessions defying . . . the rudiments of human and political reason," snowballing into violent scenarios that would be hypocritical were they not so clearly symptoms of national psychic dysfunction. Far from warning against war, the mental image of unreturned servicemen and their physical condition has come to justify continued war against others. (I have to mention that *Platoon*, the first in a new generation of Vietnam films, *does* attempt to recoup the critical potential of these metaphors. The most powerfully assaultive image of the movie is that of the "heroic" — that is, dope-smoking and peace-loving — Sgt. Elias, abandoned to the mercies of the Viet Cong, and reaching up to the U.S. Army helicopter as it takes off without him. In this case the abandonment of the good soldier epitomizes *not* American failure to win a just war, but American military insensitivity and fear as the *core* of our involvement in Vietnam in the first place. However, even this film, which acknowledges ambivalence on the part of the American military and valorizes the soldiers who doubt the ethics of their involvement, does not grant the

humanity of the "enemy." The dramatic scene of Elias's martyrdom/apotheo-sis relies for its emotional power on the filmic depiction of the North Viet-namese as an insect swarm beyond human appeal.)

As each individual "set of remains" sporadically returned to us by the Vietnamese government has been carefully and separately examined to ensure its singularity and authenticity, the United States has supported the prolifera-tion, in El Salvador, of mass graves of death-squad victims, mutilated and dis-membered beyond recognition and differentiation, strategically placed on well-traveled paths for shock effect. A member of the SEALs, an elite Navy group, testifies in Al Santoli's oral history of the Vietnam war that this tech-nique was also tried out in Vietnam:

> Each impact you had in that area was to be interpreted in terms of its terrorist poten-tial, terrifying the people. . . . We were looking for the maximum impact of that experience. . . . Sometimes we'd paint green on their face, which would mean that the frogmen had been there . . . the body would be dismembered . . . like an ear would be missing or . . . the PRUs would . . . cut the liver out and take a bite out of it. . . . Finding a loved one with a green face and stabbed—in the middle of the road—was incredible terror. (219–20)

Certain innovative "antipersonnel" weapons designed by American weapons makers are intended to maim rather than kill—for instance, the land mine that explodes at waist level and maims the genitals—because research has shown that it is more demoralizing to a population to confront mutilation and dismemberment, whether in the living or the dead, on a daily basis, than to lose lives. In fact, according to Howard Zinn's A People's History of the United States, this technique has a long history in Euro-America. The strategy of Indian genocide was to surprise and kill noncombatants—women and chil-dren—in order to demoralize combatant forces, whose warriorship per se was usually far superior to the Europeans's; this demoralization, of course, was cru-cial in preparing for the eventual complete genocide of this perceived enemy.

Schulte-Sasse points out quite rightly that the attack on Libya was "not pri-marily an act of foreign policy" but one of domestic policy, through its status as mass spectacle (125–26). The U.S. government seems to be applying assid-uously this finding that public display of unwhole bodies undermines a citi-zenry's morale. And the U.S. mass media—generally only too willing to limit themselves to simple transmission of just the images the U.S. armed forces, or NASA, or other government agencies present them with—has followed very much the same pattern. By bombarding us with media coverage of the MIAs and the body parts of the Challenger victims, by fostering and playing on an obsession with remnants and relics of the torn-apart bodies of American citi-zens, the U.S. mass media, in the interest of protecting us, train against their own audience a psychological version of the military techniques developed and tested in Southeast Asia and continually perfected in Latin America and elsewhere. As other nations get physically terrorized by wholesale slaughter, we are terrorized by images trained on us by our television and movie screens

and newspapers. A few selected images of noble carnage, talked about but rarely shown, are multiplied over and over by disproportionate media attention. (For example, the case of the MIAs and the Challenger crew: tragic dismemberment is portrayed as self-sacrifice.)

It could certainly be argued that the two forms of terrorism cannot be considered equivalent, and that actual physical violence poses a terror far greater than media violence. However, one could conjecture that the results have proved almost the opposite of what one might expect: in the Third World countries terrorized by physical U.S. violence, there has in fact been an increasingly strong anti-American resolve and more willingness toward organized oppositional activity; in the United States, the state terrorism disseminated against its own people through the media does seem to sap the public of its critical powers. Moreover, intentional or not, this terrorism gets projected onto foreign agency, such that, somehow, Khadafi and assorted communists — Vietnamese, Cuban, or Russian — end up implicated not only in the attack on Libya (i.e., the Libyans "deserved it") but even, indirectly, in such unrelated incidents as the Challenger disaster. (There was a brief and apocryphal rumor that Soviet sabotage was behind the blowup.)

Here, as in a dysfunctional nuclear family, the urge to protect becomes the compulsion to kill spirit and liveliness. It seems clear that the prevailing national atmosphere, "the [expression] of an enfeebled neoconservative social policy" (Schulte-Sasse, 126), feeds a public paranoia that would then justify a so-called strong defense. The development of this defense would require further experimentation with weaponry and terrorist techniques, and more living laboratories to replace Vietnam, Cambodia, and Laos. The cycle of aggression and objectification is thus re-engaged. The frogman terrorist I quoted earlier concedes as much point blank:

> About a third of the guys that were in my unit are still in. They go out on secret operations. And it's only conjecture, but I know enough about the way that group works and I was in Guatemala this summer (1978 or '79) and I was noticing how the guerrillas work down there. The SEALs go into . . . Central America and Latin American countries and do the training for right-wing guerrilla or terrorist units. I have to conclude that all of that in Vietnam was an advanced bootcamp to train operatives for other kinds of . . . activities that the United States runs all over the world. (213)

Each instance of dismemberment and mutilation finds its analogue, comically or horrifically psychologized, in the American media's fetishizing of American bodies and American boundaries.

It seems bitterly appropriate that the nation that first sundered the atom at the cost of 40,000 Japanese and Korean lives is now itself obsessed, in a dazzling feat of paranoid self-projection, with guarding the intactness not only of the "nuclear" family but of its own concretized concept of "indivisible" nationhood — exclusive, impermeable, a closed and suffocating system. This beast has no birth canal: Which way out of the belly?

Works Cited

Clarke, Captain Douglas. *The Missing Man: Politics and the MIA*. Washington: National Defense University Press, 1979.

Franklin, H. Bruce. *MIA, or Mythmaking in America*. New York: Lawrence Hill, 1992.

Kantorowicz, Ernst. *The King's Two Bodies: A Study in Medieval Political Theology*. Princeton: Princeton University Press, 1957.

Santoli, Al. *Everything We Had*. New York: Ballantine, 1981.

Schulte-Sasse, Jochen. "Electronic Media and Cultural Politics in the Reagan Era: The Attack on Libya and *Hands Across America* as Media Events." *Cultural Critique* (winter 1987–88): 123–52.

Warner, Michael. "The Mass Public and the Mass Subject." *The Phantom Public Sphere*. Ed. Bruce Robbins. Minneapolis: University of Minnesota Press, 1993. 234–56.

Zinn, Howard. *A People's History of the United States*. New York: Harper Colophon, 1980.

National Security Leak

What They Tell Us
About Tampons

The Emmenagogue Sisters

For more than a decade, literate Americans who want to know have been able to ascertain the ingredients in the processed foods they intend to purchase. Listed in order of abundance are the chemical additives, sugars, salts, oils, and colorings used to make the product marketable.[1] We have come to feel we're entitled to know what we're putting inside our bodies. Of course the words "spices" and "flavorings" could mean anything, but this isn't a major cause for hesitation. No matter how mystifying the information on the packaging may actually be, its presence at least conveys somewhat of a message of confidence between manufacturer and buyer.

There is, however, a class of consumer product which, though not ingested, is put inside the bodies of a significant portion of the female population, and nobody but the manufacturer knows what's in it. Yes, we're talking about those necessities of life, the keys to daintiness and feminine hygiene: tampons.

In the late 1970s such radical feminist newspapers as *off our backs* began to point out the lack of consumer information about the contents of tampons and sanitary napkins, objects women use, as the manufacturer advises, with "complete confidence." Evidently, after the trauma of menarche—finding out there is a bodily function over which we have no control, and which is culturally coded as disgusting—we shouldn't be asking a lot of questions but should simply feel relieved that, "without embarrassing belts, pins, and bulky pads," we can conceal this regularly occurring condition. Clearly, concealment is the name of the game in this area. However, the manufacturers of the tools of concealment also conceal from us some embarrassing particulars concerning their products. For example, advertising encourages women to wear pads or tampons to maintain a sense of freshness and cleanliness all month, without mentioning possible health risks of such long-term use. And the general label "san-

This essay appeared in TABLOID 3 (winter 1981): 30–33.

itary" is apparently meant to make all suggested uses of these products appear medically advisable.

Nonetheless, over the last fifteen years or so many women have become increasingly wary of the unknowns in these products. For reasons of economy, ecology, and "control of our own bodies"—goals that have become more elusive since the early years of the second wave—feminists have been discussing the use of natural sponges, diaphragms, and launderable cotton pads instead of manufactured and disposable tampons. And a lot of this started with the basic question of what's *in* tampons, which became more urgent by the early 1980s with the appearance of toxic shock syndrome, an often fatal condition caused by the use of these "necessities of life." The brand names were usually con-

"If 'natural' and 'free' were the buzzwords in tampon ads of the 1970s, they were edged out in the 1980s by 'security' and 'efficiency,' as American foreign policy became preoccupied with worldwide threats to national security."

cealed in the news stories, but at least 131 cases were reported in the United States between 1979 and 1981, and the product Rely was finally taken off the shelves after being connected with more than 25 deaths.

With this information in mind, the Emmenagogue Sisters went to our local supermarket to do a little comparison shopping. Maybe, we thought, it was the additives, deodorants, perfumes, or preservatives in the tampons that formed toxins and poisoned women. At least we could try to stick with the simplest explanation. But this proved impossible to verify. Nobody's talking when it comes to tampons. There's nothing about this on the packaging. While we found some research by Janice Delaney, Mary Jane Lupton, and Emily Toth (*The Curse: A Cultural History of Menstruation*. New York: New American Library, 1977) indicating that the major contents of these "hygiene products" were rayon and cellulose, we also knew that, since the publication of that edition of their book, some new products had appeared with unidentifiable ingredients. Rely tampons, for example, relied upon what appeared to be sharp bits of plastic foam to enhance their absorbency.

Having found it impossible to identify the ingredients of these products, we chose to focus on the packaging—because what they *do* tell us about tampons makes an intriguing story. Here's an example of the information that can be found on packages: "Designed by a gynecologist." (As if *that* were invariably reassuring!) But that is as much scientific information as is given to the menstruating population. Again, the main point of the packaging of feminine protection products has always been concealment. We all know what's in the box; just grab one and hope nobody stares at you. That is the implication of these substanceless wrappers. This is a lesson we remember first learning in the truly discreet pharmacies of our youth, where sanitary napkins (there were only two

brands, cheap and expensive) and tampons (only one brand, for the daring young woman) were wrapped in green glazed paper, as if the boys at the soda fountain didn't know that was the only product so disguised. In fact, these unmarked boxes and wrappings constituted the clearest markings: no other product was sold in this manner.

Of course now we've come a long way from those days—in some ways. For the past twenty years, tampons and napkins have even been advertised on television and in other mass media very much in the public sphere. But still what is most notable is what is not shown or said; for all the new publicity, the closest the ads get to portraying menstruation is showing a fully dressed woman on the screen successfully avoiding embarrassing moments. (In contrast, advertising for underarm deodorants or breath mints can be quite graphic in depicting the embarrassments the products can help you avoid.) According to Delaney *et al.*, a broadcasting code stipulates that none of the vital issues of menstruation or the effectiveness of the product can be mentioned in advertising. There has been an attempt to establish a uniform code for absorbency: a table printed on Tampax boxes correlates "super" and "regular" and so on with grams of fluid. Although design has changed in small ways to accommodate some recognition of the realities of menstruation—extra flaps called "wings" and new pads for "overnight" protection—still no information is given that might allow consumers to judge the plastic-mesh coverings and plastic linings in these innovative products. Thus, women are left with vague references to "freshness" and vacuous repetitions about the psychological benefits of such "freshness," mouthed by women with whom few of us identify.[2] The glamorous models, swimmers, and tennis players never look into the camera and blurt out, "Damn! I bled all over my tennis shorts!" And though the white-clad woman who used to appear on the neatly folded instruction sheet in Tampax boxes has long since given way to more efficient printing and an anatomical sketch, even her mid-'90s counterpart would never refer so graphically to everyday reality.

The terms used on the packages constitute a code supposedly readable only by the initiated: women who menstruate. Since the 1950s one key code word has been "dainty," and though it's a term involving a long-outdated concept of women, it could be foisted on us in moments of weakness. The word's meaning in this context seems to be "clean." But attaching any other meanings, such as "feminine" or "attractive," produces a contradiction. Menstruation is obviously female, but showing evidence of menstruating (e.g., blood on the backs of our slacks) is dirty and unfeminine. So the subtext or powerful suggestion of many of the code words on these packages—"fresh," "secure," "confident," "natural"—seems to be that what is being offered is "absence of signs of what is natural for women." The effect is reminiscent of the undertakers' advertisements in the subway: a fuzzy photograph and a word or two ("dignity" is a favorite), then the advertiser's name and address. (Significantly, "dainty" derives from the Latin *dignitatem*, "worth, beauty"—a curious reversal by the time it reaches a Kotex ad.)

If these euphemisms insult women's image and intelligence, so do the repetitions of these bland code terms. For instance, different forms of the word "secure" were repeated nine times in a one-page ad for Kotex Security Tampons in *Ladies' Home Journal*, August 1980. If "natural" and "free" were the buzzwords in tampon ads of the 1970s, they were edged out in the 1980s by "security" and "efficiency," as American foreign policy became preoccupied with worldwide threats to national security. But the tendency to magical incantation of single, almost empty code words in both the 1970s and '80s represented a marked change from the longer sentences and informative, businesslike approach of tampon advertising in the 1940s, when it was important that women include themselves among those in the population who could think and work.

The visual imagery of 1980s tampon packaging definitely expressed a period feeling—and the same haziness of information or focus. If human figures were shown at all, these images projected a generally blurred image of a woman who looked or acted as the purchaser presumably wanted to look or act. But this blurry figure was so vague it could be any woman, and if it didn't apply, no matter, since you have to buy the package anyway. In 1981 Tampax still kept its discreet, nonrepresentational package: those tiny flowers like the thousands of regular periods you expect to have. The Modess package, which had featured elegant women in long designer gowns in the 1960s, was redecorated with ladylike, nonfigurative lace in the 1980s. Kotex in 1981 had slightly blurry flowers—oneness with nature? For Rely tampons, we had the silhouette of a woman's face in an ironically significant teardrop. The huge block letters O.B. still suffice for that brand, as if obstetrics were of vital importance to menstruation.

An early-'80s addition to the more representational visuals for the pad industry, which enjoyed a comeback in response to the dangers of toxic shock, showed merrily waving cyclists riding off into a rosy sky; another pictured an impressionistic female figure wading in the ocean (obviously not intending to get wet above the knees, because she was wearing a dress), and still another brand showed a woman waiting—for a pregnancy or menopause, so she won't have to buy the damn things anymore? These images seem to be trying to avoid saying much of anything; but you can see how dangerous the semiotics can be in the minds of too-active readers. This last, waiting figure appeared to be dressed for work, which did seem a concession to the realities of women's lives. Maybe she was just waiting for the bus and hoping she didn't have to worry about her feminine protection.[3]

The colors on packages in the early '80s were pink and pale blue, to remind women that even if we may ride our bicycles, we must still remain in the feminine realm of pale colors and dilute experience. Since then Tampax, demonstrating that there has been some movement toward more openness and communicability about these products, has enlarged the print on its package, exchanged the earlier pale blue for an intensified electric blue, and discontinued the convenient plastic holders, which were last seen in a shocking-pink

paradox of concealment. But the ad men have not yet learned the color of menstrual blood. And what do they mean by "feminine protection"? Protection for whom, from what? The blood is ours, surely we can't be duped into thinking we need to be protected from it. Marilyn French graphically describes what is threatening, and to whom, in *The Women's Room*: one of her characters sarcastically suggests that the reason women were excluded until the 1970s from the undergraduate library at Harvard University was the fear they would bleed all over the floors of the halls of learning. "Every place women go they do it: splat, splat" (418). The protagonist's dream preceding her oral examination is of a pile of soiled sanitary napkins in the corner of the room, haunting her with the unacceptability of women in academia.

On the backs of the packages are diagrams of the construction of the pads (usually a little blue plastic and a few layers of white stuff) with no reference to female anatomy or menstruation. Tampax packages in the 1980s had mystifying photographs of experiments with tampons in glass tubes of water. In another graphic image still used in advertisements, gravity works in favor of the experimenter, who *must* know women don't stand on their heads during their periods.

From this cursory survey of "feminine protection" products, it's clear that the discourse surrounding menstruation is meant to conceal whatever women actually know about our own bodies, and to perpetuate the mystification of the process among the male population.[4] Young girls are usually equally confused. Seeing that this product is for them when they grow up, the process of maturation seems dreadful—pads look like bandages, tampons like hypodermic needles, and there is great anxiety surrounding the mention of these objects. The confusion of menstruation with sexuality, and the shame associated with women's bodies, is perpetuated. Women are supposed to control our sexuality, but the impossibility of controlling menstruation becomes the source of shame. This in turn makes it unlikely that a woman would demand to know what is in the product she's buying. Lest you continue to think tampons are merely cotton wads, or even cellulose wads, observe the "New, improved!" advertising, and ask yourself how a wad of cotton can be improved.

Postscript

While sea sponges, sometimes adorned with the shells of tiny sea creatures, were already marketed in some women's bookstores in the late 1970s, and various launderable items have been created by women as alternatives to the disposable products, other "green" menstrual products have appeared in natural-food stores in the past five years. Pads with the brand names Eco-Fem, from Canada, and Seventh Generation still do not list the materials of their construction, but they do specify that they contain no fragrances or deodorants, and are made of unbleached substances. And the concern about deodorants and bleaching agents as potentially dangerous to women has finally begun to

have a limited impact on mainstream products. The Tampax World Wide Web site (http://tampax.com) recently announced a new 100 percent cotton product called "Naturals," which is to hit the shelves in March 1996. Other mainstream manufacturers now specify the lack of deodorants and fragrances on their product packaging. The Web site information on Tampon's "all-natural" product does not mention whether these ingredients will be included. The "Naturals," we're told, are "designed to let you have all the freshness, freedom and confidence you demand for today's active lifestyle." The Emmenagogue Sisters have heard this before and wonder what it implies for women's health.

Notes

1. Since the original version of this piece was published in 1981, this information has become much more specific, in terms of calories and grams of fat, but terms such as "flavorings" and "spices" are still not chemically analyzed.
2. A similar strategy is obvious in advertising for the newly available over-the-counter yeast medications, which have displaced "feminine protection" advertisements on television. Young, androgynous women explain in breezy, matter-of-fact tones that their doctors advised them to use these nonprescription creams instead of scheduling medical examinations. It is, they claim, an economically and medically advisable solution to recurring infections. The market appears to be responding to a consumer need that has become more acute with the current health-care crisis in the United States. The product's advertising effectively detaches this kind of infection from the part of the body where it occurs, and even from a distinctly female physiology.
3. The 1990s packaging of these products has turned away from these fuzzy, flattering 1980s images. The colors are far brighter, and color-coded: fire-engine red, magenta, cobalt blue, bright green . . . for various needs. We still do not have many words about the products, but at least in color-coding we are beginning to be given some information; there are even decoder cards posted in some pharmacies to help you decide which product is for you.
4. In 1987 Emily Martin's *The Woman in the Body: A Cultural Analysis of Reproduction* (Boston: Beacon Press) addressed this mystification by interviewing women of diverse social and economic backgrounds, and contrasting their views with the economic metaphors of medical science. In 1993 Margie Profet, an independent researcher in evolutionary biology living in Berkeley, California, received a MacArthur Foundation grant to support her work on menstruation as a mechanism that protects the uterus from infection by sperm-borne bacteria. The cultural importance of her work is obvious: it reverses the traditional view of menstruation as a shameful sign of failed fertility (*New York Times*, 21 September 1993).

 And at least in some small circles information about tampons and menstruation is now becoming much more public and available. A *Washington Post* article (15 April 1995) describes the Museum of Menstruation in New Carrollton, Maryland: Its creator is a man of vision who collected products, packaging, and advertising from the beginning of manufactured feminine hygiene products. Universities and manufacturers were uninterested in this important contribution

to the cultural history of women, and turned down the collection. But though Tambrands, producers of Tampax, did not choose to sponsor this museum, the company's World Wide Web site includes a history of tampons from ancient Egypt to the present day, including a section titled "Tampax Goes to War."

Some Babe

Tania Modleski

Editor's note:
Have you noticed how more and more animals—bulls, bunnies, bears, cats, sheep, and especially pigs—are popping up on our screens these days, speaking to us, singing to us, and taking over the lead roles both in ads and in full-length movies?

Hollywood animal experts have taken steps beyond the old circus monkey trainers, or beyond the masters of equine dressage, with elaborate methods of teaching live animals to perform intricately humanlike tasks on command. And, taking the same impulses even further, special effects wizards have now developed high-tech methods of animating and automating animal images—a whole new art of "animatronics" that uses machines to create amazingly lifelike simulations of natural animal movements and can also make animals appear to speak. These developments—a merging of the human, the animal, and the machine—have made possible a mass cultural revival or transformation of a classic story genre: the animal fable. But what do we want these animal bodies to embody for us? What complex sorts of identification and displacement go on in the mass cultural imagination as we watch animals made to enact our stories, to speak to us and for us?

Tania Modleski's essay may begin to suggest some answers to such general questions as it develops a close reading of the dynamics of displacement—here leaps between various substitute embodiments of the maternal—involved in the experience of viewing one such contemporary animal fable: *Babe*, perhaps the best of the recent experiments in "animatronics," and one of the most successful films of 1995.

This essay was written for this anthology.

A public service announcement currently running in movie theaters shows a homeless man approaching a family to ask for money. The male voice-over says, "Don't give your money to this homeless person; give it to the dolphins." A cut shows a little girl putting an envelop into a metal bank shaped like a dolphin. We are then informed that the money will be used to provide services to the homeless. With shocking clarity this ad reveals the extent to which our empathy for animals is apt to exceed our empathy for the unfortunates among our own species, and it shows how the animal body enables a displacement from the visible presence of the individual whose woes we prefer not to face to a more tolerable—because more abstract—notion of a social ill.

"Babe winds up establishing a new humanism that extends to swine but not to woman."

This public service announcement resonated with recent events in my own psychic life. My mother died about a year and a half ago after a lingering and gruesome illness in which she lost control of all her bodily functions. (She also went blind, a development unrelated to "the disease," as she always called her polymyositis, the degenerative muscle disorder that, along with complications caused by the steroids that for a time kept her alive, eventually killed her.) I have been unable to mourn her death directly, but have found that since she died even a hint of an animal's suffering is absolutely intolerable to me. That this latter symptom is related to my mother's suffering and death was made clear to me in a dream I had shortly after my mother died in which I was sobbing with grief over the death of a little dog; even in the dream, however, I was clearly aware that I was displacing my grief from my mother. (As a person interested in psychoanalysis I was quite struck with the fact that an element of the dream work—displacement—came to be part of the manifest content of the dream.) Thus when the movie *Babe* came out, I was primed to overidentify with the protagonist, a pig that loses its mother to the butchers and takes his place on a farm where he finds various mother substitutes, including a dog and a sheep.

A film about a piglet who by virtue of his kindness and good nature undermines the animal hierarchy on the farm, *Babe* also may be said to promote interspecies harmony. Indeed it appears on the surface to be the perfect cyborgian film, creating a world in which the boundaries between animal/human/machine seem entirely permeable. Most notably, of course, the film's use of computer animatronics to make "real" (i.e., not animated) animals appear to be talking human language seems to take a page straight out of Donna Haraway's essay "A Manifesto for Cyborgs." As Haraway writes, "A cyborg world might be about lived social and bodily realities in which people are not afraid of their joint kinship with animals and machines."[1] We might note that

within the diegesis of *Babe*, machinery functions ambivalently. There is the "bad" alarm clock that the farmer's wife, Mrs. Hoggett, purchases and brings home to solve the problem of the duck's crowing too early in the morning. The duck is dismayed that machinery is brought in to replace animal labor, unmindful of the fact that he himself has been attempting to replace the rooster in order to prove himself useful and thus evade his fate of becoming the entree at Christmas dinner. The fax machine that Hoggett's son gives his parents as a Christmas present, on the other hand, allows Farmer Hoggett to enter Babe at the last minute in a contest where the pig successfully performs the task usually allotted to the canine species—sheepherding—and thus to avoid the fate he shares with the duck. That the wife's machinery is evil (just as her own particular animal, the cat, is the only evil animal) and that she distrusts the fax machine suggests that the utopian, cyborgian fantasy of farm life does not encompass woman.[2]

In giving the human family the name of Hoggett the film obviously means to suggest the permeability of the human/animal divide. Yet it is important to note that it is the farmer's wife, rather than the lean, Jack Sprattish farmer silently communing with the animals, who is the "true" pig, as evidenced by her snub nose, the snuffling noises she makes as she contemplates the prospect of a pork dinner, and, especially, her excess weight, which the camera emphasizes through low angle tracking shots of her fat behind. If the wife incarnates hoggishness, the male piglet with the feminine voice represents an androgynous ideal that the film makers went to considerable lengths to keep in a state of arrested development: forty-eight different piglets were used in the course of filming. Thus for all of the film's utopian thematics, "porcinity," to adopt a Barthesian kind of neologism, is nevertheless reviled by the film, which relocates it on the site of the woman's body.

In a sense, the film works to promote vegetarianism or at least to place a taboo on pork (I threw out my bologna the day after seeing the film; one of the film's actors—i.e., "voices"—became vegetarian after making the movie), and this taboo can be linked to the portrayal of the woman in the film. In her study of Biblical abominations (prohibitions against foods such as pork), Julia Kristeva sees the figure of the maternal body behind various taboos. The maternal body is rendered abject as the subject comes to differentiate himself from the originary fusion with this body and to feel himself as separate and whole. The threat of being re-enveloped in the "swamp" (Kristeva's term) of the maternal leads to preoccupation with borders, which symbolically guarantee our separateness. Hence dietary laws usually pertain to foods that confuse categories (like pork, which comes from a beast with cloven hoof), thereby threatening symbolically to plunge us into our initial undifferentiated state. According to Kristeva, Christianity abolished dietary taboos in interiorizing abjection in a process Kristeva calls "oralization." She quotes Mark 15:11: "Not that which goeth into the mouth defileth a man; but that which cometh out of the mouth; this defileth a man."[3] In *Babe* the crisis point for the pig and the duck occurs at Christmas: "Christmas is for carnage," the panicked duck

quacks. Interestingly, in endorsing a prohibition on an ancient taboo, the pig undergoes a significant transformation: no longer the impure defiled object of Judaic thought, he becomes a pure speaking subject and is purged of his bodily—hence feminine—associations.

The transformation occurs by virtue of establishing a relation of identity between the pig and the Jew. The film *Babe* opens with shots that seem deliberately to quote scenes from *Schindler's List* in which the Jews are rounded up and herded into trucks. The voice-over in these scenes from *Babe* speaks in ironic tones of how in accordance with pig lore the pigs are being taken to a much better world from which they will never want to return (here, again, there's a swipe against Christian doctrine, in this case belief in an afterlife). In equating the stockyards with the concentration camps, in positing an identity between the abominator and the abominated, the film eradicates the subject/object distinction that the Biblical taboo is said to signify.

When Mrs. Hoggett goes off on a trip, other divisions and borders are transgressed: the pig is brought inside the house, and the house cat who attacks Babe is seized by the farmer and put outside in the rain. Up until this point the cat does not speak (indeed, at one moment during the film I turned to my companion and said, "I protest the dehumanization of cats in this movie"), and is given a (feminine) voice only because she needs to be the one to tell Babe that his purpose in life is to be meat, a truth which of course leads Babe to the conclusion that his whole family has probably been slaughtered. In evilly delivering the bad news to Babe, the cat may be said to have become the abominated object as it has been redefined by Christianity. We recall Mark: "Not that which goeth into the mouth defileth a man; but that which cometh out of the mouth; this defileth a man." Thus the demonization of the cat seems to return us to a Christian outlook—and to Christian prejudices. For let us not forget that in earlier periods Christianity persecuted cats, which were associated with witches and pagan goddesses. So while in the film the slaughter of certain animals and certain humans is invoked to elicit our pity, the history of the suffering of the *cat* remains unacknowledged. (Surely a different fable might link the cat with women, especially witches, and with Jews as targets of Christian zealotry.) Like the "witches" of old, Mrs. Hoggett is associated with the cat, who asserts the illicit rule of *female* authority: while all the other animals call the farmer the "Boss," the cat uses the term "Boss" to refer to Mrs. Hoggett.

In some respects the film can be interpreted along the lines of the interpretation given by historian Robert Darnton of what is called "The Great Cat Massacre," in which eighteenth-century French workers at a printing shop went on a spree killing cats because, according to Darnton, cats were associated with the boss's wife, who had a particular favorite that they butchered. Darnton argues that the torturing and slaughtering of cats symbolized a rape of the wife through which the men got back at their boss in particular and the bourgeoisie in general. If we wanted to follow up this analogy, we could say that the men were rebelling in part against being treated like pigs. According

to Darnton, the men

> slept in a filthy, freezing room . . . and received nothing but slops to eat. They found the food especially galling. Instead of dining at the master's table, they had to eat scraps from his plate in the kitchen. Worse still, the cook sold the leftovers and gave the boys cat food—old rotten bits of meat that they could not stomach and so passed on to the cats, who refused it.[4]

So the metaphorical conflict between pigs and cats is not a new one, nor is the device of scapegoating the woman by scapegoating her animal in order to protest, symbolically, one's place in a hierarchy. What *may* be new is not only the fact that the real "boss" in *Babe* is not ever perceived as villainous himself, but that he usurps the authority she appears to represent. For when the cat provides Babe with the devastating news about his fate and the probable fate of the rest of his family, Babe runs away, and is taken back inside by the farmer, who nurses him with a bottle, sings to him, and finally gets him to eat his food, thereby appropriating the maternal function.

Throughout history, the cat's fate has frequently been linked to man's perception of its usefulness: The more it has been recognized as helpful in the elimination of vermin, plague-bearing rats, and the like, the more it has been appreciated. In *Babe*, the cat has no purpose other than, as she says, to look beautiful for the "Boss" (Mrs. Hoggett). This question of the utilitarian value of animals is at the heart of the film, and indeed part of its project is to question the valuing of animals only insofar as they are of use to man (especially as food). But this message seems entirely recuperated when Babe successfully performs the work of a sheepdog and wins Mr. Hoggett first prize in the contest. In the end the animals must prove they can serve man so as to avoid being served by him (as the main course at Christmas dinner).[5] If they win contests and bring glory on their masters, they are spared the oven. Hierarchies are reestablished, only now the pig, who seemed to throw hierarchy into question, has displaced the dog Rex, who had been lord of the animals and enforcer of the rules, and becomes in effect man's new "best friend." If the pig—according to Kristeva's analysis—has been abominated by some because it poses a threat to logical order, the film by no means ends by questioning that order; rather the pig in *Babe* turns out to be an aid in keeping order (kindly), exhibiting early on a knack for classifying and sorting the animals: the first clue of Babe's extraordinariness is given to Hoggett when the latter suspects the pig of being responsible for separating the brown roosters from the white ones.

While the film appears to be subversive on a number of levels, challenging hierarchies, mocking the nuclear family, indicting aspects of Christianity, and allowing for the possibility of crossing the borders that divide humans and animals, and animals from each other (a duck and a rooster, a sheep and a dog), it winds up establishing a new humanism that extends to swine but not to woman—appears indeed to require her expulsion along with her "familiar," the cat. Instead of relations of (partial) identity, of kinship, we are given rather

relations of substitution characteristic of oedipal dynamics. Babe's mother as lost object is replaced by Maaa, the sheep; by the sheepherding female dog whom Babe asks to call Mom after her pups are taken from her; and finally by Mr. Hoggett himself.

I loved the film, and so did most of the people I know, including other feminists. Most of us were deeply moved by its whimsy and poignancy, its ability to exert on us the kind of charm we felt on hearing the beloved fables of our childhood. Yet in order to affirm the film as wholeheartedly as most of us wanted to do, we have had to bracket off its treatment of the human female, who is made to represent the animal body that the film never does come to terms with. But in so doing, are we not psychically replaying the abjection of the maternal as it is outlined in Kristeva's thought and enacted in the film?

Thinking about my own overidentification with the film because of the temporal proximity of its appearance to my mother's death and recalling my horror of her swollen, decaying flesh, I wonder how it is possible to take in the mother's body lovingly without symbolically devouring it or spitting it out as wholly inassimilable. In the final analysis, the film leaves me with a paradox. Though some people found the film's ending to be happy because Babe saves his own life and also gets many substitute mothers, I have been haunted by the moment when Babe learns that his mother and his whole family have probably died and been eaten. In the very act of psychically substituting the animal's relation to his mother for my relation to mine, I experienced a grief stemming from a profound sense that there *is* no substitute for a lost mother.

Notes

1. Donna Haraway, "A Manifesto for Cyborgs: Science, Technology, and Socialist Feminism in the 1980s," in *Coming to Terms: Feminism, Theory, Politics*, ed. Elizabeth Weed (New York and London: Routledge, 1989), 179.
2. In promoting advanced technology within the diegesis *Babe* avoids the bad faith of the film *Toy Story*, which, though it relies on the latest computer technology to make toys come to life, is actually about the superiority of the old-fashioned pretechnological world of children's toys: thus, its hero is a wind-up cowboy doll!
3. Julia Kristeva, *Powers of Horror: An Essay on Abjection*, trans. Leon S. Roudiez (New York: Columbia University Press, 1982), 114.
4. Robert Darnton, *The Great Cat Massacre and Other Episodes in French Cultural History* (New York: Basic Books, 1984), 75–76. [In *The Politics and Poetics of Transgression* (London: Methuen, 1986), Peter Stallybrass and Allon White have a chapter on the pig that is also very pertinent to my argument about *Babe*.]
5. Much could be said about the superiority of *Charlotte's Web* in this regard, since Charlotte saves Wilbur not by teaching him how to do something useful, but by writing the words "Some pig" about him, astonishing all who see the web and establishing pigs as inherently worthy.

Angelology

Things With Wings

Maria Damon

One night in Gioia's kitchen, all of us domestic angels of the hearth are getting dinner ready. Gioia is a single mother, so once a week or so the rest of us make her dinner.

Anya (Dept. of Religious History, four-year liberal arts college): I've just been asked to review a whole spate of books on angels; it's the latest thing. But what am I going to say? I know nothing about angels except that suddenly everyone's writing about them.

Gioia (Dept. of French and Italian, state university): Oh angels, yeah. My mother just sent me a clipping from *Time* magazine. It's a multimillion-dollar business now. She's always been into it, now everybody's doing it. Cheapening it. Disgusting.

Me (Dept. of English, state university): By amazing coincidence, I just signed up for an angel workshop at the Unity Church next week. Only $25 for six hours of communicating with angels, archangels, guardian angels, seraphim, and cherubim.

Gioia: I didn't mean to put it down . . .

"Earth-angel," "art-angel," "angel-baby" say the t-shirts in the gay tchatchke shops in Provincetown, Jamaica Plain, and elsewhere. Bumper stickers proclaim their cars to be "Protected by Angels." Four books titled *Wrestling with the Angel* have come out in the last year, ranging in subject matter from being gay in the academy to Jewish theological perspectives on grief and mourning; and books of testimonial ("I believe in angels," "Angels exist. They are real,"

This essay was written for this anthology.

etc.), of debunking, and of coffee-table angel-art-thru-the-ages abound, not only in New Age metaphysical bookstores but in mainstream ones as well. One how-to book along preppie-handbook gag lines advertises cut-outs: bad hair angel, parking space angel, portfolio management angel, protection against in-law angel. Each has its special prayer and suggestions for where to hang the cutout (from the rearview mirror, etc). In this cute book there's no incest-sur-vivor angel, no post-traumatic-stress-syndrome angel, no don't-let-me-turn-out-to-be-a-serial-killer angel, no cure-my-crack-addiction angel, no abortion- or reproductive-rights angel, no free-school-lunch angel. But these are elsewhere apparent in the more serious side of contemporary unmanageability.

If "cyborgs" (any blend of cybernetic and organic being) are the signature life form of contemporary life, angels are New Age spiritualism's version of cyborgs. Thwarting the strait-laced boundaries of beings' Great Chains, they blend human form and divine energy; they change shape at will, for the benef-icent purpose of helping humans, intervening in our harmful affairs. Juxtaposed to the "miracle of modern technology," they are miracles of hybrid-ity of a different but related order, in the sense that the "great chain of being" is a technology. They are "fun," as our angel workshop facilitator told us, play-ful and majestic—the perfect guardian our parents, teachers, partners, and authority figures could never be. Rather than subordinated to or created from human-generated technologies, as cyborgs are, they predate these technolo-gies. In fact they predate time itself, since angels populated Eden and whatever came before, and time, according to the golden legend that founded Western civilization, was initiated by the human fall therefrom. The words "ancient" and "timeless"—longtime mainstays of the metaphysical marketplace—offer soothing and stable counterparts to "new," "unprecedented," "revolutionary": words that characterize modernity flailing at its apex. And as in so many cases where the postmodern resonates eerily or comfortingly with the premodern, the solution to not having "enough time" (the speed-up of modernity) may be to somehow "go timeless"—beyond time, as the strangely luminous title of Duke University Press's ethereal series, *Postcontemporary Interventions*, inti-mates. Angels offer one template for what beings will look like after time's obsolescence; they are embodied without being mortal—timelessness anthro-pomorphized. Interest in angels, as well as apocalyptic cult activity, thus increases as the millennium draws near.

In the gay community angels have long been a figure for gay men them-selves—liminal outlaws of indeterminate sexual category, who can "pass" as straight citizens or trip out beyond recognition on gender-bending style and affect. In 1972, Bruce Rodgers's gay lexicon defined "angel" as "any homosex-ual male"; the epithet hit popular awareness with Tony Kushner's Broadway smash "Angels in America." In the last half-decade, gay male America has emerged as visible and co-optable into sitcoms, congressional hearings, road-trip movies about drag queens and other normalizing media mechanisms, and gay-rights struggles have been legitimated as normative civil-rights struggles;

and this high profile may account in part for angels' recent prominence. However, while Kushner's runaway theatrical success has brought the image to the fore, it points up a much earlier kinship that gay men have felt between themselves and other figures as well: fairies, butterflies, cupids (vampires for lesbians . . .), extraterrestrials. Wings or airborne-ness appear to be the sine qua non: the Yiddish word for "faggot," "feygele," means, literally, "little bird." So when Peter G wished me a visitation from the TABLOID muse, I saw her/him as a drag queen, screaming her headlines off, raking muck with her vast yellow wings.

In addition to millennial anxieties, AIDS has, of course, exacerbated issues of mortality; in the last century, the early (hence unnatural) deaths of children and the pathos ensuing from these deaths as aestheticized events (through fiction, photography, and so forth) led to the elision of angels with dead children—the tragedy of the unnatural (parents outliving their children) found consolation in the supernatural. (The Unity Church, which housed my angel workshop, was founded during this Victorian era by American Christian spiritualists, whose origin was catalyzed by two young girls' experience with spirits/angels in their New England farmhouse. Angels provide a nice intermediate step between a direct encounter with God and the humdrum company of the strictly human.)

Moreover, the seriousness with which claims of extraterrestrial visitations are being taken in some psychiatric and scientific circles indicates a similar desire to believe in a level of existence that transcends the purely material world, disclosing to us a more humane if less human life, while still developing out of certain values and physical forms we generally recognize as resembling those of everyday human life. Extraterrestrials, like angels, visit us from putatively far more advanced levels of being and civilization. They are our own potentials quasi-humanized, quasi-alienated through high-tech sophistication. They feel pity and compassion for us, and want to teach us better ways of knowing. Even terrifyingly traumatic tales of abduction have a glorified, transcendental quality—"I saw something too radiant for my human capabilities to sustain," or "I felt communicated with on a level that my mere mortality is not (yet) equipped to process." The spiritual tenor in such testimonials in some ways mitigates the disturbing, life-altering nature of these episodes, perhaps counterbalancing the horrific nature of the actual traumas that some medical and psychological investigators believe are being displaced into these narratives of angelic abduction.

"Martha, would you like to share your angel story?" the facilitator asked a frail older woman in green pants. Martha told about her first encounter with her guardian angel, Sika. Sika had appeared at the foot of her bed twelve years ago, luminous and initially frightening, as Martha lay in a torment of advanced alcoholic delirium. "She told me to go to AA." Martha had wanted to, but had been too scared. She was scared of the angel, too, and covered her head with the sheets and fell asleep. The

next day she remembered the visitation and, with the distance of daylight reality, found she was no longer afraid. She went to AA and has since been sober, with Sika's guardianship and protection.

"Has anyone else had experiences with angels they'd like to share?" asks the facilitator.

I wake up at three or four o'clock in the morning to a scratchy sound by my head. A bat! Frightened, wings clumsily half-unfurled, scuffling spasmodically along where the floor meets the wall, by the head of the bed. My cats watch with mild wonder. I, frightened, consider my options: kill, maim, get rabies, liberate. Though these are not mutually exclusive, the latter demands the least from me. A harrowing moment with Tupperware clapped over the brown scuffle of fur and bones, with its tiny, clawed hand sticking out beyond the jar's rim, wiggling its little digits. It's too scared to fight so it's in; I slide the top on, and make it down the stairs to the front door. I open the jar and shake-shake it. My bat flops down on the landing and, in a breathlessly graceful arc, sweeps off the stone step and into the night. A strange joy for me, a sweet sensation of relief—freedom. The following day, a flurry of letters and faxes and phone calls, and I'm given a thrilling professional opportunity, writing something for an exhibition catalogue for a show on angels of a different kind: Beat Generation Art.

Beats, too, played with angelology: *Naked Angels, Beat Angels, Bastard Angel, Genesis Angels*, "angel-headed hipsters," *Desolation Angels*, "Junk/Angel" are epithets that served as tag phrases and titles for Beat work and self-representation. As Beatniks, jazz, coffeehouses and open poetry readings make a comeback in an aesthetic grass-roots resistance to hypertech brutality, and the dirt of bodies sweating in performance generates a counter-technology to the disembodied virtues of the info superhighway (what a road to hitch cross-country on), angels re-emerge into a liminal space between the ultra-rarified ether of cyberspace and the physical wreckage of everyday life in the cities, towns, and rural areas disenfranchised by the Republican juggernaut. For the Beats, angels, especially highly (though ambiguously) sexual angels, represented a marriage of heaven and hell, or heaven and earth, that counterbalanced the similar space (vertically traversed horizon) occupied by the mushroom cloud, and offered a sacralized mirror to the disembodied shadows burned into walls and streets in Hiroshima and Nagasaki. Though during the 1980s *TABLOID* was reluctant to make the facile link between the '50s Eisenhower years and the '80s Reagan era, finding it more interesting to investigate the urge to make that link, the '90s show a dispiriting trend toward the further separation of minds and hearts, of people from the resources they need—physical, emotional, spiritual, economic—that both begs for and gives the lie to neat, decade-based periodization.

When assigned a diary to accompany our reading of Anne Frank's diary in the seventh grade, I'd addressed it to my guardian angel, whom I named Mike, though I didn't associate my interlocutor with the archangel until the after-

noon of my angel workshop at Unity Church. In a "guided imagery" meditation during the workshop, I saw Michael standing behind me, towering in white robes. On his shoulder sat a tiny bat like a dry, crumpled brown leaf.

"Does your angel have a name?" asks the facilitator.

Bat-sheba.

The connection with Anne Frank jogs an uncomfortable association: not simply another child who died unnaturally but an icon of genocide, of ethnicide, her pale face and hollow dark eyes already angelic even before incarceration and death. Some of my friends, primarily Jewish ones, including Anya the angel-book reviewer, are disgusted by what strikes them as facile New Age Pollyannaism, which includes the fiction of a personal spiritual guardian, be it an angel or the "higher power" credited with personal miracles in recovery circles. "My higher power made sure I got this great job." What about the higher powers of the chronically unemployed? "So and so's higher power saved him/her from death in the camps." What about those who weren't saved? Were they not sufficiently devout? One of the books Anya reviewed, the details of which she recounted with delicious scorn, had the author suffering from severe altitude sickness in the Himalayas, physically carried many miles by sherpas to save her fellow tourists from having to spend the money to rent a helicopter to rescue her. This incident was supposed to prove that angels exist. "What's so angelic about saving a bunch of yuppie tourists some money at the expense of the sherpas?" Obscene, that divine orders help one prosper at the expense of others, or that good fortune is celestially ordained.

Angels are incorruptible, immortal but embodied "children within" who have survived horrors, dead people we can talk to, babies with wings. It is not hard to see, though constituencies vary wildly, the commonality between the current popularity of angels, the heated debates about reproductive rights and child sexual abuse, and the persistent belief that there are MIAs/POWs still awaiting rescue in Southeast Asia. Abject innocents trapped in a system that wishes them only ill are transfigured into avenging, righteous, forever-young omnipotence. An angel is an inner resource suggesting the possibility of survival, an "inner child" purged of her aura of trauma and tragedy. She is not a record of calamity but a secret certitude of redemption. "You are not forgotten," reads the MIA/POW believers' slogan. And it is not surprising that George Howe Colt's feature article on angels in *LIFE*'s Christmas 1995 issue opened with an anecdote of anxiety over the progress of his wife's second pregancy after two miscarriages. A pair of nesting pigeons, judged in retrospect to be angels, guarded the human couple; when the pigeons' eggs turned out OK, the Colts somehow felt reassured about their own upcoming childbirth—and sure enough, things went fine. Reproductive issues are, of course, matters of life and death (as well as *LIFE* and Christmas), so an intermediary being, who, according to Bernard of Clairvaux, has a body at will so it can help human

affairs, is appealed to to bless that passage between no body and embodiment. Only a being who is and is not embodied can withstand and reassure the intense vulnerability of the human in reproductive crisis.

Etymologically, angels are "messengers," monotheism's counterparts to Mercury/Hermes of the winged feet, another icon of gay culture. The wildly popular novel and film *The Color Purple* featured a protagonist who wrote to God because she couldn't tell anyone else the secrets that were sapping her of life, and safe places for telling secrets have developed a credibility in popular and mass culture that speaks to their necessity. "Recovered memory" debates simply highlight the desire for a divine and beneficent, rather than human and self-interested, interlocutor—a guardian angel, more human, playful, and embodied than a conventional monotheistic abstraction. Angels are neither corruptible nor remotely absolute. Unravaged by life's unmanageability, angels will not come home after a hard day and hit us, or twist our stories to satisfy the myths their egos need to thrive. And conversely, we can't hurt them. Powerful, super(naturally) human, they will not perish if we forget to put their needs first. They are perfectly safe to relate to.

If we tell them our secrets, what do they tell us? They listen to our secrets and they bring us glad tidings: the Annunciation, one of the most popular subjects for paintings featuring angels, combines the figure of angel-as-messenger with angel-as-infant. The announcement of conception to a virgin points toward the centrality of reproduction and its problems—embodiment and its problems—in the invention of angels. Their re-emergence in popular culture today indicates the complexity and anguish of child-bearing and -rearing in a society that is increasingly hostile to women and children, and whose resources are increasingly the exclusive domain of the very wealthy.

If we tell them our secrets, what do they tell us? They tell us how, in a sort of de Certeauian guerrilla resistance, to survive this insane lacerating of our lives—trust this doctor, not that one, cross this street, not that. The magical pointers may be so minute as to be meaningless to all but the person following the whispered suggestions of intuition/angels. In a society that is divesting itself of all but minimal dog-eat-dog rules and reverting to the crudeness of bare-bones survivalism, angel magic spiritualizes street wisdom, common sense, survival instincts and intuitions, shared outsider-knowledge about how to get by. How many angels can dance on the blade of a sword, on the nose of a Trident missile? On the end of a hypodermic needle or a razor's edge? Angels do indeed seem to operate outside of any apparent system of justice. But then, so does the current system of justice. Angels operate on the black market, in the unseen realm, the privatized unsurveillable networks of personal need and desire. Like the Guardian Angels people's security force of the 1980s, angels move among us, disenfranchised, invisible, unsanctioned by the official police, the justice system, part of an attempt to find an alternative road to peace, plenty, freedom, and joy.

> In another guided meditation, our leader asks us to imagine we are growing wings. I focus on the knots of my shoulder blades and the muscle tucked under these proto-

wings. I feel the tissues twitching and forming a self-cognizant network. It isn't hard to fill in the picture—my own vast and sweeping wings dipping to the floor, half-unfurling, reaching their full span in a series of angelic aerobic stretches. It feels "expansive," easy to move beyond the darkened room of middle-aged Minnesota women sitting in a circle, all with eyes closed, all moving beyond the mournful, overcast day into realms of unending light and limitless power.

Jazzercise

A Hybrid Practice
at Its Beginnings

Mary Louise Pratt

My sister Kathy was five and I was four when our mum enrolled us in the local ballet class back home, and our sibling rivalry quickly and bitterly focused in on the upcoming recital in the church basement. The issue of whether her appearance as a sunflower in the Dance of the Sunflowers was superior to my own as a moonbeam in the Dance of the Moonbeams was resolved when a) unforgivably, the sunflowers got their picture in the local paper; and b) Miss Ewald suggested to mum that I try the tap class instead. My sister glided upward into toe shoes, while I continued my downhill slide from tap through Highland dance to Mrs. Hymers's acrobatics class, and finally into baton twirling. It was awful.

It was, therefore, with great hesitation that seventeen years later I let my friend Carol (also an alumna of Miss Ewald's class back home) take me to a jazz dance class at the San Francisco YWCA. It was all right for her—she had been a sunflower. I told her if there weren't any other moonbeams there I was going home.

The class was *wonderful*. The teacher was *nice* (F– – – you, Miss Ewald). And Carol and I became part of the mass dance craze that is now beginning to fill YWCAs, warehouse studios, school gyms and yes, even church basements, with all the twenty- to forty-year-old sunflowers and moonbeams of the baby boom.

Mind you, this is no longer dance as a class badge, as a means of acquiring the physical poise underlying such upper-middle-class skills as tea pouring, puff-pastry filling, and fur coat taking-off. This is dance for *exercise, stretching,* and *sweat*. The incorporation of dance into the physical fitness movement has given rise to some ways of doing quite distinct from the older dance-as-refine-

This essay appeared in TABLOID 6 (summer–fall 1982): 39–42.

ment practices. Aerobic dance, jazzercise, rhythm and motion, DancErgetics, energetics, rock-exercise—these are the new hybrid combinations of dance and calisthenics proliferating about as fast as names for them can be invented. They do just what the names suggest. To the accompaniment of selections from all types of popular music, you do combinations of stretching exercises and simple dance steps. All that's involved is approximating what the teacher does as best as you can, being sure not to push yourself too hard. Says one jazzercise teacher, "If you can't smile and speak while you're exercising, you're working too hard."

Hybrid is the right word for these forms, because they are all self-consciously *impure*. They oppose themselves on the one hand to "pure" dance, done in studios with mirrors and other real equipment and apparel, in small groups with specified levels of expertise and lots of competitiveness. Pure dance lessons are longer and twice as expensive as dance-exercise, and you have to go regularly and often to learn the routines and keep up with everybody else. The object of pure dance lessons is to improve and learn new moves, or possibly even put on a performance. None of these things is particularly important in jazzercise et al. Which is why pure dancers tend to look down on it. Their hostility is held in check, however, by the fact that some of them pay for their real dance lessons by running dance-exercise classes.

The real dancers and the flabby hybrids are united, however, in their suspicion of certain forms of pure exercise, notably running. Dancers avoid running because it produces tight, knotty muscles instead of the long, stretched-out ones they need. Jazzercisers and DancErgetes avoid running because it is difficult, lonely, and hurts, but also because it is competitive, improvement oriented, and serious. Indeed, like pure dance, running has even come to be oriented to performance, in public marathons, for which the jazzercisers are evidently supposed to provide the audience. Jazzercise is designed to make you run around and huff and puff some, but at the same time it tries to minimize the discomforts.

The dance-exercise boom is a fairly recent phenomenon, but it would be a mistake to think of these forms as having no history. Dance-exercise has a pretty direct line of historical antecedents in the various forms of women's calisthenics that have flourished since the late 1800s. (Seen old photos of your grandmother in bloomers and a middie?) An early codified form was Swedish Drill; a more recent one was the Canadian Airforce exercises, which during the 1950s and 60s provided the most precise and narrow recipe ever for physical fitness. As the Airforce clue suggests, outbursts of fitness frenzy have tended to coincide with periods of militarization and war fervor, when the physical resources of the population become a matter of national interest—even those of women who, in the case of conventional war, will be needed in the factories, and in the case of nuclear war will need to survive in some numbers to carry on reproduction and family life in the underground shelters. The rise of jazzercise classes likewise coincides with the current period of militarization, and has many of the militaristic aspects of the calisthenics forms. At the same time, its

use of music, dance, free motion, and its stress on variety and pleasure miti-
gate, or perhaps merely mystify, this grim-faced regimentation.

The impurity of dance-exercise is very important, because the main appeal
of this activity is precisely that it is *not* specialized, professionalized, or serious.
There are no national standards, no prizes you can win, no performances or
competitions, no established regimens or disciplines, though you can invent
any of these for yourself if you want. There is no need for your reach to seri-
ously exceed you grasp unless you choose to set it up that way for yourself.
Dance-exercise has (as yet) no specialized spaces, or kinds of music, or steps.
The instructors have no credentials, and there's no telling how or whether they
are trained to do this, whether they prepare classes ahead of time or just make
it up as they go along, and so on. Certainly you need no credentials to enroll,
and in fact there's often next to nothing to enroll *in*—no course, no class, just
lists of hours and places where you can show up if you feel like it or have accu-
mulated sufficient guilt about your body. And you pay as you go. Despite the
huge market for dance-exercise, no specialized magazines have sprung up. A
publication called *Dancercise Today* or something like that would have almost
nothing to write articles about, and little to advertise. And no one would buy it
either, because it is important not to be that serious about it. If you are, you
should move on to real dance and leave the moonbeams alone. (A member of
the *TABLOID* collective in fact has just experienced this transfiguration,
which the collective is still struggling to survive.)

Of course, here in consumerland, we cannot expect this nonspecialized
character of dance-exercise to survive very long—indeed, it is manifestly
changing even as this article is being written. Like all mass culture practices, it
can only be caught on the fly. The first domain of specialization, predictably,
is clothes, as with most leisure activities in this culture. Here, dance-exercise
has specialized by appropriating wholesale a set of clothing paraphernalia
from pure dance. It has provided a hugely expanded market for the Danskin-
type tights and leotards industry, who have of course responded by endlessly
multiplying the kinds and combinations of tights and leotards that you can
choose from. In a recent ad, a large department store coupled a sale on dance
clothes with jazzercise demonstrations and free lessons. Real dance calls for
much less of this wild elaboration. There, your leotards and leg warmers are
functioning as work clothes, not as the costume in which you will ultimately
perform.

What dance-exercise accomplishes for people seems to be mainly two
things. First, it is a genuine form of exercise, albeit not a very strenuous one,
whose strong point is that competition and self-motivation are minimized. The
classes have an almost militaristic regimentation, as the teacher shouts the
commands that move the fast-paced sequence along. At the same time, the
music—good sound and good variety are considered very important—takes
your mind off the pain, is loud enough to be totally absorbing, and brings into
association other pleasurable contexts. Above all, what makes dance-exercise
work is the collectivity of it all, the thing that sports like running and swim-

ming can't give you. There is a fair degree of internal comradeship in dance-exercise classes. Often they are neighborhood based or workplace based, so that the same people see each other all the time. But even when they are not, there is a strong, mainly female, solidarity that is exhilarating, especially for women doing atomized, boring, demeaning work, and lacking larger social networks. This is not to say we are dealing with a spontaneous manifestation of some natural collective spirit. Attacks, rapes, and murders of female joggers (and the paranoic treatment of these in the media) have done as much as anything else to herd women back indoors. In this sense, the source of comfort is also one of oppression.

Absence of class hierarchy is another liberating aspect of jazzercise groups, though again, the release is somewhat mitigated by the presence of stringent hierarchy based on skinniness and endurance, which has obvious ageist and sexist, if not classist, aspects, and which clearly perpetuates capitalism's most narrow and coercive prescriptions on the body. At the same time, jazzercise does eliminate certain kinds of physical and sexual constraint. It is social dance, but not dance as courtship. Whether or not both sexes are present, the stress, anguish, and constant failure involved in courtship dancing are totally absent. In some respects, dance-exercise does what group sports did (and still do in some enclaves) before they got specialized, expensive, and turned into spectacle; before, that is, you had to train for months and try out and pay money to be on the office softball team.

Though there's a risk of being too static and too schematic, one way of looking at the dance-exercise fad is to see it as an instance of a practice that kind of sprang up between established practices—in this case, between dance on the one hand, and exercise on the other—and that does and means things different from either. In this case, dance-exercise occupies a position of a nonspecialized, nonserious amateur activity, distinct from both professional activities and serious amateur activities. The momentum, of course, is for dance-exercise to abandon this terrain and become a specialized amateur activity, too. And guess who appears to be the major catalyst in that process? Could it be Jane Fonda with her flashy new string of high-quality, quality-controlled, very serious, very specialized, and very effective workout clubs? Whose profits, by the way, are dedicated to the Campaign for Economic Democracy.

Everyday Life Environments

Frames, Settings, and
Backgrounds That Shape Our
Shopping, Working, Dancing,
Playing, and Imagining

Breaking Silence, or an Old Wives' Tale

Sexual Harassment and the Legitimation Crisis

Tania Modleski

In an article on politics and the body published in a special issue of *differences* on postmodern feminist politics, Joan Cocks outlines, via a reading of Nietzsche, what she calls the "degeneration of radical politics" (152). Toward the end of the piece she makes this observation: "We find in segments of the population hyper-alert to the sexual harassment and abuse of women and children (a real enough harassment and abuse, to be sure), a suspicion of all socio-physical entanglements, a distaste for the confused opaque jostling in life in which, barring the grave offense, people must fend for themselves" (154). Written before the Clarence Thomas hearings, this statement, notwithstanding its parenthetical qualifier, will from a post-Thomas perspective strike many feminists as itself symptomatic of a degeneration of radical feminist politics. Cocks joins up with men all across the land who have been deploring the fact that since Anita Hill's allegations, they don't know where to draw the line anymore, that the most innocent forms of affectionate display in the workplace are liable to be misconstrued, that the "confused opaque jostling in life" in which women ought to fend for themselves (rather than, I suppose, pressing charges against the jostler) would be interpreted as sexual harassment and men would find themselves constantly victimized by sexually hyper-alert women. As to the question of what constitutes the "grave offense," Cocks gives no specifics; but we might note that one strategy in discrediting sexual harassment complaints is precisely to deny the gravity of almost *any* accusation. Definition is in fact precisely at issue: Who is authorized in a patriarchal society to make and enforce definitions of sexual abuse? And on what grounds and in whose interests are they made? These questions—precisely the questions, I would submit,

This essay first appeared in DISCOURSE *16.1 (fall 1993): 109–125. It is reprinted here by permission of the author.*

that must be addressed by a feminist political theory—are entirely elided in the article.

Turning to Cocks's footnotes, where she lists some of the degenerates, we find the name of Catharine MacKinnon, whose work is sure to crop up in almost any discussion—and there are many such today—that deplores feminist theory's alleged hyper-alertness to women's sexual victimization. It will come as no surprise to many readers of this essay that Catharine MacKinnon is *persona non grata* in postmodern feminist circles. Yet inasmuch as feminists, postmodern and otherwise, were united in their misery over the Thomas hearings and their outcome, the time may be right for a rethinking of postmodern feminists' challenge to theorists and activists such as MacKinnon, whose first

"The question is clearly one of credibility: Whose story gets culturally legitimated and how? Whose stories are granted no relation to truth, and how are their authors discredited and relegated to the status of fanaticists and hysterics?"

book was on sexual harassment in the workplace and who was co-counsel in the Supreme Court case that made sexual harassment illegal for the first time in history. Given that the new Supreme Court justice's wife declared in an infamous *People* magazine article that she feels Thomas "doesn't owe any of the groups who opposed him anything," we might expect MacKinnon's and feminism's court win to be a short-lived victory in a battle that, along with the abortion rights battle, may have to be fought all over again (108). Theorists need to be ready to prepare the ground for and reflect on feminist practice in the struggles that lie ahead.

In this paper I want to examine, in light of the Thomas hearings, the postmodern feminist attack on the notion of a shared "experience," like that of sexual harassment, among women that cuts across race and class lines and hence can serve as a ground of feminist political action. Postmodern feminism argues against the viability of this notion by appealing both to the way that race and class divide women and to the fact that the language in which women's experiences are articulated cannot be trusted to render them accurately. Some feminist legal scholars have turned to feminist literary theory to mount this latter challenge, and at the end of the paper I want to turn to a brief consideration of the new alliance between law and literature to ascertain whether those of us in the humanities can join with feminists in legal studies to work for feminist political change.

The belief in a commonality of "experience" among women, which once would have been sufficient grounds for feminist action around the Thomas/Hill episode, has frequently been assailed in postmodern feminist theory for being essentialist, as is the related belief that breaking silence and speaking about one's sexual experience can be liberating and lead to effective political

action. "Within modernity, [the] voicing of women's experience acquires an inherently confessional cast," says Wendy Brown, writing in the same issue as Cocks and referring to Foucault's thesis that to speak about sex is simply to open further, intimate aspects of one's life to surveillance and disciplining by the dominant social powers.[1] In Foucault's formulation, attempting to tell the truth about one's sexual experience is to relinquish this sexuality to the authorities who use the knowledge gained about it for the purposes of social control. But for women, the paradoxes of speaking what they often take to be the truth about sex, especially when it concerns an act of sexual abuse perpetrated against them, are more excruciating than any encountered in Foucault. Catharine MacKinnon writes of one paradox in a way that will seem painfully accurate to many of us who were riveted to the television during the hearing. "One dimension of [the] problem involves whether a woman who has been violated through sex has any credibility. Credibility is difficult to separate from the definition of the injury, since an injury in which the victim is not believed to have been injured *because she has been injured* is not a real injury, legally speaking" (110). What MacKinnon describes is a deconstructor's dream: woman is alienated from the truth about her experience in the very act of experiencing it. The sexually violated woman, it might be said, exemplifies the postmodern condition, personifying the crisis in legitimation and signifying on her discredited body what Nietzsche called (in a phrase much celebrated today) the untruth of truth.[2] (Incidentally, we might note that the defense attorney in the rape trial of Mike Tyson tried, unsuccessfully, to mobilize an argument that involved a double bind similar to the one described by MacKinnon, but from the male side, when he claimed—with considerable agreement expressed in public opinion polls—that Tyson's victim has no case because it was generally known that Tyson was sexually aggressive with women. So, it would seem, a man cannot be a rapist if he is a rapist, and known to be such, just as a rape victim might not be considered injured because she has been injured.) In the face of the Kafkaesque nature of the legal system as women experience it, how do feminists who have witnessed a crisis in legitimation in women's accounts of their experience told in two recent mass cultural spectacles (the Thomas hearings and the Kennedy-Smith rape trial) respond to a postmodern feminism that seems increasingly to be in complicity with the phantasmatic logic of patriarchal systems?

 MacKinnon's solution to the problem is quite different from a certain vulgar Foucauldian position that would counsel silence; rather, she attempted throughout the years to get women's voices heard and to develop "an account of the world from women's point of view"; in doing so, she has frequently been condemned as essentialist. Wendy Brown, for example, taking a stand against MacKinnon's project, notes that women's words "cannot be anointed as Authentic or True since the experience they announce is linguistically contained, socially constructed, discursively mediated, and never just individually 'had'" (72). Brown is surely right to call into question a certain radical feminist naiveté about the ability of language to convey in a transparent way the

truth about experience. But, just as surely, the task for a feminism skeptical about the "transparency" of language is not to celebrate, as Cocks does, the "confused opaque jostling in life" in which women who struggle to assign meaning to experiences of sexual violation are considered to be hysterically overreacting to men who were, after all, just jostling. If meaning and language are socially constructed, as we are constantly reminded these days, how can women get to be social-construction workers in building our own truths (instead of always being the construction site)? If experiences are never simply "had" (although some, I would argue, come very close), how do women begin to discuss their experiences of *being* "had"?

One way to avoid the unproductive extremes of the transparency/opacity divide is to look at the ways in which meaning and legitimation become loci of contestation, as various narratives that shape our understanding and experience of events circulate and get accredited or discredited in the process. This is a point made frequently by contributors to the book on the Hill/Thomas controversy *Race-ing Justice, En-gendering Power*, edited by Toni Morrison. Indeed, Christine Stansell in her essay "White Feminists and Black Realities: The Politics of Authenticity," shows that prior to Hill's allegations, MacKinnon spoke in favor of the Thomas nomination because, rather than seeing Thomas's story of growing up in poverty in the rural South as following "a more or less conventional narrative" (one which "turns upon the moment Thomas left his downtrodden mother to live with his grandfather"), she praised the judge's connection with "reality." Stansell quotes MacKinnon: "He approaches issues from an actual experiential base rather than the kind of abstracted-from-life categories of legal analysis. . . . When he talks, he seems to start off with life experiences" (255). (I would point out, however, that MacKinnon's mistaken allegiance stemmed less from her problematic use of the term "life experiences" than from the logical fallacy of her thinking, which, starting from the notion that feminism draws on life experiences, concludes that anyone drawing on life experiences is feminist or an ally of feminists.)

I would like to pursue the question of narrative from a direction different from the ones chosen by the writers in the Morrison anthology. None of the contributors addresses in any detail the question of essentialism as it has been debated within postmodern feminism, nor do they, except in passing, consider the role of one of the chief supporting actors in the drama set into motion by Hill's allegations: Virginia Thomas. As a white woman trying to come to terms with the question of essentialism and with the challenge racial politics poses to theories of gender, I think it is appropriate for me to focus on the character and the story of the white wife in exploring these problems. My primary point of reference will be the extraordinary interview with Virginia Thomas in *People* magazine, on the cover of which we see Clarence Thomas, as one letter to the editor describes him, "grinning and hugging his wife like the latest television celebrity " (Stovall). The interview is titled "Breaking Silence" — and here we observe even before the first words are spoken the tendency of mass media to

appropriate the words and slogans of the dominated group (here a slogan about the necessity of speaking out) and to twist them to suit the interests of those in power. Virginia reveals that she herself has suffered from sexual harassment, but with the help of her husband got the problem solved "discreetly" (111). Virginia's revelation about her own experience places her in the company of a huge number of women. During the hearings, women continually testified to having been subjected to sexual harassment; what was disturbing about these revelations was that the women "broke silence" only so as to place their experience in the service of a man charged with having harassed another woman. Indeed, Virginia's "breaking silence" was itself emphatically *not* connected to her experience of harassment but to the silence imposed on her during her husband's ordeal: "Forced to endure her husband's trial by fire, a wife speaks out at last" (108). Virginia wants to make a clear-cut distinction between her own experience of harassment and that allegedly experienced by Hill: "It wasn't verbal harassment, it was physical," she says, thereby invoking difference of experience to deny commonality with other women—not unlike some feminists for whom anti-essentialism has a tendency to get entangled with what used to be called "false consciousness" (111).

Apropos of "breaking silence," we may note in passing the double bind of a woman like Anita Hill in relation to the mass media. Punished during the proceedings by the constant insinuation that she was telling these events to gain publicity for herself—that is, to sell her story—she was then punished for *refusing* to tell her story for fame or a fee: "More than a dozen times in the past few weeks, *People* approached Anita Hill or her representatives for her account of her unwanted time in the spotlight, but she has declined to be interviewed" (108). Having absolved themselves of the responsibility to present both sides, *People* allows itself carte blanche (as it were) to publish the outraged wife's vilification of the wronged woman.

These accusations are shaped for us by being embedded in a narrative that has had an incalculably strong impact on the nation's psyche. Insisting again on difference between the women, Virginia says, "My case was also different because what she did was so obviously political, as opposed to trying the resolve the problem. And what's scary about her allegations is that they remind me of the movie *Fatal Attraction*, or in her case, what I call the fatal assistant. In my heart I always believed she was probably someone in love with my husband and never got what she wanted" (111). And so Anita Hill becomes, in the "Virginia Thomas story," the single woman so desperate for love and sex that she metamorphoses into a dangerous psychopath. There is, however, a strong irony here when we consider that, as in the film *Fatal Attraction*, it is the wife who kills off the other woman for the preservation of the family; only in Anita Hill's case it is a question of *character* assassination. Moreover, what Virginia fails to mention is that in the film the husband *really did* become sexually involved with the woman.

The headline on the cover of the magazine trumpets the words "How We Survived," suggesting that melodrama, not the suspense thriller, was the pre-

vailing genre in the unfolding of the story. Thus, when Clarence Thomas finished his discussion of the trials and tribulations of growing up poor in the rural South, George Bush observed, "There wasn't a dry eye in the house." One of the Democratic senators who spoke on the day of the vote alluded to this remark, and referred to Richard Wright's determination in writing *Native Son* to construct a story that no one ("bankers' daughters" is the group Wright invoked) could shed a tear over, a story that would deny middle-class whites the luxury of pathos. The senator continued, "At this point in time, Mr. President, America cannot afford the sentimentalization of black culture."

The first and most well-known melodrama of suffering black manhood, another narrative that has riveted America for well over a century, is, of course, *Uncle Tom's Cabin*, written by a white woman, Harriet Beecher Stowe (and references to Uncle Thomas have indeed not been lacking in the alternative press). It is Stowe's story that Wright was writing against, countering with a more militant, angry version of black manhood than the one told by the white woman. In the context of this struggle between the sentimentalist and anti-sentimentalist versions of black America, Virginia's final remarks acquire a particularly sinister irony. Pictured with Clarence reclining on the sofa and reading the Bible (and it's really amazing that the photographer just happened by at that intimate moment), Virginia says, "Even though I grew up in a comfortable, middle-class world, I've always hurt for black America and what white America did to blacks. But Clarence taught me to go beyond that—to treat all people the way you wanted to be treated" (116). Thus the black man who opposes affirmative action, and who is not above soliciting tears when they benefit him, teaches his white, middle-class wife (a real-estate developer's daughter) to get beyond her compassion, thereby fulfilling Wright's mission in the most perverse terms imaginable.

In this battle between the sentimentalists and the antisentimentalists as I have sketched it here, it will be noted that the whites are women and the blacks are men—a state of affairs that characterized much of the mass cultural treatment of the Hill/Thomas controversy. For example, in one famous episode of the television program *Designing Women*, which features a cast primarily composed of white women, several of the women engaged in a debate over the veracity of Anita Hill. The show's sympathies were clearly on the side of Hill: the final images showed George Bush reading a speech at the swearing-in ceremony and declaring that all "men" are created equal. Several shots of white men pronouncing verdicts against Hill were followed by a freeze frame of Anita Hill at the microphone, eyes cast downward. It was a very moving ending. Nevertheless, it is striking that the only regular cast member on this show other than the white women is a black male law student who in this episode objected to the judge's inadequate credentials.[3] Here the black woman who was being talked *about* disappeared as a speaking subject, as a commentator on her own experience, and, implicitly, race and gender became polarized.

Nevertheless, African-American women found other ways to articulate the

complex interaction of issues of race and gender at work in events surrounding the Thomas hearing. One of the earliest and most moving discussions of these events was written by Rosemary L. Bray in the *New York Times Magazine*. Speaking of the particular lack of credibility of black women's accounts of their experiences, Bray writes, "The signs and symbols that might have helped to place Hill were long ago appropriated by officials of authentic (male) blackness, or by representatives of authentic (white) womanhood. Quite simply, a woman like Anita Hill couldn't possibly exist. And in that sense, she is in fine historical company" (95). Bray enters the lists in the battle of the narratives by invoking the slave narrative *Incidents in the Life of a Slave Girl*, by Harriet Jacobs, which was recently authenticated as a true story by Jean Fagan Yellin and which Jacobs wrote in part because she could not interest Stowe in telling her account of her own slave experience (see Yellin). Bray remarks that this tale "would have made more instructive reading for the Senate Judiciary Committee than *The Exorcist*," which was invoked at one point (95). Jacobs's narrative begins, "Reader, be assured this narrative is no fiction. I am aware that some of my adventures may seem incredible; but they are, nevertheless, strictly true" (1). Bray herself notes that this account, while "true," was nevertheless shaped by the conventions of sentimental fiction, the genre in which Stowe also wrote (95). Bray clearly is *not* then arguing for some immediacy of experience on the part of the writer, nor relying on the naive assumption that one's experience can be communicated through language in such a way as to reveal the Authentic Truth. Rather, for Bray, the question is clearly one of credibility: Whose story gets culturally legitimated and how? Whose stories are granted *no* relation to truth, and how are their authors discredited and relegated to the status of fantasists and hysterics?[4]

In view of the prominence of the category of hysteria in cases dealing with women's complaints of sexual abuse, it seems worth examining the term *hysteria* more closely. Postmodern theory has elevated hysteria to a paradoxical kind of truth status — the untruth of truth. Freud's thesis is that the hysteric's "original trauma" did not always possess meaning at the outset, but only acquired it at a later time when other events or the acquisition of adult knowledge (for example, of the sexual act) conferred retrospective meaning on the original event.[5] This Freudian insight is at the heart of the theory of "deferral" that functions so largely in postmodern and deconstructive thought: these theories draw on Freud to argue that there is no founding truth, only truth effects that are the result of iteration. What interests me here about the concept of deferral, using the term in its more ordinary sense, is the extent to which it functions in women's responses to sexual harassment. Anita Hill was continually badgered for not having responded immediately to the insults dealt her by Thomas; she was considered guilty in large part because she deferred her complaint. Deferral is indeed extremely common in cases of harassment. "Barring the grave offense," where, for example, the boss throws you over the desk, holds a gun to your head, and rapes you, many offenses are not immediately registered as harassment by the victim; frequently the woman goes away confused

about what happened and about what the incident really meant. Women often report checking with a confidante, whose role is to support her and help her understand that what happened was "really" offensive and demeaning and that she ought not to have to "fend for herself" in dealing with the matter.

Interestingly, then, the space of deferral is the space of women's hystericization, but it is also the space of feminist politics: it takes a second woman to help confer meaning on the first woman's experience, and this process greatly magnified *is* feminism (in fact, I have always maintained about women in patriarchy that "one is a hysteric, and two are a movement"). I hardly mean here to discredit the entire project of psychoanalysis, condemning it as nothing more than a patriarchal plot to consign women's experiences of real abuse to the category of fantasy. Indeed, psychoanalysis might prove useful in understanding not so much Anita Hill's fantasies, but Clarence Thomas's repression (assuming he did indeed forget everything that happened), to say nothing of his and Kennedy-Smith's woman hating (though psychoanalysis surely cannot provide a *sufficient* explanation for woman hating). And, yes, Virginia, psychoanalysis can help to explain women's complicity in an oppressive system as well as to understand the appeal, to women and men, of narratives like *Fatal Attraction*—the appeal, as a matter of fact, of much of the literary canon, which from *Pamela* on eroticizes dominance, invests sexual harassment with its libidinal charge, and contributes to the confused opacity about sexuality experienced by women nurtured on fairy tales, television, and entertainment magazines, as well as the great tradition. As one culturally legitimated narrative about growing up male and female, psychoanalysis takes a place with many other narratives in shaping our understanding of experience. In any case, my ultimate point here is that feminism is not about uncovering original truths but about "changing the stories," to paraphrase the title of a book by Gayle Greene, and insisting on their credibility—a process that can occur only within a collectivity.

This conclusion—that feminism is about changing the stories—would seem to suggest that feminism must recognize the great relevance of an engagement with questions of the literary; indeed legal scholars such as Patricia Williams and Drucilla Cornell are currently exploring how literary and legal studies might fruitfully be combined. For example, in a version of the criticism we have already encountered of Catharine MacKinnon's supposed naiveté about language, Cornell in her book *Beyond Accommodation* criticizes MacKinnon for failing to recognize the importance of what she calls "metaphors of the feminine" (147). MacKinnon, in Cornell's view, unwittingly validates male reality as the only reality (because, according to MacKinnon, men have the power to impose it on women) and thus is actually in complicity with the system she purports to be challenging. In particular, Cornell faults MacKinnon—referring to the latter's disagreement with the psychologist Carol Gilligan—for devaluing the feminine, which Gilligan's work tends to affirm. But Cornell also criticizes Gilligan for rooting her affirmation of the feminine entirely "in the way women are." Cornell prefers to emphasize,

with Luce Irigaray, that women are always more than that which can be captured within representation, an excess that characterizes metaphor—literary language—itself, and that Irigaray has famously said is revealed through the process of feminine *mimesis*.[6] It is through literary language, Cornell contends, that new meanings come into play. "To reach out involves the imagination, and with imagination, the refiguration of Woman. [This] kind of shift in the presentation of Woman is particularly important in legal discourse if the wrongs to women are to appear at all" (169).

While Cornell and MacKinnon share certain concerns, the emphases in their work place them in some respects at opposite poles. MacKinnon is wary of feminism's straying from an exclusive focus on women's oppression today, whereas Cornell's chief aim is to insist on the utopian dimension of feminist discourse, arguing that we need an elsewhere from which to critique the present order as well as to imagine the possibilities for a world transformed along feminist lines. But Cornell, who in her own writing does not seem to adopt the kind of feminine writing she advocates, never really discusses how feminists are to intervene in the legal system as it is today, and so she never suggests how we can make the wrongs to women, which her method purports to make appear, disappear. Part of the problem is her insufficient attention to the issue of the feminist collective, which I have been arguing is crucial in the struggle to ratify the new meanings that feminism would put into play. (This problem—the neglect of what we might call the contexts of interpretation—is, I think, a consequence of her desire to displace the notion of gender identity and to promote the Irigarayan concept of feminine specificity in its stead).

So the question remains as to how one can address a legal system to which women are forced to submit and which has not heard the truth about the metaphorical nature of all language (clinging tenaciously to its faith in language's transparency) and at the same time not simply fall victim to the belief in the reality of the dominant group as the only reality. Patricia Williams's book *The Alchemy of Race and Rights* (the very title of which denotes transformative powers) is a brilliant attempt to forge a language that points to a different future at the same time that it specifically and concretely addresses the wrongs historically and presently perpetrated against women and most particularly against blacks.

The Alchemy of Race and Rights is an amalgam of several genres of writing—autobiography, legal doctrine, anecdotes, critical theory, humor, and fiction. The book's many facets are appropriate to the complexity of its writer's cultural situation as a black female lawyer in a white man's world. Williams movingly discusses the contradictions of her position in American culture and reveals these to be at least as complicated as those expounded by MacKinnon. In the final chapter of the book, for example, Williams provides an account of her own history and ancestry that reveals the inadequacy of a model operating without recognition of the specific paradoxes of black women in relation to a law that doubly disinherits them. Williams's great-grandmother was impregnated by a white lawyer named Miller, who owned her; when Williams herself

prepares to go to law school her mother reassures her, "The Millers were lawyers, so you have it in your blood" (216). Noting that the mother was implicitly advising her daughter not to look to her as a role model, Williams writes: "She hid the lonely, black, defiled-female part of herself and pushed me forward as the projection of a competent self—a cool rather than despairing self, a masculine rather than a feminine self" (217). Unable to claim her feminine heritage, Williams also reflects on the double bind of a woman who inherits from an ancestral father the law that once made blacks into property: "Claiming for myself a heritage the weft of whose genesis is my own disinheritance is a profoundly troubling paradox" (217).

As we see from these quotations, Williams is not afraid to "risk essentialism." She speaks unabashedly of black selves and female selves as well as black and female "ways of knowing" and insists on defending these ways against the imposition of male systems of thought. Like Cornell, Williams clearly feels that a repudiation of those traits traditionally assigned to women amounts to a kind of repudiation of women as they have historically inhabited their roles. In this respect both Cornell and Williams follow Gilligan's lead in affirming "the feminine." At one point Williams illustrates the importance of ratifying the experience of oppressed groups such as blacks and women by recounting a story about a boy whose fear of big dogs is met by his parents' dismissive insistence that there is no difference between a wolfhound and a Pekinese. Williams says she has used the story in her law school classes to illustrate "a paradigm of thought by which children are taught not to see what they see; by which blacks are reassured that there is no real inequality in the world, just their own bad dreams; and by which women are taught not to experience what they experience, in deference to 'men's ways of knowing'" (13).

At the same time that she affirms "the feminine," Williams seems less averse than Cornell to employing "men's ways of knowing" as a means of contesting the legal system from within.[7] Thus Williams continually uses the principles and language of contract law to expose the inequities blacks and women encounter in this system. ("Blacks have earned a place in this society," she argues in a defense of affirmative action programs. "They deserve their inheritance as much as family wealth passed from parent to child over the generations is 'deserved inheritance'" (191).) In moving between black and female ways of knowing and white men's ways of knowing, Williams opens a space for whole *new* ways of knowing, which she gestures toward by using the literary language that Cornell calls for but does not herself employ: metaphors, allegories, fictional stories (which often read like folk tales), etc. The voice that emerges is thus a profoundly personal one, designed not only to respond to the calls of feminist legal scholars to begin to formulate a reconstructed form of jurisprudence that would acknowledge the relational nature of human subjectivity, but also to reveal how "much of what is spoken in so-called objective unmediated voices is in fact mired in hidden subjectivities and unexamined claims that make property of others beyond the self, all the while denying such connections."[8]

For Williams the task is finally to reveal such connections and also to *forge* them in creating "a collective perspective or social positioning that would give rise to a claim for the legal interests of *groups*" (emphasis added). The story about the wolfhound, she says, is meant to show that

> in a historical moment when individual rights have become the basis for any remedy, too often group interests are defeated by, for example, finding the one four-year-old who has wrestled whole packs of wolfhounds fearlessly to the ground; using that individual experience to attack the validity of there ever being any generalizable four-year-old fear of wolfhounds; and then recasting the general group experience as a fragmented series of specific, isolated events rather than a pervasive social phenomenon. (13)

(We might note that although Williams seems to be speaking against opponents of affirmative action, she could easily be addressing those postmodern feminists who decry as essentialist any generalizable claims based on gender.) One performative accomplishment of Williams's style is that instead of proceeding in an abstract way to defend "group rights," Williams enacts a collective perspective, as it were, in part by staging many of the arguments as dialogic encounters: classroom situations, conversations with colleagues, anecdotes about her family, etc. As a member of two groups that have historically been "objects of property"—blacks and women—Williams becomes the voice of the goods when, to quote Irigaray, "the goods get together."

Operating at once from within male systems of knowledge and power and from the Irigarayan "elsewhere," Williams's writing is a kind of hybrid writing fully adequate to the task that the case of Anita Hill, another African-American lawyer, makes so urgent: the collective feminist enterprise of telling stories that are true to our shared experience, that contest the oppressiveness of much of this experience and that put new meanings into play. But it also reminds us of the importance of our collective differences. Williams's own family history makes some of these collective differences vividly apparent, helping us to see why the term feminism should be, *pace* MacKinnon, "modified"—certainly by terms like "African American" that speak for these key differences in experience and perspective. Indeed, Kimberle Crenshaw has forcefully shown how a feminism *unmodified* by race led white feminist supporters of Hill to undermine her authority: "White feminist acquiescence to the either/or frame worked directly to Thomas's advantage: with Hill . . . cast as simply a de-raced—that is, white—woman, Thomas was positioned to claim that he was the victim of racial discrimination with Hill as the perpetrator" (415).

I would like to end with a story drawing on the same version of history as that recounted by Williams, a history that is, after all, partly one of white female racism. This story was invoked by one of this nation's preeminent storytellers regarding the Virginia Thomas interview. In a letter to *People* magazine, Alice Walker writes, "Black women around the country are sharing a rich chuckle at Virginia Thomas's assertion that she believes 'Anita Hill was probably in love with [her] husband.' The mistress on the plantation used to say the

same thing about her female slave every time she turned up pregnant by the master" (5). Virginia Thomas's story is, as Walker reminds us, an old story—an old *wives'* tale, so to speak—that functions to disavow the experience of the black woman so movingly depicted by Harriet Jacobs, whom Bray quotes: "My master began to whisper foul words in my ear. . . . The other slaves . . . knew too well the guilty practices under that roof; and they were aware that to speak of them was an offense that never went unpunished. . . . I longed for someone to confide in. . . . I dreaded the consequences of a violent outbreak; and both pride and fear kept me silent."[9] We cannot afford to participate in the endless deferral of women's stories; as women we must become for each other the confidantes Jacobs lacked—engaging in our own confirmation process and granting legitimacy to each others' stories in their sameness but also in their differences.

Notes

1. Brown rebukes "North Atlantic feminists" who naively "seek to preserve some variant of consciousness-raising as a mode of discerning and delivering the 'truth' about women" (73). Yet how can a feminist deny the positive consciousness-raising effects of Hill's testimony about her experience of sexual harassment? Brown is, of course, drawing on Michel Foucault's *The History of Sexuality*.

2. The phrase "legitimation crisis" is a key phrase in the discussions about postmodernity: The decline of the "public sphere" is seen to result in crises of authority and language—crises that Jürgen Habermas deplores and that, to a certain extent, Jean-François Lyotard celebrates. See the article on the Thomas/Hill hearings by Nancy Fraser, who has written extensively on the debates between Haberman and Lyotard. The idea that the body of the raped woman signifies the deconstructive ideal is unfortunately not far-fetched: see the debates over the novel *Clarissa*—in particular Warner and Castle.

3. In his contribution to the Morrison collection, popular-culture critic Andrew Ross has nothing but praise for the "hilarious" episode of *Designing Women*; his discussion of this program is followed by a concluding paragraph that strikes what Ross calls a "mischievous" note: a quotation from Charles Manson incoherently ranting about the need for more judges on the Supreme Court. Recalling an earlier essay by Ross on female essentialism that constructed its case around the Yorkshire Ripper, I can only wonder at this critic's tendency in "feminist" discussions of female liberation and female sexuality to invoke men who have committed grisly crimes of violence against women.

4. I was recently reminded of the importance of storytelling and credibility in a case I have become acquainted with of sexual harassment by a professor of a student. When the male supervisor to whom a complaint was issued heard the accusation, he continually reiterated that he believed the accused. Interestingly, however, the accused had not been confronted with the complaint and so had *not yet denied* it. That patriarchy survives in part through men's transforming into law and truth each other's stories, which at a certain point don't even need to be told because

they assume the status of the "already read," seems to me a point that cannot be stressed enough. As Judith Resnik writes: "[Women lawyers] know the risks of repeating the stories already told, of law not as a vehicle for changing but for reaffirming the arrangements of the status quo" (1938). For Resnik, "The feminist interruption of 'law and literature' occurs at the juncture between the texts of the powerful and the readers of the powerful" (1940–41). Out of the struggle that takes place at the level of interpretation—in lower courts, law classes, and other arenas—comes the possibility of generating feminist counterstories that legislate truths beyond the "already read," truths that will not be dismissed as the delusional ravings of hysterics.

5. See Breuer and Freud, especially the case study of Fraulein Elisabeth Von R. (135–81).

6. "*Mimesis* . . . is the way we can move within the gender hierarchy to engage with their metaphors of us, and give them new meaning, precisely because of the excess of what is not implicit in metaphor" (Cornell, 148).

7. Indeed, Cornell's refusal to adopt "the masculine" at any point is striking for a writer who insists on the need to go beyond binary logic. "Since we are in this bipolar world of gender identity, we can *only* proceed to what is Other through *mimesis*. The *other choice* is to repudiate the feminine, as MacKinnon does, and by so doing to reduce our desire to the fantasy of symmetry" (156; emphasis added). But why must there *be* a choice? Given Cornell's reliance on Irigaray, who declares woman to be "the sex which is not one," it seems curious that for the purposes of her polemic against MacKinnon she accepts the either/or terms offered to gendered subjects in patriarchy. See Williams's discussion of the importance of the notion of "rights" in the history of civil rights activism for an eloquent argument about the necessity of retaining certain terms that have figured importantly in (white, male) law (146–65).

8. Williams, 11. For a summary of the debates within the theory of feminist jurisprudence over the application of studies such as Gilligan's *In a Different Voice*, see Whitman.

9. Quoted in Bray, 95. However, for an interesting discussion of the subversive uses of silence in the text, see Valerie Smith's discussion of the novel.

References

Bray, Rosemary L. "Taking Sides Against Ourselves," *New York Times Magazine*, 17 November 1991, 56+.

Breuer, Josef, and Sigmund Freud. *Studies on Hysteria*. Trans. James Strachey. New York: Basic Books, 1957.

Brown, Wendy. "Feminist Hesitations, Postmodern Exposures." *differences* 3 (1991): 63–84.

Castle, Terry. *Clarissa's Ciphers: Meaning and Disruption of Richardsons' "Clarissa."* Ithaca: Cornell University Press, 1982.

Cocks, Joan. "Augustine, Nietzsche, and Contemporary Body Politics." *differences* 3 (1991): 144–58.

Cornell, Drucilla. *Beyond Accommodation: Ethical Feminism, Deconstruction, and the Law*. New York: Routledge, 1991.

Crenshaw, Kimberle. "Whose Story Is It, Anyway? Feminist and Anti-racist Appropriations of Anita Hill." Morrison 402–40.

Fraser, Nancy. "Sex, Lies, and the Public Sphere: Some Reflections on the Confirmation of Clarence Thomas." *Critical Inquiry* 18 (1992): 595–612.

Gilligan, Carol. *In a Different Voice.* Cambridge: Harvard University Press, 1982.

Foucault, Michel. *The History of Sexuality: An Introduction.* Vol. 1. Trans. Robert Hurley. New York: Pantheon, 1980.

Greene, Gayle. *Changing the Story: Feminist Fiction and the Tradition.* Bloomington: Indiana University Press, 1991.

Habermas, Jürgen. *Knowledge and Human Interests.* Boston: Beacon, 1971.

Irigaray, Luce. *This Sex Which Is Not One.* Trans. Catherine Porter. Ithaca: Cornell University Press, 1985.

Jacobs, Harriet A. *Incidents in the Life of a Slave Girl.* Cambridge: Harvard University Press, 1987.

Lyotard, Jean-François. *The Postmodern Condition: A Report on Knowledge.* Trans. Geoff Bennington and Brian Massumi. Minneapolis: University of Minnesota Press, 1984.

MacKinnon, Catharine. *Feminism Unmodified: Discourses on Life and Law.* Cambridge: Harvard University Press, 1987.

Morrison, Toni, ed. *Race-ing Justice, En-gendering Power: Essays on Anita Hill, Clarence Thomas, and the Construction of Social Reality.* New York: Pantheon, 1992.

Resnik, Judith, and Carolyn Heilbrun. "Convergences: Law, Literature, and Feminism." *Yale Law Journal* 99.8 (1990): 1913–56.

Ross, Andrew. "The Private Parts of Justice." Morrison 40–60.

Smith, Valerie. *Narrative Authority in Modern Afro-American Fiction.* Cambridge: Harvard University Press, 1987.

Stansell, Christine. "White Feminists and Black Realities: The Politics of Authenticity." Morrison 251–68.

Stovall, Thomas G. Letter to the Editor. *People,* 2 Dec. 1991, 5.

Stowe, Harriet Beecher. *Uncle Tom's Cabin: Or Life Among the Lowly.* New York: Penguin, 1981.

Thomas, Virginia Lamp. Interview. "Breaking Silence." *People,* 11 Nov. 1991, 108–16.

Walker, Alice. Letter to the Editor. *People,* 2 Dec. 1991, 5.

Warner, William Beatty. *Reading Clarissa: The Struggles of Interpretation.* New Haven: Yale University Press, 1979.

Whitman, Christina Brooks. "Feminist Jurisprudence." *Feminist Studies* 17 (1991): 493–508.

Williams, Patricia J. *The Alchemy of Race and Rights.* Cambridge: Harvard University Press, 1991.

Wright, Richard. *Native Son.* New York: Harper, 1969.

Yellin, Jean Fagan. Introduction to Jacobs, xviii–xix.

Who's the Boss?

Bruce Springsteen and the
Mixed Signals in Rock Music

Gene Santoro

For me, the most irritating, wonderful thing about Bruce Springsteen is how he gets under my skin whether I want him to or not. When I'm not listening to him, I can get plenty of distance. Maybe too much distance. Not listening means I can run all kinds of riffs on him. You know, smart-ass schoolyard critic riffs like, How can you trust a working-class hero who calls himself The Boss? Or earnest varsity-level critic riffs like, How does a rich rock star who lives in Hollywood write songs about the blue-collar world's harsh and sentimental realities and fill arenas with the very people he's writing about from afar? Why do they believe in him? Or fancy pro-league critic riffs like, What are the levels of manipulation inherent in a best-selling pop star's release, especially when he's fired his longtime band, had a long layoff, and reappeared in bad economic times that threaten record-industry profitability, which depends so much on major stars like him?

Yeah, I guess I don't really care, either. So pop culture's mammoth tail—its distribution pipeline—can usually wag any young-dog artist it really wants to, just by the way it makes its demands up front. But the same machinery can also slam a message home. Here's an example: Oliver Stone's *JFK*. I'm no Stone fan. I think he reduces big themes to melodrama. I've squirmed through every movie of his I've seen. But *JFK* got mall moviegoers who wouldn't otherwise know or care about the subtleties of the Warren Commission Report and the Zapruder film asking intense questions. When I complained to a buddy from the old neighborhood (who's currently devouring material about the Kennedy assassination thanks to the movie) about Stone's reductionism in *JFK*, his puzzled comeback was, "But that's what I *liked* about it."

This essay first appeared in The Nation 254 (April 27, 1992): 566–568, and it will reappear in a collection of Gene Santoro's music criticism, Stir It Up, forthcoming from Oxford University Press. Reprinted here with permission from The Nation.

For my money, Bruce Springsteen is usually better—far better—at what he does than Oliver Stone. For one very important thing, he's not smug or self-satisfied or condescending. But his method isn't so different. He writes parables. When he's doing it right, they resonate with a particularity that's haloed by implication. And a lot of people listen and sing along.

When I played *Born to Run* (Columbia) not long after it came out for a California pal who didn't know from Bruce, his reaction startled me: "It sounds like *West Side Story* with a backbeat." Part of what he heard were the stylized street stories. Part was the big stagy voice soaring into exhilarated pain and strangulated hope. And maybe another part came from the nature of the music itself, Springsteen's personalized pastiche of r&b, rockabilly, rock, soul,

"Springsteen is struggling. He's trying to reparse a musical language that has been aimed from its birth at entertaining a theoretically timeless and unambiguous 'youth culture' into a method for describing a blurry adult reality."

folk, blues, country. It feels curiously static, reassuringly timeless, almost ahistorical—rock 'n' roll translated to Broadway. The contrast with the sheer balls-to-the-wall dynamics of the performance is enormous. Why the gap? Springsteen is a culmination, a summary. He's the product of so much that preceded him that he has, ironically, almost nowhere left to run. It's not as if he can really change the way he sounds. It's not as if he'd want to if he could.

A couple of weeks ago, his record company picked me as one of the lucky bozos to get advance copies of his two new albums, *Lucky Town* and *Human Touch* (both Sony/Columbia). I didn't know what to expect. I didn't even know if I really cared enough anymore to write about them. I hadn't put on a Springsteen record in years. Oh yeah, I cared enough to want the tapes, but you could write that off to professional competitiveness. (What critic doesn't like being stroked by the hands he likes to bite?) But there was some kind of nagging loyalty in it, too. I mean, I feel as if I grew up with the guy. We come from the same blue-collar ethnic places. I saw him playing in boomy high school gyms and shithole clubs. And when I listened to him then I was ready—no, aching—to believe I could hop on a hog with some girl who had enough faith in herself and me so we could head once and for all out of Jungleland, even if it was only to crash and burn with a spectacular rage. And there were millions of me. I knew it. So did he. We gathered wherever he chewed up the stage with the sweat-soaked marathon shows that gradually made him a legend among us.

That's heading toward twenty years ago. Springsteen's career on disc grew more self-conscious, more sentimental, and more uneven after the astringent, bleak *Darkness on the Edge of Town* (Columbia), which followed a bitter law-

suit with his manager. He sired a generation of more or less talented wannabes, such as John Cougar Mellencamp and Steve Earle, who sang about Midwestern small towns and their clannish triumphs and troubles in rock 'n' roll accents taken mostly from Dylan and from the Rolling Stones' *Exile on Main Street* (Rolling Stones Records). On *Nebraska* (Columbia), a collection of home demos, he tried to be a sort of latter-day Woody Guthrie, with mixed results. His lyrics got more direct and stripped down; he mostly abandoned the heightened, slightly surreal sense of reality and overpacked lines that had hung the New Bob Dylan tag on him in the early days. First *The River*, a double album, then *Born in the U.S.A.* (both Columbia) felt bloated and diffuse and relentless, even monotonous: his sense of pain seemed to have devoured his sense of humor and watered down his urgency. His huge pipe organ of a voice seemed to have all the stops pulled out all the time; no more veering at will from ragged but gentle intimacies to cathedral-sized caterwauls. But though *The River* was overlong, it was still varied; it lit up regularly with incandescent moments like "Cadillac Ranch" and "The Ties That Bind." *Born in the U.S.A.*, by contrast, simply reflected his new stadium-rocker status. In its wake he took off on a prodigious world tour that apparently left him exhausted. He released a solid live greatest-hits-on-tour album and an inconsequential studio album called *Tunnel of Love* (Columbia), then retreated into silence.

A divorce, a remarriage, and two children later, Springsteen seems to have caught up with himself—and us. His voice has regained its range of characterization. At least some of his sense of humor is back. And the music, driven by that big trademark backbeat that somehow sways, has a bracing familiarity finessed by flickers of the unexpected. He's nothing if not a roots-rock encyclopedia.

Human Touch and *Lucky Town* have a fair amount of filler. (Face it: in rock, a .500 batting average for an album is fabulous.) Each sounds familiar in slightly different ways. Even though Springsteen fired the E Street Band, you can't tell by listening, except for maybe the missing sax. For most of *Lucky Town*, in fact, he plays all the instruments himself. Since he routinely taught the E Street boys their parts to his songs, it's not surprising how much like him they sounded. And as signposts throughout the stylistic shifts, each album has a couple of instantly recognizable Springsteen anthems.

The two disks are obviously a bid for attention in a sagging market he hasn't tested in years. But, at the same time, they're set up like complementary signals from two sides of his musical personality. The separation is artificial; traits leak back and forth. After all, Springsteen's personal pastiche of rock's past is the history of garage bands writ large with immense and loving skill. (Even when his lyrics don't click or get bathetic, his songwriting is awesome.) That's one reason he connects with us. One way or another, we've all been there. Yeah, the music feels somewhat static as a result. But that also underlines the fact that rock 'n' roll stopped being the innovative engine of American

pop-musical development around the time Springsteen appeared on the scene. (It's no accident that anybody under the age of 18 usually keys into rap or hard-core faster than rock.)

So let's say *Human Touch* extends his urban bar-band self. Soulsters such as Bobby King and Sam Moore match his vocals on a few tracks. The title cut boasts a knife-edge guitar solo worthy of Television. "I Wish I Were Blind" is a country-flavored lament whose grungy guitar rage could've come directly off Neil Young's *Ragged Glory* (Reprise). "Cross Your Heart" heats up its Creedence Clearwater-type swamp fever with dire guitar twanging in the sonic distance. (Springsteen isn't usually thought of as a guitar god, but he should be. He's no wanker, but he can pull off pretty much whatever he needs to on those six strings. And his use of a guitar as a stage prop is pure rock 'n' roll.) The hilarious talking blues called "57 Channels" describes every cable junkie's lament ("There's 57 channels and nothin' on") with a funny rock-legend spin. "Man's Job" matches Roy Orbison and Sam and Dave seamlessly, as if the stylistic meeting was always waiting to happen. *Human Touch* is the tape I've been wearing out.

And let's say *Lucky Town* is his Heartland America side, the one rooted more in Woody Guthrie and the Rolling Stones that inspired the likes of Mellencamp. (The title track is so like a Mellencamp cut it's either a reverse tribute or a claim to take back the territory—or both at once.) The rest, filler and all, is basic Bruce. "Leap of Faith" opens his characteristic escape hatch ("Oh heartbreak and despair got nothing but boring/ So I grabbed you baby like a wild pitch/ It takes a leap of faith to get things going") to echoes of the Stones's "Tumbling Dice." From a different perspective, "The Big Muddy," an homage to the blues with all puns intended, scorches lyrics like these with backing bottleneck guitar: "How beautiful the river flows and the birds they sing/ But you and I we're messier things/ There ain't no one leaving this world buddy/ Without their shirttail dirty/ Or their hands bloody."

So the road from Jungleland doesn't lead to Eden. It only takes you out of town. As Springsteen told Mikal Gilmore in *Rolling Stone* five years ago, "Once you break those ties to whatever it is—your past—and you get a shot out of the community that you came up in, what are you going to do *then*? There *is* a certain frightening aspect to having things you dreamed were going to happen *happen*, because it's always more—and in some ways always less—than what you expected. I think when people dream of things, they dream of them without the complications. . . . And *that* doesn't exist."

It's telling, then, that both new albums end on a gentle note of affirmation. For all its flaws, this is trying to be a grown-up brand of rock 'n' roll that can tackle notions of responsibility. Like a few others—Neil Young, David Byrne, and Richard Thompson among them—Springsteen is struggling. He's trying to reparse a musical language that has been aimed from its birth at entertaining a theoretically timeless and unambiguous "youth culture" into a method for describing a blurry adult reality. Rock's makers and listeners—the music

itself—have inevitably grown old and tired and compromised. Their dreams have gotten tarnished. But the yearnings remain.

On the morning after the 1989 Rolling Stones concert at Shea Stadium—a helluva blowout, much better than I had dared hope—I waited to go on a TV show with author Stanley Booth. Booth, of course, wrote *The True Adventures of the Rolling Stones*, a graphic portrait of life on the road with The World's Greatest Rock 'n' Roll Band near their peak. We talked about the show. Booth agreed politely with my slightly hung-over enthusiasm, then added devastatingly, "It was a really good show, but I can remember when rock 'n' roll was supposed to change your life."

So does Bruce Springsteen. His songs might not look like much more than personalized soundtracks for the rock generation, whiny memorabilia whose energies focus on nostalgia. And they can be that. But his whole approach—his empathy with his audiences, the way he leaves it to them to connect the issues he raises in interviews with the vignettes he performs as their illustrations—could also make him a kind of American pop-culture disciple of Bertolt Brecht. His parables, like Brecht's, outline dilemmas whose suggestive power doesn't stop with the music. Catharsis doesn't have to end with dancing in the aisles; you can dance in the streets, too. But the way to get people there is to point them, not drag them. Sometimes raising the issues has to be enough.

For the past two decades, the left has insisted that the personal is political, and vice versa. Springsteen's songs and performances demonstrate one way that axiom can work.

The Art of Being Off-Center

Shopping Center Spaces and the Spectacles of Consumer Culture

Peter Gibian

Introductory Note

Because this wild and woolly personal essay meanders along a somewhat circuitous route as it tests connections among a number of diverse phenomena, I think it would be best to help orient readers by providing at the outset a direct, bare-bones outline of the three-part argument to follow.

The point of departure for Part One is an extended analysis of one work by the contemporary Canadian artist Michael Snow: "Flight Stop," a well-known installation sculpture of a flock of Canada geese flying through the immense corridor of glass at Eaton Centre in Toronto. Fredric Jameson's influential 1984 article "Postmodernism" took the Bonaventure Hotel in L.A. as its memorable central figure, exploring it as an epitome of the cultural dynamics of the postmodern situation. This *TABLOID* essay from 1981–82 focuses, similarly, on a close reading of the spectacular workings of one representative building—here Toronto's Eaton Centre—and it develops strands of analysis that parallel Jameson's in many ways.[1]

Finally, though, what is stressed here is not the postmodern aspect of Michael Snow's artwork or of the Eaton Centre architecture, but the way in which this self-reflexive sculpture sends us back to replay from one angle the history of the emergence of modernism, helping us to re-evaluate earlier works of modernist art (whether in literature, photography, film, or urban architecture) through their relation to the cultural context of the modern city: to new modes of urban crowd movement and mechanical mass transportation; new modes of mass spectacle and spectatorship; and new modes of vision associated both with early cinematic spectacle and with early forms of urban consumer culture. The introductory analysis of Snow's work, then, defines the key issues—suggestions about the structures and contexts of "proto-cinematic"

This is a revised version of an essay that first appeared in two installments in TABLOID 4 (summer 1981): 45–62 and TABLOID 5 (winter 1982): 44–64.

visual spectacle and its relations to tourism, urban crowd movement, and new modes of consumption—that organize a retrospective survey of the early modernist situation. This review includes a brief analysis of Ezra Pound's "In a Station of the Metro" and his influential theories about the functioning of juxtaposed or superimposed still images in Imagism and Vorticism; a brief look at the implications of Eadweard Muybridge's works in serial photography; and a quick consideration of Walter Benjamin's analysis of the architecture of Parisian "passages" (the glass-roofed shopping arcades that are the ancestors of today's urban malls). The connecting thread here develops as an extension of Benjamin's early work on the "shock" experience of life in urban crowds, on photography and film, on the passages and the panoramas, and on the con-

"What does an homage to Muybridge's 'Birds in Flight' have to do with Eaton Centre? How does such a play with photographic cycles, with the alternation of analysis and gliding movement, with birds hovering somewhere between photography and film, relate to the larger context of a contemporary shopping center?"

nections between our visual experiences of new forms of proto-cinematic spectacle (seen in the panoramas and early films) and the visual experiences of new forms of urban consumerism (with the passages defining a new mode of shopping-as-cinematic-spectacle).

Part Two brings us into contemporary North America for a thumbnail history of the American mall, showing how the dynamics of proto-cinematic spectacle have informed the design history of the North American shopping center, creating those complex environments for tourism, entertainment, shopping as moviegoing, impulse buying—scenes for "love stories" in which erotic impulses are at play in each charged visual meeting of consumer and commodity.

Part Three explores the functioning of the "waterworks" and "rides" that are so central to the contemporary mall experience—with waterworks (geyser fountains, bubbling streams, reflective pools) serving as "natural" analogies to the mall economy and to the movements of shopper crowds; and rides (mechanical people movers such as glassed elevators, escalators, moving sidewalks, and so on) enforcing the automatic flow of moving spectators through the mall movie, defining the dynamic of its architectural story or script. Finally, a brief epilogue speculates about the possible emergence of new "arts of mass transit" appropriate to this new viewing situation and this new mode of consumer culture—calling for the development of works of art that, like Michael Snow's "Flight Stop," not only *reflect* the dynamics of these new environments but may open up new spaces for reflection *on* them.

Part I

I do not transgress this system, only disperse it....
The whole being without novelty except for a spacing out of
the reading.
(Mallarmé, Preface: *Un Coup de Dés*)

On Incomprehensibility: Migrating "Centers"

This has to be an essay in and about the *failure of comprehension*. It is about something too mobile to be grasped, too big to be really examined; no analysis can stand apart from the literal a-maze-ment we all feel any day in strolling through or buying in a *shopping mall*.

But malls are alluring in their very incomprehensibility. They offer a new experience of shopping/tourism/entertainment that is actually designed for dazzlement. Whether we are city planners, sociologists, or just plain shoppers, the shopping center keeps us awed, amused—and *off-center*.

Like migrating birds that awe us as sudden tokens of a seasonal turn, our emerging malls seem to be signs in the landscape that our whole society is shifting, changing, going "somewhere else." Malls speak for a major evolution in our economic structures, for large-scale shifts in population, and for crucial developments in patterns of consumption. The transformation seems mysterious, inevitable. As one mall critic writes, "Out of necessity, and because we're intrigued with the notion, we are moving inexorably into an age of pre-planned and regulated environments."[2]

Inexorable? A "migration"? Or is this more the automatic drift of a "moving sidewalk"?

The shopping mall is a fundamentally ambiguous or even contradictory form. Planned and closed, its "effects" are of unplanned openness. A monolithic, self-contained economy, it seems to speak for the natural cycles of laissez-faire competition. Its awesomely vast scales are obscured or underplayed; its rigid order coexists with a desire for energy, freedom, and ever-shifting variety. Though a suburban form, it recreates or "represents" the city life that it replaces and excludes; within its artificial enclosure, it imitates the natural outdoors. In a modern mall, the paradoxical theme is of *visionary freedom in enclosure*; here, wild birds can soar indoors.

Where do we stand before such a phenomenon? And who has *not* been taken by surprise by the breathtaking pace of mall development? In just a few decades, more than 30,000 of these "cathedrals of consumption" have popped up prefab throughout America, a new species of "store" which seems to proliferate like some sci-fi germ. And this growth seems unpredictable, completely uncontrolled. A resilient, adaptable form, the shopping center first tended to take root in vacant spots, out-of-the-way places, the preferred areas that developers call open field. So it gave whole new meanings to the word *center*. Beyond town boundaries, outside town government control or taxation, open-field centers began as part of a radical relocation of the center of American life: the move to the suburbs, the ascendance of the periphery. And then came

another surprise: since the late 1970s, mall development has been moving in a different direction. Because outlying regions were becoming saturated and the old town centers were often drained, the mercurial malls reversed their field, sprouting in grandiose new form to revitalize dormant areas of our inner cities. How can we follow such a mobile form?

Migrating shopping "centers" have certainly kept city planners confused. Mystified by the suburban mall movement which threatened to make their city centers obsolete, mayors and managers are now even more divided and undecided as to the effect of the mall development as it has begun to invade and transform urban life. While malls clearly tap a deep public hunger for agora-like spaces that can serve as settings for community interaction, for a revival of something like the collective experiences of urban life, malls also speak for a deep fear of actual urban experience and a profound impoverishment in current visions of the possibilities for public life. How, then, will the emergence of these self-contained, socially homogeneous, suburban "imitation cities" or "simulation cities" affect the texture of an urban setting?

Culture critics who lament the malling of America feel a similar helplessness before the overwhelming results of their studies. By the late 1980s, new malls were being built at the rate of 2,000 a year so that, as one analyst observed, there are now more enclosed malls in the United States than cities, four-year colleges, hospitals, hotels, or movie theaters.[3] (Most movie theaters are, of course, now found in malls—and we will see that the visual spectacle of mall design itself incorporates film dynamics, so that cinematic elements are built into the everyday experience of shopping.) Statistics show that shopping centers account for more than half of all retail business in North America, and their share is getting bigger every day.[4] But, as critic William Kowinski observes, "Malls have more than financial significance; they are becoming a way of life."[5] While the typical mall visit lasted twenty minutes in 1960, today it has expanded to nearly three hours.[6] One survey finds that Americans now spend more time at shopping malls than anywhere outside their homes and jobs; another study shows that malls have become *the* most popular gathering places for teens in America. And of course malls are now social centers for adults as well: gabbing retirees, mingling singles, "mall-walking" exercise groups, lone window-shoppers seeking solace from depression (as one mall promotions manager exclaims, "These centers may replace Valium!"),[7] and families with young children for whom a mall outing is now often the prime weekend activity, taking the place of the picnic trip to the park. No wonder Amherst held a conference called the "Run-Away Mall."

Even the mall developers seem surprised by the vital growing power of their centers. Early on, pioneering designer Victor Gruen developed a highly structured, standardized method for the planning of new malls that has meant that new projects are almost always "foolproof money-machines."[8] Both developer Ed DeBartolo and a Citibank consultant exclaim, using the same phrases: "A major regional shopping center has got to be one of the best investments known to man!"[9] And Cesar Pelli, another of the early innovators in shopping

mall design, is now himself bewildered by the magnetic power and unstoppable proliferation of the concept and imagery he helped spawn: "Now [malls] have become too successful—in the same way that the automobile has become too successful. They are so powerful that they overwhelm everything else—there is nothing strong enough to balance them." One result, as Pelli observes, is that "towns disappear."[10]

"Towns Disappear": The New Center

I remember my own surprise—a combination of wonder and horror—at the advent of the regional mall outside my small hometown in upstate New York. Suddenly we realized how remote we really were. We discovered an economic force that could do an end run around our century of local history and economy, our long, rugged, idiosyncratic past. It was as if an alien space colony (self-contained, windowless, prefab, ready to sell) had settled on the Butler's muddy, rocky farm field and instantly begun to lure people with its eerie neon glow. Ours is one of the Pyramid Mall chain, and indeed it seemed a mysterious monolith, representing a new sort of imperial, pharaohlike power.

The Pyramid Mall had the effect of making our downtown disappear as it introduced us to a new sense of time: none of our lackadaisical local construction; no governmental red tape or slow committee control; just one smooth organization could steamroll over filibustering town-center opposition. And we also learned a new sense of "center": this was a new sort of town with one owner, one planner; a one-stop economy under one roof. And where did all the floods of customers come from? Suddenly, the closed, dispersed, atomized villages of our surrounding counties ("You can't get there from here . . .") were melded into a unified region—a new community somehow invented as it was tapped by this new political and economic capital.

Isolated villagers and lonely suburbanites took instantly and eagerly to their new roles as mall shoppers. I remember farmers on the rare amusement day off with their whole families—gruff, crusty, no-nonsense people whose regional character has so clearly been formed by our harsh local weather—standing rapt at the mall threshold, still shaking the slush from their boots, and then gliding like sleepwalkers into this brave new world. We have to carry our snow gear in the mall; it provides plenty of insulation.

Shiny, brand new, all-enclosed, climate-controlled, muzak-paced, scaled as a miniature nineteenth-century city, the Pyramid Mall is a strange bird in this poor, stark area—as close to a Disney pleasure dome as most of its shoppers will ever get.

Bird Watching in Toronto: Michael Snow's Visionary Mall Spectacle

But if I was surprised in the mid-1970s by my hometown's primitive new center (probably the most common, stripped-down, low-budget version of the open-field suburban mall), you can imagine how I was overwhelmed when, on

a random solo tour of squeaky-clean Toronto in August 1979, I stumbled upon the opening ceremonies of what was then the newest and largest single shopping complex on the continent, housed in the longest glass-enclosed galleria in the world. Culture shocked, still rubbing the sleep from my eyes, I was suddenly brought—rapid transit—up to the state of the art.

Toronto's Eaton Centre opened to a fanfare of superlatives. It was an ultimate example of the "vertical mall," the sort of inner-city shopping center that has begun to fill the vacant holes in many downtowns. According to the owners, the Cadillac Fairview Corp., the largest real estate corporation in North America, Eaton Centre has attracted, since soon after its opening, many more visitors per year than Niagara Falls. Its 270-odd retail tenants pay some of the highest retail rents in Canada. Outside, it offers one of the world's most intricate neon signs and, inside, it features the world's largest configuration (sixty) of imitation Canada geese, suspended as if in midflight through that awesome central corridor of space.[11]

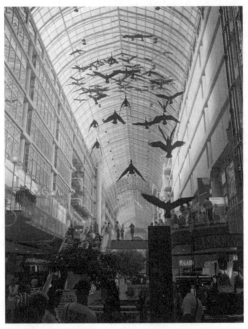

Michael Snow, Flight Stop, Eaton Centre, Toronto, 1979. Courtesy Michael Snow.

It would be impossible to avoid dazzlement on entering this incredible glass-and-tile gallery; several stories high, the equal of several city blocks long, it is a roofed Park Avenue, an indoor Yosemite Valley, a modern Crystal Palace. And these gliding model birds speak wonderfully, immediately, for that space. The Canada geese sculpture has, in fact, become the trademark for the center, another popular draw for those Niagara floods of shopper/tourists.

Spacing Out the Mall

These geese seem a perfect symbol for this most advanced of urban spaces. Yet, within the mall's closed frame, they open a new space for reflection *on* that environment. They conjure the perfect lightness and motion for the rush of mall spectators on the move, springing to this illusory life when viewed from the surrounding network of escalators and glass-walled elevators. Yet their eerie suspended animation seems also somehow to suspend the inexorable flow of those automatic conveyances. As I spent hours with different views of the Canada geese, I felt I was taking my first steps off the moving sidewalk, from dazzlement and incomprehension to a different kind of awe.

This Canada geese sculpture seemed at once an ultimate mall spectacle and an exemplary reflection *on* mall spectacle, working as a profound analogy on many levels for the surrounding mall experience. The photographic sculpture that so marks the Eaton Centre space is titled *Flight Stop*, and is the work of Michael Snow (aided by Henry Piersig and Associates in the complicated process—combining 2-D photography and 3-D sculpture—of gluing hand-tinted black-and-white photographs of one Canada goose onto various sizes of hanging fiber-glass bird forms). One of the most advanced and influential artists in contemporary avant-garde film (at least since the structural, formalist turn of the 1960s), Michael Snow also works in still photography, painting, installation sculpture, and plays improvisational jazz.

Snow's best-known film, *Wavelength* (1967), builds to waves of oceanic feeling through an incredibly reduced structural frame: It involves 1) a single zoom shot that takes 45 minutes to traverse one spare room, and 2) a sine-wave sound that slowly rises from lowest to highest frequencies. When this film came on the scene, it stunned people as "a turning point in the history of the medium" (Michelson) and "the *Birth of a Nation* in Underground Films" (Farber).[12] But if Snow's mysteriously affective minimalist work offers such revelation, its impact has remained unfortunately limited to small circles of avant-garde artists and critics, somewhat inbred "underground" coteries in New York, Toronto, and Paris.

The Eaton Centre piece must be Snow's most accessible and popular work. Its uncanny dream vision of geese continued for more than a decade to attract throngs of tourists, and to be surrounded by the incessant flash-shutterpop of a crowd of cameras.[13] Without holding back in his self-reflexive explorations of photography, film, and spectacle, Snow has here been able to engage large crowds of people. And the mall crowds really *are* involved. As we will see, the shopper/photographers, the strollers/browsers, the tourists, members in the mall's continual human flow—observing the birds from the forced movement of escalators, elevators, stairs, ramps, around and "within" this screenless, frameless sort of movie—play interesting roles in the piece. It works *through* them. In fact, working so effectively with the dynamics of this larger public sphere, *Flight Stop* verges on becoming a sort of conceptual media "happening." And such popular success only intensifies the interest of the work's sug-

gestions about the structures and contexts of photographic spectacle: its rela-
tions to tourism, to urban crowd movement, to the mall experience, and so on.

It is exciting to find serious work by avant-garde artists deserving and receiv-
ing wide popular response, and making significant statements within the nor-
mally blandized realms of corporate art (a subgenre usually involving just a
decorative daub of stylish color on walls of institutional off-white). Actually,
Snow has been working with public installation and "monument" forms for
many years, in serial environmental pieces that explore and include the flow
of crowds and the flow of time. His obsessive 1960s series of "Walking Woman"
images in various modes and media represented, like the geese, an urban
phantom figure of ungraspable movement. Serial "Walking Woman Works"
were dispersed in urban crowd settings around the world, so that "she" might
appear, for example, on a subway, at the turnstile, on the stairs, at the corner
store, in an eerie analogy to the progress of pedestrians around her, to the
effects of city duration and flow. These series culminated in an eleven-piece
stainless steel sculpture dispersed through the grounds of the Ontario Pavilion
at Expo '67, to be viewed serially in the context of thick World's Fair crowds. In
that Expo year, Snow was already beginning to translate the serial method of
the "Walking Woman Works" to film — in *Wavelength.*

Michael Snow, Series of Walking Women,
Encyclopedia, 1965. Courtesy Michael Snow.

Michael Snow, Walking Women with crowds on
subways and city streets, N.Y., Four to Five, 1962.
Courtesy Michael Snow.

Mental Spaces and Figures in Time

In all of his work, Snow operates on many levels at once — playing with the cor-
respondences among these levels. (His famous note for *Wavelength,* for exam-
ple, sees it as an attempt at "a summation of my nervous system, religious
inklings, and aesthetic ideas . . . a time monument . . . a definitive statement

of pure Film space and time, a balancing of "illusion" and "fact," all about see-ing"[14]—statements that perfectly describe the effects of the *Flight Stop* geese.) And *Wavelength*, like *Flight Stop*, can be received in widely different ways. Direct, down-to-earth Manny Farber praised *Wavelength* as "a straightforward document of a room in which a dozen businesses have lived and gone bankrupt." *Artforum*'s Annette Michelson saw in it "a grand metaphor for narrative form . . . its 'plot' is the tracing of spatio-temporal données, its 'action' the movement of the camera as the movement of consciousness."[15] Did these two see the same movie? Yes, and, most interesting, neither would repudiate the other's vision. Both levels seem to operate here.

We will see how the Canada geese of *Flight Stop* are stimulating in just this way, working from such a range of perspectives. They are both realistic and self-reflexive, metonymic catalog and metaphoric image. They are both about an environment and about an aesthetic form. And they suggest a Vermeer-like documentary picture of the structure and history of the space of a *shopping center business*, while at the same time serving as an "imagistic" enactment of the problematic modes of consciousness associated with *photography and film*. Snow's crucial contribution would be to imply the interaction of these two levels (perhaps along the lines of historian Walter Benjamin's main studies): the deep connections between the birth of photography (out of proto-cinematic panoramas, etc.) and the birth of the shopping "arcade"; the deep relations between the experiences of film and of urban crowd movement, as modern modes of perception.

The specific content of a visual work by Snow is often simply a certain room, a certain environment or space. Extended contemplation of this architectural space then begins to define an analogous mental space, which becomes the second subject of the work. Finally, these two sorts of spaces are to be grasped as equivalents, on many levels. The *space* of the room, the *form* of the aesthetic perception of it, and the *images* arising in the artwork begin to reflect each other, to resonate deeply. *Wavelength*, for example, explores the ways that its one "room" and its one "zoom" are structural "rhymes." While in form it simply imitates the shape of the room's perspective depth, the zoom also acts to mold our experience of that space into a *telling shape*. Then, at the end of the zoom and the room, we meet a photo of sea waves: no longer a picture of the room and no longer a form of cinematic motion (a zoom), the single photo image seems to work as a summation of the film's long process. These waves seem to refer to the light and sound waves that make up the film. More directly, the paradox of zoom progress (lens "movement" from a fixed tripod base) seems to be embodied in the illusory depth of this motionless seascape, a static image of tidal movement and temporal process. As the continuous zoom enters the static image, as film meets photography, *Wavelength* climaxes in a startling optical illusion: the waves seem to roll, we feel them begin to move; and knowing this is a photo only makes the oceanic feeling more eerie and intense.

"Ideas are constantly rushing ..."

Flight Stop is an environmental piece that works in the same way. Its subject *space*, of course, is the giant glass canyon at Eaton Centre; its *form* is "photographic sculpture" (joining 2-D photos and 3-D forms); the final illusionistic *image* that arises is that flight of Canada geese. Again, Snow shows how simple the elements can be for a complex statement. Here, the piece is basically an expansion, by mechanical reproduction, of a *single bird*. And the expanded form, seen in series, still presents the viewer with a single image—now an indoor configuration, a flock. Like the sea waves, these geese are a static image of process, building an illusion of natural movement out of a succession of still photos. The title, *Flight Stop*, refers at the same time to the paradoxical motion of the birds and to its equivalent: the paradox of our dual perception of the sculpture (a flip-flop beween two modes: 2-D and 3-D; stasis and motion). Not a picture of the mall space, the "virtual space" image of these birds may serve as a multileveled analogy to it, and to the mode of consciousness associated with that environment. But how does this photographic spectacle work in that mall environment—itself a form of spectacle? In what ways do Snow's geese reflect its structure? In what ways do they transform it—giving to our mall experience a *telling* shape?

Basic to Walter Benjamin's notes for his *Passagenwerk* or Arcades Project, his ambitious, unfinished study of the Parisian arcades or *passages*, is the mode of what he termed the *dialectical image*: a means, developed out of his admiration for montage and photo-montage techniques in photography, film, and other visual arts, for distilling into a few brief juxtaposed phrases, a verbal flash, a vision that both represents a phenomenon of contemporary culture and opens the possibility for a critique of it. Analyzing some of the earliest forms of modern consumer culture, Benjamin found the montage effect to be fundamental to the visual experience of urban spectacle—"commodity phantasmagoria." But he also took montage as the model for his critical method, believing that such constructed images—often juxtapositions of nature and history—could work to "interrupt the context into which [they are] inserted."[16]

The apparition of Snow's Canada geese in a mall might remind us of Ezra Pound's vision of flower blossoms in a Paris metro:

IN A STATION OF THE METRO

The apparition of these faces in the crowd;
Petals on a wet, black bough.

Such striking "photographic" superimposition provides a single imagistic analogy for the succession of faces in enclosed, urban, mechanical mass movement—a "natural" analogy (the flowered bough) that might serve in mall or metro to collect a whole kaleidoscopic range of experiences. The one image of *Flight Stop* seems to operate as Pound's Image does: "that which presents an

intellectual and emotional complex in an instant of time . . . a radiant node or cluster . . . a Vortex, from which, and through which, and into which, ideas are constantly rushing." But what ideas rush through Eaton's flock of geese? What stories do they tell?

Snow wrote me a quick note about *Flight Stop*. His understated comments are revealing in the way they telegraphically link different levels of the piece:

> It's such a huge beautiful open space—you can see the sky, and on the lowest level there are trees and fountains—I tried to think of a way of putting something in the air that "joined" these two extremes. While [*Flight Stop*] represents something "natural" it is "artificial," like some aspects of its context. As representation it's an interesting cycle: the photos are all of one bird, which was reduced to 2-D, then "applied" back to 3-D. The group is "stopped" in action "photographically" but is 3-D. . . .
>
> The response has been really gratifying; it seems to appeal to people who are specifically interested in art ("esthetes") and to "just folks," who perhaps like it for other equally "valid" reasons.

From the astonishing first view of Snow's sculpture, the "just folks" at the mall move naturally to many other levels of its working. As Snow says, we probably focus first on the way that the birds seem to *embody* the large mall space, like "personifications" of the vectors and sight lines that move along behind them, celebrating the dynamism of that corridor in their euphoric glide. Greeting each entering shopper, the perspectival "V" of the flock seems to open up and accent the perspective view of that awesome galleria. But if the urban mall builds upon dizzying *verticality*, its other main characteristic is *enclosure*; urban mall space is itself a sort of "flight stop" paradox—offering its soaring vistas indoors. We might then notice that Eaton Centre is not a natural, limitless "open field," but is a human-made frame that ends just behind the shopper/viewers. The birds have reached the limit of that space, the end of the "cage"; in fact they are not launching out, but seem to be screeching to a halt. We get a strong sense of this sudden stop in the disrupted wing patterns and wincing faces of the flock's leaders. So the overall effect of the image is of a paradox central to mall experience: *visionary freedom in enclosure.*

As we begin to circulate through the center, we get a variety of different views of the flock. For this paradoxical spectacle, like the mall space, works on *two scales*. As we will see, mall designers work with a problem of dual focus, often hoping to disguise or offset the overall effect of their monolithic framed space by calling attention to varied and irregular views of the small, competing stores within that frame—each with its own special offerings. Similarly, the *flock* of geese is an overarching form built of separate model *birds*. When we move away from the entrance vision of the flock's perspectival "V," into smaller subdivisions of the mall arcades and balconies, we begin to meet individual geese solo, large as life, suddenly bobbing in close-up detail and color before our eyes.

If we see the mall as a sort of museum, in this case a natural history

museum, *Flight Stop* speaks for the two aspects of such exhibitions: both for the abstract institutional *frame* and for the specific *exhibits*, both for the museum scaffold space (the totalizing plan of the exhibitors) and for the status of its contained objects (pictures, events, "specialties"). As a flock, the sculpture represents movement, flux, a prophecy; each model bird, however, is a frozen taxidermic effigy, a memorial.

"The Dream World of Mass Culture":
Spectacular Animals in the Landscapes
of Consumption

Certainly the Geese do work beautifully, as Snow hoped they would, as the final link in the illusion of the shopping center as a constructed natural park — helping to join the fountains (expressing our power to harness natural force), the trees and grottoes (shoppers can think of themselves as recreational hikers), the many stories of shops, and the "open" sky. The birds fit perfectly in this artificial landscape.

In Snow's film *The Central Region* we find, at the center point of an unpopulated natural wilderness, the shadowy emergence of the *machine* (the superhuman, remote-control camera eye which made such contemplation possible). In *Flight Stop*, conversely, we find, at the center of the technological marvel of Eaton Centre, a virtual-space return of the *natural*. (And Toronto has the same structure as the mall: near its city center we find an "insular island" for the birds — Toronto Island, where the original models for the *Flight Stop* geese came from. And it is crucial to note that these are Canada geese, named for the nation and often taken to be natural symbols for the nation's progress.)

In Benjamin's Arcades Project, a major part of his "dialectical" critique of consumer culture concentrates on analyzing how the commodity/object *naturalizes* the process of its own production and distribution, thereby presenting itself as synonymous with smooth evolutionary progress. The natural history theme running through the Arcades Project foregrounds the way in which historical change is often represented through half-unconscious analogy to natural change. Studying the nineteenth-century fascination with natural history, and observing how new materials and technologies then led to a proliferation of mechanically reproduced images of nature, Benjamin reflected on the mythic relations between historical change, natural change, and technological change. Studying what he called "the dream world of mass culture," Benjamin showed how, embedded within the highly rationalized systems of the new culture of consumption, and figured forth by its objects and spectacles, lies the submerged outline of a more mythical landscape, or dreamscape, in which advertising signs and consumer goods take on the character of ancient, preindustrial signs or icons: commodities are thus seen to appear in a forest of symbols. Within the visual experiences made possible by rapid advances in technology and economic organization, then, Benjamin finds a re-enchantment of the social world, a re-emergence of myth in dreamscapes

recalling the forms of the natural world. But Benjamin also stresses that such commodity symbols can operate as dialectical images—both imaging forth the utopian dreams of consumer capitalism (redemptive dreams of emancipation, nostalgic dreams of return to a primal garden, or utopian visions of history as natural progress) and, at the same time, opening the possibility of critically reading and analyzing these buried, unconscious wishes.[17]

This sort of natural, dreamworld imagery is, of course, very much a part of twentieth-century mall spectacle—especially since the advent of the enclosed mall in the late 1950s, when the major concern for mall designers became the creation of interior effects of "openness."[18] For mall planners, it seems, the more indoor the reality, the more outdoor will be its desired effects. Victor Gruen, who designed the first enclosed center, speaks for this fundamental ambiguity when he states, "The underlying purpose of the enclosed mall is to make people feel that they are outdoors."[19] To achieve this "psychological connection with nature," Gruen's influential 1960s mall plans included sky-lighting, extensive waterworks, programs of kaleidoscopic light shows, an almost tropical density of plantings, sidewalk cafés (with umbrellas to reinforce the illusion that shoppers are outside in variable weather), and "a much more daring use of works of art than ever before undertaken."[20] In fact, as mall enclosure brought a strong demand for artworks (intended, like the natural plantings, to bring a sense of variety to uniform patterns), several early mall designs featured giant sculptural *birdcages*—a surprising indication of the appropriateness of Michael Snow's Eaton Centre sculpture to the basic problems of "openness" in mall enclosure, of nature brought indoors. The live ancestors of Snow's flock of Canada geese, gliding through their glass galleria at Eaton Centre, flew in the courtyard birdcage at Southdale, the central symbol of Gruen's first enclosed mall. The later Southridge Mall, too, used its central aviary as a natural attraction connecting the vertical levels of the mall with its celebration of floating lightness, and highlighting the surrounding vertical transportation system of elevators, escalators, and stairs. And of course, like anything connected with malls, this germ idea has proliferated rapidly. The bird-flight motif continues in many present-day malls: A tall "Aviary Court" centers Tyson's Corner Mall, near Washington, and there is now a Bird Cage Mall in California. (And the general tendency toward the virtual reality re-creation of spectacular natural landscapes at the centers of the newest cathedrals of consumption has become even more exaggerated in our own day—with the great success of the all-surrounding jungle decor at the Rainforest Café in Minnesota's Mall of America, or the much-anticipated 1996 opening of the Sportsplex center in Arizona, which will allow shoppers to engage in indoor versions of eight different outdoor sports [golf, fishing, and so on] while surrounded by attractive displays of consumer goods.) Like the nineteenth-century urban crowds that flocked to enclosed panorama buildings to voyage imaginatively through spectacular dreamscapes—simulated travels through either cityscapes or natural landscapes—perhaps we come to the regulated environments of contemporary enclosed malls to experience for ourselves one

of the themes of Snow's optical illusion in *Flight Stop*: the paradox of *visionary freedom in enclosure*.

The *Flight Stop* geese may seem on a first viewing to represent just the naturalizing ideology that so worried Benjamin, telling us a simple story in which the rapid, dizzying social and economic changes that have given us the modern mall and are propelling us toward an uncertain future are seen as a migration, leaving us with a simple wish-image of a form of cultural progress that is as natural, orderly, and directed as this V-formation of gliding Canada geese. But if *Flight Stop* in these ways embodies the dream world that Benjamin saw as embedded within the commodities of consumer culture, something about it also tends to interrupt this slumber, forcing us awake, bringing such unconscious desires into consciousness. Because it is so evidently a spectacle, a virtuoso piece of illusionism, a replica so strikingly out of place, Snow's dialectical image raises a whole series of questions about the naturalistic illusionism of mall design, about the free-nature analogy for open market economic life, about the appropriation of natural power to human and mercantile ends. Certainly the unexpected presence of these indoor birds makes these issues of nature and culture strong, conscious themes in everyone's experience of the Eaton Centre.

Figures for the Consumer Crowd: The "Moving Spectator"

Where are these Canada geese going? Are they joyriding, fleeing, or in mass migration? One of the first things that shoppers/visitors notice is that the movements of the geese seem to parallel and mirror their own movements through the mall—they arise as virtual images of crowd flow. To entering shoppers, for example, the birds' flight is an invitation to mobility, suggesting the accessibility of all levels of the mall, urging people to circulate throughout, to hop onto and ride the many escalators and elevators. Certainly the flock's overall pattern mirrors the circulation of human crowds below it; the birds circle and fall just above the ramps and escalators that lead from the main hall entrance. But the way the *Flight Stop* image alternates between fixity and flow makes the geese a very apt "natural" analogy to the specific form and feel of crowd movement on those automatic conveyances. Like the transportation of masses of shoppers on mechanical people movers, the birds' flight has a soothing, floating lightness to it; but it can also have a scary feel. Like a face appearing for an instant in a passing crowd, each bird is fixed in a unique snapshot pose—standing still at the same time that it is being carried along by the flight of the flock. As sociologist Don Slater observes, "Market culture is tied to the production of crowds, a constellation of people who are freed from personalized restraint to be wafted along by individual desire." [21] Though the overall image of the flock of Canada geese in V-formation might work as an allegorical emblem for this sort of symbiotic relation between the individual shopper's free-floating desires and the wafting power of the crowd constellation, it may also serve a dialecti-

cally opposed function: it can stand as a reified sign of the ways in which the collectivity can be disciplined and reified into more totalitarian formations, a spectacular image of the ways in which the workings of spectacle can mean the collapse of autonomous action into the monolithic focus of the group. Here the V seen by crowds of shoppers would emerge as a natural image of the mass homogenized by its focus on one goal, one vector of movement; a dream image of the mass sleepwalking through a collective dream. In many ways, then, the bird flight seems to serve as metaphor for the continual flow of the consumer masses, for their instinctual group movements, and perhaps even for the migrations of population and the evolutions in consumer economy that have spurred mall development.

Of course, more basic than all this is the way the bird image operates as a figure for perception, for *perception in time,* for what Snow's letter refers to as the work's cycle of representation. Built on the stop/start ambiguities of its two modes, the configuration has an eerie stroboscoped effect. It might be seen as the spaced-out, time-lapse portrayal of one intense moment of vision—presenting the retrospective traces of the original shooting, when the model bird was killed at Toronto Island (a necessary first step before this kind of detailed photo shooting). The lead bird, which meets entering shoppers almost face-to-face, seems to grimace as if frozen in the viewfinder just at the instant of that searing shot.

Such a view stops the flow, but that is only one-half of *Flight Stop.* Snow's technical work was a cycling between the two modes of the work's title: between flight and stoppage, 3-D and 2-D, illusionism and analysis, cinematic continuity and photographic fixity, and so on. Once he had reduced a live flight to a series of analytic photos, he then sought to recreate or simulate the illusion of a living flux.

This "cycling" is repeated in each viewer's experience of this slowed-down narrative of vision. Before these suspended photos, each shopper is again in the position of the original photographer. Souvenir-hunting shopper photographers, for example, have an indicative role in the piece: they recapitulate the process involved in its construction (thus carrying its cycles of imagery one step further). Looking through a viewfinder, each shopper re-enacts Snow's original shooting of the live bird, this time stopping the flight at another remove.

Any viewer who "takes apart" the flight flow of this sculpture discovers another sort of beauty—in fixity. Here we sense the allure and beauty of the *commodity* itself, which, as Terry Eagleton writes in his study of Benjamin, becomes in the phantasmagoria of modern consumer culture a free-floating image that seems to meet each passing shopper with an "intimate *ad hominem* address."[22] In *Flight Stop,* each separate bird is an exquisite hand-tinted work, and has an allure as a high-tech version of the traditional craft form: the carved, colored duck decoy. Seen in rare standstill, the separate photos also open up a whole new realm of close-up vision, revealing fascinating new patterns in minutely analyzed flight motions.

But if the viewer can take apart the flight, he also participates in putting it back together, bringing the still, separate images back to life. In fact, the flight illusion is probably strongest for a shopper moving *around* the hanging forms, carried by the mall's networks of automatic transportation (especially for those on the escalator or in the glass-walled elevator). If the flock mirrors the pattern of the human crowds, its illusory *motion* is in part an effect projected *by* that human flow. Migrating shopper motion adds to the sculpture's illusion of cinematic flight. So the *moving spectator* (often on a mall's *moving sidewalks* or *moving stairs*) is at the base of this sort of *moving picture*.[23]

In the cycling process of perception recreated here, we are continually stopping motion and then remaking its flow. It is a version of Zeno's paradox: we view the indivisible flow of time *as if* it were an infinite succession of discrete, static instants; our memory stops time by freezing effigies in static compositions, by the spatialization of time.[24] Snow calls *Wavelength* "a time monument": *Flight Stop* might also be seen as such a memory theater, with the subtitle "How Time Flies."

How Time Flies: Homage to Muybridge

The image of birds in flight has long been the classic figure for such explorations of the problem of time. Both the theme and the bird image dominated much of nineteenth-century photography, becoming most closely identified with the lifework of Eadweard Muybridge. Muybridge's photosequences "Horses in Motion" and "Birds in Flight" were immediately taken as his "trademarks," the central symbols for all of his work, the epitomes of the enigma of rapid motion that early photographers so desired to penetrate. In a coup of a gesture, Snow's *Flight Stop* places the classic Muybridge flight sequence back in the air, in 3-D space, returning us to the crucial gestation period of the cinema with a "moving" homage to the wild and mysterious explorer some call "the inventor of the motion picture."

Eadweard Muybridge, "Birds in Flight" from Animals in Motion. *Courtesy Dover Publications.*

Eadweard Muybridge is a rich model for new works. His personal story is the story of the development of his medium at a major turning point in modern cultural history. At his originary moment, people were asking fundamental questions that remain open and intriguing. Beginning as a nature photographer, pushing the camera ever deeper into America's Western wilderness, Muybridge (like Snow) developed early interests in new illusionistic modes for these nature scenes (exploring the "depth" of stereoscopic images, the total representation of the panorama, etc.). (Muybridge's life then turns on a central mystery incident of murder and jealousy: the searing moment when he shot the lover of his inconstant wife.) Absorbed with problems of time, with some secret at the heart of flux, he then began to concentrate on the photographic sequence, finally compiling eleven volumes of studies on *Animal Locomotion* (animals and humans in an encyclopedic variety of continual motion, revealing patterns of movement that no one had ever seen).

Shooting with Marey's "Photographic Gun," 1882.

Snow's geese, seen as a succession of fixed stills, recall the intensity of Muybridge's early photo sequences. (The Eaton Centre poster, by Snow, accents the similarity by catching his forms as pure silhouettes against the analytic grid of the mall roof.) *Flight Stop*, though, is not morbid in the manner of Muybridge stills: set in space, the discrete images of one bird can form a metaphoric flock. The frames here seem to come back to life, back to collective movement, back to illusion.

But Muybridge himself was restlessly advancing toward such cinematic effects. If his "scientific" stills seem to be obsessively trying to stop time, to analyze the world's movement, Muybridge the artist also wanted to return that world to motion. Working with the zoetrope (one of the many educational optical toys popular in the 1860s–1870s), he was fascinated by the phenome-

non of "persistence of vision" (a visual form of memory) and by the virtual forms produced in a continuity of movement. Then comes, again, the crucial, obscure passage from toy to spectacle. Muybridge advanced beyond the zoetrope with his zoopraxiscope at an 1879 debut in Palo Alto that made him the apparent inventor of the photographic cinema. The new mechanism sought not to stop time but to recreate its effects. With the first combination of projecting lanterns and counter-revolving disks, Muybridge was able to resynthesize the illusion of motion from the "positives" of his own still-image sequences.

Traveling much of his later life (just before the rise of the film industry) as a sort of one-man spectacle, Muybridge showed his moving pictures widely (even for a time using the first theater built for the movies). In 1879, the year of the zoopraxiscope, he went to France, beginning a collaboration with the physiognomist Etienne-Jules Marey with a gift of a "Birds in Flight" sequence, the image that was the hit of his show, for artists, scientists, and the general public. And the wonder of this flight triggered a rush of new experiment.

Snow would recall us to this atmosphere of deep probing, wishful "quack" tinkering, and of an almost alchemical radical aspiration for the new medium. And we might remember here most especially the mechanical twist explored by Marey, whose persistent efforts to transcribe time in terms of space, to synthesize motion, led him to experiment with 3-D plastic images for zoetrope illusions: *sculptures* of successive separate moments of a bird's flight.

A "BIRD-CAGE" MALL IN A NUTSHELL? A designer's model of Eaton Centre? Almost. But this self-contained sphere is the kernel of a "spectacle" system about a century old. This is an 1887 Marey zoetrope dish, with sculptured flying seagulls turning in its closed circle. (It really *could* be a simulacrum of mall structure.) Spectators don't walk around inside this sphere (as they do inside mall spectacle; here the birds move before them. But, similar to Snow's models, these sculptures set new wing positions on a body that remains the same. We have here all the potential for an illusion of flight; set in motion, this machine could simulate the flight of time.

And here is Max Ernst's playful 1930 collage addition to and commentary on Marey's dish—imagining a woman, perhaps representative of the zoetrope spectator or the mall shopper, now swept up and lost in the dreamworld of the spectacle system. From *Rêve d'une petite fille* . . . © Max Ernst/ KINÉMAGE, 1996

Malls and Moving Pictures: "An Immense and Unexpected Field of Action ... "

What does an homage to Muybridge have to do with Eaton Centre? How does such play with photographic cycles, with the alternation of analysis and gliding movement, with birds hovering somewhere between photography and film, relate to the larger context of a contemporary shopping center? Here I think Snow is working in the tradition of early film work described by Benjamin in his studies of cinema and urban life. In this famous excerpt from Benjamin's "The Work of Art in the Age of Mechanical Reproduction," we can almost feel the bird metaphors take flight:

> Our taverns and our metropolitan streets, our offices and furnished rooms, our railroad stations and our factories appeared to have us locked up hopelessly. Then came the film and burst this prison-world asunder by the dynamite of the tenth of a second, so that now, in the midst of its far-flung ruins and debris, we calmly and adventurously go travelling. With the close-up, space expands; with slow motion, movement is extended. The enlargement of a snapshot does not simply render more precise what in any case was visible, though unclear; it reveals entirely new structural formations of the subject. So, too, slow motion not only presents familiar qualities of movement but reveals in them entirely unknown ones, "which, far from looking like retarded rapid movements, give the effect of *singularly gliding, floating, supernatural motions.*" Evidently a different nature opens itself to the camera than opens to the naked eye . . . the camera introduces us to unconscious optics as does psychoanalysis to unconscious impulses.[25]

Both film and photography seem to Benjamin to offer the means by which experiences and urges once unconscious might be brought out for analysis, and urban crowds might be awakened from their enforced dream state. But these effects seem most likely to be achieved through a sort of montage alternation between the modes of film and photography. On the one hand, film can bring formerly fragmented images together into new syncretic realities characterized by those "gliding, floating, supernatural motions"; but then still photography and slow-motion can work to take seemingly monolithic unities apart, and so to interrupt the panoramic flow of illusionistic continuity. In these ways, as Susan Buck-Morss observes, "technological *re*-production gives back to humanity that capacity for experience that technological *production* threatens to take away."[26]

Snow's work is radical in the sense that it brings us back to the *roots* of its form and content, recalling the euphoric aspirations of many early film makers and theorists: the time-lapse sequence that would catch and condense the budding of a rose; the "Crazy Ray" that could stop and start city life; an art that could take it all in, revealing the structural formations of both nature and city life and harnessing them for new creation.

For the Russian Dziga Vertov, one such cinematic moment of comprehension in 1918 led to his conversion to a life of film work. Watching a repeated slow-motion film of himself making a risky high jump, Vertov discovered something like Benjamin's "unconscious optics"—a floating rhapsody which was also a keen instrument for the technical study of movement. Seeing himself tumble through the air (in a sort of autobiographical Muybridge series, a personal "flight stop"), Vertov saw revealed an emotional progression from vacillation to firmness to success—a plot of struggle with the self that could also be read as a representative image of his nation's destiny at a revolutionary moment. If this core scene of Vertov's work is, like Snow's *Flight Stop*, minimal and self-reflexive—*one gliding cinematic sequence*—the Soviet experimentalist saw the immediate relation of such "cinema eye" vision to the chaotic and exciting urban life around him. Taking a new name to suit his new medium ("vertov" means "spinning top," for the spinning gyroscopic vision, motion in stasis), he set this dizzying mechanical toy twirling through the city. His later large-scale films let the new "eye" range wide in works charged with the energy of urban and industrial activity: "The 'Kino-eye' is the realm of 'that which the naked eye does not see,' a microscope and telescope of time, an X-ray eye, the 'candid' eye, the remote control . . . for research into the chaos of visual phenomena filling the universe."[27]

Benjamin describes a similar relation of camera and crowd, though he is not always so Whitmanian and celebratory. The vision can also disturb him. With Vertov, Benjamin sees the new photo vision as the appropriate form through which masses of people can see themselves: "Mass movements are usually discerned more clearly by a camera than by the naked eye. *A bird's eye view* captures gatherings of hundreds of thousands."[28] And film's radical trans-

formation of our modes of spatio-temporal perception seems to him integrally related to new modes of city life: "The film corresponds to profound changes in our apperceptive apparatus—changes that are experienced on an individual scale by the man in the street in big-city traffic."[29] Moving through a jostling crowd involves a person in a series of bumper-car shocks and collisions, snap views of passing faces, agonizing reminders of unstoppable flux and passing time. For Benjamin, this sort of city shock perception is also *the* formal principle of film: *continual movement paradoxically perceived as a series of stills, of separate faces.*

Man With a Movie Camera; City as Cinematic Spectacle

Of course this "perfect" urban artform—the floating film movement so revolutionary for Vertov and Benjamin—did not just suddenly fall from the sky around the turn of our century; nor did the twentieth-century city simply emerge out of the blue. But if we follow the ancestors of our cinema and of our city life through the eighteenth and nineteenth centuries, as they take their early formative steps, we find that their progress *is* remarkably parallel.

From early on, city life seems to have called for new forms of spectacle, for some union of art and technology that could move beyond static painting, that could touch on a whole new range of urban visual perspectives and experiences. The public shows and displays that emerged for the crowds in growing eighteenth- and nineteenth-century cities are often, as Benjamin observed, strikingly proto-cinematic. Each new form of "show" seems animated by a common dream, an obscure, underlying presentiment of the film form.

Benjamin often tends to see the history of a city as a history of its spectacles, suggesting an analogy between the modes of city life and of spectacle, and in fact seeing new show forms and optical devices as the clearest *epitomes* of the larger urban experience. For example, extending Marx's perspective on urban life, Benjamin describes nineteenth-century exhibitions and department stores as an entertainment industry, "a *phantasmagoria* of capitalist culture . . . that people enter to be amused."[30] Here, then, the spectacles of consumer culture are seen on the model of the early nineteenth-century magic lantern show, which produced quick-changing optical illusions, a proliferation of airy, spectral images removed from any ground. And, as the phantasmagoria was a clear prefiguration of the cinema, Benjamin goes on to analyze later urban development as it parallels early work in *photography* and *film*. Baudelaire, the protagonist in Benjamin's studies, describes the man lost in and dazzled by the modern crowd as "a *kaleidoscope* equipped with consciousness"—quite literally referring to the optical toy invented in 1817 that presents brightly colored and constantly changing reflections in a hall of mirrors, creating infinite serial reproductions—and is both fascinated and repelled by a related optical device: the *camera*.[31] While unnerved by the naked, *fixed* daguerrotype images that caught the mindless movements of the "broad masses," Baudelaire was none-

theless attracted by the illusions of *motion* granted by proto-cinematic toys, zoetropelike gadgets that could flip through a series of images. When he writes of the sort of art that might describe the crowd, the "modern," the ephemeral surfaces and settings of contemporary life, Baudelaire returns to this second vision of serial moving pictures. Indeed, Baudelaire's *The Painter of Modern Life* can be read, as Stanley Cavell says, as "a prophetic hallucination . . . an anticipation of film . . . [evoking] the wish for that specific simultaneity of presence and absence which only the cinema will satisfy."[32] Conjuring a future art capable of capturing the mysterious grace of a moving carriage, of slowing and opening up that vision to "reveal the series of geometrical figures that the object successively and rapidly creates in space,"[33] Baudelaire seems to anticipate the slow-gliding cinematic revelations we've seen described by Benjamin and Vertov—and to call up once again the floating forms of Snow's *Flight Stop*.

So the observers are deeply ambivalent. Repelled by photo fixity, they can be entranced by film motion. And if the cinema is sometimes seen as an art *epitomizing* the phantasmagoric confusion of the city, it might also serve as a means of opening up that surrounding spectacle—revealing patterns and structures within the passing urban flux.

From Toy to Panoramic Spectacle: Entering the Sphere of Illusion

Flight Stop seems to work in just these ways—as an ultimate simulacrum of the "mall mode" *and* as a multileveled meditation on that context (a "show stopper"). The formal self-reflexivity of Snow's geese sculpture sends us back to review the animating impulses of the earliest works of public show, the first motions of the moving pictures.

Here we will see how the story of early urban consumer spectacle (the prehistory of film) rehearses many core issues of Snow's *Flight Stop* (changes in the representation of time, of nature; in the effects of fixity and flux; in the enclosure of the show frame), and how this story finally merges with the history of early shopping centers and exhibitions: the spectacles (panoramas, dioramas, etc.) and their sites (passages, department stores, etc.) develop together; proto-film and proto-mall coincide.

Building upon eighteenth-century experiments with clockwork imitations of natural phenomena (mechanical whistling birds and so on), with the moving pictures of mechanical theaters, and with the effects of natural motion and change made possible by presentations involving changeable magic lantern lighting and images in dioramic series, the next advance in realistic illusion— *the panorama*—would move with these impulses into much larger scale, attract much larger and more democratically diverse crowds, and soon emerge as the dominant form of city spectacle for many decades to come. The panorama was born in a new trick of perspective trompe l'oeil—painting a broad vista on a giant 360-degree cylindrical canvas. Robert Barker patented the technique of

"La Nature à Coup d'Oeil" in 1787, and named it "pano-rama" (Greek: all-embracing view) in 1791, when he built his show building. This new form of all-encompassing mass spectacle required its own round, self-enclosed building as a "show room." With the Panorama, viewers entered the sphere of illusion and moved around *within* it, usually by a central column with spiral stairway and "ascending platforms" (elevators) or by what was termed a "photographic ascending carriage" (the ancestor of the glassed elevators in today's malls). Now there was no frame to the enlarged "moving picture"; here the roving spectator could be immersed in a *total* reproduction of reality.

Wyld's Great Globe panorama building (cross section), 1851. Courtesy Guildhall Library, Corporation of London.

The panorama name and concept spread quickly—spawning a whole family of "———oramas." The new circular panorama buildings often housed shows that brought the countryside into the city as they brought breathtaking vistas of natural landscapes indoors. But, like our malls, the panoramas could also emerge as model cities within the city, as they made possible a heretofore impossible, totalizing overview of the urban whole. A true urban phenomenon, immediately attracting large city crowds, the panoramas could present city life itself as spectacle. In most cases, in fact, the first panorama in a city would represent that very city: Barker first painted a panorama of Edinburgh for Edinburgh and London for London. (Seeing a similar work by Thomas Girtin—the impressive "Eidometropolis; or Panorama of London"—in London in 1802, Wordsworth viewed the totalizing reproduction of these mini-cities as a fearful "type" of the city experience.) Similarly, when the new "Passage des Panoramas" was constructed in Paris, the first show offered there was a panoramic overview of Paris.

And, from the building of Paris's first "Passage des Panoramas" we can see that this new form of urban *spectacle* is internally linked to a new form of city *shopping*: the *panorama* is tied to the emergence of the *passages*, the enclosed, glass-roofed, marble-walled shopping arcades that are the ancestors of our own

malls. To add to their attractions, the passages—indoor pedestrian walkways through entire blocks of buildings—very often housed the very latest proto-cinematic spectacles: the Passage des Panoramas (1800) contained its panoramas, the Galerie Vivienne (1823) contained the "cosmorama," a show built upon magnifying mirrors, and the Passage Jouffroy (1847) was home to the Théâtre Seraphin, with its shadow plays and phantasmagorias, and later to the Musée Grevin, a wax-figure museum. But, more important, the passages were part of a revolution in consumer culture that remade shopping itself into a seductive new form of visual experience.

People in Glass Houses: Panoramas and Arcades

What is the connection between the visual experiences offered by the passages and the panoramas? First, both the Panoramas and the shopping arcades were glass-roofed, self-enclosed buildings offering visual displays that completely surrounded the shopper/spectator. So in both cases it was as if the viewer could enter inside the frame of the moving picture, and stroll around immersed in a sphere of illusion. And if the new illusions thus depended for their effects upon the mobile gazes of moving spectactors, their framing architecture was also designed to impel spectator movement and thus to enforce continual, dazzling change in spectators' views.[34] Panoramas and passages were founded upon parallel advances in lighting design and visual effects; both the panoramas and the passages were pioneers in the use of hidden skylights, which made the all-encompassing images in their "shows" seem to glow on their own out of an hallucinatory darkness. Though the dioramists and panoramists were often the age's leading experimenters in such theatrical lighting, it was apparently in the closed, controlled environment of the nearby arcades that gas lighting was first used. On all sides of a strolling shopper in the passages, then, goods seemed suddenly to appear, surprising the shopper, gleaming out of the haze with a special inward light, shimmering apparitions in what Balzac called the era's "great poem of display."[35] Arcade designers also used the poured glass on shopfronts to distort normal vision, and a wealth of wall mirrors to allow sudden magical and disorienting expansions in the shoppers' sense of space.

And something about their *enclosure* seems to have been a special attraction for both of these emerging forms of "show." Both panorama and arcade, like our modern malls, offered an escape from the harsh constrictions of city life in an illusionistic representation of that life; if city crowds flocked to the panoramas to get a disembodied bird's-eye view of their own lives, their own city in images, each arcade, too, could be seen as a "city . . . a world in miniature" (in the words of a contemporary guidebook cited by Benjamin).[36] But there is a crucial ambiguity to such self-contained spectacle. Though their glass roofs are meant to give the arcades a light and airy feeling, in fact the enclosure of the life under glass on these interior streets reflects what Richard Sennett describes ominously as an "architecture of control."[37] As a "world in miniature," the arcade is not experienced as a part of the city but as a simu-

lacrum of it—a manageable replacement for it; similarly, the glass ceilings that keep unpleasant weather out but let natural light in make possible the illusion that the arcade is an exterior street, but in fact they can be seen as defining a new sort of secure space that alludes to exterior life while actually serving as a substitute for it. As one analyst observes, the arcades define new spaces of consumption "that have no outside, like the dream."[38] Here, in a movement that will be fundamental to later mall design, the introversion of an enclosed architectural frame defines a shopping experience characterized by its psychological introversion.

The Birth of Window-Shopping: Shopping as Cinematic Spectacle

Spectators entered the shopping arcade or the panorama building, then, as if entering a dream. And indeed, as Benjamin and historian Rosalind Williams have pointed out, the new worlds of consumption were very consciously discussed in their day by analogy to the "dreamworld." One small change in sales practice that is now often seen as a defining moment in the consumer revolution that made shopping into a psychologically charged and primarily *visual* experience came in the department stores that emerged in the mid-nineteenth century: *grands magasins* such as Bon Marché in Paris (1852) or the Macy's in New York (1857). These large stores began tagging each item with a set price and inviting shoppers to come and view their goods without any obligation to make a purchase, in contrast to the earlier market custom in which prices were negotiated through haggling with the merchant—a process that, once begun, usually obliged the visitor to buy. Williams describes how the advent of these price tags implied momentous changes in consumption: "Active verbal interchange between customer and retailer was replaced by the passive, mute response of consumer to things." But these newly impersonal, visual exchanges between customer and commodity could be charged with the sort of intense emotion that had earlier been a part of the human interactions of haggling; in fact, display designers now had to work hard to ensure that the goods themselves would appeal to and arouse deep feelings in customers, who were now free to browse and so had to be seduced into desiring the product, wanting to buy. This necessity brought merchandising even closer to the creation of cinematic spectacle, as Williams observes:

> As environments of mass consumption, department stores were, and still are, places where consumers are an audience to be entertained by commodities, where selling is mingled with amusement, where arousal of free-floating desires is as important as immediate purchase of particular items. . . . The passive solitude of the moviegoer therefore resembles the behavior of department-store shoppers, who also submit to the reign of imagery with a strange combination of intellectual and physical passivity and emotional activity.[39]

Arcades and department stores attracted customers by offering them the

freedom to browse, to stroll dreamily through the goods on display without being forced into any interaction other than "just looking"—the birth of what we now call "window-shopping." This move presented shopping as a new form of the earlier mode of distracted urban strolling—*flânerie*—and redefined this sort of consumption as a form of reverie, a leisure activity, a pleasure rather than a necessity. But if all buying is now impulse buying, then merchandisers must newly concentrate their work on the creation of dreamworld displays that arouse impulses, dreams, desires, fantasies. (As one telling sign of this emerging conjunction of consumption, fantasy, and illusion, we might note that L. Frank Baum, author of *The Wonderful Wizard of Oz*, was also a specialist in the design of new-style store window displays. In 1900 he published not only *Wizard* but also a treatise titled *The Art of Decorating Dry Goods Windows and Interiors*—both of them working powerfully to lead viewers far from Kansas down the yellow brick road of spectacle.) But already in mid-nineteenth-century arcades and department stores, each visual meeting of shopper and product was being envisioned as a potential moment in a love story; the novelist Zola, for example, along with many contemporary commentators, worried about the way the new shop windows, with their disorienting mirrors and other visual dazzlements shrewdly constructed to intoxicate the mostly female customers, had become sites of seduction.

As it is psychologized, eroticized, and made cinematic, the new experience of shopping also becomes subtly gendered. Because the enclosure of arcades and department stores made them newly secure public sites—insulated from inclement weather as well as from the less controlled and dangerously heterogeneous human groupings outside—they became some of the first areas where women could emerge in public on their own, and by the end of the nineteenth century, women were not only salesclerks in the new stores but also very frequently the major customers. From this time on, the consumer was generally figured as female—wandering amid the panoramic displays of goods on "indoor streets" in distracted reverie as the male *flâneurs* had earlier wandered through the city—and the female consumer became the target toward whom the fantasy-inducing "poems of merchandise" were and are consciously directed.

These social and psychic transformations in the visual modes of spectacle and of consumer display bring us very close to the birth of the cinema. The most sensational evolution from the panorama came with the career of Louis Daguerre. After serving as an assistant to the panoramist Prévost, Daguerre opened his own diorama in 1822. Like the earlier "Eidophusikon," this diorama worked with a flat picture in illusionary depth and added newly changeable lighting (moving foreground transparencies, etc.) to reproduce the *changing time of the day* in a landscape or, very often, to show old church edifices, like those in Monet's series paintings, passing through subtle alterations in light and atmosphere. In these standard Daguerre building scenes, then, the solid edifice begins to dissolve (in a way prefiguring the goals of modern mall

design): no longer a fixed solid object, the building frame becomes a site for the experience of fleeting changes in perceptual effect or mood, for effects *in time*.

In Daguerre's late dioramas, the discrete, unconnected scenes could be changed as in a silent-movie dissolve, with the slow closing and reopening of a rudimentary sort of camera shutter. Like those of the silver screen, these diorama images seemed to glow of themselves—and awe spectators now seated in the complete dark of an amphitheater. (At the time, the regular theater was not darkened like this; but this special hallucinatory darkness *was* a feature of other proto-cinematic shows in the 1800s: the phantasmagoria and the waxworks.)

When Daguerre's Paris diorama burned in 1839, he was ready almost immediately to announce the invention of his "Daguerrotype." (A parallel to and extension of Daguerre's progress from panorama to diorama to photography comes later, when, obsessed with the synthesis of motion, Muybridge moves from his last major still work (an immense 360-degree panorama of San Francisco) to concentrate on his photographic cinema.) As Benjamin notes: "In striving to produce deceptively lifelike changes in their presentation of nature, the panoramas [and dioramas] point ahead, beyond photography, to films and sound films."[40]

Part 2

Toward the Modern Mall: The Crystal Palace

In these same years, the industrial exhibition was emerging as a frame for the presentation of merchandise in another sort of spectacle. ("Europe is on the move to look at merchandise," observed Taine.) London's Crystal Palace exhibition of 1851 is often seen as the climax of this movement, an epitome of nineteenth-century spectacle:

> It was this event toward which one main stream of London exhibitions proved, in retrospect, to have been leading; it was the exhibition of exhibitions, the most lavish of shows.[41]

But if this great exhibition retrospectively collected the impulses of many forms of nineteenth-century show, in combining them it also took the next step forward toward the twentieth-century—it can be seen as a preview of coming attractions, a crucial founding moment for our current modes of exhibit and display. Stressing the union of art with engineering, science, and commerce, the Crystal Palace introduced in large scale many elements that are still formative in mall design—both in its structural *frame* and in its interior *displays*.

First was that immense amount of *glass*. The nineteen-acre building was entirely walled and roofed in panels of dazzling "crystal" glass. A daring experiment at the time, this transparent frame made it possible to create huge interior spaces that were relatively free of obstructive or confining structural ele-

ments. This was an enclosure that seemed to deny itself, and it permitted wholly new indoor effects of openness and lightness. Skylights, so integral to the panoramas, the arcades, and the department stores, are the essence of the Crystal Palace structure too—and link it to the glass gallerias in many modern malls, including the corridor of glass at Toronto's Eaton Centre.

At the Crystal Palace, the glass-frame skylights allowed designers to bring the outdoors inside. John Ruskin ridiculed this "greenhouse larger than any green-house ever built before," but the Crystal Palace *was* like a giant garden, and like many of today's malls could thus house large displays of indoor plantings—including a system of waterworks and even several full-grown trees. Many replicas of the Crystal Palace (such as the miniature in San Franciso's Golden Gate Park) have now become botanical gardens or natural history museums. The Crystal Palace's large system of *waterworks* (another feature now essential in mall design) reinforced its main theme: mechanical control of the environment. The show's centerpiece, the "Crystal Fountain," joined in the general celebration of lightness and glass with a spray of dispersed water over its tons of pure crystal.

All of this dazzlement was made possible by the support of new applications of *iron*. Designer Joseph Paxton developed with this first artificial building material (used in buildings serving transitory purposes: arcades, exhibitions, train stations) a completely new principle of *prefabrication*. Through serial construction with standardized parts, Paxton framed large interior galleries for an effect of "uniformity on a scale raising it to monumentality."[42]

The Problem of Scale

Mechanical monumentality or natural diversity? Does one stress the planned overarching whole or the plurality of individual parts? The closure of the scaffold frame or the openness and freedom of the display space within? A *conflict of scales* is evident in the architecture, the displays, the very concept of the Crystal Palace; it can be seen to continue as a basic problem through the evolution of the American mall.

Paxton (both a gardener and an engineer) achieved a pleasing balance in the Crystal Palace by contrasting the foliage of live trees with the rigidity of his iron framework. Similarly, though Prince Albert's expo speech stressed the "*unity* of the arts of a plural, diverse mankind," the wholeness of the community, he balanced this with a celebration of *specialties* (unique products by unique workers) and *specialization* ("division of labor" is "the moving power of civilization").[43] The tricky goal is an illusion of continuity built out of separate parts, a continuity that does not override its separate constituents. As we will see, our modern malls often hope to offset the large scale and lines of their closed, controlled structures with interior designs suggesting the free, organic growth of nature or the variety and bustle of "small specialty shops" in the early, unplanned city.

With its mammoth glass enclosure, the Crystal Palace *was* a city in itself—

quite a large one. Crowds of many nations and social classes jostled through long aisles, each visitor looking at all the others, entertained by the forced mass movement as much as by anything else. In its "show" form, the city experience was an amusement. For if the World Exhibitions invited "pilgrimages to the commodity fetish" (Benjamin),[44] they offered a purely visual feast—they were for looking, not for buying (again an anticipation of that mixed form we call window shopping).

Inside: An Orgy of Imitation

What the crowds saw in this packed "*Diorama* of the Peaceful Arts"[45] was often as light as the glassed building, and as playful as the browsers who were just looking. In the open space defined by that fixed but transparent frame, display objects seemed to proliferate with a strange new freedom. Just as the Crystal Palace tells us much about the *superstructure* of our malls, the profusion of its displays suggests much of what will appear in twentieth-century designs for the mall *interior*.

In the 1851 exhibits, the stress was clearly on novelty, on the latest fashion. Freed from concern with past conventions or with utility, engineers must have experienced a rush of liberated technological fantasy. There is a playful energy, a buoyancy, a Disneyland feel, in the inventions shown at the Crystal Palace. Surrounding the viewer, these displays must truly have seemed a phantasmagoria. Any everyday item would reappear here decorated or captioned with a story, as part of some fantasy or narrative. And with the fascination with storytelling comes an orgy of imitation. Seeming to prefer the copy to the original, designers introduced imitation materials, imitation period pieces, imitation craft pieces; their displays formed a true hall of mirrors.

At the Crystal Palace, innovation in forms worked in many ways as *a move away from the old solidities* : 1) freed from solid tradition or history, a wild mixture of styles appears, dominated by period imitations and incongruous blends (with rooms devoted to imitation cultures, prefiguring the plastiform recreations of "specialty" cultures in some of today's malls and theme parks: exotic fantasies in three-quarter scale of Le Quartier Francais, Olde London, Main Street, etc.); 2) freed from the solidity of authentic materials, many synthetic and imitation forms arise (hollow bricks; artificial marble, silver, and cast stone; many imitation woods; much use of papier-mâché; and the important introduction of gutta-percha rubber (a preview of our plastics); 3) freed from traditional skills and convention, ingenious machines appear to reproduce in detail the products of artisans; 4) freed from solid forms, there emerges a stress on mobility (portable and packable furniture, etc.) and on convertibility (this sort of imitation includes many multiple-use items that can suddenly turn into something else); 5) some eerie inventions here even seem to want to unsettle the solidities of death (to "preserve" a body in some new form with various improved sorts of coffins).

While some visitors found these Crystal Palace displays to be a carnival

chamber of horrors (Ruskin, Thomas Carlyle and William Morris, for example), other commentators, such as Nikolaus Pevsner, stress the vitality of "undaunted progressiveness" and lament the passing of such healthy openness to innovation in now-staid Britain. The impetus for this kind of technological invention and fantasy has clearly moved elsewhere.

A Thumbnail History of the North American Mall

"The commercial spirit has nurtured some of our most interesting American design," historian Neil Harris writes of the virtuosity of technical innovation that has formed the "architectural fantasy" of today's malls. "The last architectural form that serviced American dreams so effectively was the movie palace of the interwar years."[46] Of course, malls have now absorbed the movie-theater concept, offering their own multiscreen cinamettes, along with exhibits, lectures, concerts—even enclosed amusement park rides and carnival-style midways. But the real spectacle is always the mall space itself: its escalator and elevator rides and ramps, its vistas and displays, its gardens and waterworks, graphics and glass, its recreated ambiences and "quartiers." This larger focus is what has sparked the technical virtuosity of these new designs in space and light, extensions of the metal-and-glass structural experiments of the mall ancestors: arcades, exhibition halls, and railroad stations.

Actually, the North American shopping center itself has a surprisingly short history, but development has been rapid, and design has become extremely self-conscious. These are now highly defined, highly designed environments.

But what do designers think about when they try to organize such a complex phenomenon? In the half-century history of American malls, five phases of design strategy are apparent.[47]

Phase one came out of the car culture of 1920s-'30s California, when people discovered the one-stop attraction of putting several small stores (with maybe a grocery store as base) near a single parking area. Through all suburban mall development, this basic structure has remained the same: a cluster of stores surrounded by acres of parking lot. From outside, a mall is just cars and windowless walls, as exciting as the solid brick exterior of a panorama building or a theater. But the only mall "show," of course, is directed inward. And the paved lot can serve as a sort of transitional moat, accenting the insular feel, the otherness, of that self-enclosed "palace" at the core. (We think: "That must be someplace really different!")

Phase two brings the gold-rush rise of the regional centers, produced by the addition of large "anchor" department stores to the grouping of smaller shops. Because of the boom of highway construction in the Eisenhower era and the huge migrations of people to the suburbs, the 1950s and '60s were the golden years for shopping center development.

Centralized ownership was the radical innovation that really made things happen, laying the foundations for these new giant centers. The department

store anchor magnets, which provided the drawing power for these regional complexes, were also able to attract major financing from insurance companies, and often singly owned and planned the entire operation. Controlled by one large-scale developer, the regional center could now begin to regulate both its economy and atmosphere: carefully choosing its tenants, avoiding internal economic competition, and working for a unity of architectural effect.

Turning Backs ...Wishing Away ...

The movement toward unity in these phase two centers only accented some crucial aspects latent in the phase one designs: basic tendencies toward *self-containment* and *introversion*. Even before the 1920s, the trail-blazing J. C. Nichols was using the "Spanish Mission" model with stores facing inward on a central pedestrian courtyard so that they could be set apart from cars and (in a move paradigmatic for later malls) *"turn their backs to the street."*[48] The large phase two centers would simply expand on these principles. The influential design of Seattle's Northgate (1947), for example—the prototype of the classic "dumbbell" format of phase two designs—places its two department store anchors at either end of a central, open-air pedestrian mall framed on each side by two big, straight-lined strips of smaller stores. Focusing all interest on the pedestrian shopping street, this model allows stores to "turn their backs to the highway"[49] and relegates service activities to a hidden underground tunnel.

Harris notes that the earliest experiments in the separation of pedestrian customers from cars and from any service activities—creating a carefree inner circle distant from outside concerns (forget your car, forget the street, forget services, forget yourself)—were made at shopping centers and at Disneyland.[50] Both malls and Disney's Main Street derive from the middle-American townscape, but their closed, controlled, cleaned-up, miniature-scaled, stage-set "streets" move in similar ways to keep practical services (deliveries, employee access, building supports, circuitry, etc.)—as well as thought about practical life—behind or below the scene. While one critic describes the Disney wonderland as "acres of fibre-glass fantasy resting upon an unseen technological superstructure,"[51] mall designers combine an interest in this kind of fantasy entertainment with the more directed goals of selling. They have good reason to seek to wish away mall superstructure and let the merchandise take over center stage. The separation from cars and "the elimination of all service facilities from the public consciousness" become the "necessary ingredients" of a shopping center to a 1950s design theorist;[52] these are necessary because, as another 1950s planner sees it, the future center should be a fantasy-realm "kaleidoscope of movement . . . where *shoppers will not be conscious of the building but only of the displays* ."[53]

So already in phases one and two the basic mall structure is set—or, rather, what is set is the *denial* of superstructure, the desire for an inner "open" domain freed from external necessities. In this, the earliest shopping centers

join the most modern ones. For example, Victor Gruen, creator of the first modern enclosed mall (what he aptly calls the "introverted center"), writes that he found his inspiration in many aspects of the nineteenth-century arcades: their self-enclosure around a central pedestrian plaza, their separation from external weather, from services, from traffic, and from the hostile city environment.[54] Like the 1950s suburban malls, Gruen says, the arcades were born in a *movement away from the city*, with architectural gestures of *introversion*.

Turning Inward

In the 1950s, even with the advent of large-scale, single-developer centers, some regional malls continued to be built simply as giant extensions of the earliest plans—just your basic straight lines and big blocks on a monumental scale. But in the late 1950s and early 1960s, some developers began to place a great new emphasis on design planning and environmental control. Reacting against the early centers that simply rose up out of the demands of the road—growing uncontrolled, unstyled, on the "strip"—new mall designs would turn their focus ever more clearly inward, strengthening the existing impulse to self-containment with further major shifts in the direction of the fully orchestrated mall.

A new self-consciousness in design centered on new problems: 1) the *choice* of an atmosphere, and 2) the question of *scale*. How should the plan reflect or deflect the fact of a mall's increasingly giant size, its self-enclosure, its clearly controlled environment? Responses to these problems took two general forms—in phases three and four. Both alternatives, though, are part of a general movement inward, toward enclosure and toward concentration of effect—reacting to the imposing realities of mall superstructure with a new focus on special effects for the mall interior.

What we might call phase-three centers are the "market town" styles that deliberately underplayed their large size (they often included several department stores), reacting against the straight lines of the earlier malls with meandering, informal patterns. Even in earlier phases, this approach had been very successful. The prototype Town and Country Village chain, for example, backed its name with designs accenting "the charm of irregularity" and "picturesque congestion,"[55] adding old materials, heavy timber, and tile roofs for down-home informality. The aptly named Old Orchard mall in Skokie, Illinois, the first of the extensively landscaped malls, is often seen as the classic example of the "country market" style in its late-1950s boom years. Streams, bridges, finely gardened courtyards and shop squares of varying dimensions were designed to suggest the atmosphere of a country village. As in a diorama, the goal was to dissolve the static sense of the building frame, making it serve simply as the site for perception of changes in visual effects: "changes of pace, of scale, of direction, of shape, of surface."[56] Informal arrangements divided the mall experience into a series of cozy limited views, with meandering water

and bridges to lead shoppers on to each new surprise. As one planner comments, at Old Orchard "the lure of around-the-corner urges the shopper on" so that "he sees more than he otherwise would" and he "concentrates his attention upon the attractions most nearly at hand."[57] Some other of these phase three rustic malls have two levels, a crucial innovation (begun by James Rouse) that halves the distance shoppers have to walk, accents and insulates the courts, allows more views and more people watching, and increases the psychological intimacy of the "rural" setting.

Mall as Movie: The Erotics of Shopping—Looking, Buying

Clearly, the design self-consciousness of the late 1950s brought a great new emphasis (returning to modes of thought first developed in relation to the design of nineteenth-century arcade and department store displays) on the psychological effects of mall environments; the big new design buzzword became the "experience." With the new concentration on special effects for the mall's *inner realm* came a new concern with the emotional *inner realm* of the shopper. A seminal article by planner and pop psychologist Richard Bennett in 1957 speaks for the whole complex of emerging orthodoxies involving 1) the "village" atmosphere with irregular lines, changing effects, the "lure of around-the-corner" shopping; 2) the focus on the psychological needs of shoppers; and 3) the new stress on shopping as a non-utilitarian visual experience, a quasi-cinematic spectacle, an adventure.

"The 'looking at' becomes as important as 'the buying,'" writes Bennett, and so the mall is seen as a sort of moving picture, with a coyly erotic plot of Girl Meets Goods: "A piece of architecture—the building—should be considered as a frame for the picture of the love affair between a customer and a piece of merchandise."[58] If a mall is a successful movie, its shopper will lose herself (Bennett's 1950s customer is always *female*), forget that building frame, suspend disbelief, and consummate "the experience." Like a spectator at a panorama, this customer should step inside the frame of the moving pictures and walk around immersed in reverie-inducing illusion.

When the "buying act" becomes so deeply associated with this kind of illusionistic visual spectacle, a very special mode of shopping is involved: it enters an arena of entertainment in which the experience of looking is as important as the object found, in which customers are willing to pay for the atmosphere, for just looking, and their surplus money goes for emotional rather than physical necessities. At this turning point in the late 1950s, Bennett's excitement with the strategies of visual display is part of an effort to urge a basic mall reorientation to "the *impulse-buying* which comes after the essentials are bought."[59] (And the radical shift to what is now given the strange name of "nonmerchandise retailing" has indeed continued as a major trend line for malls from Bennett's time into the 1990s; with our current emphasis on specialty food-and-entertainment centers, it is the dominant mode.)[60]

Bennett details and re-enacts the psychology of impulse buying because, for him, the designer's goal is to help release these impulses, help free a shopper's inner desires from external concerns (with the frames of time, money, self, and so on). An interior atmosphere of fantasy and festivity can make shopping an adventure, a quest, and so bring "more dollars out of women's purses."[61] (These fresh 1950s inventions have become our commonplaces, our ad copy, our household words.) So the changing, irregular views of an "English village" mall work to keep the buyer dazzled and nearsighted, to prevent a static overview of the whole, to close off awareness of the outside. And Bennett relates this to the *carnival* model of "high-powered merchandising," with its multiplicity of attractions and rides luring customers into continual movement while providing no focal point. In fact, he says, malls probably have the most to learn from the *amusement park*, "where most people spend more than they intend." Bennett finally presents the curved lines of Coney Island as an ideal model for the country village mall. This is the vision of amusement in enclosure, of shoppers losing themselves in involuntary repetition within the oneiric circles of fun visual attractions: "a meandering closed ring which returns on itself so that one starts a second circuit before one realizes it."[62]

Closing the Ring: Phase Four's "Introverted Center"

Many of these open, village-garden style centers of phase three are still flourishing attractions, but the era's phase four design alternative set the pattern for most mall development in the next two decades. The Southdale Shopping Center near Minneapolis, designed in 1956 by Victor Gruen and Associates, added a second major innovation to the new two-level concept: it was the first large, *fully enclosed*, air-conditioned mall design. Inspired by the Milan Galleria and nineteenth-century arcades, what Gruen called "the first introverted center" offered a series of arcade entrances opening into a large covered central mall. With this move to overall enclosure, the center became a completely separate domain, sealed off, an economy in itself. As one observer writes, from this time on, "Malls aren't part of the community . . . they *are* the community."[63] Here the history of the North American mall returns self-consciously to its roots in the developments of Parisian arcades and department stores, with a renewed stress on a center's complete physical and psychological separation from the outside world, and a new interest in creating an inner world of consumption based in fantastic visual display. Like the earlier enclosed forms—the arcades, the panoramas, and the exhibition halls—the enclosed mall can be seen as a sort of city in itself. And in fact Southdale's elaborate interior displays sought not village serenity or old-style charm but a recreation or simulation of downtown activity and bustle.

In this very influential enclosed-mall prototype, Gruen arranged his indoor sculpture and trees, and the closeness of his two levels, to recreate the effects of urban variety and energy. The interior model was a suburbanite's dream of

an early 1800s unplanned city, offering substitutes for streets and an arena of concentration to those feeling the uniformity and isolation of suburban sprawl. In 1960, Gruen wrote that the new shopping spaces must "represent an essentially urban environment, be busy and colorful, exciting and stimulating, full of variety and interest."[64] And indeed the decade of the 1960s saw a mall boom with "increasing sophistication . . . in successfully repackaging an idealized urban form into the suburban milieu."[65]

In our day, two-level *verticality* and overall *enclosure* have become standard in the designs produced and reproduced by the large mall-development companies. Since multiple levels create problems of access and shopper mobility, systems of undulating ramps, connecting bridges, broad staircases, escalators and other "rides" have become necessary features. And these can only add high-tech pizzazz to the color and activity of the desired urban effect.

Utopia: No Place

But of course part of the mysterious attraction of a mall's city feel is that it *is* an effect—a designer's virtuoso re-creation. First of all, the background fact of mall enclosure always works in an intriguing tension with the surfaces of an urban ambience, reminding us of the differences between such highly defined space and the organic chaos of a town. This is, as Gruen and other designers have stressed, a representation or a repackaging of the metropolitan dynamic —a fantasy urbanism devoid of the unpleasant aspects of life on actual city streets: weather, dirt, traffic, danger, bag people. We get a *frisson* in recognizing a sameness of mechanical reproduction behind a mall's downtown-style diversity. Instead of a competition of unique one-owner specialty shops, most malls offer outlets of the same widespread franchise chains. Reproduced clones of an entirely standardized mall design, in fact, often reappear throughout the continent—with the same Muzak, fixtures, and controlled climate— denying regional differences or local color. The mall crowds are much more homogeneous (suburban homemakers, retirees, teens) than those on a city street (or in the ghettos that the urban malls have "renewed"), and those dizzying mall traffic patterns, we soon recognize, are also rigidly programmed and permanently fixed.

But too much of this sort of demystifying customer recognition is the main threat to the phase four designer. These urban-style malls, though they imitate the city rather than the garden village, share basic design goals with phase three plans. Again the accent is on changing views and variety of stimulation; the concern is still to break up recognition of the vast distances and stark vistas, the increasingly monolithic financial and structural frames, of the new malls. At Southridge, for example, an urban bustle of changing elevations, false walls, shifting angles, prismatic lighting and dispersed niches is intended, the designer writes, to "minimize the effect" of the mall's horizontal size, to "break up" and "distort the measurements of space and distance." Here again, the basic point is to "provide *no focal point* to distract from the visual attraction of

the stores,"[66] to keep shoppers dazzled by each display as it rises before their eyes—and unaware of the enclosing frame.

Landscapes of Spectacle: Skies "Irrelevant" in the Bird Cage Mall

With this late 1950s culmination of the mall tendency to introversion, as the phase four mall becomes literally enclosed, comes a great new designer concern with interior effects of openness. We have seen how Gruen himself acknowledges—apparently without a trace of irony—the problematically ambiguous indoor/outdoor, closed/open status of the enclosed mall: "The underlying purpose of the enclosed mall is to make people feel that they are outdoors."[67] His first enclosed design, Southdale, worked to achieve this "psychological connection with nature"[68] by including skylights, elaborate waterworks, and a dramatic central atrium named (in almost Victorian, Crystal Palace fashion) the "Garden Court of Perpetual Spring," which was filled with the lushest of tropical plants: palms, azaleas, orchids, and magnolias. Of course, the point here was not simply to imitate the outdoors. The mall displays now foreground and celebrate their ability to recreate a "second nature" —in this case an indoor-outdoors that is spectacularly *different* from the local scene: this is *not* that harsh Minnesota weather; these are *not* Minnesota plants. So the increasing stress on a connection with nature goes hand in hand with an increasing stress on mall imagery as illusionistic spectacle. Southdale's designs present themselves very overtly as a liberating *fantasy* of a *dream* nature, a vision of an indoor paradise freed from time and seasonal turns (so spring is "perpetual").

And these germ ideas that were pioneered at Southdale have proliferated everywhere. The sidewalk cafés—with umbrellas as playful reminders of the weather that is *not* there—now dominate all malls. Gruen's primitive programmed light shows (themselves based on effects pioneered in the glass-roofed arcades, where sunlight and stars could be seen indoors) have now re-emerged in sophisticated mall projection systems such as that at the Caesar's Forum Shops in Las Vegas, which can create dramatic illusions of an ever-changing sky above the heads of shoppers deep inside a closed mall interior. Here, again, of course, this is not an attempt to make shoppers feel that they really are outdoors; rather, such an elaborate light show is meant as a celebration of the fact that the mall is insulated from the unpredictability of real skies, a realm of free fantasy separate from the world outside—but able to allude to that outside world and in fact to subsume it.

In such thoroughly regulated environments, we come for the spectacle, the playful imitations and virtuoso effects of the designers. We want to see what sorts of natural scenes *humans* (the new panoramists) can create. And the absence of weather is actually a selling point: one mall advertised itself with this mock weather report: "Forecast: consistently pleasant . . . Skies over . . . enclosed street continued irrelevant."[69] These, then, are the spectacular skies

and controlled climates of the modern mall through which the Canada geese of Michael Snow's Eaton Centre sculpture are flying. And, indeed, we have already noted how the courtyard birdcages and multistory aviaries (with live birds) incorporated into Gruen's interior paradises at his Southdale and Southridge malls have come to define the *birdcage* as a central figure for much later mall display—reappearing, for example, in a tall Aviary Court at the Tyson's Corner Mall, near Washington, and in a Bird Cage Mall in California. Floating through the glass canyon at Eaton Centre, Snow's spectacular image of an indoor flock of Canada geese may then call up for viewers these base themes of openness in mall enclosure, suggesting that the *birdcage* stands as an apt figure for the dynamics of the modern shopping center, and for the situation of free-floating fantasy in this closed and controlled realm: the paradox of *visionary freedom in enclosure*.

The Herd Instinct: Crowds as Flocks and Schools

The enclosure of the mall now seems to be its essential feature and its main allure. Even in areas with mild climates, new developments are almost always covered and temperature-controlled. Revitalizing an old center usually involves adding an all-encompassing roof. On the other hand, culture critics now focus their attacks on this move toward the self-contained environment. George Romero's movie *Dawn of the Dead* (1979) turns a mall's closure to horror; *The Blues Brothers* (1980) betrays a similar pent-up aggression when its chase scene gets sidetracked, and its slapstick turns unfunny, vicious—as rampaging cars try to escape a sealed mall.

But there still seems to be a hunger for large, enclosed spaces where people can feel themselves to be part of a collective movement while avoiding the "shocks" and dangers of actual city life. Many mall planners point to ancient origins in the Oriental bazaar, the Arab souk, the marché. Marketing has long been associated with enclosure; the Jerusalem bazaar shows that "the covered shopping center has existed for at least 2,000 years"[70] (though it certainly was not controlled by one developer). And Gruen appeals to even more primitive "natural" urges: his centers are erected in the faith that "the human animal's herd instinct which makes him gather in groups, tribes, and nations . . . will endure."[71] Certainly some such nexus of impulses is behind the incredible drawing power of today's advanced urban malls. Just as Toronto's Eaton Centre attracted huge visitor crowds, with its feature sculpture of migrating Canada geese mirroring the movements of those indoor flocks of tourists below, so in its first year (1980–81) Baltimore's Harborplace brought in more customers than Disneyworld with a festive "chaotic marketplace" atmosphere "blending commerce and showmanship." *Time* magazine was fascinated by this new sort of crowd movement in Baltimore's glass galleria, where people become the display: in these "translucent pleasure domes visitors can be seen from outside swarming in rhythmic schools like the angelfish at the nearby National Aquarium."[72]

New Directions

The ambiguous status of the enclosed phase four "city-style" malls is only com-pounded in the current phase five of mall design—the urban or vertical mall. City planners have always criticized the suburban mentality behind the inau-thentic creations that drained the downtowns: "Of course, any real downtown is more interesting than a single mall, just as Los Angeles is more interesting than Disneyland," observed Dick Rosann, director of New York City's Office of Development, in 1977.[73] But now malls have opened in many city cen-ters—The Embarcadero Center in San Francisco, Water Tower Place in Chicago, Citicenter in New York, Eaton Centre in Toronto, and on and on—and it appears that downtowns may be rebuilt with the help of these thriving city replicas in their midst.

These urban supermalls are pushing the potentials of verticality and enclo-sure to new extremes. Often, such expanded projects absorb many new func-tions to reinforce their status as self-contained economies: They can contain dances, lectures, exhibits, concerts, all high-school events. Water Tower Place, for example, supports a twenty-two-story hotel and forty floors of high-priced condominiums, so that people can live, work, eat, shop, tour, or mingle there—both earning money and spending it—day and night. And this trend could continue: an omnivorousness is inherent in the mall concept; this hardy form proliferates by absorbing new life functions. The enclosed mall does not want to close itself off, but instead wants always to enclose more.

Shopping centers have been linked to planned communities from early on. J. C. Nichols's Country Club Plaza (1924), perhaps America's first center, was part of a planned Kansas City housing development. In the 1930s and '40s, planned towns (such as Greenbelt, Maryland; Levittown, Long Island; and Park Forest, Illinois) often had experimental malls at their center. The James Rouse Company, behind one of the earliest enclosed malls in 1958 and now one of the most prolific mall developers on many fronts, owns several of today's model planned communities (with Columbia, Maryland, as centerpiece).[74] Victor Gruen, inventor of the enclosed mall, has built on his youthful excite-ment with the "ville radieuse" of Le Corbusier in recent work on Paris's "new city" at La Défense, and he has written a book on the need to expand the mall concept (as a way out of atomized enclosure) into the planning of mini-cities or "multifunctional centers."[75]

People Movers

Because they are all several stories high (a dramatic escalation of the earlier two-story idea), vertical malls make use of new possibilities for large-scale con-struction in metal and glass. Glittering, light-drenched courts are designed for dazzlement. But planners use displays, vistas, lights, and conveyances to accent a vertiginous sense of movement for a pragmatic reason: extended verticality presents a great problem of shopper circulation. How do you draw

people along, how do you stimulate them to explore all levels? The main spec-
tacles in vertical malls, then, are often fun, fancy means of *moving people*.
Some modern mall courts have the playful amusement park feel of a flamboy-
ant Portman hotel (and Portman's Hyatts and multifunctional cities-within-
the-city, with their structured chaos and whimsy, have certainly influenced
mall plans). A few of the newer and bigger malls incorporate amusement park
rides or even amusement parks under their roofs. And some current experi-
ments even replace that glass roof with huge, light-permeable, billowing circus
tents more suggestive of the desired shopping mood. Benjamin, we remember,
described the "art of being off-center" as a sort of Dodg'em Cars ride; urban-
mall planners must work to suggest just such an experience.

The elegant Water Tower Place, celebrated as "a system to move and attract
people,"[76] greets the shopper with a cascading garden escalator that combines
a perspectival waterfall with automatic stairs. Called a "spectacular," this cas-
cade suggests an analogy from nature for the mechanical movement of people;
it invites crowds to flow. Such organic analogies for traffic patterns are now
basic to almost every mall design: when streams flow, we flow; when they
change levels, we change levels; at a pool, we stop and collect ourselves. In a
similar way, designers use trees to link mall levels visually, to encourage shop-
pers to "climb." Snow's geese—mirroring crowd circulation from the air, join-
ing all levels of the central galleria by their position in the "landscape" of mall
"earth" and "sky"—are successful in this way, almost too uncannily so. (Their
movement, suspended animation, is also reified wax-model fixity; their free
flight is closing on the end of the corridor; their natural flow is also artificially
stopped. Like the *Time* writer at Harborplace, we see this group movement
from outside, in display form, and thus the "natural" analogy, with its talk of
"herds," becomes unsettling.)

The mall designer's main goal is continual flow. The cascade/escalator at
Water Tower Place leads directly to a second spectacular—a seven-story grand
atrium traversed by three glass-windowed elevators, which glitter in spotlight-
ing and can provide a panoramic ride. Such a moving spectacle is carefully
planned to bring people in for what the designer (and we recall Bennett's views
here) calls "the experience."

Even more than the suburban malls, these new projects link architecture
and entertainment. The stress is on affective "experience," writes one critic
praising "the new concept of architecture" in Water Tower Place, because a
mall building is not "an object, a thing," but is "an environmental phenome-
non," a spectacle surrounding its perceivers: "The question of what it *is* . . . is
less urgent than the question of how it *feels*."[77] (Though this seems to beg the
question: What *is* it?) So here a planner must aim for pizzazz, combining profit
and pleasure, commerce and showmanship, in a site for the emotional
encounters of adventuring shoppers. The new generation of designers takes
much further Bennett's initial vision of the psychology of consumption. Each
passage of a shopper through a mall building is seen as a complex "visual expe-

rience," a movie: "The mall . . . is TV that you walk around in," writes William Kowinski. By making the visual experience stimulating, planners hope to prolong the period of "just looking," allowing for increasingly charged psychic exchanges between consumer and commodities, and thus allowing for the creation of new bonds with these objects. Planners call this the "retail drama," in which, as Kowinski notes, "customers are not only the audience, they are the action and the actors." This can create a strange atmosphere for the "perceiver's" main activity—for buying. If the feeling is of amusement, distraction, and continual motion, we may be so involved in moving and looking that buying comes to seem incidental; in fact, in malls we *do* buy incidentals mostly. And planners now work to induce just these impulses: They theorize about a moment of success, termed the Gruen Transfer, when a "destination buyer," who arrives with a set intention to buy a specific product, is transformed during the mall experience into an impulse shopper—a moment that is apparently marked by a telltale shift from goal-oriented, efficient walking to a stop-and-go, meandering, reflective stroll, and a nearsighted gaze.[78]

As Bennett foresaw, "Impulse buying is one result of this combination of shopping and spectacle": We just pick up what suddenly appears before our eyes, out of the continual flow of surrounding merchandise. (Is this like buying a still from a movie, or a souvenir from a tour?) The new concept in mall bookstores, for example, seems to be to maximize random tabletop displays (the new arrivals) and to minimize old-style cataloguing by subject. It may be very difficult to find the specific book that we come for; instead of such goal-directed shopping, though, we are invited, almost forced, to *browse*. Buzzed with coffee, lulled by music, we find an endless series of colorful covers rising before us. In such off-center distraction, we will almost inevitably discover a surprise, an unexpected object of desire.[79]

Into the Looking Glass: The "Dissolve"

Why do today's enclosed malls have so few shop windows? Since Gruen's experiments in public/private space, new forms of merchandising display always seek to further eliminate barriers between people and products so that we can keep moving, and so that we *can* easily pick up something if it strikes our eye. As the panorama eliminated the frame from its all-encompassing moving pictures, so the mall often eliminates the shop window. It is as if mall browsers and window shoppers have now somehow stepped through and into the display windows of the old arcades and department stores and, wandering inside them like Alice in her Looking Glass, there meet animated toys in all sizes, and hallucinatory reflections of themselves. (Gazing into this stream of faces and objects, eyes scanning after each glimmering shape in that pageant flow, somehow we find here the space for a strange new form of reflection.)

Benjamin saw industrial exhibitions like the Crystal Palace as introducing a "phantasmagoria that people enter to be amused. The entertainment industry facilitates this by elevating people to the level of commodities. They submit

to being manipulated while enjoying their alienation from themselves and others."[80] In the same way, inside the glass frame of a mall, the modern-day crowd sees itself as spectacle. The shoppers themselves become part of the window display; they become live models for the latest clothes, spurs to traffic flow, and (when impulse eating at highlighted public tables) suggestive images of the most literal form of consumption. Is this a dissolve of the shop window, or an expansion of its domain? Within the overarching frame of a disorienting glass palace, it is difficult to separate the inside from the outside of a shop, the front from the back of a counter, the public from the private space. But, after all, though the windows are gone, we know that *some* distinctions are kept—money does still change hands.

Entertainment Centers and Themed Developments

Clear examples of the new design concentration on spectacle come with the recent renovations of many old centers. For example, the Stanford Shopping Center in California, a 1950s linear mall with long lines and spare immobile forms, was remodeled in the 1970s using a strongly theatrical approach—with colorful banners and stage-set allusions to Italian arcades. A modern accent on irregularity, asymmetry, and shifts in scale breaks down the old straight lines, and is intended to work as a magnet encouraging off-center shoppers to keep moving. Architect John Field is clearly conscious of the role of spectacle in suggesting the mode of crowd movement (the pageantry here has a certain "class feeling") when he describes the center as "a parade with strong cadence and ceremony."[81]

Another major area for current mall design is the new genre of specialty shopping centers, usually for affluent areas, which do away with the department store anchor to highlight lifestyle specialties such as food, fashion, or entertainment. (With this move, contemporary malls commit themselves even more fully to the mode of shopping as recreation, as an entertainment sealed off from everyday worries, and so relegate more practical shopping for such necessities as drugs, groceries, and hardware to separate, no-nonsense suburban strips, or to new bare-bones warehouse and bulk-buying stores which completely divorce utilitarian consumption from free-floating illusion or pleasurable entertainment.) When the Stanford Center was redone, it reflected this trend by adding smaller specialty shops (stressing fashion) and accenting lifestyle departments in its anchor stores. Benjamin noted that goods began to be called "specialities" at the time of the French world exhibitions; in the 1980s and '90s the term is making a strong return, marking the widespread move away from the ground of department store utility, to further concentration on amusement, on the creation of ambience, on "the experience." With its gift, food, and fashion shops anchored by a complex of theme restaurants or of cinemas, the specialty shopping center represents most clearly the design

reorientation from "the object, the thing" to environmental "effect"—to the "feeling."

One might have expected the recently depressed economy to have had a sobering effect on mall spectacle (which was linked by Bennett to 1950s impulse-buying), but instead the emphasis on "nonmerchandise retailing" has increased. Sensing approaching trouble for the standardized, characterless super-regionals now saturating most available markets, new centers have thrown themselves into a desperate "struggle for distinctiveness."[82] Paralleling the simultaneous decline in the broad-circulation magazine—an evolution from generality to atomization epitomized in the surprising ascendance of new journals for almost *any* hobby or lifestyle specialty—the stress on specialty shop attractions over the formerly central department stores is part of a newly felt need for the "unique," the "different," the "special," the "real." And in the past two decades mall designs have become remarkably unrestrained in deploying all of the tools of mall spectacle in their fantasy recreations of their special themes or unusual atmospheres.[83]

Of course, shopping and amusement had been associated since the time of the arcades and department stores, but in the newest large North American super-projects the connection between the mall experience and cinematic spectacle is stressed as never before. Toronto's Eaton Centre was a prototype for the "destination entertainment centers" of the 1990s, but it cannot compare as a show-biz attraction to the West Edmonton Mall, a merging of theme park and mall, with its 5.2 million square feet of retail space enclosing, in addition to its 800 shops and eleven department stores, the world's largest indoor amusement park, the world's largest indoor water park, a lake containing a full-size replica of Columbus's *Santa Maria* along with rubber sharks and submarines, a large skating rink, thirteen nightclubs, a 360-room hotel, and twenty movie theaters. But now that mall's developers have even topped that, with their Mall of America in Minneapolis—actually four malls under one enclosure, complete with three hotels, multiple office towers, a convention center, a Knott's Berry Farm theme park, and the famous Rainforest Café, with its decor offering consumers a complete sensory experience of jungle life—something like a visit to Disneyland.

Equal parts amusement park and retail center, these new mega-projects are now often designed and run by entertainment conglomerates. MCA/Universal, for example, was able to put all of its moviemaking know-how into making its Universal CityWalk in Los Angeles feel like or represent the atmosphere of spontaneous life on city streets. In the same line, Disney "imagineers" have designed a shopping/entertainment center in Burbank oriented around "the lure and magic of the movies"; Cocowalk in Miami now lures visitors into a complex of Mediterranean villas; and the Sportsplex in Scottsdale, Arizona, offers an "immersive experience" with eight discrete subsections, each themed around a sport—indoor fishing, golf, and so on. In each of these developments, the increasing stress on fantasy and movielike spectacle is reflected in the

inclusion of ever-more-sophisticated people movers and motion simulators, and also in the incorporation of giant-screen IMAX movie theaters as part of the attraction.[84]

The "Feeling" of the Real

But some observers see the post-1980s rise of specialty centers and of these colossal new destination entertainment centers as a symptom of an era of potential crisis in mall development. While many mall designers have been exploring the wildest reaches of illusionistic fantasy, some are clearly beginning to struggle with an opposite, but related, design problem: the need for a *restriction of fantasy*. A nonmerchandise market can be airy, fickle, and vulnerable. Illusion cannot be projected too far from any base, object or anchor— or it may lose its attraction to visitors. Aware of latent unease with mall inauthenticity, with such squeaky-clean newness, with what might seem to be a sort of test-tube life or hothouse atmosphere, many mall developers have moved in various ways since the early 1980s to reinforce the feeling of reality in their productions. One way to do this is to try to accent the mall's relation to the grittiness and unpredictability of real city life. But often the result of this is just an unintentionally funny reminder of the lack of variety, diversity, spontaneity or authenticity in hyper-real mall display. The unsuccessful Herald Center, in New York, themed each of its floors to the typical aspects of well-known city sites—Central Park, Greenwich Village, and so on; Metropolis Times Square tries to rival in its light shows the dazzle of sleazy 42nd street outside its windowless walls; and Los Angeles's CityWalk designers consciously included irregular signage and other occasional allusions to dirt and bad taste in their re-creation of an urban scene. But all of these efforts end up as tame caricatures of lively local color, simply underlining the basic problem. Taking this impulse to its most absurd level is the Bourbon Street development, in New Orleans, which includes amid its displays a collection of mannequins meant to depict the street people of New Orleans. These images of whores, beggars, and drunks in fixed poses along mall walkways only highlight the process by which malls tend to represent city life—to experience it with vicarious detachment as imagery—while in fact excluding it from their realm.[85]

Other related design impulses attempt to tie mall spectacle to local color and history. Seeking some solid regional ground for its illusionistic imagery, the Mall of America goes so far as to incorporate displays of Minnesota's indigenous rock formations and plant life among its other attractions. And several of the leading developers, worried about shopper unease with the generic, look-alike mall form, and about the distance between malls and traditional city centers, have moved since the early 1980s to associate new individually designed mall projects with the renewal of landmark urban buildings—such as Faneuil Hall Marketplace in Boston, South Street Seaport in New York, Harborplace in Baltimore, The Gallery in Philadelphia, Grand Avenue in Milwaukee, St. Louis Station (all by the Rouse Company), and Ghirardelli

Square and The Cannery in San Francisco. In a similar way, a suburban mall, such as Olde Mystick Village in Connecticut, which reproduces—in a Disney vein, but with touches of the Sturbridge Village living history museum—a New England Main Street circa 1720, may now attempt to ally itself with the authenticity of memories of local heritage. Artworks too are often chosen to add the special regional atmosphere that would make the center a landmark. Many of these new efforts at packaging local authenticity have been astonishing commercial successes. But though it *is* producing many richly textured new urban attractions, which attempt to renew old areas without erasing them, which want to open out of sterile mall self-enclosure with more diversity of reference, such an effort to link mall activity with a touristic interest in what designers see as venerable community locations,[86] to wrap new projects in old cultural frames, to achieve that special difference of local color, is here less a pious return than a further advance. In the focus of their economies, most restoration malls reflect the furthest flights of the airy form of nonutilitarian, nonmerchandise retailing (with an almost total stress on food and amusement). If this movement does give the mall a new feeling of history, and does often prevent the abandonment of heritage buildings and sites, it also means that these heritage sites (which were not usually commercial markets in their past) are returned to us as malls—palaces of consumption. At any rate, like other retrospective themes that recur periodically in mall imagery—the Old Orchard garden village, the Olde Mill specialty center, the indoor park look in all its versions—the new restorations are symptoms of an ongoing problem in mall design; they speak for a strongly felt need for some experience of "ground."

This *feeling of the real* is a tricky issue. With the increasing self-consciousness of mall planners, and the unsettling self-reflexiveness of mall spectacles such as Michael Snow's *Flight Stop*, this issue may dominate the next evolutions of mall planning into the next century. Already, in reports of the planning for Water Tower Place, we find that this was a central design question: "Was there any way to make people, once they were there, *feel like* they were in a *real place?*"[87]

Part 3

Waterworks: "Natural" Metaphors for the Oceanic Flow of the Crowd

When the developers of Toronto's Eaton Centre repeatedly remind us that their mall attracts more visitors per year than Niagara Falls, the comparison tells us a lot about the context in which many mall designers feel they are working. The model and rival is a *spectacular attraction*. In the early nineteenth century, Niagara Falls became known as an epitome of the natural "sublime" (an experience the planners now apparently hope to equal in the *engineered natural park* of the mall). And already in the 1840s, Niagara was

seen as the ultimate test of the human ability to harness nature, to *sublimate that sublime power* for the uses of a technological utopia (see Thoreau's review of a project to convert the falls' energy to electrical power: "Paradise (to be) Regained"). But of course the context that Eaton's owners have first in mind is that of *tourism*: they hope for shopper/tourists in the image of those great floods of visitors lured since Erie Canal days by the awesome pounding of Niagara's waters. Somehow the endless flow of tourist crowds is here intimately associated with the spectacular effects of *rushing water*.

Innumerable writers have described their crowd experiences as "oceanic" — associating this flowing feeling either with ecstatic awe or with dangerous self-loss. New to crowds, Gogol finds it hard to adapt his eyes to the kaleidoscopic rush of colors at a fair: "So many people . . . that it made one's eyes swim."[88] In "The Man of the Crowd" — a key text in Benjamin's analysis of the modern *flâneur* — Poe narrates the change in a man who first delights in this new crowd sensation — "the tumultuous *sea of human heads* filled me . . . with a delicious novelty of emotion" — but finally plunges like a Baudelaire into that dark sea, able to come up only for occasional gasps of air.[89] Here the oceanic nature of the urban "sea of faces" figures the self-loss of the midcentury "man of the crowd." The opium nightmares of DeQuincey are a culmination of this sort of vision, as images of his life in London return in horror, now (as in Baudelaire, Poe, Pound) remembered as a sea of separate, helpless passing faces: "Upon the rocking waters of the ocean the human face began to appear: the sea appeared paved with innumerable faces, . . . : faces imploring, wrathful, despairing, surged upwards by thousands . . . : my agitation was infinite, — my mind tossed — and surged with the ocean."[90]

Maybe we're more used to it by now. The idea of a "sea of faces" or an "ocean of people" is a cliché we hear from every sportscaster; we think of it ourselves at every rock concert or parade, and so on. Stressing less the psychological trauma than the commercial "experience," Joan Didion — who once took courses in shopping center "theory" — finds this oceanic feeling central to American mall spectacle, and links this self-"dissolve" with the kind of off-center shopping/tourism that results in our impulse buying: "In each [mall] one moves for a while in an *aqueous suspension*, not only of light but of judgment, not only of judgment but of 'personality.'"[91]

Waterworks are now a fixture of any mall plan. Almost *all* mall designs now have at least one "water feature," notes one architect-critic: either the attraction of a "waterfall display," or the "acoustical background" of a murmuring fountain, or the rest point of a placid central pool (to "symbolically collect the mall branches").[92] We've seen how the Crystal Palace had the effect of an indoor garden, highlighted by the engineering feats of a large system of hydraulic waterworks with a centerpiece Crystal Fountain. And in the appropriately named Water Tower Place, the planners worked very consciously to make their water spectaculars serve as inviting analogies to crowd movement. A dazzling geyser fountain at Eaton Centre seems to combine these essential functions (working as a tourist spectacle, an emblem of sublime mechanical

control of nature, and an analogy to crowd movement). A marvel of engineering wizardry, this indoor geyser sends a fire-hose surge of controlled water many stories high, and then re-collects it all without spilling a drop on the shopper/spectators watching this show from the various levels of the mall. Its clockwork cycle of eruptions is more regular and rapid than that of any natural geyser; this waterwork seems to be set, not to the old faithful cycles of nature's timepiece, but to show time. And while this version of a natural spectacle first attracts crowds to congregate at the mall center, it then also jogs our eyes into movement, leading us to new notice of upper-level galleries, giving us a sense of their closeness with its quick shot. Like Michael Snow's spectacular flight of birds, and perhaps like *all* mall visual effects, shopping-mall geyser displays are centrally oriented to conjuring effects of free-floating, gravity-defying weightlessness with their release in foam: Go ahead, *climb*; why not *splurge*!

Water Displays and the Wishing-Well Mall Economy

And here we verge on a more subliminal theme in some mall water displays. If most work as analogies to crowd movement, many can also be seen as analogies to the mall *economy*. At the second Crystal Palace at Sydenham, the Victorians with their accent on narrative gave the centerpiece of the large system of fountains (a "Cascade Temple") an indicative title: "Abundance gushing from the feet of Fortune." In malls, geyser gushes of abundance are clearly seen to be recirculating systems (reflecting the mall's self-contained economy); the more common and quiet fountain series usually speaks simply for a natural flow. At Eaton Centre, just under Snow's suspended geese, a descending series of small scallop-shaped dishes slowly passes down its murmuring water. This soothing cascade parallels the movements of shoppers on adjacent ramps, and certainly invites a model form of leisurely flow. But it may also suggest in spectacle form the flow of money, from hand to dishlike outstretched hand, and the natural beauty of such release, of letting go to participate in a larger circulating system. (Without the connecting fluid, each dish would be a lone, fixed, outstretched hand.) But there is always a surplus in this fountain's cycle, and each dish quietly passes its overflow on to the next. Nothing remains static here; the display offers an experience of continual motion without reference to any source or receiving end.

The moving waterwheel of a mill, a frequent theatrical addition to mall water displays (and the central trademark of the Old Mill chain), seems an even clearer example of the same effects. These picturesque wheels, turning continually under the power of the artificial current, make the water feature an explicit re-creation of a traditional and more natural economy, and through fantasy place the mall in that mill context. They transport us back to the days when the mill was the regional center of commerce, the place where water power was harnessed for the grinding down of grain, where a refined natural product entered the economy. At base, this wheeling natural cycle has the same effect

as the Eaton Centre fountain series: serving as an aural and visual stimulation to continual flow, and as an image of the economy of interconnectedness (the wheel turns only as water passes from one mill dish to another).

There seems to be a magnetic spell in these water cycles, something that conjures us to let our money flow. We act on this impulse, for example, at collecting pools at the end of fountain systems, throwing money into the *wishing well*. In fact, the wishing well might be seen as a small epitome of the *mall economy in fantasy form* (while perhaps the larger system is itself an economy of fantasy). Each of us throws a playful coin sacrifice in as a private act of faith on an "impulse"—but only a few are aware of how such offerings add up. (Was it P. T. Barnum who said, "Every crowd has a silver lining"?)

In some highly developed malls, which have begun to take on many of the former roles of town institutions (especially for high school functions), the wishing-well economy has gained recognition in ritual form. Kowinski describes one such mall ritual, as it becomes a spectacular attraction in its own right:

> When its fountain filled up with the pennies people tossed in for luck, the mall drew crowds to watch the head cheerleader and drum majorette wade into the water in bikinis and sweep up the coins.[93]

"My mind did at this spectacle turn round
As with the might of waters."

These lines, Wordsworth's "sublime" admonishment and revelation, come near the end of his *Prelude* tour of London's confusion of "spectacles" and "public shows," as he is lost in the passing crowds, and suddenly torn by the agony of one fixed image—the outstretched hands of a blind beggar—emerging out of the festival sea of faces.

Rides: The Arts of Being Off-Center

Nineteenth-century Paris was not only the scene of many indicative developments in the *modes of early spectacle* (panorama, diorama, photography, film)—it has also been, even up to the present day, the scene of many telling new trends in the *modes of crowd movement*. Paris has seen a curious series of tourist styles: the noble, detached eighteenth-century Grand Tour-ist; the leisurely, wandering nineteenth-century *flâneur* (strolling after the picturesque); the overwhelming, oceanic sidewalk crowds of the mid-nineteenth century (that would obsess a Baudelaire or a Poe); and later Surrealist walkers in search of the random, awaiting the unexpected. And from early on, self-conscious Paris seems to have adopted and adapted the tourist's gaze, to have turned it inward on itself. Now even natives are like visitors in their city: constantly on the move, seeking out the pretty, the famous, or the exotic, always pointing to things as they pass. Window-shopping seems here to have extended its realm, to have become the dominant mode for activity in many spheres: the

mode for leisure, the mode even for reflection (as we see in the shop-window photos of Eugene Atget, for example).

Since their creation in the mid-nineteenth century by Haussmann, the crowded boulevards have become a Paris trademark. Mention of the Paris boulevard now conjures a postcard image of that unending stream of tourists, like boat people in a continual flow. Here the *café* is the only side pool, a momentary stay against the river flux; but the nourishment offered in the café is still "of the street": fluid, insubstantial, sending us out recharged with the buzz and intoxication of the sidewalk movement (in their mental effects, these are very fast foods, things we take *to go*). And the classic café structure offers no interior—the temporary café tables and chairs all face in one direction, as in a theater, out toward the spectacle of that passing sea of faces: to the boulevard, our epitome of Paris.

But in fact contemporary Paris seems already to have moved on, to another step: a different sort of flânerie. The new airport, art museum, business centers and metro improvements now speak for a strong fascination with the mechanical toys of modern mass transit. The moving sidewalk, the glassed elevator and the automatic door are challenging the place of the boulevard in Parisian life. In his film *The American Friend*, Wim Wenders uses this new Parisian environment to dramatic effect: after a murder in the metro, the escalators, moving sidewalks, automatic doors and video monitors suddenly mesh to build suspense (we have an agonizing sense of time on a people mover) and to create a powerful feeling of *enclosure*.

As a child, I went wild on escalators, but at the same time I had strongly mixed feelings about them. Of course, rides were the major attraction of any building. I would check them out first thing, and it would usually be hard to get me off. But then the advice of my mother really sunk in, too, and was never absent from my mind: "Make sure your shoelaces are tied, take a little jump before getting off—just don't get yourself caught in those turning cogs."

I still feel the same way when moving in any elaborate system of mall rides: exhilarated but uneasy; feet tingling, but always a little uncertain in my soles. I guess I still take that little jump as I'm getting off.

Remember the unbeatable thrill (and the mechanical jolts) of bumper cars? The modern "art of being off-center" is compared by Benjamin to the Fun Fair experience of riding Dodg'em Cars. And American malls seem to offer the epitome of just such an experience. If only a few actually contain enclosed carnival rides, or have an overall circus tent, all certainly aim for that amusement park feel. Automatic mass transport—in a showy network of escalators, moving sidewalks, and the almost obligatory windowed elevator—is always central to a mall. In fact, a mall's major attractions and spectacles are usually also its mechanisms to keep people moving.

Like the Panopticon's photographic ascending carriage, the windowed elevator and the escalator are mobile vista points, providing a visceral feel for the awesome sweep of a space, forcing a sort of cinematic movement on the

viewer. The people mover makes the rider a spectator. So the mall design stress is on looking; the effect is of a very modern sort of *looking in time* (as in a movie, the view passes by only once).

These mechanical people movers provoke in us a tangle of responses: both the wonder and the terror of the "technological sublime." Where are we going, or being carried? "Things are in the saddle/And *ride* mankind," we might say with Emerson. But modern mall "rides" offer a sensational visual-visionary amusement that cannot be denied. There is an allure to this sort of off-center ek-stasis, which forces us out of ourselves, out of fixity. Snow's flock of Canada geese—a spectacle of natural mass movement that mirrors the mechanical mass movements of a mall's escalators and elevators, which springs to its illusory "flight" as it is seen from those *moving viewpoints*—seems to speak for just this nexus of ambivalence.

Arts of Mass Transit

Can we expect the emergence of a serious, self-conscious art for this modern viewing situation—an art of mass transit, of the people mover, the escalator, the freeway? Will something interesting be done in billboards, in sculpture for the highway median strip or in art displays for those trapped on the moving sidewalks in airports? Malls would seem to be a natural place for new developments. But though many name artists (Rivers, Calder, Dine, Oldenburg, Lichtenstein and others) have shown their work in malls (often installing mobiles or hanging sculptures), not many of these pieces have been designed for this environment, and not many have succeeded in it.[94] Rouse Company's attempts at a "Museum in the Mall" program have been well received; but the company has also discovered a major problem: *"People pass too quickly"* to absorb such museum works.[95]

Paris has also been a scene of revealing experiments in this area. For that long history of crowd movement seems to have leveled many aspects of Parisian life: the lines that flow past monuments and shop windows pass the paintings in the Louvre with the same movement, the same gaze (*Mona Lisa* now seems to smile knowingly with her "sad beauty" at the crowds cocooned in their guiding earphones, as they pass at the set pace of the tour); before the flow of mass transit, the giant frames on metro walls can hold both ads and copies of masterpieces (and often, in self-serious promos, these two are combined). From early on, art in Paris has been face to face with this human flow.

The long effort to confront or react to just such kaleidoscopic crowd feeling on the Paris metro—a Baudelairean situation: the sad beauty of faces passing in enclosed mass transit—led Ezra Pound in 1911–12 to arrive at his famous Imagist poem:

IN A STATION OF THE METRO

The apparition of these faces in the crowd;
Petals on a wet, black bough.

Superimposing the still picture of a flower onto the visual memory of mechanical crowd movement, the poet works here not to paint a picture of the metro scene but to create an imagistic equivalent for it. The metro-forced movement is restructured to collect a movement of ideas: here natural (haiku-like analogy), Christian (the "stations"), and classical (perhaps Persephone's underworld). Through a sort of proto-cinematic illusion of montage, the urban shock of the naked glimpse in time may rise to vision; appearances may reform as apparition; flowers may bloom in enclosure, glowing with their own light in the dark.

A 1979 work installed in the Paris metro continues in this tradition. In a series of large photographs placed along one of the new underground moving sidewalks, the New York artist leads his advancing audience through a slowed-down version of a single cinematic sequence—a dissolve. The series begins with a spare snapshot of a man waiting for a train at New York's 14th Street subway station. This photo is repeated through successive frames, along with the progressively stronger overlay of a second image that finally appears alone—a telescopic view of a constellation of stars (perhaps the Milky Way). In the "plot," then, the subway rider is progressively eclipsed, or spaced out, by a cosmic vision.

Like Snow's *Flight Stop* , this is photographic cinema in its most reduced form. Like Pound's Metro vision, it works by the photographic superimposition of two images. But the piece *uses* its metro context, its moving spectators. And the inevitable gliding progress of the viewers' moving sidewalk (part of the problem?) becomes the means for an illusionistic linkage of separate images; it becomes by analogy *the movement that makes cinema* (a "solution?").

Beginning with a realistic everyday image of the situation of the metro-bound spectator (agitated, rushed, impatiently waiting "in a station of the metro"), the photo dissolve seems to enact a dissolve of self, a radical change of location (the train must have come!), and to suggest a metaphoric connection of self and cosmos (moving from the intensified time of subway waiting to galactic stillness). Finally, the sequence moves to the tranquillity of a larger disembodied vision, presenting a dimension of nature and of time unavailable to humans, except as a triumph of cinematic vision (a triumph of illusionistic continuity, montage, slow motion, and telescopic lens).

Still, cinematic vision is a flip-flop sort of affair; continuity is built out of separate images (and either the continuity or the separation can be unsettling). And the people mover is always ambivalent for us—with our awe comes unease. Whether the metaphor for such escalator movement is classical, Christian, cosmic, or natural (petals or Canada geese), the shopper–spectators who are riding will probably still want always to watch out for their shoelaces.

Notes

1. It is not surprising that Jameson's reading of Portman's Bonaventure Hotel parallels this essay's reading of the Eaton Centre, because both essays appeared in the early 1980s and base their analyses on contemporary exemplars of broad-based trends in architecture, and indeed Jameson mentions the Eaton Centre (along with Paris's Centre Pompidou) as one of the three buildings he had in mind as models for his evocation of the "postmodern." Whether or not we choose to call the Bonaventure "postmodern," what Jameson stresses in his experience of it certainly matches central aspects of what we will find here in confronting Eaton Centre or the modern shopping mall: the sense of the enclosed space as an insular city-in-miniature, a simulacrum of the city turning its back on the urban surroundings; the natural dreamscapes built of interior lakes and greenhouses; the glass roofs and walls defining new modes of reflection; the people-mover escalators and glassed elevators as kinetic sculptures defining new automatic modes of hyper crowd movement, new self-referential narrative paradigms for spectacles received in discontinuity and distraction; and the resulting bewilderment of the consumer or critic, dizzy and ambivalent as he is immersed in a phenomenon that offers undeniable, intoxicating pleasures but that at the same time, alarmingly, seems to make analytical or historical perspective or "mapping" of this cultural transformation impossible.

 See Jameson, "Postmodernism, or The Cultural Logic of Late Capitalism," *New Left Review* 146 (July-August 1984): 53–92.
2. William Kowinski, "The Malling of America," *New Times* 10 (1 May 1978): 30–37.
3. William Kowinski, *The Malling of America* (NY: Morrow, 1985) 20–21.
4. Data cited in Margaret Crawford, "The World in a Shopping Mall," in Michael Sorkin, ed., *Variations on a Theme Park* (NY: Hill and Wang, 1992) 7.
5. Kowinski, "The Malling of America," 21–22.
6. Kowinski, "The Malling of America," 339–42.
7. Sociologist John Carroll cited in Meaghan Morris, "Things to Do with Shopping Centres," in Simon During, ed. *The Cultural Studies Reader* (NY: Routledge, 1993) 307.
8. Crawford, 8–9.
9. DeBartolo cited in "Why Shopping Centers Rode Out the Storm," *Forbes* (1 June 1976): 35.
10. Pelli cited in Kowinski, "The Malling of America," 38.
11. "The Leviathan of Yonge Street," *Maclean* 92 (27 August 1979): 28.
12. Annette Michelson, "Toward Snow," *Artforum* 9.10 (June 1971): 30–37; Manny Farber, *Negative Space* (NY: Praeger, 1971) 250.
13. After a long series of arguments with the Eaton Centre owners about their various attempts to take over and exploit Snow's Canada geese sculpture, to take further advantage of its popularity, and to use its imagery as a purely commercialized commodity—as when Snow objected to the owners' decision to dress the geese in droopy red Santa hats for one Christmas shopping season—Snow finally withdrew *Flight Stop* from Eaton Centre (and began legal action attempting to set important legal precedents in regard to the right of artists to control the uses and interpretation of their works).
14. Michael Snow, cited in P. A. Sitney's *Visionary Film* (NY: Oxford, 1974) 413.

15. Farber, 250; Michelson, 37.
16. Benjamin, *Gesammelte Schriften*, ed. R. Tiedemann, vol. 5 (Frankfurt am Main: Suhrkamp, 1982). For a translation and reworking of Benjamin's notes for the Arcades Project, see Susan Buck-Morss, *The Dialectics of Seeing: Walter Benjamin and the Arcades Project* (Cambridge, MA: MIT Press, 1989). For a good discussion of the progressive uses of the "dialectical image," see Angela McRobbie, "The *Passagenwerk* and the Place of Walter Benjamin in Cultural Studies," *Postmodernism and Popular Culture* (NY: Routledge, 1994) 96–120.
17. These conceptions of natural history and of the dream world of mass culture are brought out most fully in Buck-Morss's presentation of Benjamin's Arcades Project.
18. For a useful thumbnail history of the stages of twentieth-century mall design, see Neil Harris, "Spaced Out at the Shopping Center," in *Cultural Excursions: Marketing Appetites and Cultural Tastes in Modern America* (Chicago: University of Chicago Press, 1990) 278–88.
19. Gruen in J. S. Hornbeck, ed., *Stores and Shopping Centers* (NY: McGraw-Hill, 1962) 165.
20. Gruen, *Centers for the Urban Environment: Survival of the Cities* (NY: Van Nostrand Reinhold, 1973) 37.
21. Slater, "Going Shopping: Markets, Crowds, and Consumption," in Chris Jenks, ed. *Cultural Reproduction* (NY: Routledge, 1993) 198.
22. Eagleton, Terry. *Walter Benjamin, or Towards a Revolutionary Criticism* (London: Verso, 1981).
23. For an excellent, extended analysis of the implications of such "moving spectatorship," see Anne Friedberg, *Window Shopping: Cinema and the Postmodern* (Berkeley: University of California Press, 1993).
24. Hollis Frampton, "Muybridge: Fragments of a Tesseract," *Artforum* 11.7 (March 1973): 43–52.
25. Walter Benjamin, *Illuminations*, trans. H. Zohn (N. Y.: Schocken, 1973): 236–37. In the phrases about "supernatural motions," Benjamin is citing Rudolf Arnheim.
26. Buck-Morss, 268.
27. Dziga Vertov, "Writings," *Film Culture Reader*, ed. P. A. Sitney (NY: Praeger, 1970) 353–75.
28. Benjamin, "Work of Art," *Illuminations*, 251.
29. Benjamin, "Work of Art," *Illuminations*, 250.
30. Benjamin, "Paris, Capital of the Nineteenth Century," in *Reflections*, ed. Peter Demetz (N. Y.: Harcourt, 1978) 152.
31. Benjamin, "On Some Motifs in Baudelaire," *Illuminations*, 186.
32. Stanley Cavell, "Baudelaire and the Myths of Film," in *The World Viewed* (N. Y.: Viking, 1971) 41–44.
33. Charles Baudelaire, "The Painter of Modern Life," in *Selected Writings on Art and Artists*, trans. P. Charvet (London: Penguin, 1972).
34. For a wide-ranging recent study that stresses the development in spectators of such a "mobilized gaze," from early arcades and proto-cinematic spectacles to the modern cinema, see Friedberg.
35. Balzac cited in Benjamin, "Paris," *Reflections*, 146.
36. Benjamin, "Paris," *Reflections*, 146–47.
37. Richard Sennett, *Palais Royal* (NY: Knopf, 1986) 86.
38. D. Frisby cited in Slater, 196.

39. Williams, "The Dream World of Mass Consumption," in *Rethinking Popular Culture*, ed. C. Mukerji and M. Schudson (Berkeley, CA: Univ. of California Press, 1991) 204, 215.
40. Benjamin, "Paris," *Reflections*, 149.
41. Richard Altick, *The Shows of London* (Cambridge, MA: Belknap, 1978) 456.
42. N. Pevsner cited in Simon Jervis, ed., *High Victorian Design* (Ottawa: National Gallery of Art, 1974).
43. Cited in Patrick Beaver, *The Crystal Palace, 1851–1936* (London: Hugh Evelyn, 1970).
44. Benjamin, "Paris," *Reflections*, 151.
45. Babbage, cited in Altick, 457.
46. Neil Harris, "Spaced Out at the Shopping Center," *New Republic* (13 December 1975): 26. Reprinted in Harris, *Cultural Excursions*.
47. This whimsically schematic history is indebted to Harris.
48. G. Baker and B. Funaro, *Shopping Centers: Design and Operation* (NY: Reinhold, 1951).
49. J. S. Hornbeck, ed. *Stores and Shopping Centers* (NY: McGraw-Hill, 1962) 195.
50. Harris, 24.
51. C. Rowe, *Collage City* (Cambridge, MA: MIT Press, 1978) 44.
52. Hornbeck, 188.
53. C. Darlow, *Enclosed Shopping Centers* (London: Architectural Press, 1972).
54. V. Gruen, *Centers for the Urban Environment: Survival of the Cities* (NY: Van Nostrand Reinhold, 1973).
55. Baker and Funaro, 85.
56. Hornbeck, 70.
57. Hornbeck, 75.
58. Bennett in Hornbeck, 145.
59. Bennett in Hornbeck, 153.
60. G. Sternlieb and J. W. Hughes, eds. *Shopping Centers USA* (NJ: Center for Urban Policy Research, Rutgers, 1981).
61. Redstone in Hornbeck, 75.
62. Bennett in Hornbeck, 158.
63. Kowinski, "The Malling of America," 33.
64. Gruen cited in Harris, 24.
65. Sternlieb, 2.
66. Redstone in Hornbeck, 71.
67. Gruen in Hornbeck, 165.
68. Gruen, 37.
69. Kowinski, 36.
70. Darlow, 38.
71. Gruen, 3.
72. "Cities are Fun," *Time* (24 September 1981): 42.
73. Rosann in *Horizon* (September 1977): 48.
74. Kowinski, 51.
75. Gruen, 48.
76. *Architectural Record* (April 1976): 136–40.
77. *Architectural Record* (April 1976): 99–104.
78. The new theories on the psychology of consumption are discussed by Crawford in Sorkin, 12–14. Kowinski, "The Malling of America," 71, 77, 339–42.

79. "Publishers," *The New Yorker*, (30 September–6 October 1980).

80. Benjamin, "Paris," *Reflections*, 152.

81. *Architectural Record* (April 1976):105–8.

82. All citations from Sternlieb.

83. *Architectural Record* 165: 71, 117–32.

84. "That's Entertainment," *Newsweek* (11 September 1995): 72.

85. Crawford in Sorkin, 27.

86. Ibid.

87. Kowinski, 36.

88. Gogol cited in Benjamin, "Some Motifs in Baudelaire," *Illuminations*, 197.

89. Edgar Allen Poe, "The Man of the Crowd," *Selected Writings of E. A. Poe*, ed. E. H. Davidson (Boston: Houghton Mifflin, 1956) 132.

90. Thomas DeQuincey, *Confessions of an English Opium-Eater* (Harmondsworth: Penguin)108.

91. Joan Didion, "On the Mall," *The White Notebook* (NY: Simon and Schuster, 1979): 183–84.

92. *Architectural Record* (February 1979): 117–32.

93. Kowinski, 34.

94. *Horizon* 20 (September 1977): 14–25; also *Nation* 218 (23 March 1974): 382.

95. *Artnews* 78 (January 1979): 17–18.

Contributors

Rey Chow is a professor in the Department of English and Comparative Literature at the University of California, Irvine. She is author of *Women and Chinese Modernity: The Politics of Reading Between East and West* (1991), *Primitive Passions: Visuality, Sexuality, Ethnography, and Contemporary Chinese Cinema* (1995), *Writing Diaspora: Tactics of Intervention in Contemporary Cultural Studies* (1995) and, (in Chinese) *Xie zai jia guo yi wai*, a collection of essays on Hong Kong culture (1995). She is currently working on a manuscript titled *Ethics After Idealism* (forthcoming).

Maria Damon teaches poetry and cultural studies in the Department of English at the University of Minnesota. Her publications include *The Dark End of the Street: Margins in American Vanguard Poetry* (1993), and articles in *Cultural Critique, South Atlantic Quarterly*, and *Cultural Studies*. She is a member of the National Writers' Union.

The Emmenagogue Sisters are also known as Emilie L. Bergmann, who teaches in the Spanish Department at the University of California, Berkeley, and Charlotte C. Rubens, who is head of Interlibrary Services at the University of California, Berkeley, library.

Jean Franco is Professor Emerita in the Spanish Department at Columbia University. She is author of *The Modern Culture of Latin America* (1967), *An Introduction to Spanish-American Literature* (1969), *Spanish-American Literature Since Independence* (1973), *Cesar Vallejo: The Dialectics of Poetry and Silence* (1976), *Plotting Women: Gender and Representation in Mexico* (1989), *On Edge: The Crisis of Contemporary Latin American Culture* (1992), and *In Other Words: Literature by Latinas of the United States* (1994). She is currently working on a book titled *Disputed Territories*, and is also general editor of a series of translations of nineteenth-century Latin American writing. In 1996 PEN awarded her the Gregory Kolovakos prize for her work on Latin American writing.

Peter Gibian teaches American literature and culture in the Department of English at McGill University. He is author of *Oliver Wendell Holmes and the Culture of Conversation* (1997).

Tania Modleski is Florence R. Scott professor in the English Department at the University of Southern California. She is author of *Loving with a Vengeance: Mass-Produced Fantasies for Women* (1982), *The Women Who Knew Too Much: Hitchcock and Feminist Theory* (1988), and *Feminism Without Women:*

Culture and Criticism in a "Postfeminist" Age (1991); she also edited *Studies in Entertainment: Critical Approaches to Mass Culture* (1986).

Dana Polan is a Professor of English and film studies at the University of Pittsburgh. He is currently on leave to direct the Paris Center for Critical Studies, a study-abroad program for advanced students in the areas of film history/aesthetics, literary criticism, critical theory, and contemporary philosophy. He is author of *The Political Language of Film and the Avant-Garde* (1985), *Power and Paranoia: History, Narrative, and the American Cinema, 1940–50* (1986), and *In a Lonely Place* (in the British Film Institute's Film Classics series).

Mary Louise Pratt teaches in the Departments of Spanish and Portuguese and Comparative Literature at Stanford University. She is author of *Toward a Speech Act Theory of Literary Discourse* (1977), *Linguistics for Students of Literature* (1980), and *Imperial Eyes: Travel Writing and Transculturation* (1992), as well as essays in *Writing Culture: Race, Writing, and Difference; Literature and Anthropology; Colonial Discourse/Postcolonial Theory; Amerindian Images; Callaloo;* and *Nineteenth-Century Contexts*.

Renato Rosaldo is Lucy Stern Professor in the Social Sciences at Stanford University. He is author of *Ilongot Headhunting, 1883–1974: A Study in Society and History* (1980) and *Culture and Truth: The Remaking of Social Analysis* (1989). He is currently working on a study of cultural citizenship in San Jose, California.

Gene Santoro is music critic for *The Nation* and the *New York Daily News*, and is a regular contributor to *The Atlantic Monthly* and *FI*. His first book of essays is titled *Dancing in Your Head* (1994); a second book of essays, *Stir It Up*, is forthcoming. He is currently working on a biography of Charles Mingus.

Other active members of The *TABLOID* Editorial Collective for various periods of time between 1980–1985: Ramesh Balakrishnan, Bob Buika, Ed Cohen, Chris Cullens, Dennis Deschene, Gary Dmytryk, Hugh Gurling, Harry Hellenbrand, Ron Imhoff, Annie Janowitz, Mary Klages, Wahneema Lubiano, Kathleen Newman, Ric Paulson, Ken Pottle, Laura Rigal, Thomas Richards, Jeffrey Schnapp, Jon Spayde, and Sue Zemka.

Index